MAKE UP YOUR

MIND

ENTREPRENEURS TALK ABOUT
DECISION MAKING

By Ann Graham Ehringer

Merritt Publishing
A Division of The Merritt Company
Santa Monica, California

Make Up Your Mind

First edition, 1995
Copyright © 1995 by Merritt Publishing, a division of
the Merritt Company

Merritt Publishing
1661 Ninth Street
Santa Monica, California 90406

For a list of other publications or for more information, please
call (800) 638-7597. In Alaska and Hawaii, please call
(310) 450-7234.

Library of Congress Catalogue Number: 95-073597

Ehringer, Ann Graham
Make Up Your Mind
Entrepreneurs talk about decision-making.
Includes index.
Pages: 374

ISBN: 1-56343-101-7
Printed in the United States of America.

for ALEX WADE
and LOGAN GRACE

Contents

MAKE UP YOUR MIND

Acknowledgments ❧

This book describes the common themes and recurring patterns in what sixty entrepreneurs said about their strategic decision-making. It is highly collaborative, a synthesis between the entrepreneurs and me, created in a series of personal interviews about their business careers. I am greatly privileged to have shared their thoughts and reflections. Its original and lengthier version served as my Ph.D. dissertation (and even that barely plumbed the marvelous data from those interviews). In the five years that have passed since my interviews with these entrepreneurs, their words and stories have lost none of their freshness or power; it is a joy for me to re-read them. My thanks and abiding respect to all and each of them, again, for participating in this project with me. And my thanks again to the intellectual mentors who were so important in that earlier process, and whose work remains the standard to which I aspire.

Among the CEOs with whom I am privileged to talk frequently, those whose continuing interest and conversations have been especially helpful include Jan King and the other former and current members of TEC 81 and TEC 56. It is a privilege to think aloud with each of them, as well, and I am grateful for the strength of our ties.

To Lakin Graham Crane, Wade Graham and Albert Ehringer—my daughter, son and husband—my most grateful and loving thanks for their unfailing interest and encouragement to take this next step with these marvelous stories. Wade's intellectual

Wade's intellectual counsel and editorial expertise were very important influences in the earlier version; his vision of that as this book was pivotal.

Even with all of that support, this book would not have been published now without the patience and persistence of my Merritt editor, James Walsh. I am grateful for Jim's persistence, resiliency and the pleasure of working with him. Jim says that what sustained him was the power of these stories. I think you'll find them equally compelling, thanks to Jim's insistence that I get this done.

One other note of acknowledgment, this one in the sense of awareness: I have chosen to use the pronoun "he" as the generic descriptor of both the women and the men in this book. Just because it's simpler. In my roles as chairman of boards of directors and groups of CEOs, I choose the same generic term, chairman, for the same reason—simply clarity of a role in which gender is irrelevant.

Ann Graham Ehringer

Malibu, June 1995

Introduction ✍

The ability to make good decisions is the defining quality of our lives. No matter what our culture, nationality, religion, economic circumstance or level of intelligence, the every-day decisions we make in the contexts of our every-day lives determine what our lives will be. The effects of our decisions define us.

As we come into the turn of the century, when change is more and more the only constant in our lives, the task of making good decisions is more crucial than it has ever been. Accelerating change and recurrent crisis, turbulent economies, uncertain social mores, even our lengthening lives, demand better decision-making. In business, where the lightning pace of technological change and increasing competition casts our products and services into obsolescence almost before our prototypes are in production, the consequences of our decisions determine success or failure.

In a general sense, in our common sense, we know that. We also know, in a general sense, how to make good decisions. We are taught from earliest childhood, by both precept and example, to think of the consequences of what we do—to look before we leap, whether off a bridge or into a relationship or into a business deal. And yet, for many of us, for even the best and brightest among us, our decisions often are not good and frequently are distressingly bad, leading to consequences we never intended and do not want, and down paths from which there is no easy return and often no escape. We need look no further than today's newspapers and business journals for examples of well-intentioned decisions gone awry, with consequences unconsidered and would-be gains lost. "I know better," we say to our-

selves; "I should have made the decision more carefully; I should have considered this factor or looked more closely at that one; I should have listened to my gut; I should have...."

What is missing? What is the difference between what we know about good decision-making and what we actually do about it? Why do we understand the general rules of what works and often do not follow them? Or when we achieve the objectives we have sought, why are we often unsure of what led to success other than our companion Lady Luck? What intervenes between our knowledge of good decision-making and our doing of it? This book is a description of that intervening quality.

Its story-tellers are a group of sixty entrepreneurs whom I was privileged to talk with about the strategic, or turning-point, decisions in their business careers. What emerged from our talks was a prescriptive, composed of their many stories, about the importance of an awareness of self, or what I am calling *awareness of mind*, in the making of good decisions. Hence our title, MAKE UP YOUR MIND.

This awareness of mind encompasses knowing *why* we make decisions—which is to say what ultimately drives us, and knowing *how* we make decisions—especially what are the patterns and processes of our thinking in decision-making.

The sixty entrepreneurs whose stories describe the importance of this *awareness of mind* in decision-making are all successful business people, founders and heads of small and mid-sized companies. At one time or another in their careers all of them had experienced the roller-coaster of ups and downs—of triumphs, crisis, disappointment, difficult decisions and regrouping—that is standard operating procedure for business in the 1990s. All had learned to reflect on those experiences with clarity and insight.

Our talks about the key decisions of their careers were informal, unstructured, discursive and opportunistic. Guided by my interest in the why's and how's of their decision-making, I listened as they described their careers, beginning with the influences of families and

educations and first jobs, and as they recalled the decisions that in retrospect had been turning points, leading to who and what they were today. It was my research intention to let the entrepreneurs speak for themselves with as little input from me as possible, and I tried to listen as much for their benefit as for my own. My role in this exploration—as initiator, as occasional questioner, but principally as active listener—helped to create meaning in and of their introspection and recollections, and to clarify connections among them. I was in a sense *mapping* their recollections—seeing, describing, reflecting their introspections about why and how they had made turning-point decisions.

The purpose of this book is to share that map and what we learned from it, by describing the common themes and recurring patterns among their recollections through the compelling power of their own words. As you read the excerpts from their interviews you will find what emerges is that the key to making better decisions is awareness of self, *awareness of mind*:

- understanding the *process* of your thinking,

- understanding the *patterns* of your decision-making—how you use analysis and respond to emotion, how you hone and honor intuition, and

- understanding your *personal principles*.

You will hear yourself talking again and again, discovering something about yourself in their words. My hope is that you also will develop insight into your own *awareness of mind*, and through that aware-ness—that ability to make up your mind—be able to make decisions that will create the quality of life you want to have.

You'll find the words of these entrepreneurs in two forms in this book.

The common themes and recurring patterns of their decision-mak-ing are presented in short excerpts in chapters about decisions, pat-terns, tools, influences and purposes. The entrepreneurs' excerpts are presented in italics. The first few words of each new speaker are highlighted in boldface.

Alternating with these chapters are independent stories of seven entrepreneurs. These are taken from far longer interviews. As are the entrepreneurs' excerpts, their stories are printed in italics. Specific names, times and places have been removed to assure each speaker anonymity. (Selecting these seven was difficult; all of the sixty interviews were good reading and instructive about the turning-point decisions of entrepreneurial careers.)

There is no necessary sequence among the chapters. This book is meant to be read as discursively as it pleases you. We begin with an entrepreneur's short story. Then, in metaphor and some demographics, we learn something about the people whose voices appear throughout the book. Following the last of the entrepreneurs' short stories, we conclude with a summary of their decision-making recollections and discuss the mythical "typical" entrepreneur.

Finally, in three appendices for the academically inclined, we review some of the relevant literature on what an entrepreneur is, on decision-making and on the nature of entrepreneurial strategy.

1 ❧

Over My Head
Every Three Years

I only got a high school education. I never did go on. I just had the trade school. I worked nights a lot for ten years, so I wasn't exposed to sales and [marketing]. I feel like I've learned everything the hard way. So, I'm not really a big joiner about a lot of things. I haven't been involved [in deals] with other businessmen. I wasn't even active in industry associations.

I thought a couple times about going back to school. But the nature of the business [is that I have to] spend so goddamn much time here.... Maybe, if I could have learned to manage my time better, I could have gone back to school.

Business was something I always wanted to get into. It wasn't necessarily just business—I wanted to be successful. And, if you want to be successful, I believed you had to be in business. I decided [these things] at a very young age. I thought that was pretty normal, [but] I found out that's not as normal as I thought.

I came from a farming community, a small town. Farmers are basically in their own business. But [in our family] my uncle got the farm. My dad didn't. So I had to decide what I wanted to do. I needed something to get a better job than digging ditches and working on the farm. I went in the service and decided to get a trade.

When I was in high school, I liked drawing. Technical drawing was pretty easy for me. So, when I went in the service, I decided [to apply] to be a technical illustrator. I was going to get the trade to go on to school as a technical illustrator. That job had a very small [admissions] rate. After sweeping and swabbing the decks of the ship I finally got it. I accomplished that and I was doing geographs and similar stuff at a Naval Training Base.

I thought about going into some engineering field because my math was really good. But I got married instead. And I came out of the service and there weren't any jobs there. But I didn't want to go back home. I was 21, so I came out west and started at [a technical publishing company that did] a lot of commercial aerospace technical catalogues. I was assigned to an important defense project and ended up working 80 hours a week.

Once I was in [this business], I became kind of a workaholic. Within my first year, I had 30 people working for me. [My supervisors] put me in charge and just left me alone because they had so many other [projects]. I was making good money but I said, "If I'm going to work this hard and I'm going to be successful, I want to do it for myself."

I probably could have been happy being successful as an engineer or in a computer field, [but] having my own company always meant a lot to me. I ended up going in business when I was 25. I didn't have any kind of contact with any kind of sales or marketing. But I left [my first job] for more money—went to [another technical publisher. Eventually,] I met a guy—the art director—who said he wanted to go into business. He had the contacts with customers. [I told him] I was either going into business or back to school. So he said, "Okay, fine. We'll go into business."

We more or less started in a garage with nothing, he had a contact with [a major defense contractor to do technical illustrations and handbooks]. I did the work at nights and my partner picked it up [in the mornings]. Gradually, we got other contracts. We moved to a little bit bigger building and we started doing more photo work because [that met] the customers' needs. We had been jobbing out photo work—we would do the art work and it would go to a photo shop. So our decision-making process on that was just seeing an opportunity and filling it. We said, "We'll buy our own camera and do it ourselves."

We were pretty successful the first two or three years. Every opportunity we saw, we put more money in photo typesetting and [other technology]. I always wanted to be successful in business, now I was finding out how hard it was to be successful. We assumed that we were going to do good because our sales were going up and we were getting more customers.

The only problem: [My partner] didn't do anything. He just hired a couple of liaison people and sat back. And I was still running everything, working 80 hours a week. [My partner] was kind of a classical entrepreneur. He liked to start things but he didn't want to do any work. Eventually, I bought him out. I finally finished paying him off about four years ago.

Sometimes, it seems like the longer you're in business the more unsuccessful you feel you are. Because you start with nothing and you see things grow [very quickly at first].

When you're making money, [decision-making] has a lot to do with what feels right. You'll go for the whole world, if you think you're successful and making money. If you're an entrepreneur, it's just human instinct to keep going when you're successful. The only thing to hold you back is cash flow and losing money.

I've invested in all kinds of things. Right next door [to us] was a waterbed manufacturer. It wasn't doing too well. Along the line, we got involved in that and invested some money in it.

Then, when the first cash flow problems hit...for both businesses at the same time, none of us had any financial background to get us through.

[We'd just] grown and added people with no controls. Both companies had a negative net worth. We couldn't pay our bills. I think most business people go through [this kind of trouble at some point], unless they have a financial background to begin with.

I knew that eventually we were going to have some problems. [My partner's] philosophy was to have a business so he didn't have to work. He loved to hire people. He almost treated me like an employee. So, we had to bring in another partner.

We had incorporated ten years earlier. Right after the waterbed maker deal, we brought in another partner because he'd been involved with [that company]. I thought that was okay because I started to see how I could leverage this other partner and get control. He was a 25 percent partner. The rest was split 37.5 percent for each of us.

We were jointly running the businesses, which was a mess. So, I talked to [my original partner] and said "Look, you go and take care of the waterbed company." Even though that was a good business, I wasn't going to run both. I wanted to at least retain what I knew best—which was the drafting. So, he went over and ran [the waterbed maker].

When it really started getting problems was right after he moved over [there]. We bought out that other partner, so it was 50/50 again. I started making money right away. I took over management and finance. The hard stuff. I started doing book work...payables and everything. I learned I could turn a place around.

But [my partner] continued to have cash flow problems. So he kept coming to me for money. It created a problem...and then he came to me with an SBA loan. I thought about going over and running the other company. But we split everything 50/50 and [I feared] he would just take off if I was running that thing.

I finally cut him off from any more funds from [our technical publishing company]...kind of diplomatically. He had enough problems at the waterbed maker. I said, "You're not going to drain my company." He went and got an SBA guy to come in. I didn't want to sign an SBA [loan] for the [waterbed] company. I said he could have it. But he needed

the assets in my company to get his loan.

I started to leave and he said, "Wait a minute," because he didn't want to be stuck with both companies. I ended up selling my shares [in the waterbed maker] to him for a dollar. But I really screwed up because I should have made some kind of deal with him on the [publishing company] stock. He got about a hundred thousand out of it. That was a lot of money in those days.

We kept doing real well at my company. Sales kept going up and everything. He had enough [money] over there for about a year...he was able to keep going. Then he came back and wanted some income out of [my company]. We voted him out of the corporation.

I said the only way he was going to get money out was if I bought him out. He said he wanted two million, I said he could have three hundred thousand. Then he ranted and raved, we worked out [a plan in which I'd pay him something for] five years. I knew if I gave him a cent of any kind of dividend or income he would keep his shares forever. So, we finally came to an agreement; he bought out on the high side. He was bought out nearly ten years ago.

Right after I [bought him out], I expanded and got over my head again. I made the decision to get more into [high-tech] printing. So it seems like a twenty year program. It's like every three years I take care of something. I get myself in over my head about every three years.

I don't think [my partner] was a very good business manager. Toward the end, he really wanted to keep me as a partner because he started to see the light—he couldn't sit and do things. He was great at planning things, saying, "Let's go do that...you're in charge." And then he'd disappear.

In fact, the decision [to buy him out] was made a long time before the action. It was just the nature of [our partnership] that it took longer to execute. A partner was all right in some circumstances. I think in real estate, certainly. They work well in investments because those aren't ongoing working relationships.

He kept the waterbed company. At one time it was doing—I think—$7 million in sales. He kept that going for quite a while. And he tried selling it several times, because he ended up getting pretty good money [from my business] and so he thought he could do the same with that.

No matter what people think about the waterbed industry, it's a hell of a big [business]. A lot of major companies [got in it. My partner] kept trying to get people to run it...making deals with them. He's a good salesman. He'd say, "You manage this place and do well and I'll give you a cut...you'll end up owning it."

But things never worked out [that way]. He hit some fluctuations in the market and he ended up giving the company away. For just about nothing. The last I heard, he'd gone to Arizona. There's a lot of aerospace setting up there. He went to work for some other shops. I know the guy wouldn't go to work for anybody unless he got [a lot of money]. I think a person has a tendency to go back on what they remember and know best, and the graphics business was it.

Today, it just feels like I'm starting all over again. And then I usually say, "Okay, now I'm going to make some money for me." And I expand—buy another building or a huge press. Go through all the pain of losing money to try to get it back up.

When the decision [to buy out my partner] came...and we split up, I was able to turn around [the technical publishing] right away. My confidence as a manager and of controlling the numbers came up. I knew that I could run it myself and that I didn't need a partner.

[I like talking to the other entrepreneurs in my peer group. It] isn't necessarily about direct advice. I like finding out how other people treat their business problems. You start talking to people. If they trust you, they start helping you do the deal. That means a lot to me. There's so much bullshit involved in that that you don't get real answers from people.

Coming from a farming background, I believed in owning real estate. I just believe in owning real estate. I had a house in [an expensive neighborhood], which my ex-wife got. As soon as I got the divorce, I scrambled

and bought the four acres in [a trendy semi-rural area] right away. Then I ended up buying 35 acres, which I sold because I needed it for some payments.

I've always wanted to own my own property, buildings and everything. [At one point], I was strung out in four buildings. I wanted to get it together in one building. A couple times I had buildings available, [but wasn't able to move because] bigger companies took them. But I didn't like the vulnerability of a landlord having control over me. The nature of my business is that I end up putting a lot of money in these buildings.

[So, buying this building] was easy. A lot of those decisions were planned. Coming into them, I might have handled them [badly]. I could have gotten myself in a lot of deep trouble. It just about killed me, moving to this place. You don't see it all—but there's about $128,000 worth of electrical work, just to hook up all this stuff. And $80,000 just to plumb it...ditches running through here. So, I leased this building with an option to buy it. Luckily, the building was on the market for like eight months. The owner was willing to lease it and give me an option to buy at market.

If I'd known how many problems [there'd be] financing and leveraging, I might not have exercised the option. But I said "Hell, I've got the option...." I exercised it, and then figured out how to get the money. These are things that you want to do, and maybe luck—though not all luck— makes them work.

[The drive for success] probably goes back to your family. [For me, it was] where my dad came from—not getting the farm. He wasn't a success, so I had to be the success. I think every entrepreneur—everybody in business—was pushed to compete against something or somebody...to measure up.

I looked at it as not having any choice. I buy the building. I'm doing six million a year in revenue. I just add a hundred and forty thousand a year on debt service...more than ten thousand a month. How am I going to service this debt?

At six million I've got a graphics department that's in a stabilized condition. The aerospace work [means] two hundred thousand dollars a month...maybe three million a year. I've got a color processing lab, that I can grow. It does fifty to a hundred thousand a month. I didn't do a lot to make that grow.

If you look at my equipment, it's not that unique. I'm probably in the upper 10 percent of local printers. But [one competitor] across the street has about $13 million a year in revenues.

I've got a five color press that is basically ten years old. It's not computer controlled, which would make things go faster. [Printers who have computer systems] can set the press up and change colors and everything by the turn of a handle. We do a lot of press checks. The artists come in and look at it...and everything else.

We're hampered without a computer controlled press. There are five or six other printers right in our ballpark that have computer controlled presses. So I bought the space and we maxed out on the five color press—two shifts. The next step was another press. It didn't have to be six color with a collator...it could have been a five color. But what's the difference between three and four hundred thousand dollars?

I ordered it in July, right after I bought the building. It came in November and it really didn't get operational until around February. The plans with the press had been in the works. That was always our next step. For three years, we knew exactly what we wanted—between my printing manager and the sales manager. We could have done some other things in pre-press.

I bought the building, signed the building in July, ordered the press, and then had my worst loss ever. I lost eighty thousand that month. I do all that—buy the building, my debt service goes up...and I have the worst month. [We're positioned] to make money when we do close to a million [dollars a month in revenues].

Right after I moved here, about three and a half years ago, we kind of started pushing printing again and it was losing money. I just got sales

up where our service went down on our new building. We got past all the payments. I was losing money on printing and so the issue kept coming up, "Why are you losing money printing? What's your cost? Are you getting cost analysis? You need more financial help. Do something about that."

I didn't know what to do, so I called [a financial consultant]. I said, "This is the kind of stuff you do. You've got the expertise. I'm putting it on you now, what should I do?" This is about two years ago. [The consultant] came in and set up a costing on the printing. We didn't even know exactly how we did with these jobs. I tried to make some sensible decisions.

I get all my data and then send it over to [the consultant]. And then he comes in and we have a cost estimate. Then we have a meeting with the printing manager and the production manager. We sit down and go over all the jobs. We find out where we are—whether we're estimating to the right mark. Our primary issue is sales right now. We lost one salesman and are a little bit behind the curve. We had a fantastic March and then the whole industry just really went slow. But there's business somewhere.

The other thing that's more sophisticated: the financial aspects. That's gotten a lot more complex [and] nothing's going to happen unless the financing comes in, anyway. That could have been a problem with this building, if the financing hadn't come in. I exercised an option based on a three-way trade, and I could have had trouble with my bank going along with it. I'd be getting into deep legal problems, if it didn't. So financing could have created some big problems.

I'm not learning the business by myself. I've got a lot of help here, I've got a lot of good people. I started instruction myself in meetings with the departments. Now, I've got to simplify things. I meet with each department on a regular basis...an hour a day. It's all scheduled. Tuesdays, I do the color processing. Tuesdays I also get the sales from the previous week. The photo service is Wednesday.

I talk to the department managers, [find out] how busy they are, what's coming in, equipment issues, etc. I've got a note pad at every meeting, so I just take notes—what the sales are, what we're doing, and then I keep

a record of every meeting. I may change this to every two weeks because I'm getting a little better at running things.

I track the monthly sales. I can get that from the books, but it's usually when you're sitting there talking to a department manager and then go over it with them that you really find out what's happening. I kind of took it one step farther because I started a production meeting. I got the graphics manager to start a production meeting with his people. We've got some of that going in printing—I'm involved more there [but] eventually I want to get out. I structured these meetings with people talking about equipment, what we're doing. Then I started monthly management meetings with the whole group.

Another stupid thing I'm involved in is the PAC—the project area committee for redevelopment. My building is in a redevelopment area. The process in politics is just sitting there, you make impact after being a survivor. If you're one of the survivors, you impact it by your vote. This is strictly self-interest because these are easement streets here. It's redevelopment, and nobody voted against this area getting repaved. So the streets are getting repaved. [My goal is to] take care of my real estate.

I've got a profit incentive plan. I've been doing it about four years. 20 percent of pretax profit goes back to managers. I generally make the managers take 50 percent of it at least...but they have a lot to say about how they use the money. But some percentage gets kicked back to the office staff. I can leverage that. Instead of giving raises sometimes, the bonuses work.

I think a lot of small companies try to give some kind of incentive. If you're in an industry that's going through some rough times, this can be hard to do.

I don't have any policy about six month reviews or annual reviews. All that means is an employee can run costs up and say "Where's my raise?" So we don't do any reviews. There's no guarantee. The business is competitive and I've got to keep people busting their ass to get more money. [There have been] massive layoffs in the aerospace industry, the marketplace has set lower graphics prices. A lot of shops are going out of business. I haven't had anybody ask for a raise in three years. Every-

body expects more money every year—business doesn't support that anymore. You've got to tell people that they may never get a raise because the bottom line isn't that good.

My immediate plan is to get it to ten million and then see how happy I am with that success. But I have been thinking along some other lines. I've got some property out of the country. I wouldn't mind doing something with that. I've always liked it there.

I'm pretty well committed to this business and these people. I've got people who've been here fifteen years, my key people. But I've got to have some out from the printing business, because it can wear on you. You can never be successful where you can kick back a little bit. You're always on the run. You never know what's coming in.

Sometimes my [friends are] concerned about me because I've got such violent ups and downs. I'm taking better care of myself. I went on a vacation right at fiscal year-end, which was really the wrong time to go.

The toughest decisions I've made have been firing somebody. I don't know which one was the toughest. It gets easier to fire people as you go along—it has to be done. I guess the single toughest decision was telling my partner it was over. We kind of pushed him out and that's kind of the same thing as firing someone or breaking off a relationship.

You've made the decision...it's just giving them the news that's so hard. I know some people just can't do it. But, if you're going to be successful in business, you better learn how to do it—or you won't be in business.

It was like he didn't understand. I said, "I don't want to be in business with you anymore." It had come to that. And that hurt his feelings. And then—he was a big guy—he was threatening violence and a whole bunch of other things.

The last person I fired was a department manager. After we moved, we started pushing our workload. He was good for up to about a hundred thousand in sales [a month]. Beyond that, he just wasn't good at keeping track. He'd been with me about ten years. He was a good guy, working up from pressman. And there's more to it—his boy just got diabetes.

I made the decision, but I didn't do it fast enough. You've got to make the decision and do it the next day, while you're warm. I thought about it driving back and forth to work. I was preoccupied by it, dreaming about it waking up—all that. In the end, it wasn't that bad. I don't have an ulcer and I'll never get an ulcer. Other people worry about things a lot more than I do.

Generally, I can't afford the time to get away from things to make big decisions. That's why I like [the semi-rural area where I live]. I like the driving. And I don't believe in phones. Driving is free time. I can think about things, get my head clear.

There aren't other companies like this—with three major divisions that sell the products [we do] and make money. The graphics business and the printing business are very specialized. Most printers, if they have any typesetting, work with just a couple of artists. It's like separate companies. There is a little bit of overlapping but they're sold as separate. They've got to support themselves. I used to have a division which was commercial work. But it was small, [so] I got rid of it.

Printing this year is tough enough that maybe I shouldn't even have the three divisions, [but I'm sticking with them. In one part of the company] we're doing more business than we expected. We knew where our break-even was going to be even before we went in [but we didn't expect this much business.] That's frustrating. We didn't manage that very well with the sales department.

But I had notorious startup problems with the press [we're using for that account]. The attachments that had to go on it didn't work right, and a bunch of other things. We ate two payments of $60,000 in the start-up process. In the meantime, I hired two salespeople that came on board before the press even came in.

We had all the work, but not all the equipment. It pissed off all kinds off customers...we couldn't get the work done on time. In March, we had a record month because everything was built up. We thought everything was going to keep going like that. Well, then it went way down. So we're behind the current, but that's kind of the way this business works.

There's a certain amount of financial planning you can do. [Our accountant] gives us the break-even on everything, and what our net is going to have to be. When we get that figure and say, "We're going to have to do $20 million to support this [project]," I have to look at it and say, "No way, we can't do that." But we know our competitors are growing.

When you add on another press, it's a big leap. You have to look at it as making a decision and then making it work some way. I think a lot of my gut feelings now. That isn't the way they teach it at school—they say "Do your projections. Do your market research," and all that. But I trust my instincts.

If the goal's there—even if there are major setbacks—you can succeed. It's by sheer deciding you're going to make that goal and then convincing everybody else in some way, that you can make it.

How do you measure [success]? When you get it, you just look around and say to yourself, "A lot of people are a lot more successful than I am. I'm supposed to be just as smart as they are." So how much more effort do you want to get to the next level? I'm supposed to sit here fat, happy and successful. For what it's worth, I haven't.

The major setbacks have not been about buying the equipment and everything else; they've been about the people and managing people. That's where I have more major decisions and problems. We're getting more sophisticated by hiring better people.

I think a lot about how to motivate people. That's a tough issue, too. We have a newsletter [in which] we highlight people who've done good work. But that's my other frustration. I don't know if I want to keep doing that—it's just something I had to learn. I don't feel I'm very good at it. Dealing with so many people takes a lot out of me.

I meet with three department managers plus four sales managers on a weekly basis. Plus my administrative assistant. Those are my key people. I've got a lot of respect for a lot of my people. The printing division is more of a problem—that nibbles away at me. I make a lot more decisions in there, I dictate it on them myself. I've got a separate office in

there. I'd been out of it completely and had it turned over—but that didn't work. I go in and see every job logged in. I do a lot of stuff in there—I keep a schedule of what's coming a day or two away.

Now it's more set up like a conventional business. The division's marketing, sales and production are separate. I work a lot on getting the production squared away. I set up a lot of the systems in there and I'm very involved in the hiring process. I interview the salespeople. I was at the last weekly sales meeting. I'm more involved in that because all that's so critical right now.

That's what I think about when I'm driving around. What else can I do to help because it's not working. Let's get it turned around. It's a matter of time. And, when it comes down to it, the owner's got more impact than anybody.

How I deal with people has changed. I used to try to do a lot of things on a one-to-one basis. That was based on the pretense that if I have a one-to-one connection with the department manager, he's going to have a one-to-one connection with each of his people. Actually it doesn't happen like that. A lot of things don't get past the manager. He may not be good on a one-to-one basis—he might not even be a good supervisor. He might not even be a good manager. He might not want to do that.

So, [my new rule is] if the division's making money, my involvement is a lot less.

Even so, I try to know a lot more people in there because I want to understand and have a lot more backup. I want to set something up for some transition if something happens to [my senior people]. Because I don't like speaking in front of a lot of people, I find that [I'm not strong at] motivating a lot of people. But I've been doing more of it. You give more people information, you get more accomplished and you get more control. I've learned that you've got to come in with a lot of confidence and a lot of enthusiasm...or you're not going to get [what you need done]. You've got to do that, [but] it's hard for me to do.

I wanted to make my first million before I was 25—at least by around 30. I thought that would be neat, because a million dollars was a lot of money in those days. So, I guess you envision running a million dollar company or something like that—but one million was really closer to five now. So, I guess for the sake of numbers you can't envision [much]— because the numbers change. Even if I get up to $10 or $12 million, I'll just barely be in the top 25 printers in the area. There are thousands and thousands of printers out there.

I think the gut feeling is still what drives you. You do a little bit more from the business management side, because that's what you think you're supposed to do. Like the break-even—you get that data. You say, "We're doing two hundred thousand. Should we put another press in? Or should we be able to do three hundred or four hundred?"

You can crunch the numbers. And you find out, "Well, I'll be damned. Our break-even's around four hundred thousand."

I think instinct gets honed over time. Even at six-and-a-half million, there are certain numbers that you know in your gut. You just put them on paper to confirm. You do what you want to do. [Your accountant] confirms and says, "Yeah, that is your break-even."

And sometimes you just bet wrong. Should that make you a little gun shy? I don't know. It'll make you gun shy when you first have your failure or lose your business. How do you accept failure like that? I think that's one driving thing that keeps most of them going. The downside is being a failure.

It was reasonably easy to close [a troubled division] because it never was that big. And that was something that both of my partners wanted to go into. It's more design-oriented and a higher-end field. After one partner was gone, the other partner ran that group. He didn't make money doing it, either. So, after he left, I put three different people in charge and added a salesperson. When I shut it down, it was essentially a failure.

Nobody wants to lose. Nobody wants to shut down—especially people like us...even the little ones hurt. But it didn't bother me too much because it wasn't a very big division and I had so much more potential with these other divisions.

On whether I still like getting up and coming to work, I'd have to say "Yes and no." To be truthful...I enjoy it a certain amount. I've just got to start working on what I really want to do the rest of my life. I've got to start addressing that issue. I'm seeing this come up a little bit [with some friends]. I want to have more direction [because] I don't want to go through that kind of pain, later on in life. And I don't even know if I can do it because you get so caught up with [daily work].

I'm 45, still a young kid. I got to the place I wanted. Now, I've just got to make some money—though I say that about every three years. I hope I will. I would sell if the right kind of deal came around—ten years from now. I'm good for at least another ten years. There are other things I want to do before I'm fifty...but we have to get this company profitable and I have to get the management in place.

2 🌿

Metaphors and Maps

RHIZOME AS METAPHOR: A MODEL FOR ENTREPRENEURS

In our interviews, the sixty entrepreneurs whose words and stories you will read in this book were exploring just one aspect of their careers—strategic decision-making. I describe that process as a "rhizome." In using the rhizome metaphor, I am making a distinction between entrepreneurial decision-making and more traditional definitions of business decisions.

Gilles Deleuze and Felix Guattari describe the difference between the growth of a tree and the growth of a rhizome. The tree grows by orderly divisions and dichotomies, its pivotal tap root becoming two roots, and those two four and those four become more until the foreordained higher dimension, the "tree," takes shape, as linear and orderly as its root.

The rhizome, in contrast, grows in multiple and lateral and circular ways, roots growing opportunistically and in free and spreading form, its result not a single structure repeating other structures of its kind, but something new and unique, with multiple shoots and offshoots

and reconnections. Not a "tracing" of a known form, Deleuze and Guattari say, but a "mapping" of a new form, unique to the situation and the circumstances of its growth.

Nature abounds with examples of this dichotomy—pine and fir trees, bamboo and Bermuda grass rhizomes. Nature exhibits, too, plants that contain the dynamic tendencies of both tree and rhizome—plants that begin as single roots and develop into individual trees but which at the same time also propagate around their bases in ever-widening circles of connected roots—such as redwoods, banyans or creosotes growing in larger and larger rings. Or a centuries old fungus that spreads rhizome-like beneath the ground but sends up singular shoots, individual mushrooms.

Deleuze and Guattari describe the "classical book" as a tree, with a logic of:

> tracing and reproduction...its object an unconscious that is itself representative...its goal to describe a de facto state...of tracing... something that comes ready-made...like the leaves of a tree.

The rhizome is different.

> ...it is a map, not a tracing....the map is entirely oriented toward an experimentation in contact with the real....it constructs the unconscious. It fosters connections between fields, the removal of blockages...the opening of bodies....It is itself part of the rhizome. The map is open and connectable in all of its dimensions...it always has multiple entryways...as opposed to the tracing, which always comes back to the same. The map has to do with performance, whereas the tracing always involves an alleged competence.

The mapping, the rhizome, includes everything, the best and the worst, all connecting, all heterogeneous, not just the higher dimensions in a linear order. Multiplicity is its substance. If its dimensions increase in number it changes in nature. It is an assemblage, fully defined by all of its dimensions. It may be broken, shattered at a given spot, but it will start up again on one of its old

lines, or on new lines.... These lines always tie back to one another.[1]

Classical models of decision-making, like Deleuze and Guattari's depiction of the classical book, are modelled on the logic of the root tree, progressing through orderly divisions and dichotomies to purposive conclusions—in step-by-step progression from one issue to the next.

In contrast, I believe that entrepreneurial thinking and decision-making follow the metaphor of the rhizome rather than of the tree.

Intuitive, emotional and analytical at once and in degrees, the decision-making of entrepreneurs—or at least the sixty to whom I have been privileged to listen in these interviews—defies meaningful categorization, structuring or linear connections. For most of them, decision-making is a multiplicity and a whole, carried out continuously and without separation from a hundred other ongoing activities.

Changing a dimension of their thinking changes the whole and often its nature. It is always being constructed, usually without a plan or even a place in a plan, and seems forever in the middle—a decision made, an objective met, becomes a facet of another. The decision-making of these entrepreneurs follows the metaphor of the organic rhizome, mimicking crab grass and banyan, redwood and creosote.

In our interviews, the entrepreneurs' descriptions of their decision-making were rhizomes, as well. Their stories unfolded in the telling, not in the asking. The pace, and direction, and substance of their stories came from their memories and joys and pains, not from my questions.

The entrepreneurs began in places and at times they felt were important; they followed lines of thoughts and recollections that they wanted to follow or chose to create (in the ways of rhizomes, not root trees). Even the hours spent in the interviews—not just the story, not a research objective—determined to some extent what was included and what was left out, what was amplified, what abbreviated.

They sometimes hurried through memories that were intact and through connections they had made before and understood. They paused at connections that seemed new and sometimes marveled at insights that had not seemed clear to them before. One called, a few days after the interview, to say that he felt that he had had his "mind cleaned out. [It was] absolutely fantastic!" Many of the others said, "Let's do this again, I have more to explore and think about."

My retelling of the entrepreneurs' stories is a rhizome in the sense meant by Deleuze and Guattari, as well. What I have tried to do here is convey a sense of the reality and the personality of these sixty entrepreneurs. Their stories are important in and of themselves. Their use of words, glimpsed in the excerpts which follow, is wonderful—personal, rich and evocative.

The rhizome is both metaphor and guide: metaphor for the processes, the why's and how's, of these entrepreneurs' strategic decision-making; metaphor for their talks with me, for their story telling; metaphor for my retelling of their stories; and guide for your reading. It is the core metaphor of this book.

THESE SIXTY ENTREPRENEURS

I am fortunate to know many entrepreneurs and through them to have been introduced to many others. Among them are these sixty entrepreneurs—fifty-four men and six women. Their numbers and gender distribution accumulated by happenstance and convenience rather than design. The number of interviews, as well as the length of them, and indeed the specific substance of each of them, also were random and happenstance.

Among these sixty entrepreneurs, their ages at the time of our talks ranged from thirty-five to sixty-eight. The average age was about forty-nine. Two were in their thirties (both aged thirty-five); twenty-seven were in their forties (average—about forty-two years old); twenty-five in their fifties (average—about fifty-four); and six in their sixties (average—about sixty-three). All were or had been married; not all had children.

In terms of formal education, six of these entrepreneurs held high school diplomas or equivalents earned in the military. Eleven had completed master's degrees (six of which were in business and one each was in biology, education, engineering, journalism and social work). Four held law degrees, although only two had practiced law prior to their current business careers. Four had earned Ph.D.s (two in finance and two in engineering/computer sciences). Of the remaining thirty-five holding bachelor of arts or sciences degrees, several had done some graduate work without completing a degree.

Of the sixty, in both undergraduate and graduate major fields, fifteen had concentrated in business (four or five in marketing, three in finance, and two or three in accounting); twelve had majored in engineering; two each in education, psychology and social work; two in journalism; three in fine arts and one in music.

Among the men, about equal numbers had had military experience as enlisted men or officers as had avoided military service. Several of those avoiding it had done so through dedicated effort; for others the happenstance timing of relative peace caused no call for them to join.

Forty-eight of the sixty were or had been founders of companies; of these, thirty-eight were founders of the companies they currently ran. Of this latter group, twenty-one owned 100 percent of their companies and ten owned 50 percent of theirs. Of the twenty-two current non-founders, including eleven who had purchased their companies and two who had taken over family businesses, nine owned 100 percent of their companies, two owned 50 percent of theirs, and three owned less than 50 percent. Four of these 22 companies were public.

Twelve of these sixty entrepreneurs currently were professional managers of companies owned by others. Eleven of these were or were becoming public.

Twenty of the sixty entrepreneurs had partners who were active in the company. Of these partners, six were co-founding spouses (one married couple jointly ran their company). Five had other family mem-

bers as active, equal partners: two with sibling partners, one with a son partner, one with a brother-in-law. In the nine non-family partnerships, six had more than one active partner.

In addition to the one husband-wife company in which I interviewed both spouses, the sixty interviewees included two additional married couples, each spouse running a different non-family company.

Nineteen of the sixty had active boards of directors, which included five whose members were equal partners and one whose members were inside executives but not partners. Two others had boards of advisers to whom the entrepreneurs gave significant, if non-legal, authority.

Thirty-three of the sixty were members of an international organization of CEO peers who acted as both trusted personal resources and informal boards of advisers for the members.

Forty-two of the group had had management experience as employees prior to their careers as entrepreneur CEOs; twenty-three of these gained this experience in large public companies. Two of the group had had significant academic management experience, initiating and running new departments at major universities.

Among the businesses these sixty entrepreneurs owned, ran and represented were: seven in business services; six in printing and publishing; five in engineering. Four each were in real estate and eating/drinking places. Three each were in wholesale durable goods, electronic equipment and non-depository financial institutions. Two each were in general building contracting, transportation services, trucking and warehousing, depository financial institutions and health services. One each was in food products, paper products, rubber and plastic products, fabricated metal products, miscellaneous manufacturing, air transportation, communication, electric gas and sanitary services, wholesale trade/nondurable goods, insurance and insurance agency.

Allowing for different industry standards of describing revenues, the annual revenues of these companies ranged from about two million

dollars to over four hundred million dollars. About three quarters of the companies' annual revenues were below fifty million dollars and about one-quarter were above fifty million dollars. They created and maintained thousands of jobs.

Of note is that nearly two-thirds of the sixty had experienced a personal "scare" that was significant enough—life-changing enough—for them to mention to me. Nine had survived life-threatening medical problems. Twenty-seven had survived business-threatening financial problems. Two of the latter had been forced into personal bankruptcy (and then had prospered after starting again); three others each had taken one of their companies through bankruptcy.

Although I compiled some selection variables in the process of reading through the transcripts, I did not systematically collect demographic data from the entrepreneurs. Items of information about each of them as individuals were either known to me or came up during the interviews. Therefore some evolving profiles became more complete than others; in any case I have drawn no inferences or conclusions about their decision-making on the bases of this demographic information.

My primary interest in our interviews was in whatever they chose to talk about, given their knowledge of our focus on their careers and their decision-making processes. My interest now is in sharing the lessons, insight and wisdom of their recollections...in their own words.

Shared Meanings

In our conversations, the entrepreneurs and I sometimes talked about and defined what some concept meant to us (such as "entrepreneur" or "intuition"). More often we shared implicit understandings of our meanings, through experiences familiar to both of us or common knowledge, or through metaphor. Our use of metaphor was a simple device of communication, on this level, and on another, implicit descriptions of how they felt about themselves, their companies and their experiences.

Metaphors, as Haridimos Tsoukas has summarized, "do not simply describe an external reality; they also help constitute that reality and prescribe how it ought to be viewed and evaluated." They are often "better alternative[s] than literal language for expressing the continuous flow of experience...[expressing] emotional reality lying beyond even conscious awareness."[2]

Metaphors also shape thought, as John Clancy has noted[3], and their "use by business leaders is both reflection and determinant of their intellectual framework and hence their actions."

Many of the entrepreneurs in this study used metaphors freely and imaginatively. Some described themselves, some described their companies, others described their decision-making processes. Their metaphors portray the richness of their thinking, as well as shaping their thinking.

"Family" was the metaphor used most often, very often, to characterize their companies and their own roles.

We're a family.

It's a family, I'm the father, she's the mother. It's sunny, shiny, happy here.

I'm a reinforcing figure. The [former corporate owner] was patriarchal, had a plantation mentality, where all decisions were made at the top, no communication, just shut up and do your job. The [new company] is becoming a real family, with decisions diffused all through the line, which is very difficult and scary for people. It takes a lot of my time in fathering, in bringing out the decision-making in people at line level, reinforcing them. They need a lot of love and affection and caring communication.

It's my child, it's part of me.

It's a family [a revitalized, smaller company after bankruptcy], run by a sole proprietor with a family orientation, selective about who we work for, enjoying working together, understanding there's always going to be

ups and downs, that we're in this together. They don't get to tell Dad what to do in some ways, but he's going to sit down and listen, all of us really deriving tremendous wisdom. Sharing risks, enjoying summer knowing that fall's coming.

I deal with people here in the same way that I deal with my children and my family.

I'm a parent here. Parenting the company is more than coach, the way I feel about it. You get a lot of control by being a parent if you don't abuse it. You have an opportunity to take charge, to direct, to philosophize. I like to do all that stuff...giving to employees and customers what I can that I think will help them grow. I believe in the philosophy of tough love, with employees and with customers, and I've used it with people I've let go.

I feel like a parent here in the company.

Other metaphors for their companies included:

A sponge that sucks in information from all over the world, squeezes it out, then when it's almost dry we get rid of all that stuff and we squeeze out the last few drops of pure information that is left, then package it in a different way and send it back out in more usable...in ways people have never thought of before.

It's a precision measuring tool, a beautifully made, functional trisquare, a symbol of this company and of exceptional performance by our employees.

We're plodders, because we just plod along doing the same damn thing and trying to expand on it and continue to do it. But we don't change what we do; it remains the same. It changes but it remains the same. That's one reason the business sort of bores me a little bit; there are not too many opportunities to do something that is innovative and creative.

A catalyst. Something more energizing than what I bring to it.

A railroad track. I can't change the road we're on much at this point.

The business now has its life, its personality, it is human, it goes forward. I am driving, pointing it in a particular direction but it's pretty hard to change it much.

As individuals, they saw themselves as:

A reluctant survivor.

A laser, *focused with a narrow beam.*

A defense general, *taking all the demoralized and retreating troops and turning them around to become better fighters.*

The guy with the sticks and platters, *trying to keep them all up and balanced. [But there are] only so many you can keep going at the same time before something crashes. I'd rather be able to manage well what I can manage. If I can keep four or five plates going, [I'll] keep them going—if I'm comfortable, not going crazy with stress and anxiety, and not causing others to be stressed out.*

Everyman: *competent in everything, world's greatest generalist. Having a hundred specialties...mastery over a lot of different stuff...allows me to move in a lot of different languages, with a lot of humanity and understanding and with confidence in every area of life, including the spiritual.*

A stranger *in a strange land, wandering on a path through a beautiful garden. Enjoying what I'm seeing and knowing about it and learning about it and being able to appreciate more each time. Not picking anything, leaving it in the garden.*

A helper...*on my gravestone I want it to say "he helped others achieve what they wanted to achieve."*

A coach—*coaching basketball, especially—because of the team [focus] and the need to know instinctively where each player is at all times.*

A searcher, *searching all the time...on my way to find out something. I don't know what it is. It might be something way up there or back there, that is going to be the answer to everything. I don't know what.*

An infant beginning a whole new stage of life. The past doesn't have nearly the significance for me that it used to have, I've really just kind of shucked it and I'm taking with me the things that worked for me and are pleasant for me, and I've just got the whole world in front of me, ripe for the plucking.

A prevailer who not only survives no matter what the circumstances, but who succeeds and moves forward and is open to new experiences, whatever might be around the corner. A prevailer who is striving along confidently and dealing with things as they come along and dealing with them successfully.

An awful butterfly, going from work blossom to work blossom in my life. I'm in some kind of metamorphosis now. I've become much more of a caterpillar now, in this new company of ours. I've gone in that direction with age and so forth. I chump away at the leaf instead of floating around the blossoms. It feels appropriate and comfortable.

The prince in another hayfield, doing things that the other guys were always jealous of or mad about.

A little boy, ever-curious, ever-learning and always wanting to play. I don't feel any age, and certainly not my age.

A naive young medieval traveler, who has seen and partaken of some very exciting and rich things but not been old enough to appreciate them or to handle them. Who has recently been run over by an ox cart...and has waken up and sort of smiles about the things that he's seen, in a good way, not all bad. And says "Boy, that's a tough trek." The real values are some day-to-day contentment and the financial security that by being less expansive I can achieve. Before, I made a fundamental youthful mistake and put all my expansiveness in the business, not realizing there's considerable risk to expansiveness. So the traveler gets up, after the ox cart, and says, "Well, I can paint. I can [do other things]...."

Metaphors shape thought. They describe and underscore the phenomenological nature of this inquiry into expressions of experience and thinking. Metaphors also reflect personas. They are central to the stories of these entrepreneurs and to the why's and how's of their

decision-making. And because of the richness of their metaphors, shaping and reflecting the entrepreneurs' thoughts and their companies' personas, what began as a study became a story.

FOLLOWING RECOLLECTIONS

In the discursive, rhizome-like nature of our talks, as I followed the recollections of these entrepreneurs, I was guided by a collection of questions called "notes to myself" and headed by the admonitions "Listen! Shut Up!"

The particular questions I asked depended on where each entrepreneur went with his story and how comfortable he was talking about himself. They are questions any business person should ask himself or herself.

They are questions you should ask yourself.

What do entrepreneurs say about how they make strategic or turning point decisions?

What is involved for an entrepreneur as he makes key decisions that have long-term consequences?

If one asked entrepreneurs how they make key decisions, most would answer with "I don't know" or "it's intuitive" or "out of my gut." What is behind and beneath those answers? What does an entrepreneur mean by "intuition"?

Does an entrepreneur have conscious awareness of the processes he uses to make important decisions? Can he describe any elements of his thinking process?

What mechanisms does he use to make decisions? How does he gather information, evaluate it, think about it? What influences him? What are his values? Do they influence his decisions? If so, is he conscious of it? Does he attend to them? His goals?

What influences an entrepreneur most? How does he learn? Change? Looking back, what patterns does he see? What choices? What metaphors might he use to describe his business, himself, his life?

What does an entrepreneur think is the purpose of his life? What are its paradigms? Its metaphors? Its roles?

What has enabled the entrepreneur? Impeded him? What are his decision criteria? Are they contingent on the situation? Which are fixed? Where do his feelings enter in?

When things go wrong and an entrepreneur is at a loss to explain why—or when intuition seems to fail him—does he have any back-up analytical tools or mechanisms?

What are an entrepreneur's attitudes about opportunities? Resources? Crisis? Role of conflict? Politics?

Are there differences in an entrepreneur's thinking and decision-making processes between his early years and later successful years? Between core businesses and unrelated businesses?

What is an entrepreneur's level of consciousness or awareness of how he makes decisions? Thinks? Gathers information and resources?

What is an entrepreneur's motivation? Personal security? Financial wealth? Reputation? Competition? Pleasure?

When things go wrong, where does an entrepreneur look? Whom does he blame? When change is needed, where does he look?

What is the role of emotional involvement for an entrepreneur? With his business concept? Company? Competition?

What kind of scorecard does an entrepreneur keep? How does he know things are working?

What is the role of chance for an entrepreneur? Of luck? Of inertia?

What are the sources of entrepreneurial ideas? How does an entrepreneur's creativity work? What are its phases?

What would an entrepreneur do differently, knowing what he knows now? What would he like his life accomplishments to be? How does he want to be remembered?

What is an entrepreneur's greatest success? Failure? What is an entrepreneur's greatest tribute to himself?

If an entrepreneur knew he was going to die soon, how would he spend the last months of his life? Finishing business projects? Improving or enjoying important relationships?

Sometimes I asked many of these questions, sometimes only a few. I might ask other questions or make other comments or follow some new direction, evoked by or following the direction of his thought or stimulated by his words. Some interviews just flowed without any conscious effort on my part; a few required more direction, more pulling.

Some portion of my occasional questions usually had to do with the mechanics of his thinking process: Did he talk to other people? Did he listen? Did he pay any attention to the counsel? Did he wake up in the middle of the night with a decision brewing or a decision made? Did he think aloud or alone? Did he use the old Ben Franklin or some similar techniques? What did he read? When? How did he remember? How did he learn?

Not interesting questions, some of them, but they often elicited interesting thoughts. My questions, my leads depended on the entrepreneur, on his ease in reflecting about himself, on the quality of his introspection, on whether he was learning about himself, on whether he welcomed the experience.

The richest interviews, for both the entrepreneurs and for me, were those that took on a life quality of their own—when the entrepreneur asked the questions on my list without my prompting. Needless to say, all interviews were not peak experiences. But many of them were. Many entrepreneurs suggested that we continue our talks at later times to follow up on details and other paths of thought.

For me, interviewing these entrepreneurs was challenging and fun, moving and meaningful, creative and enriching. At their best, the interviews were acts of appreciation, of connoisseurship, and shared acts of discovering insights and creating meanings. In a very real sense, the reflection and learning that occurred during our interviews became the purpose of the process and the essence of its contribution.

A Search for Meaning

In my subsequent analysis of the conversations (all recorded on tape and transcribed verbatim), patterns of shared words and concepts, insights and understanding emerged. This type of qualitative research—looking for commonalities, patterns and recurring themes among sources—is called phenomenology.

The dictionary definition of phenomenology is "the study of what appears; the visible manifestation or appearance; an object or occurrence presented to our observation in the external world or in the human mind, in contrast to that object or occurrence as it is in itself."

The crux of this definition is that it entails accepting as data what is said or what presents itself. This was not a psychological study. It was a phenomenological one, accepting what was said by the entrepreneurs, rather than probing for what lay underneath their words or for what might have been different or more accurate or more real than their stated, shared reflections. Like most of the entrepreneurs in their dealings with other people, I trusted that they told me the truth as they understood it.

This, of course, raises the important issue of subjectivity. Is the phenomenological truth of the entrepreneurs' recollections about their decision-making valid? Are my impressions of the recurring patterns and common themes justified? Can business people learn to improve their own decision-making by attending to what they read here?

Can what you learn from the words and stories of these entrepreneurs improve your ability to make up your mind?

One factor to consider is my own subjectivity—my enthusiasm for the economic power of entrepreneuring and for its potential to empower personal lives, my empathetic closeness to and respect for these entrepreneurs, and my notions about what I might hear.

Another is the subjectivity of the entrepreneurs, which one of them called the selective memory of their success. This compounds what Sheldon Kopp called the "soft science of subjective exploration."

> [This process] is not an archaeological dig for objective artifacts from which an actual past is accurately reconstructed. Imagination so subtly reshapes memory of any psychic shards we may recover that privately, even before putting pen to paper, we have already rewritten our personal histories. Today's attitudes influence even the most sincere search for yesterday's psychological truths. Any analysis of a personal past inevitably accommodates to present pressures. Reminiscence is an art that interweaves fact with fiction and unconsciously edits each retelling of our tales. A personal vignette told in exactly the same way more than twice is likely to be a deliberate lie.[4]

Yet another issue is that almost all of these entrepreneurs were reflecting on and talking about their decision-making processes for the first time. Very few of these sixty entrepreneurs were often in the public eye, and while those few may have spoken about their careers, virtually all of them acknowledged not having thought much about their decision-making processes before our interviews.

Many remarked that to be thinking and talking about themselves in this way was a very new experience, and a very welcome one. For example:

This is all coming to me as we talk.

I'm just like everyone else. I don't know how I make decisions, although I may get better appreciation for it after the end of this session....I suspect I will.

We were all learning together. The entrepreneurs learned through their recollections and reflections. As Warren Bennis has written, "reflection is a major way of learning from the past [and] may be the pivotal way we learn."[5]

For me, learning came through the joy of listening to these people. "One of the most useful of human abilities," writes Elliot Eisner, "is to learn from the experience of others....We listen to story tellers and learn about how things were, and we use what we have been told to make decisions about what will be."[6]

Yet another consideration is that the entrepreneurs and I talked at a specific point in time, on a day in their lives on which their perspectives were different than they would have been had we talked a few months or years earlier or later.

What each interview recorded was a snapshot of perception and recollection. This was particularly true for the stories of those entrepreneurs who had suffered serious reverses, of either a personal or business nature.

It also was true for those who had yet to experience anything other than life and business as usual. One of the entrepreneurs put it very well:

I was thinking about this interview and I want to register one thing which I think is probably an important bias...at least for me...from an

MAKE UP YOUR MIND

*intellectual standpoint. If you'd interviewed me four years ago, you would
have interviewed a very different person who would have given you very
different answers about the decision-making process. And the bias I want
to suggest is that I'm still pretty tentative and really recovering from
failing, and it may not change how I do things but it certainly puts a very
different angle on how I view this whole entrepreneurial process.... And
so there's the bias of just pain...I'm still speaking from the fact that it
hurts, I'm not speaking from (the lessons which I learned). You're either
limping or you remember the bad leg, those are two different things, and
I'm still limping. And I think that that has some bearing on what I say.
I'm sure it does.*

These are real people talking about real experiences—about deci-
sions that worked and those that did not—and about why and how
they made them. I think you can learn from them.

3 🖎

Learning to Play the Game

I have one version of things for the record and another not for the record. For the record: I went to school and graduate school and did a few things and then I got into this business. That's the safer explanation. But there is a different side of what's made me successful. I've had some rough years. Not that I'm ashamed of it, but I've paid my dues in different ways.

One of the things that had a big influence in my life was the Boy Scouts. The Boy Scouts make you think, unlike stereotypes you might have. Being a leader of the Boy Scouts—not just a member—makes you think. It gives you tremendous independence. My father owned his own business, a small trucking company. He went under a few times. I worked there—and saw the problems of business people and owning your own company. I swore that I would never get involved in any of that stuff...never business.

In the Boy Scouts, I was the Patrol Leader. And then our Scoutmaster quit, and they brought in a guy who was never a scout. So, I really had to learn. [But it gave me a feeling of] independence. And it was survival, too. The Boy Scouts also teach you things that you can learn in life. School doesn't teach you anything. I felt that school was a total waste of time.

Another thing that happened [to me] which I think was good—and I don't know if it happens anymore—is that I worked since I was 12. I always had a lot of money compared to other people. I've always worked. I think that's probably pretty common among entrepreneurs—they worked at a young age.

I was an average student in college. Then came the big change in my life: Vietnam. Vietnam had profound effects upon my generation. The world changed and America divided. I was anti-Vietnam. The last thing in the world that I wanted to do was to go to college. I had no interest in college whatsoever, and then comes Vietnam. If you weren't in college you could get drafted right away. So I went to college—then I flunked out because I had no interest. I never even went to [class].

When you got to my college, [you went] into a big auditorium with all the freshman. The Dean got up and said, "Look to the right of you; look to the left of you. In six months neither of those people will be here." Which was the way it was. Very difficult, very hard to get through that school. I didn't want to be there and flunked out in '65. I don't know if I actually flunked out. I left.

I learned how to play the game of maneuvering [from college to college, to avoid the draft]. That's the key to my success in business— maneuvering...finagling...whatever you want to call it. Playing the game. The story was how to stay away from Vietnam. The story was how to go to school and pass when it was very difficult and you weren't interested. So you learned how to play the game.

You wanted to be in a process of flunking out...getting back in...flunking out...getting back in. Before they could catch you and try to draft you. Working the system in college taught me a lot of things, [namely] survival instincts.

I might have liked school, had I had a few years off and gone back on my own choice. But Vietnam created [other choices]. If I knew I was going to flunk out, I would take a TB test. And I would go to the Dean and say I'd just gotten a report...[and] I had to take a leave from school.

Leave of absence.

When I was a freshman, I went to a place that had parts for handi-capped people...and said that I was in the college drama club. They let me borrow a cane, and...the [school] gave me a preferred parking sticker. Every year I would forge the renewal, so for my entire career in college I could park in the faculty lot.

I learned how to do these things...in college I did them to the largest degree. I kept flunking in and out, playing these games. [At one point,] I enlisted in the Army. I figured that if I brought all these notes to fail the physical, the enlistment physical, [I'd be safe]. I knew I was going to get drafted. So, I enlisted and failed the physical. The next time around, I flunked out and got drafted. I took the physical [but] told them I tried to get in and they wouldn't take me. That worked. Vietnam molded my career of playing the system.

One year I flunked out and [went] to live on a Kibbutz in Israel for a while. I made up my mind there that, no matter what, this thing was not going to beat me. I was going to graduate from college.

I lived on the Kibbutz by myself. Nobody spoke English. They gave me my orders in French. I got up at three in the morning and it was 120 degrees [every day]. The Syrians had the Golan Heights and I was right below them. I was sitting on this hay bed in 120 degrees in this tiny room and something came over me. I just said, "Look where I am. They're giving me my orders in French. I have no one to speak to. I'm in the middle of nowhere. I'm not going to let this beat me...."

The college thing had caused me so much grief. I spent five years in four double sessions getting my degree. I finally majored in Psychology.

I got my career at the end of college, but it was strange how that hap-pened—a fluke. I needed to fill up a course and I took metal sculpture, welding, fell in love with it. So, when I got out of college I got a job as an apprentice to a metal sculptor.

What happened to that was impatience. That's happened many times in my life. I worked for the best metal guy in [the area] as an apprentice. I was living with a woman, making $56 a week…15 minutes for lunch. This was in the 1960s—but it still wasn't easy to live on $56 a week.

I went to [my boss] and said, "I can't live on this." And he said, "For what I'm teaching you, you should be paying me." I'll never forget that.

I went to a second best [metal sculpture guy] and he loved me because I knew all this stuff from [the best guy]. He wanted to make me manager, but he couldn't teach me anything. My impatience [kicked in]. I was 21 or 22. I started my own operation. I did okay—didn't make any money but did nice stuff. Then I ran out of money. They were just starting drug groups…my mother was a teacher and she heard they were starting drug groups in junior high schools to go around and tell people how bad drugs were. I had a psychology degree and I needed a job. And they needed a resident hippie.

When I was doing the drug counseling, I also went to graduate school for group therapy for two years. It was interesting [at first, but it got boring,] so I opened up a metal sculpture place in [a resort town]. Now we go back to survival again. I wasn't making any money. In [the resort town], you're either rich or poor. And I was poor. So, I went on welfare, which was okay. I could still do my work.

When you're on welfare you don't think about [rich or poor]. I didn't. I'm a college graduate. I wasn't really raised to be on welfare, but I lived that welfare life. I was poverty-stricken for a lot of years, when most people have families and move on. There are people in that world that get married and have families and live poor, but my values wouldn't allow me to do that.

The deal with welfare was you didn't have to work. Then, they passed a law that you had to work. They'd put you on the road gang or [something like that]. My social worker says, "You have more education than anybody at the Department of Welfare." She says, "You have a choice: road gang or become a social worker." So, I went from one end of the

table to the other. From being on welfare to working 40 hours a week. I made something like five bucks more, but I had no choice. It was better than the road gang.

I was in charge of housing for the county. It was a pretty good job because I felt like I was helping people. Then came the civil service test, which I took to be promoted. I did very well and got promoted to being a therapist in a methadone clinic. I went from a job where I did some good to a job where I did no good whatsoever. You couldn't even see me unless you had had two years heavy duty heroin.

I felt I was just like a jailer in a jail. But I learned more about playing their game, from dealing with junkies—who really played the game. [I was getting close to 30 and] I was getting tired. From 16 or 17 to 30, it had been a long road of being a hippie, living that counterculture life, for so long.

[The place I was living] was great, but it was getting small. Dealing with the junkies was driving me crazy. I got laid off [from the Welfare Department] and got unemployment—which was great. Then I started managing a rock group. I had all these rock groups and we went around the country...little bars where you had to fight your way out. I did that. I had romances with women. But, on my thirtieth birthday, I was unemployed and broke.

I'd had about a million jobs. That's another thing about entrepreneurial people—they usually need to have a lot of jobs [before they] succeed. Not necessarily the way I did, [they're usually] more mainstream.

Every year, on my twentieth, thirtieth and fortieth birthdays I [went] someplace and I'd write a letter to myself to be opened 10 years later. I started in Israel, when I was 20 on the Kibbutz. When I was thirty and opened the 20-year-old's letter, I said, "Shit! Nothing's changed."

I'd seen the world, but nothing had changed. I was in [a rural resort town], unemployed—not much different than being in the middle of the Negev. I'm getting old, that was my realization. To be thirty and to have no money, to have friends being successful....My family had not totally

disowned me, but I was the black sheep. Sculpture was not doing me any good at all. I went up into the woods by myself and made the decision that I was leaving. I started my new career, moved to another state.

I didn't see [my family] that much...but now things were bothering me. I'd lived this life. I was one of those guys that had a lot of stories. I had no ambition whatsoever to make money. I never thought of it.

I got to [the new place and found] a job managing a chain of retail stores. [Within a few years, the company] got an opportunity to franchise with a major chain. I made a proposal to become partner with the owner—and had a lawyer write up a contract. But I make a fatal mistake. [The owner] didn't have a lawyer. I found a lawyer and said, "Draw up the contract and you can represent the corporation."

We had a 21-page legal document. I went to [the owner] and he started using that lawyer as a corporate lawyer. I believe he stabbed me in the back. He said, "You move too fast for me. I can't sign this thing." I said, "Either you sign it now or I'm leaving." He said he couldn't sign it. And I left.

At that point, my father and his cousins had started another company. I'm out of work again, [so] they suggested that I start a [satellite branch of their] trucking company. It was the last thing I wanted to do—but I needed a job. So I started to do it temporarily.

I had no idea how to [run] an airfreight company. I started in my living room [with] no money. [My family] would tell me they hired all these people who weren't doing anything. They had done it all their lives and I had never done it, but I had street smarts.

I had a lot of experience, different lessons on life. Dealing with junkies was one of the most important things I learned—not to trust anything anybody says. [Junkies] are the most persuasive people. [Having worked with them] helped me tremendously in business. You learn to take everything with a grain of salt, no matter how persuasive people are....

Airfreight is a wild game—more so than trucking. People don't know that. I had no money. I didn't have trucks, anything. People would call me at my home and say, "Let me speak to operations." I didn't have two lines, so I would say "Hold on." I'd change my voice and say "Operations...."

Whatever [my cousins] are doing in their company, it doesn't work. Whatever I try in this one, it works. So I start hiring people, then comes the big accident. I'm working for less than a year, I have a head-on at almost 100 miles per hour—a woman drunk. [I was] banged up. My parents come out. My father takes over because the company is just starting to take off. I wake up and the first thing I see is my sister. I haven't seen her in years. And I say, "Aha. They think I'm going to die." My sister would never come that far [otherwise]. But I knew I wasn't going to die. I did go through two years of hell.

Meanwhile the business was going okay. They put a body cast on me. And I go out selling in this cast. We were doing well, but my cousins were having a lot of problems—drugs, not working and all that. Finally, I couldn't take it any more, and I left. And I was a minority shareholder. I called up my competition [and worked there for a while].

[The family company] went into Chapter 11. The other guys were out of their minds. They called me back in [to resolve the] Chapter 11. I figured I might as well go back. Maybe I could sell the furniture. I went back to [the family company]. We needed about two million dollars to get out of Chapter 11. [We did that pretty quickly.] I made a goal that I'd get financing [to buy out my cousins], which I did.

I knew everyone in [the industry]. That helped. Basically, from six years ago till now it's been all work—no wildness, none of my usual behavior. For the last six years I've been pretty much...a good businessman. When I came back [and the company was] in Chapter 11, it had revenues of two million. Now we're at forty million. You take some risks and you play the game. I play the game—and the game is no different than it was when I was in college.

Building our new terminal was good, wild, challenging. We were getting evicted at the airport. I met a guy who had a little place...rather than leasing, I got him to sell me the place for no down, interest only. I parlayed the next piece with the City. So, when I got around the whole thing, I got 100 percent financing—which is good.

I'm bored. I'd love to get out of here, but it's not that easy.

I always have different businesses going. And I always fail. I've tried a garment company and a computer company. I had a business overseas. I've done a million things. I had race horses...I have a mortgage company. I don't spend enough time [on some of these investments]. I do them more for fun. Also, I think you've really got to try 21 things and you'll hit one.

I don't believe you can fail [in business]. You learn from each experience. Generally the [investments I make] fall upon me. This would be a good idea, that would. I'm always open to different [ideas]. I'm impulsive. I don't do any market research, I just do it.

Now [this company] is getting where it's too big to keep running from gut [instinct]. You have to change. I'm trying to bring in professional management, but I tried that once before and it didn't work out. The guy I put in wasn't the right guy to run it. Even though it's a bigger company, it still takes the wheeler-dealer attitude to [run] it. And that's what I'm good at. I'm terrible at the day-to-day organization.

I give people a tremendous amount of authority to do whatever they want. I'm not a control freak at all. I'm not real interested in business—that sounds strange, because that's what I do....

I've been lucky. A lot of it has to do with luck. On the day-to-day business stuff, we plan. But I don't particularly like business.

I'm 44 now. I thought I would be able to retire this year. It didn't work out. I have a boat and I was planning to take it [somewhere].

I was trying to set up this thing with my cousin and a professional team, didn't work out. That's not to say that it couldn't work, but I'm not willing to take that kind of chance on the company.

Trying to figure out what to do next is a major priority in my life. I'm trying to search now in terms of myself—what I want to do. Somebody told me that, at a certain point, [you realize that you] never wanted to be so big. The company controls you and you don't control it. This company is at the point where it controls me. I'm stuck.

I would say I spend 90 percent of my time here in this office thinking about what I want to do next and 10 percent working. I'm really lost. I know I'm trapped right now. The business is [affected by] things I can't control. I've learned. But I need to learn more about my weaknesses. I'm not going to change, I don't have that need for achievement....In business, that's actually a good thing. Unless you can say, "I'm just going to walk," you're stuck as you are.

An important point: I don't like what I'm doing. I never liked it. The people in [my peer group] all seem to like what they're doing, so it's different. I'm much happier fixing the engine on my boat or something— but not this. I like parts of it, it's certainly nice to have the money, but....

I have been involved in psychology for a long time. I have been in therapy for many years. I believe in therapy and I believe in psychology and psychiatry. I've spent a lot of my life in it.

I took a test recently that said I am very high in persistence. I don't have that great need for status. I just took a test [and] scored the highest in creativity and lowest on the need for status. I studied these things in school, so I don't take them too seriously. I guess they're a lot of well-balanced people in the world that run pressure packed companies without therapy. Maybe they drink. I don't drink or smoke, but therapy is good for me.

I'm not married. Another reason I'm successful as an entrepreneur is that I take tremendous risks. I could have never taken those risks had I had a family. And so I missed out on a family. That's the biggest thing I

regret. *I would trade all of this in a second for a family. My sister's got kids in college. The other day, I was doing something on the boat and I said, "Goddamnit, I should have my teenage kid to do this." I could still do it. The good news is my future's great because I can get a lot with money.*

The risk taking in my world is ridiculous. If something feels good and everything says it's too dangerous, I'll still do it. This new terminal was the hardest thing I've ever done. I had my house and everything [else] on the line. And I made it. I believed it was right. But nobody in their right mind would have tried this. [The location] is a toxic waste dump, we didn't have the money....

Even though I'm impulsive, I generally think out major decisions. I'm a basic thinker. I'm introverted and my strongest asset is thinking. I don't do many things well, but I can think well. My process is intense...on major decisions.

I do all my business from my head. I don't write anything down. That's another negative—but I'm pretty accurate, pretty good. But there's no difference between a computer and the brain. You get input all the time. I have no problem thinking I'm wrong. If I'm wrong, I'm wrong. Somebody's got to make decisions and I don't have any illusions that everybody's investment is the same. My investment is much greater, so my decisions are more important than someone else's decisions.

Sooner or later, you're going to lose. I've lost plenty. And I don't like losing...but that's where I believe you really learn. I think the key to growth is failure.

And I think you should call it failure. A lot of people want to change that word. "It's not failure. It's a learning experience." No, it's failure. That's what it is and that's the word you should use. Anything else is a rationalization. You need to fail. People that haven't failed haven't achieved. You don't need to fail as much as I have, but I believe that people need some failure. A guy that's failed as much as I've failed is unhireable.

We have our share of conflicts in business. But right now I'm not at the level where I get that much conflict [at work]. I'm at the godlike level where I don't get it. [Employees] might have conflict out there...but they wouldn't generally come to me.

When people look at a $20 or $40 million dollar business, [they think that's achievement]. For the guy behind the seat, he's already there. His goal is to make it a hundred-million-dollar business...a billion.

It gave me a lot of thrill to get to $20 million. Now I don't give a shit. Maybe at a hundred million I'll care.

When you're at $2 or $3 million, it's like any idiot can do this. Then you see business people at a higher level and it takes some smarts. It's not as hard as being a doctor, maybe, but it's not easy. This is pretty demanding in a logical sense. And it's hard to play with one-and-a-half hands tied behind your back—which is what I do, because I only spend 10 percent of my time [managing] this.

[Many entrepreneurs] say, "I've done all this stuff but I feel a terrible empty void in my life." The reason: their ultimate goal was to make money. There are important interpersonal issues—what do you want to do with your life? But they have no place in business. It's like being in the military and asking your General, "What should I do with my life?" It's not an appropriate question in the middle of combat. He wants you to go out and kill the enemy.

Capitalism is a very shallow means of existence. That's why rich people get their rocks off by giving money away. They realize, unless they're real idiots, that once you get past a certain stage why are you going to play that game any more? How big a yacht do you really want?

We had good values in the 1960s. It was maybe extreme about anti-capitalism, but we were saying there were other values in life. So when I say sold out, I mean that in terms of not doing anything meaningful, except make money. And I don't rationalize that I'm creating jobs for people. I don't believe it. They could go somewhere else and get a job—they don't need me.

When you're playing business, you have to learn how to play well. It's my opinion you have to play well or you're not going to have a business to play with. You need the skills of business—nuts and bolts, hard nosed and fairly boring.

I've always thought about personal goals and how I've sold out...In my life, I've sold out to business. This business isn't exactly creative. It's making money. I'd like to be able to have a shot at starting over again. I'd go to school [and] pursue something that I consider of value. I don't have enough guts to do that now. I'm too secure, too comfortable here at the top, godlike. It takes a lot of guts to come down from the pedestal.

I always had goals. My latest thing is, if I ever got three million dollars in cash, I could live on the interest. [But that number] keeps going up. Everything is relative. My girlfriend wants to get married, that's more pressure on me to live the straight and narrow life.

You can never tell the future [completely], but I can almost guarantee that I won't be in this business in [ten years]. I will have gotten enough money and [be] pursuing some crazy thing. I think the future will be brighter when I get past 50. It depends on how hard and how smart I can work now.

When I was [managing bands,] I met a singer. She told me about a friend of hers who worked real hard, got $50,000 in cash, put it in a suitcase, sat out on the beach—on the suitcase, and said, "Now what? I've reached my goal, now what?" It was his goal to get $50,000 in cash in a suitcase and sit on the beach—and he did it. So he went to Hawaii. I always thought that was a good story.

4 ❧

Patterns of Decision-Making

Asking an entrepreneur how he makes strategic decisions often is answered with an "I don't know," followed by some thoughtful reflections about how his personal decision-making process does, in fact, work for him. These sixty entrepreneurs described a wide variety of personal decision-making approaches and tools, from a mathematically-based process of analysis that was formal in everything except its written form to a process based almost wholly on emotions and feelings.[7]

About half of these sixty entrepreneurs talked of consciously using some form of analysis to reach their strategic decisions. About half talked of relying primarily on their emotions or gut to make decisions. Almost everyone, in fact, used some combination of analysis and feeling in making major decisions. For even the most analytical, the decision had to feel right. For even the most emotional, thorough preparation and fully-informed knowledge often were important parts of the decision-making process.

These groups, each roughly half of the sixty, were not mutually exclusive. The mix of analysis and emotion that an entrepreneur used varied depending on the nature of the decision being made, among other things. Investment decisions usually, but not always, called for analysis first; hiring decisions usually, but not always, called on emotions first.

This is not to say that an individual entrepreneur didn't describe himself as totally logical or another describe himself as totally emotional. But on balance, almost all of these sixty entrepreneurs acknowledged the importance of both analysis and feeling in their decision-making, and most were quite conscious of how analysis and feeling worked together in their own decision-making processes.

This consciousness is an important part of our *awareness of mind*—of our ability to make up our minds. It's knowing when and how to use analysis, when and how to heed emotion, when and how to honor intuition in making decisions.

What was most significant in the summation of their recollections was that they described instinctive patterns of thinking and feeling, using first one and then the other to arrive at their decisions. Two consistent patterns emerged: analysis confirmed by feeling and emotion supported by data. They also distinguished between emotion and intuition.

They described *emotion* as attachment to a decision—as wanting it, having a feeling for doing it—or as detachment—not wanting it, not being attracted to it.

They described *intuition* as an adjunct to either pattern, an additional tool of analysis, an unexpressed knowing that supplemented the data. It was a separate unexpressed knowing that helped them evaluate both thinking and feeling. Intuition allowed these decision-makers to say: "I really wanted to do it, and the data supported it, but my intuition said it wouldn't work. So I didn't do it."

It is clear from the words of these entrepreneurs, as well as from our common sense and the scholarly literature on decision-making, that both analysis and emotion or feelings are important in reaching good decisions. As the entrepreneurs emphasize, the challenge is to be sure we appropriately consider both, since our instinct is to start out with only one—analysis or emotion. But using only one runs the risk of short-circuiting the other and of leading to a bad decision.

IMPORTANCE OF THE PROCESS

An underlying theme of their descriptions was that the process of arriving at a decision often was more important than the decision itself. They said that the process of making the decision would (not could) make or break the implementation of the decision. For many of these entrepreneurs, the decision-making process was the significant issue.

The process by which a decision is reached can be at least as important if not more important than what the actual decision is. [This is true] in any case in which the successful implementation requires more than the action of the decision maker. Which of course is true of almost all decisions in business. What I've come to appreciate and value is that process. I try to learn more about the process.

I don't believe in being results-driven with analysis. If I made a decision that produced a bad result but I still feel comfortable with the process, and I can't see any reason to change the process if the same circumstance was presented to me, then I would not change the decision. In my own way, I'm a process freak. I believe that good process produces good results. I really am a believer that good decision-making is enhanced, is facilitated, is most likely to produce good results if done in a framework of sound process.

They described the decision-making process not only as their own thinking and feeling, but also as their conscious working with other people, their own conscious working through other people.

The interesting thing is that sometimes it ends up in a decision being made that everybody's happy with. Because there are indeed both the left and right brain factors that influence decisions, and...I have the general sense that, there have been far too many times to count, when it turns out that there are decisions that everybody's happy with, they are even better than the original one.

Many described the decision-making process itself as an issue of good management of people and ultimately as an issue of leadership.

I think that's got a lot to do with leadership, which to me is seeing the bigger picture....people are just starving for leadership...I think a lot of people seem to have difficulty making decisions even when the decision is clear, and it was an easy thing for me to do, to assume that leadership....I like the process of management. Call it control, call it power, you can call it a whole lot of things...but I like that. The leadership aspect for me is really one of the most exciting aspects about being in business. You sit around the table, you discuss an issue, you discuss a plan, you get everybody focused in one direction. I think that's very satisfying.

I've had to learn a whole new set of management traits. I don't come up with the answer. Yeah, for awhile I bit my tongue, I've always got the answer....That was a decision that we figured out as a group, in about five or six meetings. What I'm trying to say is that if you don't come up with the answer...[instead] but you say "Okay, how are we going to answer all these questions?" Silence. "Well, we need some volunteer, we need someone to take each part of these questions and report back," they're in the [decision-making] process. If you sit and listen and don't come up with the answers you achieve two things. The first thing you achieve generally are better answers because what you think are the answers often have limited value compared to a couple of different perspectives, you get a better decision. But much more importantly, you get people who will do what the decision dictates because they've internalized it.

The other thing that I'm absolutely sure of in organizations is that the tenor of the organization will come from the top. And you can't fake it. If you get to know the person who's running the organization, you'll

have a pretty good feel for the organization....it does permeate somehow....business and the decision-making process. One of the things that I keep emphasizing over and over again is why you have to work day-to-day and make decisions in terms of the long run. I've always said to everybody all the time...don't ever make the short-term decision, make your decisions based on something that you can live with a year from now or two and feel good about. You won't always have it turn out that way but that's got to be the guiding principle. I think that if people, in living their own lives but certainly in a business environment, will get a few guiding principles from their company, and stick with those, [things will go well]....My philosophy is that there aren't many single answers to things,...that you always do what you say you will do...that you need a couple of very basic principles that set you in a certain direction. And if you're going to lead companies, if you will stick to [your principles], you will be a much more successful leader than if you get yourself real heavily involved in every little detailed decision as to what's right and what's wrong.

But the decision *was collegial, I am very strong in the word collegiality. That to me is the essence of really good leadership and management. As you get well-informed, motivated people....*

I had to *[consciously, deliberately] change my entire way that I'd been doing things [to] develop an ability to galvanize people through whatever process, towards a common goal. And so I changed from a whatever to really an operations personality. And I learned...the only way it would work...develop enough organizational charisma to be the strong leader to bring together a whole bunch of very diverse personalities and diverse companies and I decided purposively to try to develop that skill....I listened to everybody. Spent a lot of time travelling around listening...interactive, and after a year or so I realized that, "Yeah, I've got some good ideas but there are an awful lot of other people with some very good ideas, too." So we all changed. I was very conscious of those changes, very much so. I was feeling good about myself because I was beginning to see that I truly was becoming the CEO, the chairman, the leader.*

USING ANALYSIS CONFIRMED BY FEELING

Among these sixty entrepreneurs nearly half described their strategic decision-making as, primarily, a pattern of reasonably careful analysis first, after which they asked, "Does this feel right?" Common themes among them were thorough preparation, adequate data gathering, setting of priorities, sensitive analysis of the relevant alternatives. Many said that they tried to think thoroughly about the decision to be made, bringing to bear on it as much research, information and data as it took for them to be comfortable. Often they were very conscious and deliberate about the steps they were taking. Just as often they had no conscious awareness of any logic, order or rationale in their analysis.

Relying on Analysis

A few entrepreneurs said that they had learned to rely primarily on conscious, analytical decisions. One said:

I take out the Ben Franklin yellow pad and write copious notes to myself on the left side and the right side, going through that analysis out of absolute necessity. And fear. About how to sell the company at a loss but somehow recover it. Which I eventually did. And that was a conscious decision, that was well thought out, believe me....I learned that if I could just force myself to be a lot more analytical and follow my analytical conclusions, that they were a hell of a lot better than my instincts. And that lesson has held over the years. What had rubbed off for me was the need for intensive and extensive financial analysis before we went in and did something. Even if one did all the analysis and made a bad mistake, at least you could have said you did the analysis. And I was learning that the analysis was really the backbone, at least for me, in making [strategic] investment or business decisions. I had done so much analysis on companies that I could take the template for the successful ones that we owned, put it over another one and know very clearly if it was a good deal.

We gathered lots of information before making the decision, talked to lots of people, went through all the exercises, touched, digested, tore apart

all the information, talked to others, looked at everything, looked at how it all applied to us. It was a long exploration process. Once we got all the information, there really wasn't any decision to make. There weren't any other alternatives except what we did.

I listened to everybody, until I could say with some certainty that this is really a matter of analysis. I knew I could identify, so cold and calculating had I become, what I had to do and what I had to concentrate on....I learned that the only way to be able to make decisions in a situation like that is to find a bubble that will encompass all your problems and stay in that bubble....And I don't ever stop to say: "How does this feel?"

Another stressed what he called "order" as the controlling factor. This clearly functioned as analysis.

I bring a very carefully ordered method of thinking [to decision-making] and that's something that's irreplaceable....The process is one that, first of all you determine (a) whether or not you get the business, (b) what its potential profitability is, (c) whether you can do it internally, what are the internal ramifications?

There are a number of issues I have to address...but the decision-making process goes to deciding first of all what is your set of priorities right now? What are your objectives? And the first objective is to get this company showing black bottom line...you get the guys doing the numbers and see if they all say yes.

And another explicitly denied relying on "gut instincts."

I make very few decisions without data and very few decisions based on what my gut tells me...only if I've spent a lot of time in that field and also I've got at least enough data, whatever that is, to listen to my internal computer. I go to people that I trust and talk to them...I take a lot of notes...and organize it by files....If you're looking in a direction, if you're looking at something you want to create, then data has a way of glomming onto that like a magnet, you see pieces here and there and that would be

something you would compute against....Somebody said that whatever you concentrate on tends to expand. And if you're not looking in a certain direction you won't see it....

It may feel great, *but I'm not getting involved in something just because it feels good. I've got to make sure I'm making the right decision. I really need to sell myself on the logical side....If I can justify something logically, then I know that the emotion of it can be transmitted to other people....I can know that [the emotion] is the basis for the market, but the other side is can you make money and is the market going to last, and there are a lot of other questions that need to be answered. So I put together a notebook of data, and all of that went into a business plan...so that when I talked about it I could talk with real conviction, because I'd really done my homework. I was an expert. I really believed in it one hundred percent, I had no questions....*

The Role of Feelings

But virtually all of them, even the entrepreneurs who described themselves as very analytical, acknowledged the role of feeling in their decisions (as well as luck and timing and other things beyond their control). For example, an entrepreneur who described himself as probably "more analytical than most people in terms of thinking about thinking," said:

I tend to go through decision-making in a very digital sort of tree-type of approach. Point one, point two. I don't like idle decisions, so before I even waste the time accumulating information to make a decision, I decide what I'm going to do with it depending on whether the answer is A, B, C or D. And I try to influence other people in this way....

What I will try to do is organize it in a hierarchical way, so that I can virtually make a mental outline....I base decisions on conscious factors, even those I might make on an intuitive level...and I can see that the factors that caused me to make an intuitive decision made intuition logical [in that case].

Somewhere inside the factors that go into the decision-making are at least two quantitative factors and two right-brain factors that are incapable of quantification. On the quantitative side, it's the risk payoff, that is how much do you lose and how much do you gain depending on the various outcomes, and this is usually a spectrum of outcomes so that it's hard to be precise, and the second factor is the probability associated with each of those outcomes, so now I multiply it and get an expectancy. So the probability and the quantitative loss or gain with various outcomes are the two quantitative factors. On the non-quantitative side, one is very strongly whether you like it or not, whether you enjoy yourself doing it, and the second is what sort of non-quantitative value I attach to it. In other words, there may be things I like doing, that are a value to me, and I weigh that. I would use some process, perhaps a formalized one, to discover what really has value to me, what has significant value that perhaps I have repressed. I think that process would have to be guided.

Let me describe a construct that I think is not necessarily a conscious one but that fairly describes the process that I would use. Imagine that there is at the top an overarching objective, which might be called survival or might be called profit on a monthly basis. Now from that there flow five subordinate positions or areas of activity. From each of those in turn there flow five or six additional things...there's a whole tree....When I'm down contributing to or making a decision or taking an action way down at the bottom of this tree, I don't think all the way up to the top again. Because the connection is almost impossible to make without redoing the entire thought process that led me to conceive of this largely unconscious tree in the first place. What I think one does is think one level up from where you are, but accept on faith that that one level up is indeed an appropriate seminal objective that will support the over-arching objective....You have to assume that that one rivet is being put in that one place because someone figured it out.

My thought process is that before you want to go acquire a piece of information, you need to know what you are going to do with the answers. If it isn't going to make a difference, why do we want it? We have

> *to make a decision as to whether we know enough about the range of possible answers to this question, so that we can then in turn decide whether we will have different actions depending on whether that range of possible answers will help us [make the decision]. [And] we have to carry the analysis forward enough so that we can come up with a pro forma plan.*

Yet, this same, very analytical entrepreneur said he feels fortunate to have had a "transition."

> *...of learning that it was okay to have feelings, and whether I wanted to deny it or not, that I had a right side to my brain that could influence the things I did and how I did them....[Now] one of the criteria [for my decisions] is am I comfortable with it, do I like it?...This is sort of a change in style for me, that rather than giving an answer or making a decision, I would tell someone what my feelings were, as a starting point for discussion....And what I would try to do, on the other side of the coin,...I'd try to ask them what their feelings are. I would try to mix the acquisition of information about feelings and quantities, to have the benefit of both sides.*

This entrepreneur also said, later in our interview, that he really made his decisions intuitively, because he relied more on judgment than on data. Even those who describe themselves as highly analytical, the engineers and the scientists among them, regularly but not routinely detour from analysis into feeling when the decision is finally made.

Said another very analytical entrepreneur:

> **I use a lot of tools,** *mathematical tools. So going through my office, you see a lot of formulas on the board. I'm trying to convey these to my people, bringing in all the analysis, all the formulas. I use a lot of that, and I have to say that probably intuition sometimes does have some part in my decision-making process, but I rely on some scientific method if there is such a thing. Probably more so than the average I guess because I got into this business from a completely, completely different business.*

[This is] more stable and predictable, and allows me to be more analytical about my decisions. Although even before, I thought about that business very mechanically, very logically, in my head. Trying to use formulas, trying to prove mathematically things that we plan, that they will work.

[I have hired someone to replace me] and of course, again, being analytical, I didn't want to give up my authority before I knew that the guy can do it. Like the chicken and egg. Prior to him I had another one that was not exactly what I thought he would be and he was disappointing. So I got the new guy and I know that I can trust him, he is good at managing people. I could have hired a smarter guy, if I can say that, but I checked the other qualities that he has and I can balance him with the skills,...but he has all the other qualities that I need. I feel fortunate to have the people that I have right now....I think I'd say that [decisions are] a 90 percent numbers game with me.

Other entrepreneurs used analysis as consciously, if less formally.

What I was doing *in my mind was prioritizing what was important and what wasn't important. I mean that I know what I need; what I need really in a lot of cases comes down to numbers, and I am very insistent on doing my own analysis, my own economic analysis....I will never take a position or make a decision that I don't firmly believe in, that I haven't thought about and don't firmly believe in....I need to not only see numbers but be able to touch them and feel them and massage them and know how they work and what the sensitivities of a situation are and what the impact is of every decision that I am making. I really try to be extremely well prepared and to know what I'm dealing with. Hands-on preparation. I absolutely insist that the person doing the negotiating or making the decision also did or directly participated in the analysis behind it....We overkill with good information and effective diligence. I want to have at my fingertips every possible piece of information and diligence that you can bring to the table, and then you make decisions based on your gut instinct....You're just very well prepared and that's just fundamental. You take as much of the guess work and luck out of it as is possible. There's always going to be an element of luck, but you really try to be extremely well prepared.*

Do Your Homework First

This is a common theme: do your homework and your analysis, all of it, as thoroughly as possible, first; then make a decision you believe in, a decision that feels right, knowing there is going to be both luck and feeling involved in the outcome.

The first step is do conceptualize what you're trying to do, and then to work it out, step-by-step, consciously and deliberately, very analytically. I think I have, maybe everybody has, but I think I have this dual personality. I can be absolutely analytical and logical about things, but at the same time I have this other side, the emotional side that is kind of doing something at the same time. I think that you need both these things, to be able to figure it out but also to transform it into feelings.

From an analytical point of view, I can tell you all the steps to do strategic thinking, and it takes into account all these factors. When you're doing your own internal decision-making, you tend to eliminate a lot of factors and focus on a few. There's a whole bunch of things dancing around in the background, but you focus on a few. And maybe if I did step back and analyze it analytically maybe I would come to an answer quicker, I don't know....I think I've learned to trust my gut. I think I've learned that many times over and over. I don't always do that. I listen and I analyze, and if I come to a decision that my gut doesn't like, and if that's any cause for indecision, that's where I stop. That's where I will put off a decision, and if the analysis and the gut says it's right, I'll do it.

Where I am in my life is we take risks and you can't really ever collect enough information. One of my early mentors said there are two ways to do things and both start by making a decision early on with only fragmentary information. Now if you're wrong you're way the hell ahead of the other guy because you know you're wrong and you're now on the right track. If you're right, hell, then you're lucky and you just keep going. So I guess the bias in my thinking is to look for the relevancy of the information to the decision and get going. Waiting to get more information isn't my natural chemistry....I tend to be a pencil and paper guy. I try to develop the relationships of things. Drawing pictures and arrows.

I tend to be a linear thinker. I guess I'm interested in the sensitivity, the potency, of a particular factor in terms of how it affects my decision. When I'm looking at an important decision, I really dig hard at it. I set out the criteria, clearly, on paper, and use that as the screen in which I tested the various alternatives....It's a very rational process. And the nice thing about it is the very real world payoff [whether it has to do with my business objectives or my personal objectives].

I weighted those alternatives, every single alternative, whether to sell it, whether to sell it to X or Y, whether not to sell it, whether to keep part of it, whether to sell all of it, yes, whether to sell it or not, we analyzed it all. Whether to go to an outside firm to help us sell it, whether to sell it ourselves. After a great deal of analysis, we worked out a plan. Very analytically. There was no guesswork in this whole thing. No intuition. Except gut level intuition about the various people involved, the people in the firms we wanted to sell it to, the people in the firms who wanted to buy us. There is one guy who wanted to buy the company who would have paid us cash for the full price. But I gut-level didn't like him, and I sure as hell wasn't going to work for him for the next four or five years.

There are kinds of questions where I'm generally carefully analytical, like selling this company, and other kinds of questions where I'm deliberately not analytical, where I let my gut tell me what my decision is. For me, those are about people. I think it's just people that you deal with, and you're not always right about them, but I think you've got to go with your gut. You can do your analysis about their background, etc., but it still comes down to do you like them, you know. And I decided a long time ago that I'm not going to do business with people I don't like.

I make a lot of decisions analytically now, about sales and marketing ideas, about new products....I think I do a lot more investigation. I'm getting to be a hell of a lot more analytical. I think what has evolved is that I'll never make a decision about bringing in new people without having some checks and balances from an analytical point of view.

These are other common themes: learning that intuition, gut and feelings need to become part of the analysis about people, and about which people fit the entrepreneur's objectives; and simply learning to be more analytical. And simply learning to trust oneself.

I wanted to pull it out...we put together fifteen different permutations of how to pull it through. Without any exaggeration, I have the diaries to prove it, every week and sometimes more often, we reanalyzed those fifteen different permutations based on current events. Every week, it was a terrible time. And I finally convinced myself that I couldn't pull it out no matter what I did, through going over it and over it and over it. There again, there's a situation where keeping that diary made making that terrible decision pretty clear. I kept going back and reading that stuff, but for all the re-evaluation, the outcomes weren't changing and our options were getting fewer....

I have come through this [bankruptcy] and acquired people who counsel me in ways that you can rely on their counsel. I had none of that for years, and I pay attention to it, that's the first thing, and the second thing is that I, through the diary and this sort of monthly looking at life and planning, really forcing myself to do it...a combination of counsel and a much more drudgerous ongoing recording process and analytical process about business and about decisions...is how I do it.

HEEDING EMOTIONS SUPPORTED BY DATA

Another group of entrepreneurs, again about half of the sixty, tended to combine analysis and feeling in reversed sequence: making decisions on the basis of emotions, first, and then seeing if they were supported by data and/or analysis. One entrepreneur, careful and thoughtful in his decision-making, talked about the importance of being "emotionally connected," "tuned in to your emotional side when you start to make these major important decisions."

Maybe the size and portent of the decision is what made me finally really start to turn inward into how I really feel about work and about things and about what I wanted to do with my life. But as I say, now I

know I'm attached emotionally to just about everything, every decision....Once you open the lid it sort of spills out and it feeds into you. As I say, you learn to trust it because it's so much smarter than your eyes and your brain and your other senses....I think I began to trust it when I began to make some major decisions in my life and now I use it all the time. It's just like a tool. I'm plugged into it. I feel the weight [of decisions] in my emotional track rather than in my mental track.

It's funny, the yellow pad theory, I've done that and I'm certainly aware of it. When you do that and you're completely objective and you don't manipulate yourself, don't let your brain load one side or the other, all you really have are cold statistics. You have the data, the raw data. But in my process inside, it's almost as if you had a meter with a prod, a needle [that measures] all of that data....The needle is measuring feeling...the totally abstract feeling of myself being happy and comfortable with a sixth sense of it being right....how I really feel emotionally and deeply about [it] without an interference of the brain. Well, that's what happens in this process. Sometimes the brain might say, "Well that's going to make a lot of people ticked off," or whatever. But somehow this sixth sense or this center says, "Yeah, but it feels right. Got to be the right answer." And I have learned to trust that, absolutely.

My brain may come up with a solution and my network [my epicenter] will say, "Nah, it's a solution, but it doesn't feel right. It doesn't fit, it doesn't fit the puzzle, it doesn't drop right into the puzzle, it doesn't feel right." And then my brain goes back and brings up another one and then another one and finally, that's it, that's it. It's like instant recognition. It's like you try all those pieces of the puzzle, and you pick another up and before you drop it in, you know it's going to fit the puzzle. You could be blindfolded and know that's the right piece, the right decision.

This metaphor of the right piece fitting into a jigsaw puzzle, "the right fit," was used by several entrepreneurs to describe the feelings they have about good decisions.

Another entrepreneur noted the importance of emotions in his decisions, the importance of exploring "my own personal motives, and what I wanted to do."

And that's when I really became in touch in a massive way with the issue of human beings in corporations....[comfortable with my decisions] because they're emotionally sound, and they're emotionally sound because they're balanced and because they're not based on the price of the stock next week, but on what's going to be good for [the organization and the human beings here]. Look at...we spent a lot of time and money just to hire somebody who's a top academic in that field, commissioning him to do a study, just to make some decisions about a diversification we're handling...to understand a marketplace, and then to build an organization to fit it.

Learning to recognize the role of emotions in decisions was emphasized by others.

One of the things I've been working on personally is to develop the emotional side of my [business decisions]. Business-wise, it's trusting my instincts. Most of the decisions that I've always made here have been basically out of my head, mostly intellectual, just based on the facts. Now that's the way I perceived them, but what I realize now in looking back is that a lot of them really were based upon how I felt. I just didn't recognize it. I wasn't aware of it.

I think that my instincts always guided me, it was just more of an unconscious thing. At an unconscious level I trusted it without being aware of it. Now I'm trying to be more aware of it so I can tell the difference. I've got to look at two things [about a major pending decision]. Number one, since I'm resisting this move, I'd want some supporting information as to why we have to move. Then I'd have to take a look at myself and say, "Okay, is this just because you don't want to move? Are you just digging in your heels like a little kid who's saying it's my ball and if you don't want to play with me then I'll take my ball and go home?" If that's what [my resistance to making this decision] is, then I can't really afford to do that.

You know you've got to take a look at the reality of what you feel, and then bite the bullet.

Acting on Feelings Alone

Making major decisions because of their feelings, and just acting on the feelings, without supporting them with data or analyzing their consequences, was a theme that many of the entrepreneurs repeated.

I couldn't put up with the injustice that was building up [with my partner]...and I just decided that we couldn't go on like this, either we were going to sit and watch him pout, and everything I'd worked for go down the tubes, or I was going to have to act...no matter how hard it was or terrible to do....

It was emotional, because I wanted to finish what I'd started,...and it's an area that I don't understand enough to give it as much analytic thought as I normally would and there just wasn't enough information for me to think as far ahead as I normally would.

These major decisions as I'm recounting them seem to be as highly influenced by my emotional state as much as anything else...I get charged up....

What's keeping me from wanting to build [the business] are my own hurt feelings. Okay, when am I going to get past my hurt feelings, I'm kind of mad.

I had fallen in love with it...[the business] is very seductive, there's a real power about it. But the only reason I sold my interest in that firm was that I needed, but it wasn't a conscious decision, I needed money for [the new business] which by that time was totally an obsession with me.

It was really starting to bother me...then when you start thinking about things like that, it's the time for you to leave....I think it started almost two years before I left...at the end of one day I said this is a little too much, the hell with it...I made that decision over a weekend, and I didn't have the slightest idea what I was going to do. That was like, it's really true, there's always the straw that broke the camel's back, it's true. It doesn't have anything to do with, it's just one minor thing, at the end you

say "Okay, this is it." You just don't care what you do after that....It's very tough [leaving] a relationship of twenty-odd years with this man, we really were almost like a father and son....It's a decision that you make and you don't think about. I had sat down, before that, and did something almost like a balance sheet, about all the objectives I had said I would accomplish, what was accomplished, what did I give, what did I get, almost like a balance sheet, and I ended feeling good about it because I didn't leave anything undone, not anything that was in the middle. I basically did everything I told him I was going to do. What I gave was a multiplicity of what I got, so I wasn't feeling that I was leaving them in the middle of something.

In our interviews there also were a number of descriptions by entrepreneurs deciding to take an action and then only later figuring out how to explain it or make it work. This entrepreneur said it well.

***That's** what I'm working on: the first one is going to be the overall gut feeling of what we are doing, the second one is going to be the justification for doing it, then you need to be able to do it, so then you figure out how to do it.*

THE ROLE OF INTUITION

What of intuition? With only a few exceptions, these sixty entrepreneurs all said they had made intuitive decisions. Many said they now were conscious of using intuition in their decision-making and of wanting to get better at using it. The question is, what is intuition?

During our interviews, the entrepreneurs used the words "intuition," "emotions," "feeling," "gut" in ways that were meaningful to them, individually, and we usually explored and clarified what each of them meant in using any of this group of terms. But we didn't try to isolate definitive meanings. Among these words, "intuition" was sometimes the generic term for all of these concepts as well as for creativity, insight and innovation. One entrepreneur, very concerned with exploring the "semantics of what intuition is," defined it in several ways.

It's a kinesthetic feel that some people have and some people don't have, a kind of left-brain, right-brain thing, what makes a Picasso a Picasso; I think that there are fewer people with strong intuitions at a young age than old, because life experiences add up to knowledge and wisdom—that's the word: wisdom....[When I said my intuition took over] the word that came to my mind was guts....It's experience, it's a holistic thing, it's really hard to describe because it's a combination of mental and chemical, I mean it's like your gut tells you things and there's a chemical reaction that's going on in your body, which is driven by mental, which is your mind, so that the mind is triggering some kind of anti-bodies or something which is tightening your stomach muscles,something that your gut is saying: this doesn't feel right....it's really a hard thing to articulate, it takes some brainstorming to get through that, but it is mental, it is wisdom, it is time and experience.

This entrepreneur's use of the phrase "gut instinct" indicated both some of the confusion about what it means and some of the power of its meaning to him.

I am a strong believer that you make decisions based on your gut instinct and that almost all the time your first gut instinct is ninety percent of the time the best. I try to be extremely well-informed. Not by going through any particular analytic process but by really understanding the environment which I'm working. I try to know the people that I'm working with extremely well and know what their needs are and what their motivations are and what their wants and desires and what they want to achieve out the back door, and everything else beyond that is pure logic.

Number one, good decisions are made by gut instinct, and they're made out of opportunity, out of a feeling for opportunity, as opposed to a feeling of fear. Because if you operate, there're always going to be pros and cons of everything, and if you operate out of fear you're never going to make a decision. You've got to be willing, you don't want to do something that's stupid, and you want to always be able to calculate what your downside risk is, but you've always got to focus on the opportunity, and the world is so full of people that are going to devil's advocate everything.

Tacit Knowing

A common theme among other entrepreneurs' definitions of intuition was that it is an unexamined decision, or an unexplained knowing.

> **I think** intuition means decisions that you can't articulate...no one's explaining the underlying mechanism...not quantified in my mind....

> **Intuitive** is, I suppose, that we've at least thought about it [the decision] to the point where you believe it's right even though you haven't analyzed why and figured out why. Unconscious is where there's been no thought at all given to whether this is a good or bad decision. [You just do it.] You've just done something driven by your emotions perhaps rather than by any semblance of rationality....I think unconscious decisions probably do turn out to be bad, more often than not.

> **Just went forward**, no market research, of course not, who does those kinds of things? That's silly. If you have the money you spend it. And you go with your hunch.

> **I guess** that intuition is there. I just have strong feelings about things, when they feel right or when they sound right...just know it works. But I didn't know it then. I know it now.

> **I suspect** that an intuitive decision is nothing but a subconscious logical analysis that our brain is not explicitly used to handling, in other words somehow internally the brain goes through these calculations and doesn't come up with clear conclusions, but comes up with what we would call a weighted conclusion—it seems more right to do it this way than that way. That's on the macro level and that's what people call intuition. I don't think there is something called intuition, I think it's some subconscious computation.

That intuition might be some subconscious computation relates to descriptions by other entrepreneurs which have to do with judgment, and with a process of improvement through modelling, with learning, and with recognizing the "smell."

The process itself keeps getting better or polishing itself because of the input, like a model—a typical model of where every time you make a bad decision your intelligence says okay and then takes that data in, so that you continue to make better decisions and fewer erroneous ones....the mind listens more to the whole and comes up with better synergy.

It's certainly gut reactions...[expertise] like an old 1088 IBM sorter.

Nothing formal, intuitive thinking...because of the fact that I had such a wide variety of experiences and a wide variety of jobs...that probably helped with the decision-making...it wasn't anything new.

I don't think anybody arrives at those kinds of really major business decisions through a capacity or power of analysis. I think they're inspiration....so there was an awful lot of business talk. When it came to running [this company] it really was trust your guts and intuitions.

I knew intuitively. I think if you want to find out why, it comes from my family background...the discussion over the dinner table...you'd get a feel for it...it becomes instinctive...[and then you do it and learn] but the decisions are based clearly on experience, and they are informed decisions, they are not decisions without any basis, they are clearly decisions that are made from years of experience...in the brain the pathway is there, you just know from your experience what's the right way to go about it....It's expertise and that's experience.

They would have known because they would have been in a similar business and they would have been able to walk in and smell it.

I think all of our decisions are in part intuitive. I really do think that. You hear the expressions "doesn't pass the smell test" and "you've got a gut reaction." That's intuitiveness in part, a lot of what we do is based on those.

Intuition comes, intuition is just a decision made on a hell of a lot of input, a reasonable rational decision, that's what intuition is. Absolutely [based on expertise of a very high order]....It was intuitive based on the

fact that I've been in this business thirty years, thirty years out there talking to people [so I put the feeling I had with an idea I heard and built the new business].

[After being in business for so long, I can make decisions that I couldn't have made twenty years ago], but I have to learn to trust myself. And that's what I'm learning now. Before I think I made them without being aware of it. Now I make them but I'm more aware of them and so they're fuller, they're more meaningful to me.

I don't use the term intuitive because I don't believe it. I think what we call intuition, other than the sort of new wave view of it, but what we call intuition...is the sum of tremendous experience that comes in a flash. It's [expertise based on experience] but it exhibits itself in an unformed way.

Common themes about the nature of intuition, then, were that it is an unconscious knowing, unarticulated, and unexplained—tacit knowing; that it favors the experienced and the expert; that it is an exhibited form of expertise based on experience; and that it is a valuable tool for better decision-making.

But that it could be dangerous and deleterious to good decisions also was acknowledged by some of these entrepreneurs. One said:

Almost every [other] decision that I have made intuitively has been wrong in the long run...when I didn't follow it up with my homework.

Even those who describe themselves as impulsive and gut-driven also say they think about major decisions carefully.

Even though I'm impulsive, I generally on major decisions really think it out. I'm a basic thinker, I'm introverted, and my strongest asset is thinking, so I don't do many things well but I can think well. If I'm thinking, on the impulsive stuff where it's not a life or death decision I'll be impulsive; when it's major I really do think it out. So my process is intense thinking on major decisions.

Patterns of analysis confirmed by feeling or emotions supported by data, both augmented by intuition, are parts of the decision-making processes that these sixty entrepreneurs described and explored with me in our interviews. As a group, they were almost all analytical in one degree or another, in a discursive rather than formal way, and most of them were consciously, deliberately as analytical as they knew how to be.

Only one entrepreneur described a decision-making process of the classical tree-like type, and that was modified by his conviction that ultimately he makes decisions primarily intuitively, judgmentally. Virtually no one reported consistently relying on his intuitive capacities, but virtually all of them used intuition as a decision tool.

As a group, these entrepreneurs were very respectful of their own feelings, as well as of the importance, for good decision-making, of their emotional connections with the issues and with other people involved in them.

Also, as a group, they were eager to improve their decision-making, but to do that by becoming more aware of and more skilled at the processes that already work for them personally, rather than by filling in the blanks of someone else's formula.

These entrepreneurs, in their own descriptions, made strategic decisions through processes which combine elements of analysis and emotion and intuition in very personal, very individualistic, ways. Their decision-making followed the method of rhizomes more than of trees, utilizing and ordering only the processes and parts of processes that work best for each of them, whether they preferred a pattern of analysis confirmed by feeling or a pattern of heeding emotions supported by data.

THE RHIZOME OF PROCESS

The excerpts that follow are what a few of them referred to as "my process," and which, taken together, are representative of the rhizome-like decision-making processes of this group.

I do my best decision-making when I have the checkbook out...I mean, it either feels right or wrong....When I'm on the brink of reality, when I'm at the brink of making the change and knowing that I can make the decision that's going to be the major one, then I'll really start to internalize and sit with options and alternatives and listen to my system....It's not really formal, but I know that it takes place closer to the point of decision. And I also kind of turn up the volume. In other words, there's always ideas and options and alternatives, you know, in your psyche.

Analysis and data are probably first, I really do work the numbers, then probably instinct. I take the data and work it, work it, work it, and then I come to some conclusions. And then I say, does this feel right? Does that look right, does that feel right? And then I'll talk to people here and we'll try to look at processes, versus actual performance, and come to conclusions.

It's a very careful process of trying to determine what's important to you and what you can live with, and what you can't live with, and what's going to make the other people happy, and more importantly, what's going to create [trust] and a long-term relationship.

First of all there's that seed: well, maybe I shouldn't carry it, maybe it's time to get out, well I don't want to get out and there're all these reasons, and then the next month something else would happen and I'd say, I really have to start thinking about getting out of this and I can see that it's getting worse. That's what I refer to as the procrastination process because I think I knew when it first came up that it was time to get out, but I just wasn't willing to let go of it.

What I do is a lot of pre-thought, pre-work. I rehearse almost every meeting I've ever gone to. Before I get there I think about what's going to happen and what's going to be asked. If my due date on making a decision is a month away, I'll immediately collect some data on it and look at it. I put the decision away and don't look at it again. A few weeks later, when it occurs to me, I'll look at the data again. As the date for the decision approaches, I think about it as I go to bed at night. While I'm driving the car I might look at it, or often times hold conversations with

myself, whole conversations, in my head. I'm sorting and sorting, always sorting. Then one day I'll wake up and the decision is made, and I'll sit down and dictate a fifteen-page memorandum on it. Somebody will say, how did you do that overnight? It never happens overnight, it's a process that took place over thirty days, sixty days, ninety days. It's part of exercising my "don't-make-a-decision-unless-you-have-to" process. Later I make these instinctive decisions, very fast.

On the other side, while it's true that it's instinctive and I'm relying on my internal integrity in making them, there's a lot of this processing that's been going on over a long period of time, and the ability to do that is born out of ten years of familiarity with the issues. It's my expertise based on my experience. When people say wow, you did that in just three minutes, I say, yeah, it only took me twenty years to set it up and that's really true. Of course, that's the benefit you and I have as decision-makers today that we didn't have twenty years ago, because we have that additional twenty years of experience and it's etched in our memory banks and anything that we do is going to be done in light of that experience....I really think that's what's happening, there's a lot of processing going on all the time on different issues, and sometimes if somebody asks you your opinion on something you didn't even know you had an opinion, but you do and it's very logical and well-ordered, and that's because you've processed it already, and when you need to draw it out, you draw it out. Some of the processing is conscious and some of it's unconscious, but it's always going on. Something else that's part of what I do is sequential processing. I'll seem to be doing a lot of things at once, reading, listening to music, thinking about a problem, but what I'm really doing is focusing on one at a time briefly, [which I can do] because I already have all the patterns.

I'm basically an outside-in kind of decision-maker. I spend an awful lot of time filling my computer with data about what's going on out there, and when I make a decision I really look at it as though it's a sales presentation to myself. As if I had to sit down and put all the pertinent data in one page, and I get whatever data is needed to make that decision. It works for me, I've used it for all my major decisions. Also, no matter how experienced I may be with the data and the area of the

decision, I can't short-cut the process. I think if you short-cut it it's like a chain, you've got to have all the links. If you don't it can break apart. And it doesn't take much to destroy a decision plan, there are at least a hundred different ways to kill it.

It's also that I want to see as broad a spectrum of things as I can and understand them so that when I'm out there and my scanner is going back and forth, I can understand whatever I see. The more I understand the more I can relate it to other pieces of the spectrum, the easier it is to move on it and to employ serendipity and to say I know something about that, let's go do that. I also want to be conversant about whatever the issue is, and when I have a decision to make, to have as much data about it as possible.

Another thing I really like to do in decision-making is to build a model and have a structure or graph, I like to be able to see things pictorially, to visualize. So I like to visualize a model, and see where things fit in this model. That gives you a systematic way of hanging your data as you go along, and of exercising the model and seeing if it works. So you go back and adjust the model of the decision, always filling it out, flushing it out, cranking it until you can get predictable results for your decision.

I think that part of [decision-making] is training your mind to, it's like playing three-dimensional chess, very much like that because it's merely aligning the pieces into different patterns and your mind either rejects them and you try something else or it works and you keep going in that direction. Partly, too, it's training your mind to work faster, like any computer searching through the files. Also I do contrary thinking or what I call contrary thinking, which is if somebody says it ought to be corporation, I'll start thinking why can't it be a partnership or why shouldn't it be something else? I also always know the numbers, and I have tremendous debates with myself, searching through everything to try to understand why. Sometimes I find that the circumstances aren't right for it, and then I try to find some other pieces that fit the decision. And occasionally I'll rethink decisions that same way.

Things that are repetitive decisions, that are based on something that's happened before, I'll make very quickly now because I've got the experience of before. Things that involve fundamental sorts of shifts I will tend to stew with for a long time. Months. Or four months. I think I'm typical of many people, I will procrastinate on something until I have to make the decision. So I do often times create little traps for myself where I force myself to make a decision. I'll maybe set up a meeting with somebody, knowing that that is when I have to make the decision. And I will constantly set up situations to force myself to make a decision by a certain time. Play that little game with myself, or I'll make promises to myself. I always keep my promises to myself, and they're very hard to get out of. I'm very good at creating a situation where I can't get out of it, I'll box myself literally so that I have to make the decision.

I like to set a course and maintain it [instead] of leaving as many alternatives open as possible, as some of my friends do. They wait right down to the wire and pick the best alternative then. I kind of pick the alternative that I like best at the outset, steer toward it and just go right down the line, kind of steady and driven by the course. My best decision-making usually comes right after I wake up in the morning. I usually wake up early, always have, and I'll lie there, I think that your subconscious works on decisions constantly, and when all that input into your personal computer is sufficient, when you're relaxed the decisions regurgitate. Bingo bingo bingo, you make three or four important decisions early in the morning. I'm going to do this, that and the other thing with this company, in reshaping it, and what to do and how to do it. A lot of times I couldn't sleep at all, a lot of times I'd be awake four or five hours into the night, with a great deal of anguish, should we do this, or is he any good. There are literally ten, fifteen, twenty major decisions every day in this business.

SUMMARY: PATTERNS

The common pattern of strategic decision-making among this group of entrepreneurs is one of combining personal decision processes—using analysis and heeding emotions—into patterns that work for them. They relied on analysis confirmed by feeling or they heeded

their emotions and supported them with data, and they attended to their intuitions, to the tacit knowledge of their experience and expertise.

Among the descriptions of their decision-making were issues of luck and timing, talking with others, objectives and values, their personal qualities, their use of experience, learning, playing games and of awareness of how they think. But there were no rules, no order, no rationale to describe how these things worked together for each of them, and no prescription for how analysis, emotions and intuition fit together for them.

For most of these entrepreneurs, their process of decision-making was situational and contextual, its progress depending on the issue, on the circumstances and on what was happening with them at the time. Depending on what they were trying to achieve, and the urgency, and their resources, they might use all of their tools of decision-making, or only a few of them; they might be influenced by many other people, or by no one; they might stick with their initial analysis or change it.

In whatever pattern of decision-making they felt most comfortable, the arbitrators to which they were most attentive were their own feelings. Whether their feelings were an on-going, unconscious part of their analysis, or whether they evaluated the decision against their feelings towards the end of the process, for most of them, the question "Does this feel right?" was critical.

The common model of decision-making among these entrepreneurs is the rhizome—opportunistic, meandering, discursive, unstructured. And holistic, with all of its parts interwoven and connected. The rhizomes of their decision-making worked much like vines growing up the side of a rock, opportunistically following a line of thought until they were blocked or redirected by something in the way, some relevant information, and then searching out again in some slightly altered direction—like the vines seeking sunlight, going around crevices, following less obstructed paths or meandering among them.

These sixty entrepreneurs described two patterns in their decision-making processes: one led by analysis, the other led by emotion. They acknowledged the separate role of intuition in augmenting either pattern. The lesson here is that understanding the process of your thinking (does it grow more like a rhizome than a tree?) and recognizing the patterns of your decision-making (do you instinctively start with the facts or your feelings?) are key steps in being able to make up your mind.

MAKE UP YOUR MIND

5 🖎

A Measure of Independence

I'm not certain why the notion of being in a business has been so pervasive in my life, I don't know whether it's because I was seeking financial independence at age 10, or whether I was simply seeking a means to have an outlet for creative energy. Or trying to get the hell out of the house or escape from reality.

My business life started when I was a newspaper boy. I discovered that newspaper boys don't make as much money delivering newspapers as they do getting new customers. So, I quickly got out of the newspaper delivery business and set myself up as an independent contractor to go and solicit subscriptions. I actually set up my own bank account. I started paying people who were regular newspaper carriers for the right to go and canvas in their areas. I took the money from that and put it into a stamp collection. That became really interesting to me. But the more interesting part of the stamp collection was that I could set up a stamp store, which I did.

I didn't get back into business again until I was in college. Then, it was one of those things where I didn't necessarily need money—but I needed

something to do apart from just the classroom routine and the Saturday nights chasing girls. I wanted to have a business, so I did things like set up a laundry route for all the fraternities. Again, it wasn't necessary because I desperately needed money or couldn't afford the tuition. It was just something that I wanted. What was the reason for the decision? I think a desire to achieve a measure of independence and achieve a measure of self-worth, which was not to be found in chasing girls on Saturday night and studying real hard.

In spite of my early interest in doing things that made money, making money wasn't the objective. It was the building up of something. It was the germ of an idea that I could see become a bigger idea and then a bigger idea...in spite of all that when I got into graduate school. I thought this was a pretty neat place to be. Academia seemed like a wonderful place. I really thought what I was going to do was continue my education to the point where I'd get my Ph.D. and teach economics at some ivy-walled school.

I was accepted at Harvard, with the notion of going there to take a Ph.D. in economics. At that point I was also married for the first time— and both my wife and my father-in-law had a big influence in my life. My father said, "Don't you think it would be wise to work a bit before you continue on this mad idea?"

So I went out and worked for an interesting [New York-based conglomerate]. It still is an interesting company. I went to work for [the chairman] as a gopher, sort of personal assistant. I was twenty-two or twenty-three. Within five years I'd progressed from being the chairman's assistant to president of one of the major subsidiaries. I was 27. I suppose by any standards that was marvelous. It seemed like the normal progression for me.

I'll never forget coming home one day to my wife and saying, "I think I'm going to resign." Her response, besides being aghast at the whole notion was, "Why? You're 27 years old, no one else has ever done anything like this in a company this size. You're making sixty thousand dollars a year which is a hell of a lot of money. What are you going to do?" I said, "I'm going to buy my own company."

The reason I wanted to buy my own company was because I wanted to achieve again that same sort of independence, not necessarily financial. Just the independence to act, to create. It's very difficult to create in a large company. My experience is that the reason people move up the ladder in large companies doesn't necessarily have to do with brilliance— in many cases it has to do with being on the right political side all the time. You see it in law firms, accounting firms, big corporations, and so on.

I looked at people who had entered into the system five, six or ten years prior to me. Some of these people were actually working for me. I saw their experience in the last three or four years had been a one-year experience repeated three or four times. I was the president of one of their bigger companies. The next logical step was to become a group executive. That wasn't all that difficult to do. But [the chairman] was only 20 years my senior—he was going to be around for a very long time. If I couldn't have his job, where I could influence the direction of the company, then I really didn't have any other place to go. So I might as well leave.

So the motivating factor—the reason for the decision, if you will—was not necessarily great riches that could be achieved by getting out and doing something else. It was to achieve a measure of independence so that one could put one's own ideas into work to create something in the business world. I thought about this all the time but I never discussed it with anyone else—not even my wife.

Some people reach decisions by analysis; some people by intuition; some people by thinking about them night and day. That's primarily how I make decisions—waking up in the middle of the night and thinking about the same thing over and over. So [the decision to buy it] had been going through my mind twenty four hours a day, certainly all my waking time, for six months. It would have happened sooner had I been able to find a company to buy.

I had that feeling that now is the time to move on. I just didn't have the vehicle with which to move on. Now's the time to go out the door and get my taxicab—but I couldn't find a cab. The notion that I really didn't

have any place to go—which was shocking to my wife—was a great relief for me because I realized that I needed to find a taxicab. I looked for a large conglomerate which had grown very quickly through acquisition and, like a lot of companies in that position, got into trouble. It would begin to have to divest itself of a number of companies.

I didn't have any money, so I had to buy something that was a loser. Something that no one else wanted, so [the owner] would virtually give it away. I didn't spend a lot of time canvassing my friends on Wall Street to find the right kind of business—in those days there wasn't a lot of money for LBOs. [Eventually, I found one conglomerate that fit my need. It was] run by a fascinating man. He had a subsidiary he wanted to sell. It was a loser.

The company was a women's hosiery maker, for which the owner was willing to accept five hundred thousand dollars, which to me was a fortune. I went to a big New York bank, with whom I had had good relationships because they were [my employer's] principal banker. We worked out a deal where I borrowed all the money to buy it—the first LBO in my life. I bought the company.

I went to see [my boss] and explained why I was doing what I was doing. He was very upset and said all kinds of things. He said the same thing to me he'd said to thirty or forty other people who'd left—"You could be president of this company some day!" I kept a straight face and we departed and were friends, for awhile. Now I had the business. I thought "I'll be rid of all the corporate politics. I'll be rid of all the fluff that goes with the big corporation. Now I can be pure." And discovered how wrong I was.

I bought a business that was a failing one. I knew that going in, but I didn't realize the degree to which a failing business can get even worse real fast. I had done very little research into this business. I had no experience in the hosiery business whatsoever. I had no experience in soft goods manufacture, no practical experience in shop floor type of running things, or distribution, or advertising.

I had gone from being sort of a staff assistant to being a president. So I couldn't say I'd been an accountant, couldn't say I'd been a salesperson

or a marketeer and so on. I'm sure that if I'd looked for another year and a half I'd have found a better company to buy, but I was anxious to go. I'd made up my mind.

Of course, I had an MBA—so I knew everything.

After I bought the company, I decided to find out what the hosiery market was like. I decided to look at it as if I was a management consultant brought in to tell the owners what to do. I should have done it the other way around—and in later deals I did it the other way around.

My perception, and this was instinctive, my perception was there was something wrong with the marketplace. I didn't have to be a genius because sales just kept going down and down. We were obviously not doing something right in the marketplace. So, I started spending a lot of time talking to people who were selling ladies' hosiery. In those days, the distribution was primarily through hosiery counters in department stores—not unlike cosmetic counters today.

I must have spent four or five weeks, not only wondering if I was really going to go broke and could I ever pay the bank back this money, but also talking with people who were selling ladies' hosiery—the Bergdorfs and the Bonwit Tellers and the Marshall Fields and so on. I was trying to find out what was new in the marketplace. Why was it that we couldn't sell.

In those days ladies were not wearing stockings anymore. They were wearing pantyhose...this was 1965, '66 maybe. I thought, "Fine. We'll just order up pantyhose. That's simple enough." And then I discovered that the machinery that I—sorry, that the bank—had paid money for was what they called single purpose knitting machinery. You couldn't knit pantyhose on it. So, we were producing a product in a market that was getting smaller and smaller all the time. Another market existed nearby that was growing—but we didn't have the capital facilities with which to capture that market.

So I went back to the bank and said, "Remember me? I'm the guy that borrowed all that money. I'm back to tell you that I have to borrow a

whole lot more. I have to junk all the productive equipment that we acquired." I'm sure they thought, "This is a very bad loan. How did we ever get snookered into doing this deal with this kid?" They said, "What's your plan?" And I had a marketing plan that I probably took out of the textbook in those days, or certainly the outline of one. "This is the U.S. market for ladies hosiery by type...by style...blah blah blah...and the net result is we should be making ladies' pantyhose."

The head banker said, "My wife doesn't wear pantyhose. That's a fad." So we did a very sophisticated marketing survey—on the mezzanine floor of the bank. This bank officer and I went around and surveyed probably fifty of the female staff. Thank god for me they were all young. We asked them what kind of stockings they were wearing. Not a single one of them wore stockings, they all wore pantyhose. Based on that sophisticated in-house survey, this guy said, "You're right. We'll lend you the money."

We threw out all the knitting machines and replaced them with pantyhose machines and renamed ourselves in the marketplace. We spent some money with the package designer and some other consultants and we came up with a line of ladies' pantyhose that were elegant and had more colors than anyone else had at the time. We had more different kinds of styles than anyone else had at the time. I was concentrating purely on the market because I felt that in this company's instance it didn't really matter what costs were—it was just a matter of what the market was.

Ladies' pantyhose were really cheap. The packaging cost more than the product. And the bindings—the elastic band on the top—was about three times as expensive as the pantyhose themselves. In those days, ladies' pantyhose were selling for six ninety-five or seven ninety-five a pair. We soon reached the point where we couldn't make enough of them. We had the factory running 24 hours a day, seven days a week. We made a whole lot of money, a sinful amount of money. It was embarrassing.

It was—and still is—my habit wherever I traveled to look at the competition. So, I was in Germany and went to a big department store in Dusseldorf. I went to the ladies hosiery counter and discovered they were selling a brand of pantyhose for four marks—about 99 cents. I

discovered that they were made in Israel. So I went to Israel, found out how they were being made, realized that this was the future, came back, got my friendly banker, and I said, "I'm selling the business."

He said, "Look, we thought you were mad when you first came in and we knew you were nuts when you came in for that next loan. But do you know how much you're making? You can't do this. You're nuts, boy."

I said, "No. I've seen the future and the future is not $6.99."

I sold the business and made a lot of money. I don't remember how much money I made, that was not important. What was important was that I bought it, found out what was needed, was able to get the company galvanized to do it—and got the hell out before the market collapsed.

I didn't have to do a lot of analysis here, either. When I was in Israel, the guy was showing me all the export orders he had for what's called an unboarded machine. He was describing to me how you could make a lot of money by selling ladies' pantyhose at 99 cents. He was talking about people selling pantyhose in supermarkets and other distribution channels.

I didn't mull it over at all. This thing could happen in a matter of a year. The department store counters for $8 would be no more. Rack jobbers would be doing it. It was very clear. If I didn't do this I was going to be as broke as I thought I would be when I started the company.

This was a consumer item, with the big margins that are typically attributable to consumer items. Your primary interest has to be what's happening in the marketplace. (I later owned another company that was not consumer-oriented and had very thin margins and a very high material cost. The necessary emphasis in that company had to be on reduction of material costs.)

After selling the hosiery company, I was 29 or 30. I didn't have anything to do. I was looking for something to buy. At that time, I thought I would spend the rest of my life buying and selling companies involved in fashion. That's where all the excitement was. I thought, "I'm really a genius.

Why do people work for a living? They should just buy companies and go look at a market and make a lot of money." What an asshole I was.

I was also a frequent reader of Women's Wear Daily *and all the rag press. Another company came up for sale which was making ladies's innerwear—that's a trade name for ladies' underwear—bras, girdles, panties. People don't wear girdles anymore but they wear chemises, slips, etc.*

I thought, "Since I'm so damned smart and know so much about ladies' fashion, why not buy this company? It's old and sort of break-even, not making a lot of money. I can be in the marketplace, see what makes this thing work." They had a factory overseas. [I thought] it would be fun to go there from time to time.

I bought it because it was in a field that I thought I had some expertise in. What I discovered was that I wasn't a marketing genius whatsoever— and that the only reason the hosiery company had been such a great success was that I happened to be early into a market that was rising in spite of itself.

I had in mind that it was always going to be driven by the market. So I bought a company for which yes, there was a demand—but it wasn't an overwhelming, buy-at-any-price type demand. So I realized that it was not going to be market-driven. It was going to be driven by a slow process of getting the right designers and having a lot of luck...working with a million and one different distribution channels. I didn't do a very good job with that company.

I was looking for a way to do something with it where I just didn't have this one leg to stand on. I didn't see it as a very good leg. I thought, "I either need to merge this thing into somebody bigger and take back a piece of the action or I need to sell it outright." Or I need to spin off part of it. I started thinking in terms of the financial structuring of it—forgetting the marketplace.

I had to step out of the business, look at the business as if I didn't own it. I took out the Ben Franklin yellow pad and wrote copious notes to myself on the left side and the right side. I did it out of fear.

[Eventually,] I lost interest in it. It was a gradual feeling of unease and given to panic. And so a conglomerate came along that wanted it and bought the company from me—at a substantially reduced price than what I paid.

So I took a bath. However, I sold it for stock and had every expectation that this fast-rising conglomerate whose stock I now owned was going to be worth five times what I accepted it at. I even went to work for that company briefly. They asked me if I would do mergers and acquisitions for them. I did it for nine months, I doubled the size of the company, from $120 million to a quarter of a billion.

This company had five operating groups, and each operating group had its own president. Each operating group had its own strategic guys there thinking, "Our market consists of six niches and we have four of the six. If we could find the fifth one, it would fit right in." So I had some real good guidelines as to what they needed. It was simply a matter of finding a match. That wasn't hard to do.

It was nice at that point also to get back into the womb of a bigger company, having been burned badly in the second deal. I did a lot of financial and market research into public and private companies, initiated some contacts and developed some relationships with a bunch of investment bankers. Then I went out and bought a bunch of businesses for them.

After I doubled the sized of this company, the stock was selling at [more than three times where it was when I sold my company]. The chairman and I were talking at lunch one day. I said, "I see no reason why this stock should sell at thirty times earnings, when the rest of the market's selling at twelve to fourteen times earnings. It's over-valued." And he was saying, "It's going to [double from where it is now]."

I was very nervous about my stock. I bought the companies for the five operating groups, but I wasn't running them and I wasn't integrating them into the operation. And I was buying them frankly faster than they could be assimilated, and it was a big hype.

And then we had a bad quarter. The stock dropped very quickly from about forty dollars a share to about twenty dollars. I could see a bad quarter would give rise to a real bad six months. The chairman didn't want to hear it, so he fired me. Shoot the messenger. But I'd almost recovered as much money as I'd lost on the purchase and sale [of the underwear company].

I learned that if I could force myself at that early point in my life to be more analytical—and follow my analytical conclusions—that the conclusions were a hell of a lot better than my instincts.

I decided that I would start my own investment banking firm to concentrate on what the big boys call corporate finance—what the little guys call mergers and acquisitions. I would do [what I'd been doing for myself] for someone else, on a fee basis.

I took in a partner—a guy who had been working for me, he was a sort of an accountant. We hired a secretary and got a nice little office. I'd made so many contacts among investment bankers and attorneys and accountants in the deal-doing process that they kept feeding me ideas. It was very easy to mine that source with companies that I knew were interested in acquiring [other] companies.

We did a lot of research on who was acquiring what, so we had this enormous data base. In those days you didn't have computers, so the data base was manila file folders, stacks of them. We were able to match up buyers and sellers. The first year we made a little money—I think the two of us made eight thousand dollars. But I had enough money to keep us alive. The second year we made over a million dollars, which wasn't bad. But then I began to think, "This isn't fulfilling. All I'm doing is match-making. To be unkind, I'm really a pimp."

I realized that I'm not real happy peddling one set of aspirations to another set of aspirations. I really need that feeling of contributing something. So, I didn't know what I wanted to buy, but I knew I wanted to buy a company. It was [a decision] based on a great deal of unsatisfaction with my business career at that point.

I was good at being the vision for an operating business. I didn't give a damn what the title was. So, again, it was a matter of trying to find a business. This time, we—and I include the guy who was my partner— did a real study. Instead of buying the first damn thing that came along, we decided to look at industries, to see what we could see.

Finally, we began to narrow down some guidelines. This is very analytical type work. We were looking for industries that were highly fragmented, no one dominant force. We couldn't buy IBM in the computer business, so we had to find an industry that was fragmented and hopefully heading for a period of consolidation. We could pick up some of the fragments and wait for consolidation.

We found an industry that met all of my predetermined criteria. It was fragmented, had maybe two billion dollars worth of sales and about fourteen or fifteen hundred companies operating in it. There was no dominant force, only one publicly traded company. And it was an essential service, a service industry.

I was a little turned off by manufacturing at that point. We looked at the chemical business, we looked into millions of things, but we finally decided on an industry that is referred to by insiders as the textile rental business. It's really the uniform rental and linen supply business. Table-cloths and napkins and uniforms, like at a gas station. The uniform rental company owns those garments and they rent them to the gas station. They rent waiters' uniforms, or sheets and towels and pillowcases in a hotel. It's a very large industry—though you may not think about it as being one. And it's very fragmented.

The industry had shrunk in ten years from about three thousand down to about fourteen hundred companies. It was essentially one guy in a city buying out his competitor, then maybe buying out another competitor in another city. It was also a very mature business in the sense that it had started back in the twenties as a force. My perception was that a lot of these companies would be owned by people who would be at a point where they were ready to sell—family-owned companies.

Then it was a matter of just finding one. I was living in the east at the time and I found one in the south through a guy who specialized in brokering these things. And we bought it.

It was making money and so we paid a fair price for it, also borrowed all the money, again. [The accountant and I] were 50/50 partners. It was a terrible mistake but I didn't learn that until later.

So we bought the business, not because we wanted to run it and not because I liked the region but because it [fit the model]. We left management in place, because the company was making money. I had no desire to relocate to improve the operating profitability or the market share. What I really wanted to do was find the second, third, fourth companies and build up the business.

We found the next one in the midwest. We looked at all the financials. It was in the same market obviously, but we didn't buy it because we could move the geographic markets...we were simply looking for another similar operation. The goal was to buy [these companies] at the cheapest possible price...and to acquire enough of them to either take the group public or sell it to somebody else—to reach a critical size.

The idea was a cost reduction kind of a thing through a larger corporation and to achieve a higher level of operating earnings. Did we have certain return on investment characteristics or criteria or considerations? No. [Our premise was] to achieve operating efficiency once we assembled a bigger company. I was learning that the analysis was really the backbone, at least for me, in making an investment decision or business decision. We bought another company in the midwest, then one in the east and another in the midwest.

Along the way, I also started two real estate development companies. I had a lifelong interest in buying old buildings and fixing them up. This was avocational, a hobby. It was a creative outlet. Those decisions were purely from the heart. Federal architecture...a classic building. I had a friend who was an architect about my age. He was, to my mind, brilliant. He and I could [work on these projects together]. He knew a lot;

I didn't know anything except I loved the building. But I had the money and the chutzpah to go into the bank to tell them that we should buy this building for seventeen thousand and spend forty thousand on it to fix it up. At one time I owned a hundred buildings. And I had a wonderful time doing it. Some guys go home and do woodwork, I fix up buildings.

We bought one building and fixed it up. It was wonderful, a great experience...over budget, naturally. And then the tenants in the building would call at midnight. "I've left my key," or "The water pipes have burst." I thought to myself, "We've got to buy some more buildings...it's more fun to do this if you can afford to have a full-time manager." So we bought some more buildings, only to have a full-time manager so they wouldn't howl at night.

I don't know what the decision-making process was there, it was just to get rid of the annoyance. And then the manager was fine but then there was nobody to take care of the maintenance. The manager was then calling me to say he needed to hire a plumber. So we realized that we needed to get much bigger so we could have a full-time maintenance man. When we got to that point, we realized we had to be bigger so we could have a full-time rental crew who would be showing the buildings...so on and so on. It was still fun to do the buildings, anyway.

The real estate development companies were really purely from emotion. It's one of the few times that I've ever done anything just for the emotional release. And, I was pretty busy in those days. I was getting a divorce. And the laundry company had gotten to maybe thirty-five, forty million dollars in sales.

Then a large industrial laundry, with seven plants on the west coast, came up for sale. It was owned by another company who was in trouble, and so therefore they were willing to sell it for half of what its true value was if someone could move fast. I had been spending a lot of time there over the years...doing this mergers and acquisition thing. And I wanted to get out of the east. My old friends at the New York bank were willing to lend me all the money to buy the west coast company.

[The purchase] was based on good analysis only because we had done so much analysis on individual companies within this textile rental business that we knew all the operating ratios. So, it was simply a matter of looking at theirs and seeing the high here the low there. Because we had a group of companies already in the same industry, we could take the template for the successful ones and put it over this one. It became very clear that this was a good deal. It cost five million dollars, but it was worth at least ten.

So I moved my operations. And then the company did very well because it had good management. It had been oppressed by the former owners, all the cash had been stripped out. We had to strip out two thirds of the cash to pay for the debt, but at least there was something left in there. And they had a chairman who understood the business, and wanted to make it bigger and better. So the combination of what I wanted to do and what they wanted to do came together well. We were able to make wonderful, sympathetic, symbiotic business decisions.

When we decided to get into this textile rental business, I knew that the only way it would work, was if someone could develop enough organizational charisma to be the strong leader to bring together a whole bunch of very diverse personalities and diverse companies, and I decided purposively to try to develop that skill. The objective was to assemble many pieces of similar companies into an operating company. So I had to develop the management style of getting all kinds of very diverse personalities to work together toward a common goal.

I had to change my entire way that I'd been doing things. I had to develop an ability to galvanize people through whatever process required. I learned some of the frustrations of operating a big company. You can't be the Czar, it just doesn't work. I still made the decision that we would buy a business in Sacramento or Spokane, based on a lot of analysis. The integration of that business into the operation was a very long process. But, once you had solicited opinions and given people [orders], the force of the organization becomes awesome.

I listened to everybody. Spent a lot of time travelling around listening until I could say with some certainty, "This is really a matter of analy-

sis." I know that collectively all these strange personalities and these different companies, different geographical venues [could create efficiencies]. I became cold and calculating [in pursuing this].

I'd become almost like a U.S. Senator. Before you introduce a piece of legislation you have to find out how everybody else is thinking. Even though I owned the damn thing, I didn't own the personality. So, I had to find out where the political winds were blowing. If there's an enormous resistance to this idea, than either the idea must be crazy or I'm going to have to do a lot of work to get people to agree.

This was twenty years ago. [About that time], I found a commercial laundry out of the country that was similar to what we were doing. I was bored. Everything was working fine. I thought it would be fun to buy this operation. I bought it and that was probably socially the most important thing I ever did in my life.

I thought this would be a damn good business. It fit right into our other textile rental activities. But, when I got there I discovered that the opportunities for expansion even within this existing market were huge. It was a monopoly—we had a pure monopoly for an essential service. We couldn't go wrong. The expansion possibilities to other islands were enormous.

The company had been owned by some Canadians. All the key people were white colonialists, either British or Canadian. A company that had four hundred employees—ten of them were white, and 390 were black. The blacks were regarded with the same sort of colonial disdain that had been in evidence for years and years. I never realized how strongly I felt about these kinds of things until that one came along. I met some resistance. My response was, "You don't like that? You're fired. Next complaint please." Frankly, most of [the natives] were the intellectual superiors of the whites.

This will sound terribly corny, but I also made the decision with a lot of thought about giving some hope to people in ways that they'd never get otherwise. I had an opportunity to give people the chance to become middle class. I had the chance to give a lot of people the opportunity to

own a house. Over the period of time that I owned it, I got rid of all the white faces and promoted locally to senior jobs—including the managing director, which is equivalent to CEO. We expanded from one little location to seven separate cities. All with internally-generated cash.

They were bringing me ideas in a way that I had never been able to extract out of my American management staff. The American management style meant I would spend a lot of time listening and a lot of time soliciting views, always being the boss, always being the guy who would say no. But it was a different kind of relationship there.

There, decisions were made out of analysis—but a lot of the decisions were made not unilaterally by me but were brought to me. The native managers would say, "We have thought about this and we think this is a wonderful idea. We will kill ourselves to do it. We'll move and go live on another island for a year," or "My brother who now works for the Ministry of Public Works speaks fluent French. He will move to the new location."

Decisions were made there more by emotion. But you couldn't lose. If you went there, you'd have found no laundry facilities to support the hotels or the government. Everybody had their own little rinky-dink laundry which doesn't work. There are no retail laundry and dry cleaning services at all. If you wanted to get a suit cleaned, you had to send it by air off-shore. So it wasn't difficult to make money. Staff wages were fifteen U.S. dollars a week and we were charging twice U.S. prices—and people were happy to pay.

I was spending a lot less time with [the mainland U.S. companies]. My partner, who started off being a bag carrier, was making a heck of a lot of money. He was beginning to believe his own stories about his omnipotence. He had moved, found a place that he liked a lot, bought a couple of Mercedes, was hanging out in the local watering spots—not spending a lot of time in the business. Then he got into financial difficulties.

We still owned the company 50/50, even the one overseas. We had a buy-sell agreement, in case one of us died. It provided a basis for valua-

tion of different businesses so that one could buy the other one out. He invoked the buy-sell. He desperately needed money.

We'd been partners six or seven years. But he was becoming, through his lifestyle, very self-important, motivated by material things only, not able to galvanize a group of people together at all. We started having to sell off the businesses because I couldn't afford to buy out the other half interest, except by saddling everybody with a great deal of debt. So we sold the U.S. operations to [a big hospitality services company].

I sold the overseas operations to another group of Canadians, who were living there. My management felt betrayed. I still feel sick about it.

It seemed to be a much better idea to sell everything, than to load the businesses up with a lot of debt. I wasn't convinced that the U.S. businesses would be worth all the debt I would have to incur to buy them. So, again, by a matter of analysis it was the smarter thing to do.

It's hard to remember all the details of the sale. This was the early 1980s. I was in my early 40s. It's hard to be analytical in the face of adversity. Often, at least in my experience with my own thinking process, in periods of adversity I tend to look for just a simple solution, as opposed to being [more creative]. In this instance, I was ready to face a lot of litigation with my partner. And the smarter thing, I believed, was to take an easier way out—to liquidate the businesses.

[My partner] filed a very nasty lawsuit, demanding judicial windup of the companies, which was provided for in the buy-sell agreement. If one party couldn't raise the funds within sixty days to buy out the other, the agreement provided for complete court liquidation.

So the simple thing, rather than hire a legion of lawyers to fight things through years of depositions and so on, was simply sell it.

I retired. I didn't have another plan. I wasn't standing outside the last hotel waiting for the next taxicab. It was awful. I came back here. And after about six months, I realized that I should do something else. But the

only thing I knew how to do that gave me fulfillment was to go through the whole analytical thing to find another industry and another company, to find a way to acquire it, and to run it.

Some people brought me deals to consider, but they were classic things where there's a company not making a lot of money, an interesting industry, a new one I'd never been in before. I could buy it for not very much money. [But I passed on these.] I couldn't go to work for someone because I hadn't worked for someone for a long time. You have to be a very detached thinker to run a business well. I can do that.

I've bought businesses from entrepreneurs, true entrepreneurs. I was never an entrepreneur. I've bought businesses from guys who went through whatever decision process they went through, and it was all agonizing I know—who never were able to step back and look at themselves through a microscope. I'm sure there are [entrepreneurs] who can do that, but I've never met one.

After carefully analyzing [businesses] through most of my business career, I failed to apply the rules to myself. I retired, then within six months, I found this other business. And I bought it—a truck trailer manufacturer in the deep south. The company's greatest need from my analysis was reduction in cost areas. My partner was a heavy-iron guy, smokestack industries. He had had heavy manufacturing experience. He'd owned a manufacturing company that he'd sold and was looking to do something else.

I borrowed a lot of money, signed a lot of personal guarantees. The company actually had been losing money when it had been owned by a bigger firm. It had been losing money at the rate of between $500,000 and $1 million a year for three or four years. I thought that we could see a way to turn it around in its first year of operations. The year before we bought it, it lost a million dollars; the first year we owned it, it made about a hundred thousand. We did a major turnaround. It was good. And the staff there in the deep south was...very similar almost to the overseas staff I'd had before.

They voluntarily got rid of their union. They regarded the union as a deterrent to their own ability to go forward as a group. It was wonderful. This company had had labor problems, it had had everything you could think of—and in a year things seemed to work out. Then the second year of operation we also bought a company that made garbage trucks and industrial disposals and waste compactors and things like that. The trailer company was about fifty million a year, and the waste equipment company was about twenty million a year.

The second year we also were sued on a products liability issue that had occurred in 1974—many years before we got there. The matter was tried and the plaintiffs won. The award was three million dollars, which was greater than the company's net worth. So, in order to protect our investment and the employees and everybody else, I filed for Chapter 11...put the company in bankruptcy. That was a very interesting experience. It was a very conscious decision, it was based on the same kind of old-fashioned analysis weighing all the opportunities and all the unfavorable things.

The bankruptcy bought us a couple of years. The secured creditors kept attacking, they kept trying to convert it to Chapter 7—a liquidation. We had personally guaranteed the debts of the company, so the bankers got personal judgments against the guarantors. That meant a couple million dollars was gone. Then we settled on a plan of reorganization, got it passed, but couldn't live up to the terms.

It was fascinating going through the bankruptcy court, by the way. I loved it because it was a chess game. I didn't like it because I was personally tied up in it—but I loved it from the intellectual or analytical perspective.

The plan of reorganization which was finally approved was almost doomed from the beginning. Within six months, it didn't work. Because the plan tied itself to the operations of the waste equipment company, which we had to sort of pledge to take care of the truck company, it brought down that company, too. All was lost.

I decided to retire again. After a period of time, my wife said, "This won't work. You can't sit out on the rock by the pool all day long and stare at space. You'll sit there all night long if I let you, but I won't. You must do something...buy another business. I know you don't want to take any more risks, but you have to think your way out of this."

She was right. I began to think my way out of it. She suggested that I go to work for someone—and I said I didn't think I could deal with working for anyone. But we were travelling some, and we met some foreign investors who wanted someone to run their U.S. operations. It seemed like I could work with them. I was accustomed to being the chief executive, I was accustomed to working with people, liked to work with people very fulfilling, so I went through the same rational decision-making. I would be working for somebody, but they'd be thousands of miles away— not a boss knocking down my door. So I did that. And that was fun, that was good, and it was in some respects very revealing because I didn't have my own funds at risk anymore. I'd just come off of two or three really bad situations.

It lasted until these owners said. "We really would like you to come here and take over as the CEO of the parent company." My response to that was that's very flattering, but what's alternative B? They essentially said there is no alternative B. It was either A or A.

So I went to work for [a local real estate management company]. That was a year and a half ago. That's it. My biggest frustration [now] is the inability to be in control. Of course, there's always frustration.

6 ⬿

Decision Tools

Whatever patterns a specific entrepreneur might employ in his strategic decision-making, all of these entrepreneurs described things they did, techniques they used—decision-making tools—that were primarily within themselves. They also described decision tools that involved working with others. I have called the former clump of decision tools the *self at work*, and the latter *working with others*.

Words these entrepreneurs used to describe the *self at work* included "consciousness," "creativity," "focus," "information gathering," "ideas," "inner voice," "insight," "knowing," "preparation" and "thinking."

The excerpts that follow illustrate examples of decision tools described by many of these sixty entrepreneurs, indicate the range of their descriptions, and highlight some of the common themes and patterns among them.

THE SELF AT WORK

Conscious thinking, of course, was one of the principal elements of most of these sixty entrepreneurs' descriptions of their decision processes. They commonly described their thinking as going on all the time, and going on for long times about particular decisions.

So I started thinking about the next step...sort of had it in the back of my mind for a long time...there had been a long process of just thinking about it a little bit here and there...evaluating the problems that existed...you think it through when you live it...all the time...It's an on-going process. I don't get away from that process.

Even though I'm impulsive, I generally on major decisions really think it out. I'm a basic thinker. I'm introverted and my strongest asset is thinking, so I don't do many things well but I can think well....when it's major I really do think it out. So my process is intense thinking on major decisions....There's no difference between a computer and a head. The brain is a computer, and so you do get input all the time. Making the decisions, I have no problem thinking if I'm wrong. If I'm wrong, I'm wrong.

I'm thinking all the time....The thought process, even a creative one, is always kind of on....We all have that subconscious thing that keeps running and we say: Shut it off. I want to sleep. Just leave me alone. Once in a while you get that, that's a really weird sensory experience. I click it off and I turn it on again in the morning...the shower's great for thinking....Eric Hoffer said the greatest distinction of man as a higher level animal was that he could think of a problem, go to sleep, wake up and still have it in his mind with a solution....I [use that as a tool] all the time. My subconscious saves me everything.

My mind never seems to be at rest....Never stops, it's twenty-four hours.

Part of [entrepreneurs'] addiction...is we have to be busy all the time. You don't allow yourself the time to the important thing which is to sit back and think....We make ourselves frantically busy all the time during

the day at work...but what we end up doing is maybe to the detriment of our families. But at home at night and in the shower in the morning and on the golf course on the weekend or sitting on the beach while you're supposedly relaxing, you're in fact thinking about work...I find that I do most of that kind of [decision-making] thinking in the so-called off-hours. The reality is as an entrepreneur I to a great degree work all the time....you might think about something for a year, but you keep playing with it all the time....I don't often wake up at night, only in moments of major crisis. I don't usually wake up with solutions, but maybe I do because I know that I get, that I make an awful lot of decisions...I will make an awful lot of decisions in the process of exercising, running or walking or riding a bike, and I'll also make an awful lot of decisions in the shower in the morning. So I kind of think that maybe the process is going on while you sleep....I think making decisions in the shower is a habit, it's not conscious...ultimately the decisions get made then, they don't get made sitting around the office.

I think...all the time....*I thought about that day and night for six months. [I wake up in the middle of the night] worrying a lot. Worrying and problem-solving is about the same, a lot. [Solve things in the middle of the night] damn it, but I don't like it....I'll see things clearly sometimes [then]. I wake up a lot. My mind works too much, it's like...Someone said to me once that [my] greatest strength and biggest weakness is [my] mind. And it never stops. It's always cranking. Just cranks all the time. Sometimes I'd like to shut it down.*

Many of these entrepreneurs woke up thinking in the middle of the night, and they did a lot of decision-making in the shower.

I wake up in the middle of the night. *I'm up at three in the morning, every morning. I think that's when...ideas [come]. You start figuring out the reaction to your actions. Do [the pros and cons] in your head.*

I think about things *and about five in the morning when I start to wake up solutions come to me....I get away for some mini-vacations. When you have time to put aside the daily distractions that you have and the currency of decisions that have to be made, you can sit back and think about where you want to go and what you want to do. I do a lot of*

reading and you pick up ideas every place....so everywhere you turn you see opportunity of some sort....I think you enter it [information] both objectively and subjectively and do your thought process. You hold it to use it as it may apply either to that situation or to some situation....I know you don't forget, but I don't know how you implement them. What kind of an interpretation or spin do you put on it because what you hear and what you remember and what you implement with are not necessarily all the same things. Because everything changes. You change and your attitudes change and therefore the way you filter that information into your conscious or unconscious mind may come out differently than the way it was put there.

Sometimes *I don't get to sleep at night, [thinking]...not be able to go to sleep until five or six in the morning.*

I'm a muller. *I do get concepts, generally on major things. I don't make up my mind very rapidly...I'm basically a muller and I get the concept, not necessarily my own...and I'll let it. I'll savor it...[sometimes] not necessarily conscious thing. Sometimes very specifically consciously, and I'll get into long discussions with myself, sometimes very specifically....sometimes I will specifically mull over it,and I will spend specific time with myself on a subject....I think thinking is an ongoing process. I don't set a lot of time away for it, you can't stop thinking, and unfortunately one of the reasons we wake up in the middle of the night is we're doing some extra thinking. Don't really [solve things then]. There's just a lot going on in the mind. And it's so stupid...I get up, I get mad. You know nothing's accomplished in those hours except lack of sleep. And that's no fun. I don't find that there's anything productive that happens whatsoever, at least not for me.*

I think all the time. *I wake up at night. And that's a curse and a blessing. I think that's probably why some of us maybe drink more than we should because that dulls the brain and we don't think. Or it's why, before faxes and all that stuff, you'd go packing in the High Sierras or away to Mexico, it doesn't turn off the mind but turns off all the other...that's like fishing, freshwater fishing is fabulous therapy because you have to think, you're thinking all the time about the fish and the line and your focus is there, and the mind doesn't have a lot of room to think*

about....I'm a great believer that if you throw something at the subconscious, at the right time it's likely to pop up...you can hone that skill, you can really consciously hone the unconscious....You do that consciously, you consciously step away from the subconscious.

Their thinking tended to be solitary.

I just had to get away to think. I'm very lonely in those things. I do a lot of talking but then I go away and think.

[Didn't talk with anyone] No, thought about it all the time... thinking about the same thing over and over, and that's primarily how I think I made decisions....twenty-four hours a day, certainly all my waking time, for certainly six months....I made the decision, [solitary] absolutely, after thinking about it night and day. And going in a dark closet and staring at the thing.

Although some deliberately did their thinking out loud.

I think out loud, and people say, "Come on, get off it, that's stupid." Or people say, "Hey, that's great...or that's stupid but oh my god you gave me an idea, you said that, why don't you do this?" You take it, you hash it, you throw it back again. It's not good within the company, because people think you're very idea-a-day, [but] it's very good for yourself because it helps, it basically uses other people's intelligence to shape and refine, and most of the time you take the idea from the other people, you throw the idea and they really take it and change it, and they give it back to you and they think it's your idea but it's their idea that you've incorporated. And that is a style that some people don't do, and some people do that. I do....At night I take work home all the time, all the time. Not physically taking it home, but thinking about it. I don't explicitly [work at night], I think at night.

And their most serious thinking took place away from the office, much of it at night, and much of it while driving.

I think as I'm doing things, as I'm driving, as I'm in the shower, as I'm playing golf, as a sentence or word you might say triggers something in my mind ...

Generally I try to think about a decision when my mind could be off somewhere else, driving, for example. I do a lot of my thinking when I'm driving, that's why I refuse to get a car phone. I continue to build it up in my mind, until it actually reaches a point where it's time to implement something, then I'll do it. What I always try to do is boil things down to the essence, and then store it in my mind, in an evolutionary way, and with some type of classification so I can retrieve it very easily and relate it to other things in my mind,...I try to put everything in a philosophic sense and try to understand the fundamentals. I think that's one of the reasons I don't need to take notes, because I understand the fundamentals. I can get the grasp very quickly of not only the overall but also the details because they're only built on fundamentals...Obviously, you'd never be able to solve a problem driving from here to there, but I start that process and I store it away and next time, or when I'm in the shower....

I think driving back and forth to work, preoccupied by it, all the time, dreaming about it, waking up about it, all that. I like the driving,...I don't believe in [car] phones...I can think about things, get my head clear, it's...nice.

They most often characterized their thinking as "mulling," reviewing, wandering around. This description reflects the opportunistic nature of a rhizome.

At about four in the morning, all of a sudden I start to think about things and I wake up...I do my most productive thinking early in the morning, in my mind, and wake up, ah! that's what I need to do, that's the answer....I don't put it on paper, but I do a lot of analyzing, a lot of thinking and mulling over in my mind as to what the options are or what the alternatives are, and I'm very aware of doing that. It's not something that just all of a sudden hits me, I don't act on impulse. I will mull things over...and it will sometimes take me a long time to make a decision.

I let things wander around until the obvious solution pops out. I think about it a lot but I don't sit down and think about it. I think about things when I'm sitting on an airplane, when I'm...in between doing other things.

I think of [letting things wander] as simulation. You have a problem and you sort of run through your mind different scenarios, with what-ifs related to the issues in mind. I actually get quite detailed. We used to call it daydreaming, I now call it simulation....what you're doing is you're running through aspects of solutions, you're getting yourself familiar with the problems...never completed...I've always said that the problem is not finding the solution, the problem is defining the problem. And if you can define the problem, the solutions are easy. Maybe that's not quite true, but I find that often to be true.

I think it's *very conscious, I spend a lot of time thinking about what's going to happen and how I'm going to do something in the future....I'm constantly reviewing different things,... constant evaluation and reviewing and putting myself into different things, and then after a while they kind of cut away and I'm ending up with one way of doing it and that's the way I walk.*

About *to make the biggest decision that we've made in years in our firm, and this is not an intuitive decision, but the idea has come to me dribble from drabs over the last two months...all these factors coming in, yeah, they're being filtered....*

Always thinking, you never stop...you just direct it a little bit.

For as Long as It Takes

The most common theme of their thinking, as it is described in these excerpts from roughly a third of the entrepreneurs, is that it is an around-the-clock process, going on constantly no matter where they were or what they were doing, sometimes painfully. It is a process of which they were aware and which most of them used consciously, a process they understood in individual ways and worked at using more effectively. It was an opportunistic process, rather than an ordered one, responding to stimuli of the moment, sometimes coming back to the issue, sometimes not. In general, their thinking was an active process of taking in information, letting it "stew" and "mull" and wander around, of sorting in the back of the head. Most of the prob-

lem-solving thinking of these entrepreneurs took place outside their offices, notably in the early morning, after a night of conscious and subconscious work, in the shower, in the car, during their non-business activities. It was often a process of "popping out" the decision when it was time, of having a decision ready when the decision was needed, whether the decision deadline had been imposed by circumstances or by the entrepreneur.

Also among the excerpts are repetitions of the common theme that thinking about particular decisions goes on for extended periods of time, for as long as it takes. For these entrepreneurs, thinking about major issues is thoughtful and thorough; it is not impulsive. But it is thoughtful and thorough in discursive, unstructured ways, following neither a step-by-step progression nor a prescribed form.

The excerpts about thinking also indicate some of the other decision tools of the *self at work*, such as exploring, being focused, getting information, being introspective, preparation, reading, and writing.

Reading

For example, many of these entrepreneurs used reading as a decision tool, for generating ideas, for information, for learning about their environments and specific concerns, and for personal growth.

> *Read, read. I mean, when I was saying to you that I am appalled that the* Wall Street Journal *and the* New York Times *were not available in..., it seriously bothers me. You know you exploit opportunities, so you read, you need to read. Today I would say if you are in business you need to read the* New York Times *to know what's going on politically in the world, and I'm still biased after ten years in California; you need to read the* Wall Street Journal; *probably you need to read* Forbes; *you need to read* Business Week; *and that's it, you probably don't have time to read more, and I don't read highly technical things...that's for the guy who works for me to read. But you need information, you need a constant flow of information. Things are changing very rapidly today, much more rapidly than they changed ten years ago, and if you don't stay with them you'll lose track of them.*

I do a tremendous amount of reading, we all do,...we explore...and we get ideas for the next steps.

Reading, really focused about what I'm thinking about. At night, at night. I can't focus on that kind of reading during the daytime, but when you get sitting down somewhere, on an airplane because that's a place where I could think. And so really, so you start searching....

I do a lot of reading and pick up ideas every place....And one of the things I've always liked to do, I read a great deal of historical biographies of philosophers and statesman. I've enjoyed trying to understand how they looked at things and how they approached decisions that they had to make, in governments and in times of peril and so forth, and I don't know that I use that knowledge of what I've read, if I can apply that, I don't know that I have, at least not consciously, I haven't. But there are a lot of people I've kind of looked to philosophically for some of my guidance.

I read on the subject,...I read general types of publications, Forbes, the WSJ, The New Republic, two or three other newspapers every day.

I read a lot of stuff, from a lot of different places.

I don't do a tremendous amount of reading...but I've done enough to understand....management training, business, even reading articles in things like Inc. magazine.

Some of them didn't like reading at all.

I have to beat myself up to read. I do it, but I don't like doing it.

Writing

Writing is a decision tool that was more often not used by these entrepreneurs.

I do all my business from my head. I don't write anything down, that's another negative, but I'm pretty accurate, pretty good.

I never [write out pros and cons]; I think people that are hooked in that kind of, I think have trouble.

Where I take pencil and paper is when I say, let's see, is it better to...[otherwise] you drive your car and think about it. Over time I've done less of [using pencil and paper] and more of sort of letting it wander around, to try to come to a conclusion. Only start using paper when it gets so big that I can't see it or communicate it [or it is so structured], or some bureaucracy decides they have to have it.

Never did [take pen to paper to say "Well, here's where I'm going to take the business."] Never do that.

There were exceptions: several entrepreneurs wrote regularly, using their writing as a serious decision tool.

I'll focus on that decision only, and after all the thought process, then take a piece of paper...I'll do that just to help organize it for myself...to see what the balance sheet looks like.

I make notes all the time...ideas for new businesses, ideas for new opportunities. Long memos primarily to myself, this is what we should do, writing the conclusions, but never the what-ifs.

I have become a firm believer in basic writing. It revitalizes me and is a benchmark for tracking progress. I write things down before meetings, and also after thinking in bed in the morning.

I look at the Ben Franklin thing as very micro or very focused on one issue, quantifiable...has helped me solidify some things....I ended up writing a business plan...I wrote this business plan for myself, to convince myself to do this. And it made me organize my thoughts and put everything in one place, the notebook also convinced the other guys....Took six months, all during the time we were negotiating I was putting energy into gathering the data and writing the plan.

And two of the entrepreneurs kept personal journals.

I [write a lot] and do a lot of different things. I keep a journal and as something is developing and it's important enough to think about in a macro sense, or even a micro sense, I will probably write about it in the journal. And sometimes in the journal I'll actually draw charts. And maybe get some more data together and I'll just write down what's in my mind. I write about every three days. I usually write at home, at my desk. I sometimes take the journal when I travel, write in airplanes. And I write about a lot of personal things, my objective is to try to be as honest as I can be with my own feelings, and when a fairly major business issue develops, I try to write. [To explore what my feelings are] and then look back and read what I wrote....For ten years. You ought to see how many journals I've got in the safe.

I keep a diary, a very complete diary, a long diary, I write a page to a page and a half, type-written, every morning. It's interesting, it's helpful, the way I use it it's helpful. [It helps me think] and I review it at the end of the month, I do back over it and reread it just to think about the next month...through going over it and over it and over it, and there again there's a situation where keeping that diary made making the decision pretty clear.

Focus

Focus, or being focused, was another decision tool of the *self at work.* For many of these entrepreneurs focus was both a by-product and an objective of their decision-making processes.

One of the main things that I had to do was to decide what is it that I want to do in this business....It's very hard to do more than one of them...so I really make it a very strict point to focus on what we do....it's kind of like a seed that I plant, and I'll just kind of keep it in front of me for a while and see how it develops and how I feel about it and what direction does it go in....it works for me...if it grows, if I can think of other branches, so to speak,... then it's something that I want to follow. If it just kind of sits there...then that's telling me that...right now is not the time to do it, perhaps sometime in the future but not right now....[would be a] change of focus.

When you're doing your own internal decision-making, you tend to eliminate a lot of factors and focus on a few, there're a whole bunch of things dancing around in the background, but you focus on a few.

I know [we have to] narrow where we're going especially as we get bigger...we have to get more focused because as a team we can only play so many sports out there.

My objective...the objective of this company is [our work], it's nice to make money at it, but our focus isn't the bottom-line, our focus is what we do.

You know, in addition to all the other things, like doing it right, I think I've been successful because I've been very focused on making money.

I'm a great curve ball pitcher and as long as we're in a league that's got curve balls, come watch me pitch! That doesn't make you a good baseball team and it certainly doesn't make you a good league. It can carry a team, which in turn reflects well on the league but it doesn't make it happen. So in the first many years...almost all of [my] emphasis...I was real good at what I did, but today I focus on being a manager...the focus of my management, the focus of the business that came out of the ashes...has to be to do the work well but I can't focus on doing the work well.

There also was appreciation for its negative side, and the suggestion that shifting focus was a problem for many entrepreneurs.

But when I'm focused on something I will put a lot of things on the side and really focus on it....but that's not necessarily good. You can stop paying attention to things that are going on to the degree to which I'm capable of not paying attention [at all]....And it's hard for me to know at what point I lose interest in it....And I suppose if I were smart, at some point I would hire someone else and I would say your job is to [do the things that I have lost interest in doing].

Creativity

Creativity, too, in the sense of generating ideas and thinking out-side-of-the-box in solving problems, is a decision tool of the *self at work*, and it is a tool that most of these entrepreneurs described as very important in their decision-making.

> **Everybody** *is not creative in the same way. But the ability to think creatively is important, very important. Having just a creative way of looking, the putting, of feeling that it was the right thing to do.*

> **You can never create**...*if you don't have knowledge and know what you're talking about, but you also have to be creative to be able to evaluate what is really working, is this useful to me? Does this have any use or not?*

Many of these entrepreneurs described themselves as creative. A very few felt their creativity was a gift:

> **I'm fortunate** *to be gifted, I've always been a creative person...creative aura is more of a chemistry....*

> **My creative genius** *or whatever it is...I'm able to create on my feet...my higher level thinking opens up...and I'm able to sometimes just see things very clearly.*

> **[Ideas** *were coming from]* *that, well, the innate creativity that I was blessed with in terms of....*

Most said that their greatest creativity came in the form of a solution to a specific, important problem. Two described having the creative ideas that launched their businesses:

> **I was sitting** *in front of the computer [thinking about my work] and it was as if the entire solution to that problem, not all problems, it was like it came up on the screen....the solution I thought of when I was sitting in front of the computer wasn't the solution I ultimately implemented, but I did implement it with the computer and it came out the same way.*

There was a day I'll never forget. I'm sitting in an office [thinking about our work], I still can picture it very clearly, and it was as though I saw the light, and I sat at the desk where, I'd say, for three to four hours straight I wrote. And like this whole program came out of me, I just wrote [the entire program that started this company].

Virtually all of these entrepreneurs said the creative process had to be managed by direction and purpose, and that it had to be worked at.

I tend to have a lot of ideas fairly frequently, and I've come to recognize that most of them are bad, or at least not really good, and so it's a question of having a great idea but then deciding which ones I'll follow up on. I don't seem to lack new ideas, but it's hard to know....

I always try to find by-products of technologies, as I said, I think there're enough technologies here, I think it's a question of how you use them....I've learned also not to get too far ahead of technology so my ideas can be implemented now....I'm always thinking where is there a need and where is there a solution. It's conscious. I work at it. It's like someone practicing the piano...I try to reduce things to their fundamentals and from that go through processes deriving the solution...I always try to think of where the solution is.

I [had that idea] in self defense because they weren't paying enough...I don't think there was any studied reason, it was a need that you see and you go....All of my things are a response to either a problem or a need or a desperation, when you don't know what else to do....Sometimes I get some information, I think about it and then I germinate on it, or sometimes you just look at something and say, why isn't it this way? Sometimes it's just happened,...it's kind of the fulfillment, the rounded part...of what it looked like in the front part of my head a long time ago, but I could never put it together.

Introspection

Introspection is another decision tool of the *self at work*. As it was described by many of these entrepreneurs, introspection was the most fundamental of the decision tools of the self at work, and the most

difficult. Many of these sixty entrepreneurs were forced to introspection in periods of great personal stress and turmoil, by business failures or relationship failures, by the death of people close to them, by serious illness and the awareness of mortality that accompanied that. Only rarely had a positive opportunity, such as these interviews, been its initiator.

These entrepreneurs typically founded companies, or bought them and grew them, on the strength of their own unilateral (or close partners') ideas, work habits and outward visions. Only when life had taken an unexpected sour turn had they been apt to look inward and begin asking "What about me? What is it that I really want?" And only then, say those who were introspective, did their strategic decision-making really begin to make long-term sense in their lives.

A very few entrepreneurs, even having been through the worst of times, still described themselves as not being introspective.

I can remember realizing that I wasn't happy peddling on from one set of aspirations to another set of aspirations. I really needed that feeling of contributing to something. So, I didn't know what I wanted to buy, but I knew I wanted to buy a company....[but] you have to be a very detached thinker to [plan a platform for your next career], it seems to me. I can be detached from business, I can do that. But stepping back from oneself, I can't do that, I've never been able to make a decision by looking at me....I'm sure there are people [who are able to step back and look at themselves through a microscope] but I've never met one....No, after carefully analyzing, at least most of my business career, what I was going to do next in business, I failed to apply that [analysis] to myself. You have to retire to something, as you just said, and I retired. Then within six months, I found another business and I bought it.

Is there anything I would do over? Yeah, I would talk about it. But it's too late now and I don't really want to talk about it, I don't really want to deal with all that, I don't really need it, I don't like confrontation, I don't need it in my life.

But those few are the exceptions. More often, these entrepreneurs were conscious and deliberate in using introspection to benefit themselves and their decision-making. Their introspection sometimes had led primarily backward.

I started when I was twenty...every year on my twentieth, thirtieth, fortieth birthday, I used to go someplace and write a letter to myself to be opened and read ten years later....trying to figure out what to do next is a major priority in my life....I would say I spend 90 percent of my time here in this office thinking about what I want to do next, and 10 percent working....I've always thought about personal goals and how I've sold out....If I could [do anything I wanted to do] I would go back twenty years...I'd like to have a shot at starting over again...knowing what I know now...and pursue something that I consider of value.

I've tried to understand what motivates me to do what I did and when I make mistakes to try to understand the human equations that caused those mistakes. I never dwell on them, but, and I could see back a whole series of mistakes, if I were the person then that I am now, psychologically, I would have been much richer and I would have had a lot more fun. I would have avoided a number of serious errors,...I would have been, there would have been much less chaos in terms of mistakes that created big problems.

And often their introspection had led primarily forward:

I'm conscious of my mortality in a way that I try to get as much as I can out of my friends and my family and the people that are all around, people that I work with, people I care about....for the last twenty years, I've been polishing my ability to listen to myself.

Now I'm paying attention to the sound of my voice, to how I feel, to how I react to other people. You know, all of a sudden I'm uptight in a situation where I normally wouldn't be and so I've got to recognize there's something else going on than just that situation. I'm becoming more aware of that.

I went through the first personal inventory deliberation process, "What are you doing? Why are you doing it? Why did you do it? What do you have? Is it enough? Is it not enough? If it isn't what do you want? What do you want when you grow up?" That first process was to say something's real wrong here...the second part was I had to decide whether I really was going to put this thing back together....

I'm working very hard trying to get a good understanding of me. Trying to ease up this way and ease up that way....Just recognizing it. I don't know any other way to do it. I've buried so many feelings so far down...that it's hard to get in touch with a lot of that....I'm searching to find fulfillment as a human...to find a reasonable map of where I see myself in my own mind....Where did it come from in me? I started inquiring, "Why am I not happy?" And I started reading ...tapes...seminars...teachers...friends...and there is in my self and I think in every person a certain internal integrity, it's like a gyroscope spinning.

I think I need to step back from a lot of things right now and just stop, and try to listen...and hear inside and act on that.

Of the long list of tools of the *self at work* that this group of entrepreneurs described using in their strategic decision-making, those they used most often, and to most effect, were the tools of thinking, reading, writing, being focused, being creative, and being introspective. Of them, introspection seemed to be the fundamentally useful and the most difficult for almost all of the entrepreneurs, and it was usually initiated only in times of great turmoil and crisis.

WORKING WITH OTHERS

These entrepreneurs also used another group of decision tools. In this group, which I have called *working with others*, it is the entrepreneur's relationship with others which is primary. Among these concepts they described consensus, listening, planning, developing strategy and tactics and negotiation.

These tools are among the "how's" of his decision-making, and his prowess and success with them were the bridge to the "why's" of his decision-making. The "whys" include both the influences of others and his own purposes and personal values. It was clear that an entrepreneur's ability to work with others in decision-making determined to a great extent the quality of his decision-making and also the quality of his life.

Consensus

Consensus has become a motherhood-and-apple-pie word in management, and virtually no one among these sixty entrepreneurs disagreed with its importance for getting things done, and its importance for implementing decisions.

> *Talking about consentual decision-making, I very strongly would rather have people implement their own decisions, even if they're not the ones I think are ideal, because I've learned over the years that when I force decisions on people I often don't get the results I want....The interesting thing is that sometimes it ends up in a decision being made that everybody's happy with. Because there are indeed both left and right brain factors that influence decisions, and I can't give you any real specific off-the-top-of-my-head examples, but I have the general sense that there have been far too many times to count, when it turns out that there are decisions that everybody's happy with that are even better than the original one, if the process is just approached properly. So I guess that's an important point I'm trying to note here. It's that the process by which a decision is reached can be at least as important if not more important than what the actual decision is. In any case, in which the successful implementation requires more than the action of the decision maker. Which of course is true of almost all of them in business. And I think that what I've come to appreciate and value is that process, and to try to learn more about the process.*

Part of the support for consensus among these entrepreneurs came from their knowledge that the complexity of doing business today, and the constant change that is its only certainty, requires best efforts from everyone in the company.

We made [the decision] as a team. I've always, we've always done it that way, because there were times when I could have made unilateral decisions—I was also the biggest stockholder—I could have just been autocratic about that. I'd had offers from a number of companies to buy us out, and nevertheless we always made that decision as a group, that we didn't want [to sell out], that we wanted to continue on. I think I've always recognized that in today's technology you can't really achieve anything in a garage, or you can't build an airplane as the Wright brothers did, just two of them in a garage. It really takes a lot of talent, it takes a multi-discipline approach, and they all have to be part of the team, they all have to have a stake in it. It has to be [each one's idea from the beginning] because then each one puts his real mind and heart into it, because each one has an important role, the hardware person, and so forth, they really have to make it work, and they have to believe in it, they have to be part of that process....There were times when I felt that I was outvoted by the group, even if I could say this is my company, I hold the shares to exercise my vote. I never did that, because unless everyone's behind it, somewhere along you're going to fall through anyway.

Sometimes seeking consensus had come from the entrepreneur's feelings of family about the company group:

When I'm gone [travelling for four-five weeks], my managers get together to make decisions. I do not reverse the decisions of any manager [even when I'm here], I live with the consequences. It's so much more important to have a consensus team working for you...and when those hit [terminations, workers' comp claims], I feel we're a family, so those things hurt personally.

Once the kind of major opinion leans in one direction, then we all sort of put our energy behind it. If one of us had a dissenting opinion and wanted to be right even at the expense of seeing the others fail or losing our company's money, so that he could say I told you so...that's not very bright. If you're going to have a relationship, then you sign on and you put your energy and your heart into it and you try to make it fly with everything you've got. And we've had an unwritten agreement from the

very start, that that's what's going to work. And it's worked wonderfully, we've grown the company, we're very close friends and we respect and trust each other.

So there's a lot of team work in the creative end here, a lot of that. And I don't always like what they say. [But if I can't persuade them, I listen.] Very few things come out of here without a consensus. I'll tell you that, very few.

These entrepreneurs valued the process of arriving at consensus for the added depth it brought to their decisions.

Historically it's been very much an I decision, but I mentioned earlier that I continually try to acquire new tools. One of the tools I've acquired relates to the cognition that if you get people to sign on to the particular trolley you're taking, you may very well get better results, and so now let me say that that's an I decision, it's an ego-oriented individual decision to use this particular tool of getting people involved in a successful manner. Now, I am happy, I am okay with calling it an I decision, because the fact is that underneath ...I know where the decision will go if it has to. That doesn't mean my first choice, it means that the first preference in a general sense is to get a decision that everyone can tie into and move ahead on, with the major caveat that I don't think it's real bad. Okay? It doesn't have to be what I think would be optimum or best...I am not saying that I'm going to give up the right to make a decision or that I'm going to somehow say that everything has to be decided by a consensus and we have to persuade a majority vote, but I can respect a check on my opinions and my analyses and my evaluations. I've learned that the older I get the less I know.

The way you make it work is you have everybody sign-off on what goes into the box....Another part of my style is to really get consensus....I've always believed in a group process, always believed in getting as much data before I make a decision as I can....I always found that a group is smarter than I am. And everybody's got a different way that they rub the elephant...and see [it] a little differently. My view is hopefully from the trunk, some people have views from different angles, and then you get them all together and you get the true picture.

I attempt to build consensus...let the competent professionals who work for me work through some of the other decisions...I prefer in major decisions in a company this size to build a consensus, to ask others for the input that relates to their own department. And I'm really [learning and being informed], absolutely. But one guy's a little more equal than everyone else. It's just that we all put our heads together. If there is dissension, this morning we had dissension...two guys said yeah and I said no...on to the next issue.

Consensus is very important to me. I mean if you'll take a decision that you're not clear about, and you'll find everybody's against it, then you probably made the wrong decision. And if you are one hundred percent convinced then you try to convince them by creating the consensus, but sometimes you really don't know, then you open it up for debate and you learn something, people, there's a wisdom, and if nothing else, even if nobody knows the answer but you find eighty percent want to go up the hill, at least you know there'll be more dedication to going up the hill than not going up the hill....I would try to understand why I don't seem to be convincing them, am I missing something, could they be right, am I wrong? I would try to understand, I would delay, I would want to make sure that I'm not missing something or that I'm not sentimentally attached to the decision. [If] it doesn't happen, I would change my mind. I would be persuaded by their argument or I would persuade them....Pretty soon at the discussion you find people are switching their opinions, or you begin switching....I spend the time, really getting to be a better consensus manager, since I had to change the whole direction of the ship without appearing to change it.

Listening

Listening is another essential ingredient in the recipes for apple pie and better decision-making. Among this group of entrepreneurs, its adherents included those who describe themselves as quite skilled at listening, and those who were working hard at learning to listen. The listeners shared several purposes: listening to get feedback on their ideas, listening to get information (including information in the nature of evaluating their people), listening to learn, listening to train, listening to convey respect for others.

Many entrepreneurs listened primarily for feedback.

> **I do a lot** of bouncing off the people. [Thinking out loud.] I bring people in my office and say, "Here's the idea, what's wrong with it? Find fault with it, what do you think?" And I want them to shoot holes in it....Oh, they may be stupid and not agree with me, but definitely it's okay....And I trust [certain people] it depends on who they are....If they didn't like it, well [I'll change it].

> **I just listen,** you've got to listen, you've got to listen, you've got to stay involved, you've got to talk to people a lot. The environment of working here in a small office is I spend, I can't tell you how much of my time I just spend walking from office to office to office talking....It's very effective....You always listen to other people's opinions, but you never let them sway you unless you honestly believe it. I mean you have to have a great deal of confidence in your own judgment, and every time I've let somebody sway me off my own best judgment it's been a mistake. It's so consistent it's incredible.

> **You assemble** just the raw information to begin with, then I'll distribute it and see what the reaction is, and then I'll refine the answers and then I'll go back, and then assess it again,...and then at that point, [I'll say] here's the way we're going to go.

> **I'll make** the decision. Well, I'll make it based on a lot of input....Push comes to shove, all things being equal, but I'll certainly listen to every side of this thing....[Opinions and recommendations of other people] they're very important. I mean, I certainly am going to look at the finances very closely, I'm going to look at the humanistic side of it very closely, can we do it, can the people do it and the personnel do it and the computer do it, is the office all right, do we have enough people, I mean I'm going to listen to all those things....I'm probably too democratic in a lot of ways...I run ideas by the people and I respect the people we have with us.

> **I would get them** together and say, "Well, I'm thinking of doing this, what's your reaction? Do you think it's a good idea?" I listened to them very much....I would probably argue with them a lot, trying to decide

which one has the better logic. What's wrong with, why shouldn't I do it this way, these are all my reasons why I wanted to do it, why I think it's the right decision. If they can come back with arguments that make more sense to me then I will rapidly change my opinion. And I think that there're an awful lot of areas in business that, my philosophy is that there aren't any single answers to things, and there're an awful lot of areas [where] you can go either way and it isn't the end of the world. I think that in terms of my philosophy on the successful businessman, you need a couple of very basic principles that set you in a certain direction. And if you're going to lead companies, if you will stick to [those principles] you will be a much more successful leader than if you get yourself real heavily involved in every little detailed decision as to what's right and what's wrong.

Others listened primarily to get information.

Making *a decision, it's listening to people, sensing their attitudes, sensing their emotions about things....Typically you end up doing what you really feel good about anyway and the people who agreed with you are proud of you and the people whose advice you didn't follow [are okay because] you haven't slapped them in the face, so I tend to share information, I tend to listen, hope to listen, very important. Somebody once said something that I like: "It's hard to learn anything if you're doing all the talking." So, I might not always take the advice of a peer or fellow executive or a worker, but I know that it shapes my perspective and it has added data that helps me congeal it and hopefully make the right decision. [And] I've got both parts listening. Because the brain kind of accesses the intelligence, the epicenter kind of accesses the creative aura or the ability to think outside-the-box, if you will, and then there's the third thing. The third thing is passion. And that's what my emotional connection is.*

Others listened primarily to learn.

There's real value *in listening to others and learning, it stimulates me and refocuses me on other issues.*

By then I was smart enough to bring in lots of advisers and I would get as much advice as I could. One of the techniques that I used was to go out in the field and spend time in the companies, where we were on the factory floor, getting an instinctive feel, talking to purchasing agents and salesmen, and accounting people and union leaders...get to know people in the trade better, because we were running a conglomerate and we probably were in twenty different industries at the same time, I couldn't be very smart about most of them. That would be my way of expanding my instinctive judgments, then in order to nourish those judgments I would bring in various kinds of advisers...I get a lot of advice from board members, other specialists...I seek it out a lot, I talk a lot individually...with people in the company...I want to pick their brains.

Yes, I've been proven wrong, too. I do try to keep an open mind and with people I work with I always try to instill that.....it's always looking for an alternative, it's always looking to overturn the past, and prove that the past was not as adequate as a new concept....When you have an idea, you hold onto it, if you really believe it, but in the back of your mind you always have to be open that somebody might come along and say, here's a new way or you're all wrong, and accept that and listen. It's all right, I think that's very important in terms of making sure that your own business, the ideas that come from your own company always get the most objective hearing and are not missed, but at the same time that you're not ignoring the competition.

I really listen to people, absolutely. I soak it up like a sponge [even if it doesn't quite fit with the way I was going]. I think that's the reason our projects are so successful. Because I have a group of consultants that I respect and I listen to them, and I'm one of my consultants and it's an ingredient in this overall melting pot of ideas. My ideas are just as important as theirs, no more important.

Listening was also used for training and team building.

If I had a decision that I was feeling strongly towards doing, I would then explore that thought process in my thinking with my managers, because I wanted them to understand and to grow as managers, and I didn't think they could do it unless they understood what the direction of

my thinking was, what the proponents were of gathering that information, and to help advise in a way, to feel part of this decision-making process even though I ultimately made that decision and I knew I was going to. But I feel it's part of building a team, it's part of having them feel they're involved, it's not some policy imposed from on high, it's an education process, you know, it's lifting up their eyes from the paper to realize there's a bigger world....

Several described using listening to test and evaluate employees.

Every now and then I like to attend some of these meetings and listen, and they know..."Oh, we have lot to learn." Yeah, but don't learn for the next six years on my account, you'd better learn fast....I find out whether they know the answers or how hard it is to know the answers...all the challenging questions that nobody thought about and then based on that, I really make up my mind about that person's capability....I give them a lot of space...that's why I'm asking questions, to see how they react to it.

I basically try to keep them well informed but there are areas that I will keep to myself quite deliberately, things that I'm thinking about. And I often find, it's not as a test but it's an interesting way of evaluating people. I've found that the good people tend to come up and ask questions about a lot of the things that you're withholding from them, and maybe make suggestions in those areas, when they know that you're open to getting ideas from them. The kinds of arguments they could make, and the kinds of process they went through, and the degree to which they really participated in the process and were successful with it, told me a lot about how much I could trust them to run...I've never told them that these little sessions were in effect major proving grounds. Because I've found that many people can be very successful if you give them the system, but I knew that we were going through a fairly rapid growth phase and I knew that we were going to have to come up with new systems. And so I needed people who were able to solve problems and deal with new situations, as opposed to people who could simply replicate what we did.

Only a few of these entrepreneurs complimented themselves on being good listeners.

One of the things that has made me successful is being able to hear what other people are saying and to get beyond what they're saying to what they're meaning. And to be able to put aside the personal threat that any of that might represent, I mean, get to the essence of the situation. That clearly translates very well.

I think I have the capacity to listen to other people and not make quick decisions and allow them to bring things to me for me to make decisions, and me not just sitting back and saying no, whatever. I learn a lot from other people, I admire other people.

One of the things I've always been good at is understanding where other people are coming from so that I can almost finish their sentences, and things like that.

I'm pretty good these days at listening to people and integrating what they say.

I learned to listen to them, and hear what they didn't tell you about what's going on....I really did learn it well enough. It's a switch I have. I have an amazing capacity for concentration and I can look you right in the eye and you'll be absolutely persuaded there's no one else in this entire universe I'm listening to, but my mind's going...I've been concentrating more recently on just staying monolithically focused instead of doing two agendas at once. Oh, just, I think it's the right way to treat people in the first place when you're dealing with people.

Even though listening required some effort of these entrepreneurs, they understood its importance. To these people, the need for focused listening, for learning and for paying attention to the people to whom they were listening was an issue.

I have forced myself to try and be a more attentive listener. [One of my key employees, who's been with me in business for a long time] teases me about the fact that there are times when he will be talking to me and I will be doing two or three other things at once, I'll be typing on the computer and I'll be making notes and maybe I'll even be dialing something on the phone and when I get it I'll interrupt a second to do that.

What I learned is, and he didn't say so directly or in any offensive way, but it doesn't leave him feeling that I'm respecting what he has to say. So I've tried to force myself and I make no bones for the fact that I have to force myself to do it....I try more and more to give other people the respect of focusing my attention on what they're saying. Not to try to look as if I'm listening, that's a by-product, what I try to do is listen, yes I do try to listen, I try to eliminate distractions. It requires a conscious effort of will for me to do that. But I've done a lot of things with a conscious effort of will and I can do that....Also what I've found is that there aren't enough people around who are strong enough to stand up to me on the fly, so that what I'm doing is shutting down the opportunity to really hear what's behind whatever they suggest. Now, it may be, if I'm missing even one in five I'm robbing myself of a lot....Do I believe that I'm missing out? I've had enough people tell me that style does lead to missing that I'm willing to treat it as a strong working hypothesis. And [I do think it's a loss to me], you see I don't believe that I have a monopoly on the right way to do things or [to make] good decisions.

Learning to listen was a very significant, ongoing task for many of these entrepreneurs, including some of the most successful and experienced among them.

He said, "You know if you had been more effective in convincing us," and he was right about that, "We would not have had two years out on a limb and had to have really sort of shock treatment to recover, and in a sense although you think it was our fault that we didn't listen to you, I can tell you maybe it was your fault we didn't listen to you," and there was an element of truth in that...I felt he was right. What effect does [my knowledge] have if I can't convince people? Is it your fault or is it mine? You know, and maybe it's mine. He says, "I don't know, I'm a lousy manager as well, but clearly you don't communicate well, and you don't manage well either up or down, so you need help." After the initial shock and upset and anger [of being told by your employees that you do a lot of things to make their lives very difficult] goes away, you realize that you want to be better, you better listen. It was a very good thing....I had to learn to listen....And what I learned in these sessions is to listen to

people with a very open mind, absorb everything they say, on the real plane use that information and perhaps amend my objectives or my tactics, on the management plane, even if I were willing not to take a single iota out of that, to absorb it so to make them feel good, make them part of the thing, and then slowly change them around without appearing to be changing, but just asking them and letting them talk to you, change them not by talking to them but by letting them talk to you....absolutely [benefits from learning to listen]....My decision-making is much easier, because I'm more willing to listen, and therefore I have more information before I make a decision.

Planning

Planning, too, is a decision tool of working with others. Planning ultimately cannot be done alone, for the same reasons that listening is essential and consensus is beneficial. The liveliness of a plan, as well as its life, and the implementation of plans require the cooperation and work of other people. And that is true for life planning, as well as business planning, unless one is a hermit. No one among these sixty entrepreneurs was a hermit.

Planning, among these entrepreneurs, happened. Most of them began with no plans, with only ideas of how much money it would take to get off the ground and only vague visions of how successful the business would someday be.

I didn't have any thought of where I'm getting the money, no thought, no nothing. So I go out and I get the wire guy to make the wire and I get the coating guys and I get everybody together and I work out a share of who gets what. I said, "We can make it." And I didn't have a plan. Nothing.

And actually never put more than $5,000 in the company, that's all I ever had to put in and from there on it just [took off], it was just direct it in the right direction, it took off....[acknowledged as an industry leader] in our fourth year, so those years just flew by. It was a matter of not losing control more than directing it to a particular place.

Never had a business plan. When we get so crowded we can't move, we just get a bigger space, the business kind of drives us....I'm pro-growth, I've always figured that if business comes in the door, I'm not one of these guys that say well, we're going to get to twelve million dollars and, since I don't want to go and do all these other steps that it takes to make a business grow to fifty million dollars...that's all I'm going to do, that way I don't have to do these things....

That was all easy because a lot of those decisions were planned, [but] now coming into them I possibly handled them wrong and I could have gotten myself in a lot of deep trouble. Well, they weren't planned, it was just in my head, the reason [I said planned] is that...I believed in owning real estate...I just believed in owning real estate [that was just in my head, so I bought the building]....Then when we [looked at] the break-even on it [very expensive new equipment, already purchased] and everything, and what our net was going to be...say, we're going to have to do twenty million out of here to support [the new equipment], well you look at it and say, "Well, no way, we don't have anything else [work], that isn't, we can't do that." But we knew what [our competitors] do when they add [the equipment], so you add on another [piece of equipment], it's a big leap, but you look at it as that. You make a decision and then make it work some way. I don't know whether I can keep on.

This was the point, for this entrepreneur and many others, where planning began to happen. As long as sales and profits grew without problems, most of the entrepreneurs regarded plans as unnecessary, if they thought of plans at all. But as the business became more difficult or more complex, or simply larger, or the troubles mounted and mistakes took their tolls on assets and cash and on spirits, and on self-confidence, or as the entrepreneurs began to deal with aging and the specter of retirement, planning began to look as though it might serve a purpose. Only then did most of these entrepreneurs begin to plan, as opposed to having a "plan" in their minds. Planning happened. Retrospectively.

It just got demoralizing because we were here, we had made the decision to go with the equipment, all that, we had made our equipment decisions and our business needs had shifted. So that now we had pro-

duction standing around, they were unhappy, there was unrest and there were all kinds of things that evolved from this shift. And that's, then that drove us to plan more of our own destiny rather than me going out selling things and reacting to whatever the needs of the customers were and growing the volume. Now, we decided to sit down and see if we could control any of our own destiny. So, we had to...tailor our environment as much as we could.

I don't plan my business like that, that's too simple, that's what you're supposed to do, you don't do what you're supposed to do, I don't. I do plan, but I don't do a lot of planning. I really do, I do see the future, I do start seeing the pieces of the puzzle that need to go into the future. My way of getting to those pieces of puzzle, you know those little pieces are not specifically organized, I do spend a lot of time in thinking about the future, I do talk about that future, I do visualize what it's going to be like when the business is two, three times larger, oh yeah absolutely. As I indicated, last year we did eleven million dollars of sales, this year we're going to do probably closer to twenty-five million...and I've got a fifty million dollar company and growing, so I'm thinking the future, I'm not thinking where I'm at....I have a sense of how I'm going to get to it...And then you learn from that that maybe we better do a little bit better planning up front in the future and making sure that when we...I'm spending a tremendous amount of money right now to put the plan together, that's what I'm doing now, putting together the plan.

We did, we had a definite plan for what we wanted to do. I think the only thing we didn't realize was how big this was going to grow. We knew what we wanted....We decided to do that [a strategic plan] this time...be able to predict our growth and not have to go through another building while we're doing this at the same time.

Plan with a capital P...I'm trying to think of whether it's written....There was an unarticulated thought in the back of my mind, as to where I wanted to be....It was not the kind of thing, and I have rarely done what I am about to describe, if ever, where I sat down and said, "Well, let's see, the time is now to prepare some lifestyle decisions and to think about where I'm going and what I want to do and where I want to be." Let me say, though, that I am much more amenable to the possibility of doing

that now at the age of fifty than I would have been twenty years ago. I haven't done it, I have not done it because my life has been moving at a fast enough pace in the direction, that I haven't felt a strong need to really sit down and do it, but if I get to the point of significant dissonance, I'm very likely to sit down now and try to do it in an organized fashion. Certainly I've given lots of people advice on how to do it...so I've talked a lot about methods I've learned, read about, but seldom applied myself.

I hadn't thought *ahead to what's the next step....I took six months and really dug hard at what I wanted to do. I had three criteria...had to use my work history...to find a company where [I was experienced at] the principle problem...I wanted a speciality business, not a commodity business....I put it on paper.*

It was only *in the last two or three years that we've started to think in terms of strategic planning, like looking ahead, where do we want to be, I really had no idea what we could create....where [the company] was at that moment in time and looking forward three years and projecting what its structure needed to be, and then looking at personalities within the company and saying are we structured correctly to get to that position? And so we have the people necessary to fill that structure?...I think my vision pretty well clarified and the strategic thing was important.*

Several of these entrepreneurs had had training and/or experience in strategic planning[8]. Some used the planning process as a management tool. Others were not so sure.

All you did *was extrapolate things at 85 percent a year, that was as far as it went....It was bullshit. I learned such a disrespect for the planning process....This very much relates to a decision-making process. I am essentially a disbeliever in long-range planning that has any meaningful specificity about it. Or phrasing it another way, the farther into the future you look in your crystal ball, the cloudier it is, which I'm sure many people would agree with, yet I'm not so sure that those same people apply that in terms of the forecasts they try to make either for their own life or for whatever else. I try to look at where I want to be far enough out ahead so that I'm forced to adopt a vision rather than anything*

specific.

Even in business *and we have written some extraordinary three-year plans over the last ten years. They're all wrong. I mean, we followed them basically and so you don't consciously stray off of them, but if you put it aside, it's almost as if the result doesn't match the process. Three years later you've followed most of the tenets or most of the processes you've set out to follow, but the end snapshot doesn't quite look like the one that you painted....Most of the time the unforecast and unforeseen elements impact us more than we can possible imagine....I have aspirations, I have very definitive goals, very specific processes and things we want to accomplish. Yes, those are quantified. But, how we'll look as a company in three years, or what the world around us will look like in three years, I'm not going to write that in my plan because I just don't believe....And it's not a factor of being smart. Maybe it's smart if you don't write a plan.*

Strategy

What, then, of strategy and tactics? With the exception of those entrepreneurs who had had specialized training, in marketing for example, or those who had been, or were, professional managers in large companies, almost no one of these entrepreneurs used the word strategy. Even among those who did, there was a strong sense that strategy was developed first in an implicit, personal way and only later was discussed and developed more fully with key staff members. Without using the "s" word, most of the entrepreneurs who described their strategy-making process emphasized their own roles, and authority, in its development.

I'm going to use it *[the word strategy] because nobody else will, the strategy decision...something you do not make every day....These decisions are made infrequently, otherwise you have a disaster if you keep changing your strategy....This is what I call the lonely decisions...that you want to be in that kind of business...financing because it has the tendency to be long-term decision[s]...lonely decisions because you normally don't talk to the people who are running [operations], you really do it [by yourself] in a sense and then you can talk to them.*

The responsibility that can be shared is shared and the responsibility which shouldn't be shared I'm not tempted to share....It's one of two things I can't delegate. The first thing I can't delegate is anything that has anything to do with my pocketbook. Anything that is an equity decision, I make. And anything which has to do with marketing and development of marketing is ultimately my decision. But I've restructured the company with a very flat organization chart...key core team members...are involved at least in discussion and, most often, in the decision-making process on every other major decision we make.

So my focus had always been to build sort of an invisible skeleton in the company....

My personal...beginning to think strategically, and to be more sensitive to the importance of human resources programs and organizational development all the way down into the various units, at one time we must have had sixty companies. And I believed that every unit had to have a strategy, and I made every manager have a corporate plan.

Similarly, only a very few entrepreneurs used military imagery in their descriptions.

I am, there are significant strategic changes going on in the business, I am trying to get ahead of the crowd by repositioning the company early....I look at strategic planning almost as a military exercise: having realizable targets, proper direction, real resources, while maximizing you have to take some risk, have to bracket.

That's a mathematical decision, but that's tactics, rather than strategy. The strategic moves, you make them implicitly, I think....I think of what I want and I improvise on how to get it. And that's why I made the distinction between strategic decisions and tactical decisions, you make strategic decisions and you stay with them, but your tactics must be incredibly flexible, every morning you cook a new one. Because every morning the world changes, every morning you learn something about what you were trying to do and you change your, you know, the top of the hill, you want to go to, but you don't know what's the best way, and rigidity in the goal is very good because it keeps you focused, but rigidity

in the ways to accomplish the goal is very bad because it keeps you unable to take advantage of changes in the situation....I can't be thinking shall I [change my goal]. Because that will drain my energy, my intellectual energy will start getting drained, and my mind will go away [from the goal] but more importantly, again to use the war analogy, if you tell your troops this is the final defense line, guys we die or live here, they'll fight to the death. But if you say to them, we'll stand here, fight a little bit, and then we'll retreat, all the troops are ready to retreat, the moment the fight gets a little tough they'll want to retreat because you told them this is not the line. So if I set a goal and I say well, if it doesn't work I'll jump quickly to another goal, I won't concentrate and I won't give it the same...I don't know, that you feel it in your guts, you feel it in your guts whether that front is going to break, whether this method is going to work, whether this approach is going to be successful, and you keep putting effort into that before you decide to put good money after bad, on throwing good troops after dead troops, I'm going to pull back and find another way. That I don't know that one can quantify, ultimately you feel it.

For most others, strategic planning and strategic focus were clearly not part of the process.

We'll develop *many cash cows out of the applications because we'll have something that we can do with a lot less effort than is being done today. And in the process we'll continue to learn about this whole business and eventually decide which pieces of these packages that we develop will actually get put out in product form....So I can oversimplify it and be a little bit smug and smart ass by saying, we decided just to have some fun for now and to figure out what we're going to do later, but there's a little more, maybe this is another I think somewhat rare example of underlying strategic plan to get us from here to there. I've never really quantified it in my mind, I just sort of intuitively believe that I prefer this approach.*

Negotiation

Another important decision tool of *working with others* is negotiation. Common themes among these entrepreneurs were developing mu-

tual trust by putting all one's cards on the table, or of understanding the other party and playing whatever game was required to persuade him.

My style of negotiating...you basically put your cards on the table and you develop a mutual trust. And you develop a feeling in the other person that you're not going to screw him....It was instinctive...I consider myself to be a fair, ethical and moral person, and I always try to look at things from a perspective of the person who's sitting across the table, and while I will never give on things that are fundamental to my position, I'll always explain to them why I can't give on this, and I'll never just take a position and say, well no, I don't do, I can't do that. I say, I can't do that because that really creates a problem for me...X, Y, Z. And I'm sure you can understand, and, you know, negotiating is like business, and you're talking about how you make decisions...you know what result you want to achieve, and the person sitting across from you, you know what they've got to take home, they've got to feel that they have had their day at the table....One of the fundamental elements of my negotiating strategy is that you always leave the last dollar on the table, always leave something on the table, no matter what, even if the other side has walked out of the room, shook hands and gone home and left a dollar on the table, you do not pick it up.

I got into his head and said "Okay, that's the power game." ...I got exactly inside his head and I did everything to get his reaction, which reaction would be exactly what I wanted....now I understand how he thinks.... He always changes everything. He will never agree on anything because he wants to show you that he [has] the power. You have to adjust your thinking process and give him the stuff that he will change to the stuff that is what you want, so everybody is happy....It was a fantastic game.

Another common theme was of preparation for negotiations.

We [partner and I] prepare thoroughly, read and read the information, learning to negotiate without thinking about it. Spend hours and hours preparing, talking it over, strategizing every move, every phone call, every position, every goal, every option.

SUMMARY: DECISION TOOLS

In evolving summary, then, this group of entrepreneurs described using both analysis and emotions in making strategic decisions. They tended to favor either a decision process led by analysis confirmed by feeling or a decision process led by emotions supported by data. In either process, their intuition, based on their relevant experience and expertise, was an important factor. In either decision process, also, the entrepreneurs used a collection of decision tools with which they were skilled and comfortable. In one group of decision tools—those of the *self at work*—the entrepreneur alone was primarily involved. Among these were thinking, reading, writing, focus, creativity and introspection. In the other group the entrepreneur primarily worked with others. These decision tools included consensus, listening, planning, strategy and negotiating.

The thinking patterns of these entrepreneurs tended to be characterized by both active concentration and "mulling" and "wandering around," on an around-the-clock, wherever-I-am-except-the-office basis. They were thoughtful rather than impulsive. Their reading patterns tended to be frequent and purposeful—reading for information and ideas about their business environments and their company concerns. Relatively few of them used writing as a decision tool; those few who did tended to write regularly and to review their writings for meaning and direction.

These entrepreneurs tended to regard focus as a key determinant of their successes, but acknowledged that staying focused was a serious problem for them. They regarded creativity, in themselves and in their employees, as very important for good decision-making. Many described themselves as creative, and most regarded creativity as a skill that had to be learned and managed.

The decision tool of the *self at work* that seemed to be most important, most influential, for these entrepreneurs was introspection. It was also the most difficult to achieve, and it tended to be initiated by the entrepreneurs only when they suffered experiences of great personal stress.

In *working with others*, the entrepreneurs valued consensus for getting things done and for promoting the cohesiveness of their people, and for the added value it brought to their decisions and their implementation. They used listening for a variety of purposes in improving their decisions, including getting feedback and information, for training and team building, and for evaluating employees. Very few of them thought they were good listeners. Several described having a very difficult time trying to learn how to listen and how to stay really focused on listening.

Planning was more often an effect for them rather than an affect. With rare exceptions, planning happened. With rare exceptions it was appreciated by these entrepreneurs only retrospectively. The same was true of strategy. Negotiating, on the other hand, was a decision tool at which most of them excelled, and in which they took great pride, and for which they planned.

Of course, none of their decision-making occurred in these neat categories, these imaginary clumps of decision processes and tools. Rather, all of its aspects were intertwined and interwoven, beginning and ending in connected fits and starts, intense and focused on occasion, fuzzy and tenuous on others, opportunistic, discursive, and influenced by other people and events.

MAKE UP YOUR MIND

7 🖎

100 Percent of Our Net Worth

I don't know if it's a characteristic or a quality of entrepreneurs, but I can think all the way back to when I was a teenager. I always wanted to start something, whether it was a social club at school or whatever. When I was in high school, I probably started three organizations from scratch just to be started.

I worked full-time my last two years in high school and all through college, I had to, but my mind was never at rest. I was always wanting to try something, look for something different. I spent four years in the Marine Corps as a pilot and an officer, even there I took some part-time work, tried to start a couple small businesses. In my last year in the Marines, a couple of other officers and I started a string of laundromats and a janitorial business. [We were] always probing and looking for something.

Coming out of the Marine Corps, I spent a couple of years with [a major defense contractor]. I felt very confined, but it was a source of income. Even there, entrepreneurs gravitate toward one another. There

were a couple men in the department that I worked for and we went out and started a...yard for cattle. I raised cattle. One of the [people at work] was an expert and it sounded interesting. So, I studied it and tried to learn as much about it as possible.

After [the defense contractor] I went with a finance company [and stayed] with them for several years, learning real estate finance, some mobile home finance. I was a little more at rest in that position because there was a learning process going on the financial side that had some business [application]. I enjoyed it—almost like a graduate course.

Then I had an opportunity to go into banking—another finance company was going to move me to the east coast and the banking end. By accident [I ended up taking a job at a major regional bank]. Being a business-oriented bank, this place had interest for someone that wanted to learn about business and had as much unrest in their minds as I did.

Joining this big bank was like dying and going to heaven. I was out in the field. Every hour I was meeting with an entrepreneur and he or she would be telling me their stories and I'd be looking at the financial statement and investigating their business. I was seeing success and failure and absolutely loved it.

Many of the officers in the big bank left after a couple of years and went with clients. [I left and joined a group that] disposed of four or five companies and acquired three or four companies. We really got that final process right down.

[A short time later,] the executive VP at the big bank asked me to come back. He said he would make sure that I was on a reasonably fast track. I guess he sensed in me my restlessness. I don't think it was necessary what I wanted to do, but financial considerations at the time—family considerations—led me back to the bank. Then I was back with the bank about ten years.

It was a pretty short period of time [that I was satisfied,] about a year or a year-and-a-half. There had to be other things. I was working all day

long with entrepreneurs. My favorite past-time was looking at the business opportunities section of the Wall Street Journal. But was there any organization or any plan to all of this? No. I was just kind of wandering through life...bouncing from side to side.

[While I was working with the investment group] one of their company's primary business was...asphalt painting. It's an entrepreneurial business, a wonderful industry. Almost second to none, from a profit opportunity. From a competitive standpoint, there are so very few in it that are truly professional. Toward the end of the year [I was away from the big bank], the founder's son-in-law and I attempted to put together the business and take it for our own. But I just didn't have enough financial strength...didn't have access to the financial resources to go forward with it.

What happened was that when I came back to the big bank, I was able to provide the [founder's son-in-law] with the loan so he could take over the company. So, for more than 20 years he's been operating this company. He's now making about $25 million [in revenues]. So, our plan was correct. But I didn't have the financial resources to put it together. We get together four or five times a year...[we're] very close friends. He spends most of his time playing golf. When I think I'm working seven days a week, I wonder who got the better deal.

I've just wandered, reacting to opportunities...trying to search out different things. I must have been in my late thirties when I started to think in a more strategic basis. I began to start to formulate thoughts about where I wanted to be in five, ten, fifteen years. I decided that I was happiest in banking, but I was not happy being in a large, corporate setting.

About that time, I began to follow the independent banking segment of our industry. I'd track independent banks, how they performed, what they did, what the rewards were for their managers and owners, etc. I would interview for executive positions at independent banks, as much to gather information as the opportunity to see how it was priced, etc. [as to get the job]. Then, a few years later, I saw a small ad for a group of people who were starting a bank locally. I didn't believe this was possible to do.

In those days one institution could block another from obtaining a franchise or a charter. [A nearby] bank had blocked several applications in the area. And I had just been involved in financing the start up of a small bank, which was started by 10 or 12 people. [Anyway,] I answered the ad and I liked the people that were involved and I told them "If you get your charter, I'd be interested in sitting down and talking with you. But I don't think you'll get your charter."

[Several months later,] they were turned down for their charter. But, in that period, I'd grown to know the founding chairman very well. I had also talked to some of my best clients and customers—and they encouraged me to do something. I also reflected on the fact that big bank had just come out of [some financial problems]. It had been on the verge of going under...because of mistakes made outside of our lending market. I was bothered by the fact that we had built a very good book of business in an excellent area and could lose it because someone made stupid loans to South America.

I didn't like that lack of control. I didn't want to wake up as a branch manager for [some big bank]. So when the group [with whom I'd interviewed] disbanded, I got together with the chairman and said, "Let me see if I can write an application. You bring your two or three key people, I'll bring in 4 or 5 and we'll resubmit the application. I'll write it from scratch because I know independent banking."

I told my boss I was going to...form a bank. He said, "That's the stupidest thing I've ever heard. You want to go start a bank to be making loans to bicycle shops and things like that? I'd like to have you stay with me. You've got a good career ahead of you. But I also have a lot of young people coming up in the organization...so I [could use] your position for the next guy coming up."

So, I kept him informed what I was doing. I never really [went] behind his back. I've told everyone in this organization that their own self-interest is more important than the corporate needs and objectives. I've had a number of our people come to tell me about opportunities—sometimes I've encouraged them to take them, sometimes not. We've had a couple

of people leave here...and I've helped them with their contracts and ne-gotiations. They hurt us when they left. But I think you've got to have free and open exchange about what you want to do with your life.

So I wrote the application at night. We filed in late spring and the appli-cation was approved in February of the next year. I turned in my resig-nation that month—expecting that they would ask me to leave immedi-ately, because that's usually the process. My boss laughed and said, "Well, your really not going to be any competition to us. You're not going to hurt us, so we're going to keep you around for two or three months while we find your replacement."

My secretary and I left three months later. It was a wonderful experi-ence. We went over to [my partner's] offices and I said, "Well, where do we sit?" He said, "I don't know. I figured you'd figure all that out, after we have offices." I said, "Well, I didn't rent anything. Do we have any money?" He said, "No. We don't have a thing."

So, for about a week, my secretary sat in a hallway until I got us a little suite. I went down to [the local office of a big regional bank] and said, "We're going to need a hundred thousand dollars to cover expenses for the next six months until we get the bank started." They said, "Do you want to borrow it personally? Or do you have some collateral?" So, now I was on the other side....

I had to put a second on my house to get the loan. The other directors didn't put up that kind of money. About $25 to $30 thousand was our payroll and all of those kinds of things. When we...started the bank, we had loans for each of the directors to buy their stock. For some of them, I arranged those loans with [a big regional bank]. It must have been $600 or $700 thousand, and eight or nine loans. But we got the bank started.

In the first four or five years, it was all tactical. It was responding to situations and opportunities that we created, It's only been in the last two or three years that we've started to think in terms of strategic

planning...looking ahead. I really had no idea what we could create as much as we have. I didn't have the contacts. [We're just] hard-working, good business bankers. But I wouldn't have made a book that we would be at $100 million after three years. The regulatory agencies have told us that they doubted very seriously whether we would be any larger than $50 million after three years.

We didn't have much in the way of capital—$4.5 million dollars. Our maximum individual loan was four hundred thousand, so it didn't look good. But right out of the shoot, our old customers kind of rallied to our side. The net worth of [one early corporate customer] was probably ten times our net worth at that time. But they moved the whole banking relationship over after 33 years with [a big regional bank].

We just had wonderful support, and so we really took off. It hurts me at times that we can't give the same support to some of the small and medium sized businesses that come to us—but we're restricted from a regulatory standpoint. I get at least one occasion a quarter where I see a really good young business that needs support...and I'm reasonably sure will make it. But it doesn't have the capacity or the collateral to carry the credit extension. You say to yourself, "If I ever made any real money, I might be tempted to set up a venture capital group for very small business...where you're not pushed to meet some investment requirement."

The first four years were so terrific that I let the bank get away. Then we ran into problems. Excessive loan losses. Excessive non-interest expenses, most of it was commercial. We just grew too fast. And we got hit with three things: the effects of the recession, high interest, which always increases loan losses, [and] we weren't making good credit judgments. We were making [decisions] too fast. We didn't have the right policies and procedures. We were trying to move in and fill what we thought was a vacuum, because we started four offices in less than two and a half years. It took us two years to get those problems worked out.

I really did let it get away from me. But it wasn't so far that it couldn't be pulled back. I got it cleaned up. During that three year period, the board

supported our activities and our direction a hundred percent. We've had a very close-knit group for years and I think the reason for that is that they look at me more as an entrepreneur than as a professional banker managing their business. If I had not had that exposure, I might not have been able to hold the bank together during some of those difficult periods.

About a year and a half or two years later, [a friend from the big bank where I had worked] came to me and said, "I want to go into independent banking. A small bank has offered me an opportunity." I sat down with him and said, "If you want to open the bank at seven in the morning you can open at seven. You can close it at two. You can do all these different things." He was very much a control person—like I think all entrepreneurs are.

He went with that bank for 14 or 15 months. He was entrepreneurial, but he couldn't adjust to working with a board of directors that was not expert in his field. He wasn't insulated from that board and he didn't have the patience to give them the opportunity to express themselves. So, he left and went to [a regional power house] and he was successful. Now he's president of [another regional giant]. It's interesting, there was an entrepreneurial spirit, it couldn't flourish in a small business environment, but in a major corporate structure it just blossomed. He went right to the top.

I don't think I would have made it in the larger corporate organization. I feel very comfortable in the smaller environment.

There was just no question [that I would invest heavily in the stock of my bank. My wife] and I have a small condominium in [a fashionable neighborhood] but every dollar that we have and every dollar that we can borrow, we buy bank stock. I kept a second on the house. At one point, we actually sold our house and I used the equity from that to buy stock. We lived in an apartment for a while. That might defy good judgment as far as investment, [but] a hundred percent of our net worth is directly tied to the bank. I didn't feel that I could ask the shareholders to

invest, directors to be exposed, officers to change careers, customers to move relationships, if I wasn't willing to put everything on the line. If it doesn't work I'm wiped out. On occasion, investors have said "I'm not pleased by the value of my stock today...but I know you're losing more than I'm losing."

[Another friend of mine] was president of an independent bank and got into some trouble and left. He was president of [a mid-sized bank] for four or five years, and they had some problems. Each time he was working with a board, but the board didn't really have a serious equity interest in the venture. It's difficult to maintain control and direction of the management, unless you share the entrepreneurial risk.

I look back over the last eleven years and, considering all the interest that I've paid, I probably won't make that much from the investment. But I don't think I would do it any differently. Maybe I could have put the money in one house that would have made more than what I'll make off the bank stock, but I don't know whether entrepreneurs go through the same [thought process] as investors. I didn't pencil it out on paper, but it seemed like the right thing to do.

I looked at the numbers a couple of times. I could see that, depending upon how well the bank did, the return over a period of time would be anywhere from 12 or 13 percent to as high as 20 or 22 percent. That's not considered a red-hot investment, but it was sufficient—given what else I was trying to do. It just seemed to me that it would be pretty hard to follow a CEO that wasn't willing to take that kind of risk.

My decision-making at the bank has evolved to a process that kind of comes from the bottom up. We'll throw out a particular idea in a series of committees...[seek] input from the various officers in the bank.

My executive management team consists of seven people. Those individuals gather information, sift through that information and try to come to some conclusion. We've started a year or two ago preparing strategic plans that carry us out over three years. We are just now taking departments and forcing them to create tactical plans. We're becoming more organized.

You have to go through this evolution if you're going to build an organization of any size strength, stability. Is it good from my personal standpoint? I don't really care for it. I see myself leaving the bank in the next two or three years...something like that. Not leaving it totally, but turning it over to professional managers. I think in two or three years we'll be at a billion dollars [in assets]. In five years we could be a billion and a half. That would make us one of the pretty good mid-sized banks in the [region].

I made it clear to the board that sometime in the near future that I would like to move in a different direction. In my study of the independent banks, [I found] most were focused around one personality, possibly two, with very little management depth underneath. So, I structured the bank [so that there are] at least three executives who can take my place. And another two coming up so we're relatively deep organization, for our size. We have a lot of young officers at the VP level, coming along very nicely. I could continue to maintain an equity position and not be concerned about the direction of the bank.

We could remain an independent bank, continue to grow and develop, stay highly profitable. But my guess is that because of our size and condition there's a good chance that someone will come along that the directors will feel would be in the best interests of everybody to buy us. [To survive] as a financial institution today, it takes a lot of money. It takes muscle. For us to go out there and compete the way we are...like David and Goliath, but even by a factor of two.

You reach a point in the entrepreneurial cycle where the entity has to be turned over to professional managers to continue to grow. In the evolution of an entrepreneurial business...the first leg is the entrepreneur...then there was a professional manager, the second leg...then there was interdiscipline, committee-type management.

This organization can't be run on a strictly entrepreneurial basis any longer. It will have to become more professionally managed and organized. [That should happen] over the next three or four years, but it's

not an environment that I necessarily want to be in. I can do it—if I have to do it, I will. But, if I have the ability to do some other things, I'd like to be involved to a lesser degree.

[Changes I've made in the bank have] flowed from the basic strategic planning process. Prior to that point, we had a senior officer managing the operational side of the bank—the regional offices—and we had a senior officer managing the credit side. Everything from a corporate standpoint was mine, including finance, investments, non-banking subsidiaries and overseeing the two executives.

In looking at the bank, we determined that we wanted to be less dependent on industry deposits, which have been a wonderful business for us. We want to continue our dominance there but have less dependence...broaden the book of business to include more in the way of traditional middle-market customers. Wholesalers, manufacturers, distributors. That decision was made on where we'd like to be in three years. So, we said, "Okay, let's look at the responsibilities of those executive officers."

My role becomes more of a coordinator. I'll set the long-range objectives, based upon what the industry is going through and investment bankers tell me...management consultants and so forth. I'll say "Here's where the bank should be. Do you agree with the position? Do you think you can get us there? What will it take? Do you see some other alternatives?" So that's the process. I'll set some broad policy targets and then try to defend them against the group.

I never have any difficulty with changing my position. In fact, sometimes I change my position frequently. I don't have any difficulty saying, "All right. I think your arguments are correct and we'll move on them." But then I also don't have any difficulty, if I really believe that I'm right, saying, "I appreciate your thoughts and opinions but this is the way it's going to be."

[In my decision-making process] analysis and data are first. I really do work the numbers. Then comes instinct.

In the last six or seven months, I've been studying seven other banks that I consider peer banks. I've been trying to analyze them seven ways to Sunday. One of the CEOs is a personal friend, so I made a deal with him that we exchange any and all information. He's in another state, and I talk with him maybe every other day. We just brainstorm. We have been able to accomplish more in size and geographical location. We're providing more in the way of service. [He's] much better in the area of profitability. We talk and I take that data and work it and come to some conclusions.

Then I take the data and go into the bank and say to them, "Does this feel right?" If the data says that we should have one loan division employee for every 4.5 million in loans, does that look right? Then I'll talk to individuals in the division, and then we'll try to look at processes versus actual performance. [That's how] we come to conclusion.

I guess the ordinary decision-making process that you go through [informs even the most important decisions]. When you feel the information is accurate, it's relevant, you've got enough of it, [you act]. I don't know if I ever get to a 100 percent position but I get to 85 or 90 percent and start moving. Then I test that last 15 percent as I start to put something into place. The validation of the decision is made by the results coming from the direction that we move.

[The information-gathering process] is assemble and refine. Like the loan-to-employee average—you assemble the raw information to begin with, then distribute it and see what the reaction is. Then you refine the answers and go back. Then you assess it again...refine it once more. And then, at that point, you say "Here's the way we're going to go. Here's what we're going to do."

By nature I'm a salesperson. I've had a lot of sales positions. I like to create a team kind of agreement to a particular position. I don't like to hurt people...maybe I'm too conscious of their personal feelings. Sometimes I take excessive amounts of time to try to build a consensus with the different divisions.

But I find that's changing. Ten years ago, I probably spent twice as much time as I do today [building consensus]. But I still use a salesman approach to trying to implement an executive decision—unless I reach that point where I'm just absolutely sure it has to be done and I can't go any further with trying to build up consensus. That's when I say, "God love you and God bless you...but there's a way that it's got to be done." And if I'm wrong, I'm wrong. I don't have any problems doing that.

I have a much clearer vision of what the bank is and where it will go and what must be accomplished. Back in those days, [when we were just starting,] I really didn't have any idea. There was a great deal of experimentation. But, the road we're on...we can't change much at this point. We do minor things, but the major thrust of the bank is unchangeable at this stage. So, I really do believe that I can look forward three to five years and tell exactly where the bank will be.

But that [can be] bad. It kills entrepreneurial spirit. I think that...to be a real entrepreneur...you can't sit there and say, "We're $750 million today, next year we'll be 800." [You have to be more daring.]

[Running a company is like] driving. You need to tell which way the road is turning up ahead....for the first two or three years. Then [maybe you can] just hang on. The bank now has its life. It has its personality...it goes forward.

When you really look at it carefully, most businesses lose their identities in the process of growing and succeeding. What are the odds ten years from now this bank will be what it is today? I think very slim.

I guess one of the most difficult decisions I've had to make would be changing the basic structure. For 11 years there were basically three senior executives...in charge of loans and operations, and the CEO. Then, I brought in a fourth executive who would report to the other two. This was an executive that we had all known, for 27 years. He was well known to the organization, well-liked—but he was still outside of the organization. And all of our people had grown and evolved from within. We really hadn't gone to the outside.

It was the first time that we brought an outsider in to the bank at the highest level. That was a long and very difficult process—convincing the board it was needed, going through the interview process, and then negotiating with the two [existing] executives. I had to change the entire structure of the bank....I was working with middle-level officers, who would be reporting to the new executive.

[I hired this new executive because it fit] the strategic plan—or a combination of the strategic plan and his availability. Would I have filled the position if he had not been available? I might have waited. The strategic plan clearly pointed out there was a need—but if he had not been available I might have postponed filling the position for a couple years. But the plan did identify the need.

The decision wasn't really intuitive. We'd known him for 27 years, and he was...absolutely perfect for our working conditions. So, it wasn't intuitive. It was pure observation [based on] direct contact over a period of time.

Implementing change is very difficult to do at the top. I watched the bank where I started go through it two or three times—and it never worked. It failed every single time. I don't know if it failed because they didn't have the right person or because it was impossible for that individual to get the support of those he or she needed.

Probably the two things that give me the most pleasure are watching young officers and staff members grow and develop and watching a young business you've helped move forward. We've had some real successes [in both]. It's certainly fun to watch that young person getting [ahead] but it doesn't give quite the thrill of watching a couple of people start a business and grow and develop.

The stock price is my biggest disappointment right now. But, in two or three years, it should develop. I think some of the public corporation CEOs that I've met are more effective...[or] their attitude is more focused. I run the business as best I can—the results are the results.

[An old mentor] and I were standing in a shareholders' meeting once. Someone questioned him about some decision that the bank's board had made: "How could you make that decision?" He said, "I made it because I've got the votes! You understand?"

I thought that was great. It was like saying, "Mind your own business. I've got the votes I made the decision." I agonize. I try to get the best possible return for the shareholders' money. I think I'm maybe too sensitive in that area. Lots of times some of our directors will be sitting around talking...."If we were a very large corporation, we'd do so and so." But I've got very specific details to consider. That's what counts.

I'll give a brief example of what bothers me [about being head of a small or mid-sized company]. During the Christmas holiday season, my wife and I always have a lot of cocktail parties to go to. One year, we went to several parties in one night. Go in for a half an hour, have one or two hors d'oeuvres, work through the crowd and [move on].

One of our directors was having a party that night. It was mostly friends. There might have been some prospective clients there—but, at that point, they didn't know me and I didn't know them. We got there at 11, walked in the door, found a chair near the fireplace and got a drink. A double scotch...a great holiday drink. Just then, an old guy walks up to me: "You're the President of the bank?" I said yes. He said, "I'm Mr. R., I own some stock...." So I can't have my drink. I've got to [talk to] a shareholder.

I haven't discussed that with other CEOs of public corporations, but [the constant contact with shareholders] is the heaviest weight. Our stock has performed reasonably—original shareholders are in good shape. But we've had two or three additional offerings, and the return based upon today's price is moderate. Now you can rationalize all day long, "Look at the economic conditions....Bigger bank stocks are down even more...we just had a public offering...." But we've lost some ground in our stock price. And there are some people who won't let you forget.

I'm 54. I might want to try something else. Be less of a participant. [But I've got] nothing specific in mind. But I think, my guess is that sometime [soon] someone will make an offer for the bank. If I had to rate the probability of that happening, [I'd say] maybe 60 or 65 percent. It depends upon a number of conditions, of course. Current activity is not as high as people expected at this time, because we're going through a down cycle. Once the cycle reverses—and it will—then there will [be more deals done].

[A friend of mine] was CEO of one of the Fortune 500 companies. Then he started a winery...extremely successful. And he formed a golf club [which has] a revolutionary design. If I could find something [like that] that I thought I could do....

Older entrepreneurs—in their 40s, 50s and early 60s—make very rapid decisions. True, they have that body of knowledge that has come from experience, but I think they also have another motivation. They're more aware how finite their life is and they want to get it on, get it accomplished. They recognize that time is a finite resource and it's running out. I see that in some of our clients, a developer doing a major project, the last hurrah for his career. In his 60s, he's making decisions that, if he were in his 40s, would be entirely different.

I know my perspective changed dramatically [after I turned 40], it has to do with true recognition of your time span. I feel the compression of time, absolutely. You can't make that many mistakes. You have less time to work with. When you're in your twenties or thirties, you think, "I'll try it for a few years, if it doesn't work...."

I think what I would do would be try to catch up on some personal things. We've never travelled...and my wife would like to do that. I'd probably take a good period of time and do some travelling. Catch up on a couple of other personal things.

Then I'd start from ground zero. I'd sit on the beach or whatever and start to look at business opportunity ads in the Wall Street Journal, go to venture capitalists and investment bankers...try to set up a very orga-

nized approach and look at each and every opportunity. Look at the industry, sit down and do my own forecasting. I think I'd do something that I had some emotional involvement in, maybe if the opportunity came but something to do with golf or automobiles...financing.

[I want to] say, "Okay...here's the house free and clear. Here's the annuity and here are the T-bills. Now that's taken care of, I don't mind taking whatever the residual is and pushing that up again." I think that's basic urge in the entrepreneur. The older you get you'd like to see some reserve. I've seen older entrepreneurs go under, and they...the devastation is immense.

My guess is that I end up doing something else in the next four or five years. It will probably be a private venture so that I only have to answer to myself, or a small group.

8 🖎

The Influence of Others

Virtually all of these sixty entrepreneurs clearly announced their own authority and freedom to make decisions unilaterally, by virtue of their greater ownership or investment or expertise and experience. Yet most of them also described working with other people in making decisions and being influenced by other people.

In different degrees and a variety of relationships, they worked with and were influenced by their boards of directors (or advisers) and their peer groups, by mentors, by their partners and their management teams, and by their customers, and by their friends and families.

For most of these entrepreneurs, accepting the influence of others was a learned skill. Those who had spent their early management years in larger companies, learning to succeed in groups within organizations, generally were both more comfortable and more adept at

valuing and maximizing the influence of others. Those who had mostly, or always, held what they felt was unilateral decision-making authority—the stereotypical founder-owner-entrepreneur with no other significant organizational experience—tended to be least good at working with others and least effective in using the influence of others. Only when some serious threat or downturn forced them to re-examine their own roles in their problems did some of them begin to see the value of the influence of others.

Many of this group spoke of the pain of this kind of learning—learning to listen with their backs to the wall. And, when finally forced to it by circumstances they could not control, many spoke of learning to listen and to accept the influence of others as the beginning of better things for them, including making better decisions and having better quality of their lives. A few of them seemed not to have learned to value the influence of others and were still suffering for it.

These entrepreneurs solicited or accepted the influence of others for many reasons—in order to examine and hone their own thinking, in order to get broader and deeper perspectives, in order to get more and better information, in order to get others to buy in and own their decisions, in order to make better decisions themselves, in order to help their employees grow, in order to communicate their visions and goals. They listened only to people they respected and wanted to work only with people they liked.

I think it's that I have high standards and I don't like, I used the word bullshit, which I see in certain customers, the way they conduct themselves and...that's people I don't want to deal with, I just don't want to.

There are a lot of people I won't do business with or a kind of people I won't do business with and I don't. Life's too short and I don't need the aggravation.

If I think a guy's a bad hombre, I won't deal with him.

And I decided *a long time ago that I'm not going to do business with people I don't like.*

Management Teams

The greatest influence on the decision thinking of these entrepreneurs came from their key people and management teams.

I would talk *to my management team...I won't make that kind of decision myself, mainly because I don't own it...they would really have to own it with me.*

Creating a team, *I always try to make sure that there is an indigenous team or core...I had people who were very creative with getting hardware to do different things, I had some people who were very good with software,...and people who were good in accounting, I wanted to make sure we covered everything, covered all the bases....We made [the decisions] as a team...because I was doing something different than Einstein, Einstein was a theoretician and a loner theoretician. I was trying to put the theory to practice and I was trying to create the business, and that required bringing people together and it required always looking at alternatives, and watching your backside because the competition's always there and they're going to come up with alternatives, so you can't be blind sided, you've got to always be considering a better way and that new way will come...bringing people into the decisions.*

[Seeking other people *out to talk] has helped me a lot, been critical [to my success]...I would get [my management team] together and say, "Well, I'm thinking about doing this, what's your reaction, do you think it's a good idea?"...I would probably argue with them a lot, trying to decide which has the better logic..."What's wrong with, why shouldn't I do it this way?" If they come back with arguments that make more sense then I will rapidly change my opinion....My philosophy is that there aren't any single answers to things and there're an awful lot of areas [where] you can go either way and it probably won't be the end of the world. I think that, in terms of my philosophy on the successful businessman, you*

need a couple of very basic principles that set you in a certain direction. And if you're going to lead companies, if you will stick to that you will be a much more successful leader than if you get yourself real heavily involved in every little detailed decision as to what's right and what's wrong.

This same entrepreneur honored his management team's influence even when its decisions didn't work out well.

If I'd been more analytical about [that decision], I don't think I would have come to the decision that we ultimately came to, I say we because I do try to involve the people that are running things. I try to keep that, if you will, team concept. Probably half a dozen people at the company....I wanted them to participate...because I felt two things would happen. One is I thought I would get something valuable out of it, and two it was a way of forcing myself to do, to think about their operations and make them better at what they were doing.

One spoke of learning, through the pain of failure, how to use his management team more effectively.

The focus of the business that came out of the ashes is I'm running a business that has to do the work well...today I focus on being a good manager. I've changed my philosophy on a lot of those things. We had 240 people. When it was over we had seventeen....I'm very blessed, those seventeen ultimately became eight, they were the people who were with us the longest, knew the stuff....It's a big part of the strategic plan...two things I can't delegate....Anything that is an equity decision I make. Anything which has to do with marketing and development of marketing is ultimately my decision. But I've restructured the company with a very flat organization chart, an organization chart which consists of eight key core team members....And these eight people are involved at least in discussion and most often in the decision-making process on every other major decision we make....We've really installed this as a serious management tool. We meet every week. These people were the majority authors of all of the underlying work in the strategic plan, in return for that type of work I made an undertaking to them that the

majority of my time would be spend in marketing and development to try to give them the stability which they're looking for. They in return need to do the work, and need to, for example, be brave and raise difficult issues, and we had lots of old issues, lots of tough things. It's really working well, we have yelled at each other and money's tight....They know they won't get raises until we achieve a certain cash cushion in the bank, and they get the books so they see it, so it's really an interesting development and a different style. I like it. Because the responsibility that can be shared is shared and the responsibility which shouldn't be shared I'm not tempted to share....And that was the change.

A common theme was that of the entrepreneur relying on his management team for input but ultimately making the final decision himself.

I talked to the senior people *in the company and we decided to grow the company and diversify. I don't run a dictatorship there. I try to have, I know that one day I want a good management team that can carry on the business without me. So, in order to do that I know that I've got to put people through the process of doing thinking and dealing with situations and performing judgments on imperfect information and all this sort of thing, so I probably don't do it as much as I should, but more and more I involve people in that process....Now when you have 40 percent of your business going to one customer and that 40 percent essentially goes away over the course of a few months, that is a big threat...you know, at least I didn't feel terribly alone with that decision because I had the management team working with me and we were all in the same boat, so we were all working as hard as we could to see what we were going to do about staying the course....We were committed, we had a couple million dollars worth of equipment on a ship coming over...I was happy we'd made the decision...what was bothering me was whether we could fund it, whether, in fact, we could pull it off, when we had just lost 40 percent of our volume....Nevertheless, it wasn't as participatory as I think it should have been because, basically it still came down to my decision....Actually since then, I've been more participatory with them and more where I'm not making the decisions, where I'm saying, "You*

guys make the decision." Well, I want to evolve a team. I want to be stronger then, I want the company to be stronger and have better management.

I don't want people *here that are going to be carbon copies of me. I want different input, I want different perspectives because ultimately no matter how good I am, a decision with sets of input is going to be better than just one decision that one person can make.*

Sometimes [my decisions] are totally private *because I may not like discussing it...but not too often. If a decision is important, you shouldn't make it unilaterally, you are depriving yourself of input from others. The only decisions I guess I would make unilaterally are decisions that for some reason I can't share with others that may be personal in nature, or because I have a hidden agenda that I can't share with others, or because I have a certain bias.*

Sometimes the decision influence was reported to work in the other direction, on others, from entrepreneur to the management team.

Without appearing manipulative, *you can make the team want to change. You can guide them in that direction, you can influence them sometimes by making it known that that might not be a bad idea, but sometimes more discreetly by enumerating facts that make you believe that, that may not be the reason you really made that decision, but you've got to rationalize these things, they've got to buy in.*

Partners

The influence of partners was strong, as well. About a quarter of this group of sixty entrepreneurs had active partners with whom they had good working relationships. Of these, about half were family partnerships and about half were unrelated-party partnerships. About a quarter of the group had dissolved former partnerships (primarily with unrelated parties) which had not worked well.

When partnerships worked, they were reported to work very well and to be sources of strong positive influence and support for the

entrepreneur. Their strengths included complementary skills and broadened perspectives and trust.

Well, now we'd been together all these years and we're still together. We've never had any outside directors, we've been the profit-sharing committee, the executive committee, the partners, the everything, and we're very proud of that because most marriages don't last eighteen years anymore, much less four people in business together. Twice as bad as a partnership, four guys....We owned them jointly and we'd run them independently....We formed a holding company which we all own and then each of us has head operational responsibilities....Each of us has total trust and confidence in each other. We all work hard. We all, I think, have a common vision for the holding company and that is simply to grow the companies. But they're all structured differently. My style of management...I'm sure is dramatically different...We're accountable by the numbers....It's a closed corporation, we've gotten along famously for eighteen years, we don't want to change the mix. We've never sold stock, we've never let anybody else in, even our key people because we knew that would distort the basic chemistry that we had. So we have an agreement among us that we will never have to dispute a decision. We'll argue and we'll talk and debate and vote and we, one way or the other we kind of come to trying out something or deciding that that feels right, they make a decision much like I do. That that's the right thing and it feels right and we think it will work and let's put some energy behind it....None of the other agreements, my partners are very human, very emotional, very giving and loving people. They're special, they have, they're materialistic and capitalistic as you must be in business today, but not first....Relationships first.

I talk frequently, openly with my long-time partner, we have very complementary skills, we're nicknamed "slick" and "silk."

We are fifty/fifty on everything, no ledger sheets on what we take out of the business, it's up to our individual conscience. I'm a procrastinator, put things off. He's impulsive. I have to slow him down. He has to run behind me and shove me to go faster....We don't second-guess, always come to an agreement on the decision.

There's this partnership or two-person thing, this constant communication with each other...extremely valuable really....Shorthand really, yes, to get to that point, if you ever do it's because you're open to each other, you're honest, you're not afraid of each other, you're not afraid of yourself, not afraid to say stupid things and the other person is not taking advantage of that. It's a lot of very sensitive things going on, of course, to make this successful, but we did a fantastic job there really, enormously talented way of facing each other....[partnership for] twenty years.

We both go very fast, we communicate well. Because we both move quickly, and we had a deal right away that was whichever one of us is on the spot makes the decision, if both of us are there okay and we usually make the same decision. The guy who wasn't there never questioned it, that was just understood between the two of us....If they'd been bad decisions I suppose that we'd have started second-guessing each other, but times were good, through that time period it was hard to make mistakes....I think it's a combination of having the experience, of having seen it happen enough times...and learning, what's good and what isn't, therefore having the experience to rely back on...but as important is the relationship between the two people where your thought process is enough alike and you reinforce each other enough and you know that you've got, once again, a good partner. And the two of you say, "Yeah," and we'd do it pretty fast, we'd talk it over, it didn't take very much talk, sometimes there were alternatives that we'd have to settle on but we'd get it quickly.

Among those partnerships that worked well were a husband-and-wife team. This couple jointly founded and ran their company. Each had separate areas of primary responsibility (he handled product development; she handled administration). They made strategic decisions together and didn't act on any significant decision unless the other agreed. Agreement sometimes involved a lot of controversy and some private yelling.

She does all the [organization] work. I go back to my office and close the door and come up with some other idea. Crazy. For a while [I had trouble staying out of it] but not anymore....I screwed it up. I just screwed up all the organization because I can't focus long enough on details....I

knew it to a degree because I brought her in and said, "You better, you know, either we're going to stay tiny, sell the thing, or you're going to come in and run day-by-day operations because I can't do it."...It's fifty/fifty....No one can get along with me. I don't trust anyone [but her]....Then she finally just said, "Forget you man, this is going to be equal. I got operations, you can have creative, but don't step on my toes." And so now...we really are equal....I'm not the easiest to deal with, I'm not....and she complements me cause I go [baby, immature, intense, angry, perfectionist] and she goes nice and even. I don't think she's got the excitement, the nonsense that I do, but she's got this ability and it's a great balance and so we're a good team....Strategic, long-term, that's her influence. She'd much more long-term oriented than I am. I make the money fast, go in for the kill, fast, and she's very long-term, methodic. I think we do know each other's strengths and weaknesses....I'm the front man because she has better leadership skills than I do. I lead through enthusiasm and I can lead people through walls....she can't motivate the way I can...but she is the glue that keeps it together and she's the leader here. She really is....I make the new product decisions, she's not real involved in that. Marketing, she's not real involved in that....I have a lot of spontaneous humor and so when things get too heavy...but I will back her though, I mean, and then when big issues come up I will come forward in the meeting and I will support her position and we will never argue publicly, I mean never....She's up all the time...not me, at all. She's always telling me to cut it out, I'll bring down morale. I've got to watch myself because I react way too strongly...she never responds...[but] she'll go for it....I think we complement, it seems like we do complement each other.

He's very proud...at one point he said to me, "If this business is going to grow you have to be here. This has to be a joint effort. I'm not doing this by myself." The decision to make the company grow came from me....I decided to really take on more of a leadership role, it was not defined, that was my goal....what I wanted [the company] to be was what we together, what our dreams were for this company. But in a lot of ways it really is more what I want it to be. He really is much more in tune with product and that's why he gives me credit a lot because this is not really

the direction he would have picked if he was at the helm, because this isn't his style at all. But he sees that it works, he let me do it but it wasn't what he would have done if he was here by himself....His way of thinking about [some decisions] is different than mine. We worked it out....We [may] fight about it, and it depends, we're both very strong....Sometimes we go with his way and sometimes we go with my way....He's never once said to me, "Don't do something or don't do this." He's always been really proud of every step I've taken, so it's like, if someone's proud of you and pushing you along and pushing you along you continue to grow....And then you come to a place in your life where you're both growing and changing and thank goodness we've been able to change with one another.

Another couple was a former husband and wife who remained good friends.

She still works here. *And she's a good partner. A good partner. We're very different people, and we have a lot of things in common, and, as I say, we're very close and we get along well. We're just not staying married. But we can work together and she is somebody that I talk to and she can give me a lot of different perspectives. We talk, [we're both owners of the business].*

These were both partnerships in which the spouses clearly shared ownership. While no one was anything but generous in compliments about his spouse in the interviews, several other entrepreneurs expressed dissatisfaction and frustration with having or having had spouses in subordinate roles in their companies. Where authority was shared in the company as it was in the personal relationship, working together seemed welcome and productive.

But, where one spouse exercised unilateral control or believed he was the experienced expert—and the other had no right to express a divergent opinion, sparks flew and disappointment flared for both parties. These entrepreneurs appreciated the support of spouses and respected their counsel (which, with only one exception, they described as "intuitive"), but they didn't want their spouse's active in-

volvement in the business. Said one: "It pisses me off that I can't control her."

The successful exception to this pattern of unequal authority and frustration occurred in situations in which a spouse was asked to come in to manage a short-term project or solve a specific problem in line with his professional experience.

I have decided to have my spouse [who has a Ph.D. in psychology] help with management problems with the supervisors. To have weekly meetings with them just to discuss things. Her role is to look at it through another set of eyes. She is a people person and asks the "why" questions....It's not a job here. She has a private practice....Her value is that her approach is really different than mine. Just the mere idea that we have put her there is valuable to the supervisors.

The influence of partnerships which did not work was even stronger for the fifteen of these entrepreneurs who had dissolved them. It also was very negative, serving to convince the entrepreneur never to have another. (Which is not to say that he didn't; several had later partnerships and typically regretted those also.)

The principal reasons for partnership failure described by these entrepreneurs were inequities in the work load and in business results. Noteworthy, too, is how difficult it was for many of these disheartened partners to sever the soured relationships.

[I was bothered that] I'm taking a hundred percent of the risk now, as well as doing a hundred percent of the work and bringing in a hundred percent of the clients for fifty percent of the profits, this does not make sense to me....I think he was waiting to see whether or not I was just going to terminate the partnership, there again I have a hard time doing things like that.

And I in essence made him a sweat equity partner. I put up the money and I had the idea [for the business] and I made him a sweat equity partner over three years....And we sat around one day and my partner

was grousing about this, about the work not being there anymore...and I was getting a little tired of [doing all the work]...and I did a real stupid, knee-jerk thing which I didn't think about, I said, "Okay, you son of a bitch, you get the work, I'll just sit here." I'm gambling with my own goddamn income too but I did it, and you know, revenue went down and went down low enough to where we weren't going to pay ourselves any more and we weren't, we sat in the same office for five years, literally in the same office looking at each other....Finally I said, "We gotta change the partnership agreement."...he balked and held out and I pulled it, we separated under the terms....It was terrible, it was the worst, the hardest...

The only problem was he didn't do anything, and he just hired a couple of liaison people and he sat back, and I was running everything working eighty hours a week....I knew eventually we were going to have some problems because he took, his philosophy in the business was to have a business so he didn't have to work....in fact my decision about him was made a long time ago before that, you know, it was just the nature of him...my confidence level came up so I knew I could run it myself, and when I knew I could do that I knew I didn't need a partner....I've really been negative about partners [since then, I] probably went a little overboard, I've voiced it a lot...I think [it's not okay] to have ongoing working relationship partners.

On dissolving this partnership, I'm hung-up with past history, his past efforts in the company. He really started the opportunity by starting the company with me. Although with incorporation I took over running the company, he managed the sales. But he is doing very little work now, even in sales, and I feel I am doing it all. He is taking a lot of money out, not working, not following through. [We were very complementary], I am analytical, he is bubbly and up and not analytical. [I think about] how can I fairly repay his investment while protecting my interests and the future of the company.

We were fifty/fifty partners. So I believed in his capability to go out there and sell the goods and bring in the business, and I believed in my capability to solve problems and get it out the door. And after two or

three years we were going no where, nothing was happening, same amount of business and on and on and on, you know, not that he and I didn't get along, but nothing was happening....Started to realize that it would probably never work, [I can't] really work well in any partnership....being number one is the only way I can work.

Growing distrust and divergence of goals also led to partnership dissolutions.

One day I called over there to find out how much money we had at the bank and I thought we had twenty thousand dollars. And the guy at the bank says, "Yes you've got twenty dollars and thirty-one cents." "No," I say, "it's supposed to be..." "No," he says, "you've got twenty dollars and thirty-one cents."...and I ran all the way, I'll never forget, I ran all the way over to this bank and looked at this banking thing and my good partner had decided to go to the race track. And that's when I learned you have two signatures on every check and I have to this day, or I sign them alone....I learned, the minute we had a problem, he just went and took the books. All of them, and he left, he took every goddamn book, everything. Which taught me that a partner can't steal from himself. So I learned that one the hard way. I mean, you never give the books up, which came back to me again later. And actually I made that mistake almost twice again.

I said, "What is going on, is there some truth to this?" And...and he sat down like a little kid who'd been caught in a lie, you know, and for the longest time he didn't say anything. Hung his head and he said, "I lied to you."...I was furious....I said, "We've been working as partners [for years], how could you do this without, how could you make such an important decision or move without talking to me about it?" And he said, he made sort of a, he said, "Well, I didn't want to interfere with you running the company on a day-to-day basis, I didn't want to worry you, I didn't want you to be worried about it."...I mean, I trusted him, and I felt like, I thought a lot about it, and I was so disillusioned, I mean to have somebody lie to me.

I thought he'd be great...he turned out to be a sour apple and so I got rid of him and from that time I've never had a partner in the company cause I figured that was my root, that was the thing, the father of my source of material wealth or whatever, so in lieu of [partnerships] I always gave them profits from the company as though they were partners, but I never gave them a piece of the company, rightly or wrongly. And yet, I go out and get into other partnerships with other people and some were good and some were bad, mostly they were good, a couple of times they were bad and that can gang up on you too.

That was when I learned the partnership wasn't necessarily a partnership...we finally got into a truce, the truce was basically that we communicated through a third party.

We were fifty/fifty partners. It was a terrible mistake but I didn't learn that until later....He desperately needed money so he invoked the buy/ sell...had been partners for six or seven years, we had been growing very much apart, he becoming through his own lifestyle someone that he didn't deserve to be, frankly, very plastic, very self-important, motivated by material things only....

I was very concerned about [my two partners], my gut was always concerned about them. I didn't think they had, I hate to use this word and it's not the right word, ethics. They just didn't seem to have ethics. And they were purely and solely driven by money, and I knew that going in, and they always tried to tell me that everything's driven by money and I always try to tell them it's not true, very few people are driven by money, I know a lot of people in business and a whole lot of decisions they make, and yeah money is important but there's a lot of other things that are more important.

Customers

Customers were major influences on strategic market and product decisions. Several entrepreneurs described meeting the needs of customers as the engine of their business, and the retention of fine customers as the measure of their business success.

That's the major success of the business. I want the business to be successful but I don't need the reward of having it. I don't know if that makes sense. The measure of success of the business [isn't gross revenues or profits] it's retention of fine customers, fulfilling their needs. I've gotten rid of customers. Because they weren't so fine. They didn't measure up.

I'm able to put on that other hat pretty easily in other situations. I can put on the customer hat...because I think it allows me a whole different insight and different perspective rather than just ours....Bottom line, it's my responsibility. Now I look at the reasons for the bad debts and a sizable portion of them...are decisions that I made because of the customers. Maybe someone I dealt with for twenty years just screwed me....It was just the circumstances, the way it worked out. I think the decisions that were made were made appropriately based on the information that we had. We could not foresee the things that happened.

Many entrepreneurs spoke specifically of customers as their equals and in some sense as their alter egos in those decisions.

I learned not to be scared of clients, not to talk to them from under but to treat them in a more healthy way, as equals.

[The criteria for my decisions is absolutely clear: my customer.] The nice thing about it is that what I like and what they like are often the same. So I have a double satisfaction because I'm building what I like to build and my [customers] like it too....We do a very careful job.

[I vetoed that decision] because it seemed phony to me and I didn't believe the customers were dumb.

Boards of Directors

Two additional sources of influence from others were the entrepreneur's board of directors or board of advisers, including organizations of CEOs and peers in whose small groups members functioned as informal boards of advisers for one another.

Among the few entrepreneurs heading public companies and certain private companies with boards of directors, there was a great deal of respect for the combined counsel of the board members.

I get a lot of advice from board members...I seek it out a lot, I talk a lot to them individually...I want to pick their brains.

I started another company, again with some very good people I attracted to the board, as I try to attract in all areas, some really good people....had our three pictures in Fortune magazine, we were probably the best known three-person...company in the world. And I had these very talented people on the board who believed in me and were willing to go to extraordinary lengths to try to help...and this very wonderful board stuck with it to the end and put a lot of time into it.

There was also some dissatisfaction with the restraints the board placed on the entrepreneur.

You know, we were real lucky because from the beginning we were able to recruit a very strong board of directors,...it's just an incredible group...I need to feel I'm growing, as entrepreneurial as I can be in this company, as much control as I have, I'm still reporting to a board of directors, it's a public company...I have to be very risk adverse. And that limits the upside of what you can do.

I'm on the board of directors of the company that acquired mine....hard to get it through these goddamn directors, and talk about numbers, god, I mean, they're maniacs with them.

I choose [my board of directors] carefully but in the end they're all a compromise. You remember I was concerned about my two partners? They're on my board of directors. I was concerned about investment bankers, but the only way I could do a deal was with investment bankers and on my board of directors they are all investment bankers.

Another side of their feelings about boards, shared by many of these entrepreneurs, was expressed by this founder and head of a public company.

I have a board of directors. I'm the only member, after being one of thirty-five. I'm the only one. I don't have to have this special meeting, I can meet by myself in the car, I can...and you know, it's something when people put more than a quarter of a billion dollars of their own money in and they are not even represented on the board, it's unbelievable. At the same time they've made a lot of money...basically they are owners, but they can't vote.

A few of these entrepreneurs also served as directors on the boards of other public and private companies.

There probably aren't a lot of people who spend sixty days a year in boardrooms [as I do] and so you develop a certain expertise and a certain comfort with the process and a lot of interchangeability [in helping].

In the meantime I was making surrogate decisions, on some boards, and contributing to decision-making on those boards and watching how other companies do it, all the way from [smaller public company to a very large international public company]...those decisions are usually ratifications of what management wants to do, they are very seldom independent decisions, your only decisions are whether or not you have confidence in management, your contribution there is not decision-making, it is only to ask enough questions about what they're doing so they will carefully think through their own decisions.

Boards of Advisers

A few of these sixty entrepreneurs had formally organized boards of advisers. Without legal authority or responsibility, these advisory board members were only as influential with the entrepreneur as he would allow them to be.

My idea of using [an advisory] board...is as a means of holding you accountable and making change happen.

I don't know whether I want to be accountable to that kind of stuff...I just don't [think I could be accountable], it's too much pressure for me. I could use them to throw ideas out, which I think is good...[but] maybe that's my problem, I just don't want to accept responsibility, I have to be, that's why a board would bother me if I had to be responsible.

Let's take finance, for example,....I don't feel capable anymore just making those decisions all by myself, I don't want to...I will have an advisory board....[Don't want a board of directors], it's the legal restraints and the legality with a real board and all that bullshit, you know so much of this stuff is bullshit so I don't want to get involved with it.

I've relied on them for lots of different kinds of decisions that I didn't feel I was technically able to make or I wanted someone else's point of view because I valued it and I valued someone else's judgment...but most of it [what I'm doing] I don't want to change. I like doing it the way I'm doing it, I don't want to change. And there's an awful lot of that, I fight that every day....I don't even want to think about change.

[Our board members] provide a couple of purposes, one, they supply the lubrication in the family situation because they both are considered to be independent of me. Two, they're both as senior as I am, if not having more experience than I do, therefore they cannot be bowled over by my reaching into my bag of tricks. They know them all.

Peer Groups

Like that of boards of advisers, the counsel and influence of the entrepreneur-member's peer group varied according to the entrepreneur's respect for it. In a general sense, the entrepreneur signalled the group's importance for him by his continuing membership. In a more specific sense, the thirty-three entrepreneurs who happened to be members of a peer group at the time of our interviews described unanimous satisfaction with the "take home value" of their group interactions and with the counsel of their chairmen. The peer groups, they said, served as their "informal board of advis-

ers," as "an independent sounding board for my ideas," and "for my issues and problems," as "intellectual pollination," as "contributors to my thought processes," as "definers and refiners of my ideas," as mirrors of their own value.

> *It made me realize* who I am and what I am....Well, it's like they held up a mirror for me and let me look at myself.

> *I've done a lot of listening*....The group has been very valuable and I think [the chairman] just as an individual has been equally as valuable because the one-on-ones are real important and he's helped me, I think, gain an understanding of what my potential is as an individual and as a businessman and I have expanded my horizons incredibly.

They said the peer groups helped them to "learn the (more sophisticated) skills of business and the nuts and bolts," to "get business problems straightened out," to "save money by doing things differently," to "hear other perspectives," to "meet other people to network and get honest feedback."

> *They've given me a lot* of support. Kick me in the rear end a lot. It's a place where I can just get some honesty. I don't always agree....There's so much, what I've learned. [And] it's been bad for me in a sense that I realized really bright people can take it so fast it'll make your head spin....You're going to be history if this continues. Your net worth is a quarter of what it was a year ago. And I'm sitting there, and I'm going, oh my God....I've seen how fragile business is being [now]....I never really understood that you can tank it so fast and I could be tanked, I could be tanked overnight.

> *It's been very stimulating*, that would be the key word that I would use. I think to have the opportunity to talk to other people where without that I would be very isolated, because I wouldn't have the people at that level to talk to, makes a tremendous difference. Having the opportunity to bring up issues to discuss has been helpful. But I think that I've gotten even more out of the issues that other people bring up. Sometimes one is not aware of having issues until you hear about it from other people.

The easiest example is...listening to what they had to say gave me some other input and we wound up changing [what we had been doing in the company]...that paid for my yearly dues. And that happens a lot and I learn a tremendous lot from the other people.

So what it's done is broaden my horizon by bringing in people who see a different picture.

They also found in their peer groups support for significant personal change.

Even though I felt that was the right thing to do, still I was going through a difficult time...one member said, "Well, what do you want to do, what do you want to do?" And I couldn't answer the question, I mean, I [wanted] to be able to answer the question to myself: what do I want to do....It was just about life and, you know, it wasn't clear to me and so it made me realize that I needed to focus on finding out what I wanted to do.

The thing that happened when I joined is that I saw success defined in different ways, I all of a sudden discovered that...my fellow members [who ran their own companies] had their freedom, complete absolute freedom...plus they were creating things, and they could do other things...so I was being challenged anew to exercise different muscles, so to speak...and it's been very interesting to see how everybody is striving to be this whole person and what they're missing. And it doesn't matter how dominant everything else they have is, they see something that somebody else has [a personal quality] and that they'd like to have. I saw what I considered my true partners, the members of my peer group...were showing me another definition of success out of their freedom and independence and I wanted to experience that.

Mentors

Mentors, or more often unconscious mentoring by someone senior to them, influenced the decision-making of about a quarter of these entrepreneurs.

I had a guru....I would go over and talk with him about my thinking process and negotiating strategy. And, of course, he did as all good mentors do, he just really held the mirror up...helped me to verbalize...and make the decision.

I had a wonderful mentor...he gave me a lot of freedom as well as...opportunity and challenge.

The founder was still there in the business, who had been there since he started in his garage, literally, fifty years, and he'd always done it his way and he was a micro manager, so he went in and actually made the micro decisions. He was difficult to work with, he didn't delegate well. Great coach, great teacher, I learned a lot from him....That was the first time I had ever worked with any boss [who was] a mentor.

Family

The influence of others also included the influence of family members, whether or not they were directly involved with the entrepreneur's business. It provided both positive support and negative questioning, and it impacted on business decisions, family cohesiveness and personal growth.

These entrepreneurs also spoke of the influence of family while they were growing up, directing at their families primarily credit but also some criticism. They talked of the sacrifices their parents had made for them and of the burdens they had felt, and of the molding of themselves by their families. They described either strong values and comfort with themselves, or insecurities and discomfort with themselves.

I think at a different day and age [my father] probably would have been very successful. He just had a good financial mind, he had good instincts....[But] when I was just dealing with him a lot of my energy was just put into the conflict, the arguments. Just trying to keep from being frustrated.

My father had a real good quality of being able to relate to just about anybody. And I think I admired that and I wanted to do the same thing....I had a drive when I was a kid and it's still there, that I want to be able to be conversant about whatever they are about, and I think I learned that from my father.

I had a very strong mother and a relatively weak father. My parents were products of the depression. They had a lot of messages about the need to be educated....They went all through their lives with deferred compensation...for me.

I started out [working] very young, probably out of need to be an entrepreneur. My father had a real depression mentality and if you wanted something you had to work for it, and if you didn't work you didn't get it. My mother had an emphasis on education, so hopefully there was some balance, but I think my father's was more lasting than my mother's.

I felt the burden of handling that for the family and again having to learn how to take care of other people and be an adult when you don't want to be....It was a burden on me, it was only later that I developed a very healthy respect for what my dad had accomplished, overcoming incredible odds.

It didn't seem like it at the time, but clearly my family loved me....my father was very demanding...his basic approach [however well I did] was that he had done better, which obviously comes from his own insecurity....Who my family was, you know, the particular make up of what I am, has allowed me the ease of decision-making and the comfort with my successes and failures that other people just don't [seem to have].

To be real frank with you, I was raised with a really disturbed mom...[it really impacted the way I am].

I have been raised in a family that dealt with feelings [which I have brought to our family and to the business].

The most profound basis *for all of this in my life is the fact that I lost my natural father when I was twelve years of age, and my brothers were off at war, which left my mother and me alone and in desperate straits, emotionally and watching what my mother went through left a profound underlying security fear, so I vowed that would never happen to me.*

I think that my parents *instilled in me a very strong morality of right and wrong and fairness and the way you deal with people, and that dealings with people are a life-long process and not just an encounter here and there, your relations with people are a whole series of encounters that go on and on and are linked to one another, and somehow a belief that you win some and you lose some and in the end everything evens out.*

My mother was an influence *in saying that you needed to accomplish something out of your life and you need to be, and you know, all this sort of thing. And my father wasn't terribly successful. Successful in the sense that, I take that back, he was successful in the sense that he was happy and he made, his life was enjoyable, from that point of view [he was a] success in human terms.*

I was raised *in a very unstable family and was very concerned not to repeat that [with my own family].*

It was due to the way I was raised. *But I got out of high school just a very mediocre performer and a non-achiever. I don't think that's who the real me was, but that's what I had learned to be.*

I didn't have much *of a [father] role model....And what decisions do you make when you're a little kid? You usually, you watch somebody else do it, find out how they do it, and I don't, I think I rejected, my mother's decision-making was emotional, highly volatile, and I reacted negatively to her decision-making process. Very consciously....I suppose at a young age that I decided that I ought to, that I'd seen a lot of the wrong way to do it.*

Family Business

About a quarter of the group described their parents' influence on their own choices of education and careers. Fully half of them recollected learning about business from their families, by example, by osmosis, from working at an early age, at the dinner table, from fathers and mothers, grandmothers and grandfathers, Godmothers and first fathers-in-law. Several entrepreneurs said that their business acumen came from the family genes.

The interesting thing is you learn by example, and I have a leg up on the world [because] my father was the president, chairman and CEO of three major public companies and I got the opportunity to see him in action very intimately, and I look at his successes and then I look at his shortcomings, and he was an incredible people person, like me, and he still is, he put an incredible amount of time into developing people.

I loved it because it was business-related. I thought I wanted to go into business because my dad was in business, my grandfather was, that's what the exposure was, so it seemed like a viable type of career.

My father was a very dynamic successful businessman...and led an extremely tumultuous career, and I had some, I had some understanding of business, not a lot because my father and I didn't share much of anything, but I'm trying to use that as a reference point to say, it's sort of like you know the smell of pine needles but you've never been in the forest, you know. Well, that's what business had for me, business, "General Motors," people with real balance sheets, it was there.

My dad was more on the track I'm on, let's-go-for-it track...and you walk into one of the guy's offices and my dad's picture's on the wall, so he did something for them.

So I grew up with a campus-type environment, students, professors, a lot of that rubbed off on me, no matter how young you are, just listening to the interchange....And then being so close to actual bombings and seeing the building stumble and knowing that people died or are injured

in that rubble, gave me a sense of, one senses the fragility of life and the importance of pursuing it to its utmost, but at the same time a sense of confidence that if you remain with the conviction of what you're doing there are ways to survive it all. Survival was...very traumatic.

I think if you want to find out *why, I think that comes from my family background and that is that I came from a father who was an entrepreneur, my father was a lawyer and an engineer and always had his hands in a million different businesses. And I think you do learn that from your family, the discussion over the dinner table of what was going on in my father's life, you'd get a feel for it....He was actually never really very successful until he was very much older and then he finally was successful in the end....I'm sure you learn these things from your family, it becomes instinctive, how do you know about business.*

I know in five minutes *who I want to work with [and what decision to make]...[it was from my folks], their genes.*

Not all of their learning-business-in-the-family influences were positive.

There were times *when I certainly had over-extended myself beyond what my dad thought was okay. He had a way of keeping all the boys kind of always pissed off at each other, and for fifteen years my brothers and I were at each others' throats.*

So things just didn't work out *too well for us working together and there were a lot of things I wanted to do that I wasn't able to do in working with him, so by going out on my own I was able to do that.*

Marriages

Talking with spouses about business and business decisions was important to most of these entrepreneurs, on both the day-to-day events and the big issues.

In discussion and consultation with my wife, we had been talking about careers and where we want to live, because I've always talked about what goes on in my career with her.

Also my most important adviser is probably my wife. I talk with her a lot on these subjects but I also know she has her own biases....I think that if she would have advanced some very strong reasons why I shouldn't do it I sure would have listened. But I also, I think I was also paying my respects. I thought that I just wasn't going to carve out that much time for something that I was going to do without talking it over with her and getting the depths of her despair about it.

One of the things we do about once or twice a year, we kind of just go drive some place and say, "Now, what do you want? What do I want?"

Another common theme was that of getting full support from their spouses when these entrepreneurs wanted to mortgage the family house to go into business for themselves, or start a new company, or grow one.

Now my wife helped because she really, she knew how frustrated I was working for other people sometimes and she said, "No matter what they tell you it's probably going to be the same thing all over again, if you really think that this is something you want to do, do it." So I started the company with $5,000 and courage.

A common theme among some of the older entrepreneurs concerned their own personal development, from being not-so-nice people in their early careers, when their spouses and families paid the prices for their advancement and the growth of the business, to being much nicer people later on. The lucky ones made the transition earlier rather than later, usually after a compelling personal wake-up call, and they were grateful for that. Their stories followed similar scenarios, whether they talked of growing a business or climbing a corporate career ladder.

I gotta tell you, during my career going up I was a son-of-a-bitch. Very thoughtless. I still work at [being nicer]. I was very career driven. She

paid a lot of those prices....the long investment in career versus home life. I started to get more human when...I went home one night and her brother had been dying of heart disease and I came into the house and I still had a couple of things, you know, the computer running, and I had...to make two more phone calls. She took me out in the driveway and gave me a come-to-Jesus performance review about this whole scene....and a book called Type A Behavior and Your Heart,*...and I said, oh shit, guess what, they've been looking in your keyhole....There were some intuitive things going on and some signals from my wife, some desire to see my kids grow up and associate with them. Those things all happened at once. So...much more sense of family and that these kids only had a little bit more time to be with us. Our kids are probably one of our proudest achievements....[And now] we just spend enough time to talk about what we want....A master plan isn't really a big deal for us. Get up in the morning and say thank God you got life as good as you've got it, try and control some things, and we've said if we lost it all and went into an apartment that we'd, you know, be tougher [and just fine]....and get on with this [next plan] of mine to teach.*

This is not to imply that all of these entrepreneurs sacrificed family to work in their early career years. Several did not. These people spoke of understanding from the beginning what great value their spouses and children were to them. But the more common pattern in the early years was business first, everything else later.

Several also described their marriages as the most positive influence on them, especially following their own transitions to becoming their better selves, using words like "magnificent," "stability," "a good partnership base," "makes decision-making more solid," "my most important accomplishment."

Friends

These entrepreneurs also talked with their friends, and they spoke frequently of the powerful impact of their long-time friends (who sometimes were also family members) on their decisions and their

lives. The input was not always welcome, as one entrepreneur noted in describing the old friends "who stay in my life badly." But much of it was. And much of it revolved around being helped by friends.

Friendships that were lasting *even though the jobs have changed, not transitory at all, they were solid because the chemistry was real blue...friends over the years....People have always helped me. You know, the metaphor would be like people saying, "I'm cupping my hands to get you over the wall first." You know, they just want you to win....Most of the time I think people who are successful are helped and sometimes surrounded by people who really want them to win....You don't do everything right and you don't always do a superb job. But if they want you to win, they overlook the times that you goof and they herald the times that you win, and this is important.*

Our old customers *kind of rallied to us.*

[Old friends] *have helped me and everything else, you start talking to people and if they trust you they start helping you do the deal. So that means a lot.*

But really *having supportive people around me, couldn't ask for more supportive people.*

I loved maintaining *relationships and the contacts and all the wonderful people, that have developed over the years.*

SUMMARY: THE INFLUENCE OF OTHERS

Management teams, partners, customers, boards of directors and advisers, groups of peers, mentors, family and friends all served the decision-making of these sixty entrepreneurs. For the entrepreneurs who were able to accept it, the influence of others brought new perspectives, additional information, enthusiasm and ownership of decisions, opportunities for personal growth and development, better communication of visions and goals, better decision-making and better decisions.

Judging from the stories of these entrepreneurs, the most successful of them, in both their businesses and their lives, clearly were those who actively sought the counsel of others, who open-mindedly listened to the opinions and advice of others and were able to comfortably change their own minds when it was appropriate, and who genuinely welcomed the influence of others.

The exception is the entrepreneur who blames his trouble on taking the advice of others.

> *I can go back and identify where I made the mistakes, retrospectively. Yes, we should have done [this or that]. We should have done a lot of things I wanted to do...and the staff talked me out of because it wasn't conventional....Those are the only regrets I have, that I listened to other people and didn't persevere with my own ideas.*

Open-mindedly welcoming the influence of others is not an instinctively easy attitude or behavior for many people, and it may be more difficult for entrepreneurs and especially difficult for founders. The influence of others, nevertheless, is a major determining factor in the entrepreneur's ability to reach his goals and embody his purposes. It is an important bridge from the "how's" of his decision-making to the "why's."

MAKE UP YOUR MIND

9 ❧

Wedded to the Long View

My business career started consciously while I was a junior in college. I went through on a basketball scholarship. I think my athletic experience [gave me a different perspective]. I was profoundly affected by my athletic experience and how coaches could inspire. How it worked when you worked with a team and what it was like when you had hot dogs on the team that wouldn't cooperate.

In college, I was involved in politics and also involved in other campus activities and I could see the difference. I didn't like the social structures...all of those things influenced my sensitivity. At that point, I knew little or nothing about psychology, psychotherapy, psychoanalysis. I was very ignorant of those subjects, but soon that changed and that changed my life.

An opportunity came to start a company built around cellophane adhesive tape. The idea of tape was fascinating in those days, that you could see through a piece of tape. My dad and I found somebody that had developed equipment that would print on tape...the concept was that

retail stores throughout America would love to advertise by buying the tape with printing on it. So when we developed that technology it was very primitive, and we started a business around it with $10,000— $5,000 of my money and $5,000 of my dad's.

I found time to get this business started and graduate from college. The thing really took off. It was one of the early decisions that I wish I had done differently. At the same time there was already a company, public, doing very well. We began to compete with them because they had the same kind of products—but they were ahead of us by ten years. Instead of building our company, I sold it.

We should have...raised capital for it. [But] I wasn't sophisticated enough to go into the capital markets...and my dad hadn't been in business and didn't know anything about finance.

I wasn't sophisticated enough to know what I had. I was 30 years old and I had a hell of a lot of cash. My dad sort of quasi-retired and I went to work for the company that bought [ours]. It dominated the trading stamp business in the U.S. at the time.

One [reason we sold] was emotional. My ambitions were so intense and my dad's were so laid-back by that time that we had an incompatibility in terms of what we wanted to do with our lives. The only way we could resolve it was to sell the company. We argued a lot and talked a lot—and ended up not getting along very well. It was strictly done because of the divergence of ambitions. And it was not good communication. I wish that there would have been somebody [to whom] we could have spoken and resolved it in a different way. But we resolved it by taking the cash.

In retrospect, if I could have found a way to buy [my father] out, I would have had a great base for a great company. [But] I was so anxious to get out and I was so driven and so certain that I could build an empire someplace [else]. I also knew that I needed a lot more experience... seasoning...before I really could do what I wanted to do properly. I was in my early thirties.

I knew even then that I wanted to get very rich and I wanted to be very influential politically. Even in those very early stages, and I could see that I couldn't do it in that milieu. At 33, I was running three other factories around the U.S. that produced what we produced. We began to dominate that tiny little market of pressure sensitive tapes and labels.

After about two years, the CEO called me in and talked about strategic vision. "Five years from now they're going to have high-denominational trading stamps, so no longer will the supermarkets have to pass out as many as they do now. They'll be passing out one tenth as many, because of the higher denominations. I see this coming. I want to put you in charge of finding an upstream merger for this entire company—the one we bought from you plus our own parent company."

And so they put me in charge of finding an upstream merger partner. It was a great challenge, and I was very flattered. I quickly found [a big west coast conglomerate] and they bought the whole company. They made the owners of that company extremely rich and I became a VP at [the conglomerate] and oversaw what they just bought. I was 34.

I came into that part of my career knowing it wasn't going to be a long-term thing. In those days, the big corporations in America had no knowledge of issues like organizational development or human resource departments. I can remember going away on retreats with the [conglomerate] people...there would be fist fights in the halls and drinking and no sensitivity to morale of any kind. It was just dog eat dog.

I saw that you could do business more effectively if you thought in organizational development terms, instead of just in power terms. Most of the executives just thought in terms of power and accounting—amassing assets at the top. They wanted very powerful people...no women. They believed in amassing assets and they believed that that's all that was needed. They believed in great charismatic leaders at the top but they had no idea about penetrating deep down into an organization and building a team.

The [conglomerate] experience lasted about three years. They wanted to send me to the east coast to a much larger division. I didn't want to move, so I resigned....I negotiated out of my employment contract. That was another key strategic point because it meant either I was going to decide to work my way up the ladder of this huge corporation. They were giving me a chance, saying "You have the ability, if you want. But we're going to move you all over the world, and eventually maybe you'll end up back running the whole company or some part of it...by the time you're 50." It was a very serious strategic decision, I thought about the offer for a little while—and decided that I was basically an entrepreneur.

At that time in my career I didn't know that much about the importance of reflection alone. I did talk to a few advisers. Unfortunately, I didn't have a mentor. I had people at the company that thought a lot of my abilities and were pushing me along—but I couldn't really talk to them. I certainly spoke to my wife about it, but I wasn't in a very good marriage at the time. I knew that it wouldn't make sense to move my family.

It was an instinctive decision. I didn't want to be in the large corporate culture. In those days, there wasn't very much said about entrepreneurs...about taking a risk personally. Big companies dominated the American scene. In those days I was not particularly knowledgeable about being an open person or about getting a lot of advice. I was just driven and knew I was good. I was going with my instincts.

In retrospect, I wish I would have known a good career counselor or a good maybe psychiatrist. I couldn't get that kind of advice from my father. It was a lonely but instinctive decision I made. The instinct got down to the fact that I didn't feel comfortable in a big corporate culture and I didn't want to move. It had slowly came to my consciousness that I was really an entrepreneur. I was a person that liked to take small companies, build them and sell them. I wanted to be less entangled in large bureaucracies.

So, I didn't go forward with [that company]. With another partner I bought a company in the printing and plastics business. I knew nothing

about printing but the other guy did—and we built a very strong mid-size company over a three year period and sold that. That was an easy decision, I had just been remarried at the time. I needed liquidity [because] I had lost all my net worth...the previous marriage had completely wiped me out.

My partner was technically pretty good and I knew a lot about how to market and structure [a company]. I became much more sensitive to people issues. We bought a tiny printing company and built around that. I think we bought it for a hundred thousand and built it up to sales of $5 million when we sold it three years later. That was a pure entrepreneurial experience. We started a business, found a market niche, penetrated it, built the people around it, gave a little equity to one of the very good marketing people...invested very little.

The [growth] was clearly planned. We also built a large building, which we leased to the company—so, when we sold the company, we still had the building. Property values were moving rapidly, so we made a lot of money on the real estate as well. The exit wasn't planned. I knew I wanted to exit, but I had no idea. A fraternity brother of mine was beginning to take over [another conglomerate]. He said, "You're the only guy I know that I trust that's had experience in conglomerates. I want to build one. I'll buy your business from you. I'll issue you stock. And I want you to help me build this huge conglomerate."

So we sold it. The stock ran up a lot from where we got it. I was in charge of the communication and printing company that [this conglomerate] bought and also in charge of acquisitions. Now I was remarried [and] beginning to think strategically. I became more sensitive to the importance of human resource programs and organizational development—all the way down in to the various units. At one time we must have had 60 companies. And I believed that every unit had to have a strategy and I made every manager have a corporate plan. By then everything was planned and I pretty much knew where I was going. I was smart enough to bring in lots of advisers...get as much advice as I could.

One of the techniques that I used [was to] go out in the field and spend time in the companies...on the factory floor... getting an instinctive feel. I would talk to purchasing agents and salesmen, accounting people and union leaders. I would spend a lot of time with them. I used to read a lot of trade magazines. If found I was ambivalent about a decision, I would subscribe to plastics journals and read a lot about the trade. I'd get to know people in the trade better. We were running a conglomerate and were in twenty different industries at the same time. I couldn't be very smart about most of them. In order to nourish [instinctive] judgments, I would bring in various kinds of advisers. Then, I had to subject my conclusions to the board.

This company was one of the high-flying conglomerates of the time. We were hot...we were in the spotlight. The stock was going forward by leaps and bounds. [Then] my boss lost his perspective in my view and started buying companies every week or two and leaving them behind for me to run. I finally sat down with him and said, "There's no way we can run this company strategically. I know why you're buying these companies—you want to pool the earnings so that every quarter looks better than the other and you don't have to rely on real operating earnings. I don't think this is a good idea."

We had some severe disagreements. I remember one. We had a very beautiful young receptionist in the corporate headquarters...and we had a Lear jet. I used it one day and I saw that this young woman was no longer the receptionist—she was the stewardess on the plane. I figured [my boss] was going too far.

I told him that I thought we should do three things and we should do them immediately. One, we should raise a lot more capital for the company because our stock was at a very high price. [I thought] we ought to raise a huge amount of capital and just sit on it. Two, we should personally sell a lot of our stock, so that we could be liquid forever. Three, we should impose tight strategic planning on every unit in the company.

He disagreed with me on all three [points]. So, I resigned, which shocked him. I was resigning just as we had bought a new home—we'd bought it

three months before. The day I resigned, I went home at noon to see my wife and all this furniture was pouring into the house...all this new expensive furniture. I told my wife what I'd done. She came from a very conservative insecure family financially...she was stunned. "How are we going to pay for this furniture? How are we going to live like this?"

I spent [a lot of time] thinking about [what to do next]. My lawyer by then was a good adviser...I talked it over with him. I was concerned about some of the reporting, to the SEC and the public, because I thought that was very sloppy. I wanted to document that internally and get some legal advice about what to do about that in case it blew up.

By then, I'd entered psychoanalysis. I got a great deal of early advice and counsel there. I began to explore my own personal motives and what I wanted to do. That's when I really became in touch in a massive way with the issue of human beings in a corporation. I was able to expand my working experience with therapy. Ever since then, I've tried to understand what motivates me to do what I do.

When I make mistakes, I try to understand the human equations that caused them. I never dwell on them. But I can see a whole series of mistakes [I've made in my work life]. If I were the person then that I am now, psychologically, I would have been richer and had a lot more fun. I would have avoided a number of serious errors, and that's simply because I finally began to get in touch with myself psychologically. It would have been much less chaos in terms of mistakes that created big problems.

About that time, I conceived the idea for my company because I could see there was a need for credit for small entrepreneurial companies. It was about six months after I resigned [from the second conglomerate] that I developed this idea. I found a partner who was brilliant financially and we founded the company.

[The idea was to provide] capital to companies that couldn't get it from the banks. It was that simple. [I got the idea] from all my entrepreneurial experiences...from finding out what the problems were with all those

small companies that we brought public. Why did each one of them sell? A lot of them [sold] for estate planning purposes...[the founders] wanted to get liquid. But almost every one of them had problems with credit, problems with capital.

They got [capital] because we were big and we could provide it. We could provide them with capital so they could find their dream. We literally started the company as a venture capital partnership. The psychology part of it was reflected in the fact that I asked...a respected psychoanalyst...to be on our board as a founding member. His job was to help us make good judgments. That was a reflection of my respect for people input. He was the first psychoanalyst in the country that we could find—and there were a lot of psychologists—that ever went on the board of a public company.

He's still on the board. I buttressed him six or seven years ago by bringing [a well-known organizational psychologist] on the board for the same reason. I was also beginning to get interested in public policy and politics about that time.

[People decisions] are more important than financial decisions. You can have all the financial strength you want, but if you don't have the people your chances of succeeding are very remote. And the chances of having any fun are also very obscure. Some executives today realize the priorities.

If the people in decision-making positions in the company become too concerned abut the price of the stock, the decisions they make are too shortsighted. At this company that got to be too important. I have said on some occasions to our strategic planning people, "This corporation is like a neurotic individual. Maybe most corporations are, but I'd like this one to get healthy emotionally."

We explored what had caused it be neurotic and found a number of different reasons. The most important is that it was too concerned about the short term. It cared too much about the price of the stock next quarter. This caused us to make some short-term decisions that were not good for the shareholders.

That [kind of thinking] produced more crises than it needed to...more crises than the external conditions should cause. Mostly we've been doing extremely well, but a number of times our plans didn't turn out the way we wanted them to. There was more stress than I thought needed to be. We faced options that we didn't want to face...corporate neurosis. I've had several board meetings that were devoted to that. I've talked to my senior staff about this. We began to realize, not too long ago, that we didn't take a long enough view. And that the price of the stock was kind of symbolic.

It's like [the fact] you're only married to one wife. You don't want your wife to be neurotic, even if all the other wives are neurotic—and they probably are. I suppose most businesses out there are also neurotic, but I don't want this one to be. I happen to be blessed with the knowledge of and sensitivity to what neurosis means. I've come in the last five or ten years to understand it with regard to a corporation.

To this day, we're still suffering from some short term decisions...some neurotic decisions that we made five years ago. [But] I believe that, once we get past some of those past bad decisions, almost all the decisions we're making today are sound. Five years from now, they will pay off handsomely. These decisions are emotionally sound because they're balanced...because they're made not based on the price of the stock next week. [They're based] on what's going to be good in the longer term.

I haven't succeeded as much as I'd like to. My company has frequently run into difficult times—after all we're a financial services company. The last 20 years have seen dramatic changes in that whole industry. Some of the time, we've called it right...other times, we've made mistakes.

I've never had a long run where I didn't have to keep my hands in [the business] and could go off and have the kind of fun I love. To me, fun would be writing a book. I did [write one, but it was] under duress almost—at a time when we had some problems. I didn't have the luxury of taking a year off to write the book. I had to write it and promote it while I was running the business. That was fun...but it would have been great fun if I could have taken a year.

We almost agreed to sell the company to [a money-center bank, but] our investment bankers felt that it was premature...that the company had a lot of potential ahead of it. We've had some other discussions about selling it over time, but we've never felt the price was right. Because of the cyclicality of the financial services industry, we've always felt that [we have unrecognized potential]. Even today that's true. As an investor over the years, I have sold some of my stock position. When the stock is low, I've bought some back. But we've never felt it was right [for a total sale].

It took ten years to build the organizational structure we have today. We have three major operating entities now. I build companies up and sell them—so not selling this one is a kind of failure. It goes against my nature. I built this one up, had some problems with it, built it up again. And I haven't found the opportunity to sell it. I had that as an objective and I still do. I don't want to build a huge corporation out of this thing.

It is perfectly reasonable to change objectives. In [this] case, the reason I changed the objective [was that] it didn't seem like it was a practical time to reach that objective. It had to do with the giant gyrations in the industry. So, part of it has been circumstance...[but] I take responsibility for not being able to achieve that.

In the last couple of years, I have become completely wedded to the long view. We don't have the financial public relations counsel we [used to]. I've found that constant activity with the press and the analysts and the financial community doesn't matter a hell of a lot to the price of the stock. I can't influence it enough to justify my time, and it's poisonous to the internal planning and strategies of the senior management team. I do not get involved in the day-to-day details of running any of the operations anymore. I'm completely confident that there is a leader and a manager for each of the three units. They're confident [and] have good people behind them. If—God forbid—something happened to them, they have excellent backup.

I chair the strategic planning committee of the company and stay very closely involved in the financial aspects. [I'm involved] in the major

transactions, once they're ready to get done. But [I've] tried to set a tone in the last year-and-a-half [of delegation]. [I remain] the persona of the company. I was involved in our recent development of a new venture capital fund—attracting institutional investors. I make the first presentation and maybe the second one when [investors] visit here. Then I turn it over to staff and go on to the next group. I've been meeting a lot with...huge public and private pension funds. Forming a marketing plan and strategy for that whole project has taken up a lot of my time.

I do a lot of different things [to keep track of my thought process]. I keep a journal. I write in it about every three days. As something is developing and it's important enough to think about in a macro sense, I will write about it. Sometimes I'll actually draw charts in the journal. And maybe get some more data together. Or I'll just write down what's in my mind.

I usually write at home...at my desk. Sometimes take the journal when I travel...I'll write in airplanes. I write about a lot of personal things. My objective is to be as honest as I can with my own feelings...and then look back and I'll go back and read what I wrote. I'm 62 now. I've been doing this about ten years. You ought to see how many journals I've got in the safe.

I get a lot of advice from board members, other specialists...any place in the world that I want to turn to. I seek out [advice] a lot. I talk a lot individually here or someplace else...with people in the company. I want to pick their brains. I read on the subject. I don't read trade journals as much as I used to. I read general types of publications...like Forbes, *the* [Wall Street Journal], The New Republic...*two or three other newspapers a day.*

Over the period that we've been talking about—since I've developed a lot of critical involvement—you'd be surprised how much somebody like me can get from the political universe. [I can learn things] about what's coming or what the problems are or just about leadership.

Working closely with the people that come around a political campaign, [which I've done recently, gives me] a whole new perspective on what's going on in the world—besides the financial issues and marketing issues. I think my job is to build instincts and to constantly nourish those instincts...in addition to the formal study.

Instincts are built on experience. They're built on your reading and studying...they're built on your travel. When we went biking in Holland two weeks ago, my wife and I had dinner at the home of one of the Dutch industrialists. I got a better perspective on entrepreneurs in Europe than I had before. I found out first-hand what impact the reunification of Germany was going to have on other European businesses. In theory that shouldn't help me a damn bit, because we don't do business in Europe—but it helps me tremendously. Those are ways that you build your instincts.

I also read a lot of books on other subjects. I've been studying the former Soviet Union for [several] years. I've gone there twice. I thought about writing a book about what's going on there. I [also] read a lot of books on psychiatry or psychotherapy. One of my most important advisers is my wife. I talk with her a lot...though I know she has her own biases. From all those experiences comes a certain balance that I can bring to [business] discussions.

When we create a whole new project, such as the stressed-debt area, there are people in the company who have far better judgment about which security to buy—when to buy it and when to sell it—than I do. But sometimes they get carried away in their own emotionalism. So, I have to look at what the results are. We have policies in the company and they're easy to bend [but] when they're bent I want to know why.

I talk to our director of internal audit, low down on the corporate charts. But I get a lot of input from [that person] as to what's going on with the company...who's breaking the rules and why. I'm not trying to catch anybody. I'm just curious to see how policies are being used or not used.

For example, our Chinese Wall. We have an investment group that invests in securities for our clients, so we've had to establish rules about

what people can buy and what they can't. If we make a loan to a public company, we know more about the company than their own board does. By the time we're through with the audit...our people [might] buy stock in that company. So, we've had to spend time making sure that our policies acknowledge the dangers of insider trading.

[The director of internal audit] is responsible for developing and imple- menting those policies. He reports to me—but I don't see that much. He officially reports to the chief financial officer. But he has a dotted line reporting to me, and everybody knows that I read all of the internal audit reports. They know I know because I send back notes asking more questions. You learn over many years where you can write notes and get answers back that, so that everybody knows you're looking.

To diversify into asset management after being a lending credit company for 17 years [was a difficult decision]. To have the chutzpah to go to institutions and say, "We can manage your money in this extremely dif- ficult area"...and all the strategies that center around that [was tough.] It meant I had to throw myself into it at this point in my career...and work hard.

I talked about the diversification into asset management with my wife because, just like the book I wrote, it was going to take a lot of time away from our family life...being together. I also had to weigh whether I wanted to do both of those things at this point in my career...whether my ambi- tion was getting out of hand.

If she had advanced some very strong reasons why I shouldn't do it, I would have listened. But I also think I was paying my respects. I just wasn't going to carve out that much time for something I was going to do without talking it over with her and getting the depth of her despair about it.

I think those were two tough decisions. The book decision was tough because it was going to take a lot of time. I had never done it before and I didn't know whether I would be any good at it. It was a whole new world and it was going to take away from my business...for a little while. It was a little bit self-serving in an ego sense. To have your name on a

book that's prominent...boy, you must be feeding some part of your ego that's always wanted that. It detracted from the business in the short run. Long-term, it helped tremendously. [It] brought great attention to the company.

[Comparing myself today with earlier in my career,] I see much more reliance on the psychological aspects of my own thought processes—and those of others. More patience than I had before...less need for instant gratification. It's like the way an adolescent boy relates to a woman to the way a mature man relates to a woman. More confidence—and more awareness of the downside.

I think confidence is based on accumulated experience. But I think confidence is also based on a lot of successes. I never have gotten over the awareness that something I can't control could come along and wash me away completely. I don't mean death, I mean in a corporate sense.

What I've learned is to understand and respect and appreciate what would be left—even if I wouldn't be thrilled about [the loss]. In my personal investments, [I've] diversified enough to deal with that in a way that would be reasonable. I've never gotten over the fact that this company—like most companies that are smaller—and there are much larger, are vulnerable to all kinds of things, scares the shit out of me.

I think the most important accomplishment to me is a good marriage. Nothing compares to it. Developing a really good family and relating to it in an intimate and rolling kind of way is by far the most important accomplishment that I've had. Second, it's probably business—this business. Although it could have been a lot better, it's been great. Third is probably my influence and impact in a political way...though it's not really big yet. I think it's still building. I think I still have a lot to offer in that sense.

10 🖎

The Influence of Events

In addition to the influence of other people, this group of entrepreneurs described many other influences on their decision-making and their decisions. They included luck, learning, lessons, change, culture, the family business, being poor, being thirty. They recalled the effects of early work and early achievement, of success and failure, of being fired and feeling trapped, of being scared by financial or medical or personal problems, and of going through significant personal changes.

Early Work

Over a third of these entrepreneurs said they had worked since they were very young, at a lot of different jobs, sometimes from some measure of economic necessity, often from personal drives for independence or achievement.

Did all the traditional things, worked in a store, mowed lawns and all the rest of that. That was a constant from the time I was eight or nine

years old until really through my senior year of college....that was automatic, you didn't have a choice.

Worked since I was twelve...*I've always worked and I think that's pretty common among entrepreneurs, they worked at an early age. I've had about a million jobs.*

I've been working *in one way or another since I was eleven, so I was responsible.*

My first job was at the age of ten, *delivering fish, very innovative in that I wasn't big enough to have a bicycle but figured out that if I had roller skates,...was wonderfully successful.*

I'd worked solidly *since the seventh grade I guess, and I'd been financially basically self-supporting since I was thirteen, but I didn't really like any of the jobs, I hated the jobs....and my biggest fear in life was "God! is this all there is?"*

That was probably my first *entrepreneurial bent, [I worked at] everything from shoveling snow to putting chains on cars, coming from a very family where there was not extra money. Since probably the sixth grade, I bought every piece of clothing that I ever had. I didn't have to, but if I wanted something that's what I did.*

I never did not work.

Most came from middle-class families, many of whom had family businesses. Several others described their families as poor, and said that had been a strong motivator towards success for them. There were a few exceptions on the upper end of the economic scale, and that situation, too, was a strong motivator towards success. Occasionally learning about the family financial circumstances had come as a shock.

I guess I never asked questions. I played sports morning noon and night, the reason I'm leading up to this is because when I got out of high school, because you know then I found out I had to go to work and earn a living. My mother or father always said, "Here's a dollar or two," and I never worked. "Here's your handkerchief, son," and I didn't lift a finger, my mother put my clothes away.

Family Influences

The influence of the family business was strong. Sometimes it came in the form of unconscious experience and learning, and often it produced a child who said, "No way, not me, I won't do that." But more often than not, he did. If not follow in the family business, then he started his own in a related field.

*My father owned his own business...*actually it wasn't small, but local, and he went under a few times, so I worked there and saw the problems of business people and owning your own company and swore that I would never get involved in any of that stuff....I said, "No, that's the last thing I want to do. But I need a job so I'll do it temporarily."...I started [a similar business for them] in my living room, [3,000 miles away], no money....and whatever I was figuring out [to do] was working.

My father started it and I worked with him for ten years. And we didn't really get anywhere and we didn't get along, and so I decided to go out on my own....The last thing I wanted to do [was to go into business with my father.]...We were very different people....a two-generation gap. He was still of the generation where he had [certain] expectations of a son and I just didn't fill that bill and so it made it real difficult because I was always a disappointment to him regardless of what I did, because it wasn't what he wanted me to do. And we just couldn't see eye-to-eye and, from a father-and-son standpoint, we never had much of a relationship and so business-wise we didn't either. For me it became, I liked what I was doing, and so I created situations where we were separate and where I could do as much as I could do on my own, but that was still limiting.

"A Business of My Own"

Several knew early that they wanted businesses of their own and that they definitely didn't want to work for others. Several also described "not having much of a childhood" because of a combination of parental attitudes and their working early, at a young age.

I started working when I was thirteen years old, in my parents' business...and by the time I was sixteen I was probably as good as anybody on their staff at doing that [adult] kind of stuff and it sort of became preordained that I would go to business school...didn't have much of a childhood, so much of how I developed was to act like an adult and be an adult when I was a young person. Also prevented me from learning how to be a child and from enjoying a lot of the other kinds of....

When I was in high school I always worked and I always kind of didn't want to work for anybody.

I've always been independent...since I was fourteen years old, and had my own little junk business that I ran....I could, never in my whole thought process did I really ever consider working for anyone else for any period of time. The only purpose of that, the time that I did work for somebody else [was] to develop skills and I did that when I first got out of college...the longest time was four or five years.

I always wanted to be in business, and it probably wasn't necessarily just business, I probably wanted to be successful, and it involves being in business if you want to be successful. And I think I decided that at a probably very young age, and I thought that was pretty normal,...because I came from a farming community, farmers are basically in their own business, but my uncle got the farm, my dad didn't get it so I had to decide what I wanted to do.

Early Achievement

Virtually all of the entrepreneurs who described working from a young age recalled their achievement in those early jobs, and remembered the feelings of self-confidence that it brought to their ability to achieve in the future and to make decisions. Rapid advancement in the initial jobs of their adulthood, and throughout their careers, was a common theme for all sixty of these entrepreneurs. For the most part, they had moved swiftly and successfully from early achievement to their current CEO roles.

I got immediate raises, immediate bonuses and things. In fact I was told, and probably accurately, that I grew up in the company and progressed faster than anybody ever had in its history. I became sales manager and then I became general manager and then I became president, all in about a year.

I started in the shop learning how to use every piece of equipment they had, and after about two years I was in charge of quality control and also in charge of process engineering.

I was the youngest branch manger [at twenty-six] at IBM, after a ton of management training there and incredible screening for behavior, attitude, drive, communication skills, integrity, high energy, high aggression, need for achievement and high dollars, in an extremely competitive environment.

After a year I was number three in the office, out of three or four. No, there were about twenty-five.

At thirty-three I was running three other factories all over the U.S., so they put me in charge of finding an upstream merger partner. It was a great challenge and I was very flattered and I quickly found [the perfect merger partner] and they bought the whole company. They made the owners extremely rich and I became a VP and oversaw what they had just bought.

It was just a job, but I wound up running the station there real fast and they moved me to another one.

When I was first out of college...I started out very fast...here I am a brand new partner...I was getting [the best] assignments, I was being asked to do [the big] things.

*I'm not well read, but I observe....*Took a cut in pay, within a year I was job superintendent...it was like a duck took to water.

I started as sort of an office manager who then put in some time as a project manager and cut my teeth for a couple of years and then very quickly jumped up to being the VP for finance and contract and administration for a company which in 1970 was doing a hundred million a year.

I was just twenty-one, just out of the service [not an officer, no college] and had thirty people working for me, on this big contract for [a big defense contractor], they put me in charge of it and then just left me alone, working eighty hours a week. I thought about it and said, "Well, if I'm going to work this hard I'm going to do it for myself, so I'm going to be in business, and if that's how you make success, I'll be successful."

School

Several entrepreneurs intensely disliked school or college and didn't do well there; about an equal number excelled. Most others said little about their school experiences except to note their general level of achievement. Exceptions were the engineers, scientists, and to a lesser extent those trained in accounting or law, many of whom described how strongly their professional training had molded their early thinking and decision-making habits.

My decision-making is probably skewed to the physicist in me. I think that I think in the abstract order very readily, and...I can probably be more comfortable with abstractions than the average engineer businessman. But my thinking process probably from the earliest stages was framed

by the scientific method type of teaching—data and evidence, hypothetical hypothesis, you test them, what are their practical applications.

Military Experience

Those with military experience valued it very highly and credited it as a major influence on their decision-making.

So I aggressively went about becoming a regular Army officer, and I graduated with honors and went directly into the military....It was more freedom than I've ever had since. Again, it's learning how to, what the system is and how to use the system. So other than the actual combat part of it, I really enjoyed the service. I had some unique opportunities to do unique jobs...had a fabulous opportunity to do a lot of things because we were basically a separate organization. [I had incredible] responsibility and authority and independence.

So even though I rather like organizations and very much liked the team aspect of the military and the kind of reaction to adversity that you all go through all the time in that,...I use a military analogy, one that I bought off on in the military training, is when you're faced in a combat situation you basically have three decisions, either you go forward, go back, or do nothing, and the one thing that is almost inevitably the incorrect decision is to do nothing.

Management Experience

Similarly, those who had had management experience in large organizations, even at junior and middle levels, emphasized how influential it had been for them. Big company management experience was described by virtually all who had had it as a big plus when they headed their own companies. They saw it as an opportunity to learn to work well with others, as an opportunity to experiment and learn without personal financial risk, and as an opportunity to develop broader perspectives and better thinking processes than they could have achieved on their own. Several credited the sensitivity to other people and the people skills learned in those other-company man-

agement experiences for much of their ability to make good decisions and for much of their current success.

Being Thirty

Becoming thirty, or being in their thirties, seemed to be a measuring time for a great many of the men in the group. "How far along am I, in my career?" they asked themselves then, "Have I achieved what I should have achieved by now?" Some said "No, it's time to get going."

I remember thinking that I should have achieved more than this, I mean I wasted my twenties. I've gone out and fooled around with this business and I've learned a lot and everything but you know I'm going to be thirty and I'm a failure. I mean, basically, I have a wife and family and friends and everything, I'm never a failure from that standpoint as I've said, people have always sort of liked me and rallied to me, but I haven't achieved any financial stability. I was still living from month-to-month and I was distraught and this new job was going to be perhaps more of a career than a job and so it was an important choice for me and so, I was trying to be very sensitive to the decision.

I was getting older. I was close to thirty then, so you know by that point you'd better be getting along in your career.

I didn't have a framework to allow me to reach a clear decision that starting a company was better for me....I had just turned thirty-one. Not only did I not have the specific experience of starting a company or working on my own company so I would know whether I liked it or not, clearly though it was a way in which I would have maximum influence, but I also didn't have the kind of exposure and familiarity.

Once again I was really in a state of major change, and I was thirty.

I was thirty. Went back to Alaska [I'd commercial fished there after I got out of the Navy], went back to Alaska again and got on a boat, but [I knew] I was really too old to be doing this.

Until I got to be thirty-five, so I was a very late bloomer. I mean I know people who at twenty-five had more aims and goals than I had. At thirty-five, late bloomer, I decided it was time to begin a career of sorts.

At about age thirty life gets real black and white, specific ethics, right versus wrong.

Others said, "Yes," or more often, "Yes, but...."

That was one of the early decisions that I wish I would have done differently in retrospect. I wasn't sophisticated enough to know what I had, I sold it, and I was thirty years old and I had a hell of a lot of cash....I was so anxious to get out [of the business with my father] and I was so driven and so certain that I could build an empire someplace, and I also knew that I needed a lot more experience. I was in my early thirties, needed seasoning, before I really could do what I wanted to do properly...I knew even then that I wanted to get very rich and I wanted to be very influential politically.

By my thirtieth birthday...it was the year I made partner and all my clients that I dealt with were billion-dollar corporations. So here I am a brand new partner, and one of the things I remember very clearly was wondering "Am I really this good? This is sort of the impostor syndrome, maybe I've pulled the wool over a few people's eyes...I'm as successful as anybody I know in the world, nobody my age is doing any better." And then it [trouble] started in my personal life....

[At thirty] substitution of energy for ability. Enormous drive, a non-analytical decision-making process, probably a need to call attention, probably a need to be stage center, yeah, seeking leverage....But leveraging of relationships, leveraging of markets, rapid growth of capital, and impatience with the time necessary for most people, a knowledge that if you didn't make a million dollars by the time you were thirty, you weren't ever going to make it. Well I made it and lost it two or three times by the time I was thirty.

[I was just thirty] and I thought, boy I'm really a genius, why do people work for a living, they should just buy companies and go look at a market and make a lot of money,and I must know a lot about [this business]. What an asshole I was.

Being Fifty

Other common times for measurement were the mid-fifties and later. Then many of these entrepreneurs had began to feel a compression of time and a diminishing sense of their ability to do many of the things they had dreamed of doing in their lives, and their decision-making reflected that pressure.

[In my business I observe a lot of] entrepreneurs in their late forties, fifties, early sixties. They make very rapid decisions, quick decisions, leaning forward, because they have that body of knowledge, that expertness that has come from experience. They also have, I think, another motivation, and that is they're more aware how finite their life is and they want to get it on, get it accomplished, because they recognize the life they have is a finite resource and it's running out. And I see that in some of our clients, like a developer doing a major project, the final hurrah for his career, but he's in his 60s, and maybe taking some risks or making some decisions that if he were in his forties would be entirely different, because in his sixties he's feeling the time constraints. I know my own perspective has changed dramatically, and it has to do with true recognition of your time span....It's a compression of time. Can't make that many mistakes...have less time to work with. When you're in your twenties or thirties you can say I'll try it for a few years, if it doesn't work [no problem].

I think the sixty year old *entrepreneur is captive of his experience. He's not going to do anything innovative, he'll make better decisions in terms of asset retention but not asset creation. At sixty you're protective, at sixty you keep your legs crossed....And it also has to do with energy levels and health. I don't think you can ever forget the importance of health in this whole process, because it would be so easy to give up....I don't have a concern with running out of time because I'm, obviously I*

don't have a sense of immortality, no. But I also know that I could end it. You should ask your entrepreneurs how they feel about suicide. As to whether or not it holds any fear for them....I'm feeling enormous frustration that I can't get things moving, can't get things started. And sure, you feel you're running out of time, but that's not a function of age, that's a function of resources. What do I do six months from now if something or a series of things still haven't jelled?

Damn right I would have *done things differently. Wouldn't we all. If I'd known at thirty-seven what I know at fifty-seven, it would have been a lot easier.*

I did very well *for a long time in business and then I lost some money and then I made some money and you know, that just goes up and down, but that's what you do. And it doesn't bother me much. As I get older it bothers me when I lose it but, because then you really can't go back and regenerate your financial statement, but it really doesn't make any difference as long as you do the things you want to do with the people you want to do them with, then everything else is sort of relative....It's like I tell my sons...you always remember the [times we went on a] fishing trip but I don't think you ever remember what you did the week before you went fishing or what you did the week after you went fishing, but you do remember the week we went fishing.*

In their fifties, many of these entrepreneurs had made or were making deliberate decisions to spend their time differently. For many of them, the business had become less important and other things much more important.

I've gotten tired *of the conflict situation, tired of some of the conflict and pressure and I have started really actively trying to figure out ways so I don't have to deal with the conflict. One of the things I've used the three others partners for is, I've said "Look, what I enjoy is putting deals together and I'm going to spend all my time putting deals together, and if somebody wants to sue us, you deal with it and if somebody's unhappy with their job, you deal with it, I'm not going to deal with it." So I'm insulating myself that way, and I don't feel a compression of time in*

terms of things I felt I had to get done, I feel it in terms of I'm not going to spend time doing things I don't want to do anymore. I'm either going to delegate it or ignore it. And I'm pushing now hard, I just made a decision not to live here full time, not too much longer, and [a decision] not to work seven days a week any longer.

You begin to feel that, you realize that time's running out and you begin to think about, "Well, what was my father doing when he was this age and what happened to him from that age until the time he died."...I want to get this time and get on with a few other things, I want finally to learn how to play the piano, I got to get moving.

I see an end of the road, and so I feel compressed, I don't know if I feel compressed to the point where I need to do more...I don't feel I'm missing out on anything because there isn't enough time to do it...when there are things that I like to do, whatever it might be, let me tell you I make time to do them.

I have a script that says I'm going to [get out of running my business and] teach the next twenty years. I don't have a sense of getting older or anything else. My sense of things is I've just got the most exciting and fruitful part of my life coming.

What I've said to myself, especially in the last couple of years, is "I've got a whole lot of things to do and I don't have a whole lot of time to do them." I've got to be very conscious about how I commit the next ten or fifteen years and maybe I need to take six months off and think about it, although I imagine in six months I wouldn't come to any better decision than I would if I spent half a day....Part of the reason I can ask those questions is the financial ability to sit around for awhile and not hurt while I think about that. If I was in a position where I had to get a job, that would take away a whole lot of options.

What I want to do now is very different than what I wanted to do ten years ago. Then I was still thinking in terms of building the business. Now I want enough security, which I have anyway, to be able to spend whatever years I have left doing other things besides working, like enjoy-

ing myself and enjoying life. Maybe in part that comes from the fact that I lost my father a couple of years ago, when one starts to lose one's parents you realize you're the next generation to go, and I have lost friends who have died, and so you begin to say, "Hey, you never know what life brings," and all I ever do is work, and I will never have done all of these other things that I want to do.

Feeling Trapped

Feelings of being trapped were expressed by a few entrepreneurs in their early- and mid-forties. They described feeling trapped by where they were and what they were doing, unable to decide to change things even when they seemed to have the power to do something else.

I always have different businesses going, and I always fail, I'd tried a garment company and a computer company, a business in Timbuktu. I've done a million things, I had race horses. [But] this company is at the point where it controls me, I'm stuck....I'm really lost as far as the fact that I know I'm trapped as far as right now because...I don't know, it would be like running away if I left....The other thing is I don't like what I'm doing, I never liked it....I'm much happier fixing the engine on my boat or something, but not this. I'm here, I like parts of it, it's certainly nice to have the money, but...well it's not that simple. How? Unless you can say I'm just going to walk and go back to Woodstock, but there is no more Woodstock, we're stuck as we are.

I feel trapped by the family business, by my job and to some extent by my own family responsibilities and maybe too [although I don't really feel this way] by my concerns for the well-being of all these others.

Financial obligations trapped some. Financial downturns scared others. Both strongly impacted their decision-making. Serious medical problems or significant personal problems, including divorce and deaths of family and close friends, also influenced their decision-making.

Almost lost it...*on the verge of going under....We got hit three things, we got hit with the effects of the recession...but we also got hit with, we weren't making good [business] judgments, we didn't have the right policies and procedures and then thirdly we [expanded too fast], we were trying to move in and fill what we thought was a vacuum...so I really let it get away from me [and then I started making better decisions]....*

I think we all go through life *thinking that we're indestructible and no need to worry about the future, everything is fine. Then I had open heart surgery. At that point I realized...I'm not indestructible and I really should do things a little bit more from a sense that other people need to know, other people need to get involved....that probably was a good warning really. You carry so much of it in your head because you didn't need to write it down. You knew it. And then you started to realize that there's a whole lot that goes on that's still up there that you have to find a way to share.*

I have now landed *[in success]. I am able to work twenty hours a week, earn two hundred thousand dollars a year, play golf, travel...I have my office on full automatic...I have all these bright people...and a whole series of events happened which led us to taking marriage counselling together and finally us breaking up....and we get robbed at machine-gun point, we get burgled, at my home, and that's a year apart almost to the day that happened. All of a sudden I don't feel so invulnerable any more, I mean I'm laying on the ground, the guy's whispering in my ear, "My partner's going to kill you probably." I don't move obviously, and I'm lying there trying to figure out how it feels when the bullets hit your back....I probably haven't really fully experienced that even to this day, I mean I'm such a controlled person, I put such a strong lock on that, I functioned immediately after that, other people were more upset than I was after it was over, and yet I know I was in harm's way there, and my sense of invulnerability starts to fall.*

The Effects of Change

The impact of change as a constant in their lives—of changing situations, changing cultures and changing environments as well as of

personal change—was strongly felt. They described decision-making changes motivated by a dozen different reasons—changes in the economy and in their industries, changes in their health and their relationships, changes in their own levels of perception and awareness and in their goals.

Their decision-making had to respond to changes in the regulatory climate. The effects of these environmental forces were enormous, on their businesses and on their decisions. They were perceived to be totally out of the entrepreneur's control and were most often described in a combination of anger, bitterness and resignation.

I think what's happening [to our industry] *is really sad, because it's very labor intensive. In the long run, if you talk about strategy, I would like to find an industry that doesn't have employees. That would be terrific. Nowadays with the minimum wage increases—Congress is talking about a minimum benefits package....The payroll itself is a small portion of the total labor costs, the majority of the labor expenses is in an area they call "payroll-related." The insurance, the workman's comp, all this stuff. You really can't do anything about it [and] some politician thinks it's great. You can't fire people. They always think that you are the bad guy. People think you're making a lot of money. But they don't know that you are keeping 22,000 employees with their families employed. The industry is really getting tough, but the good news is the players are getting fewer, so soon we have more [market share]. We have a good system and we can add to it without adding additional infrastructure, or we can acquire companies. And we can take existing locations and convert them to something else that works. So we have all that working in our favor, but the labor aspect and the government, the liquor [regulation] problems, it's mindboggling. But that's the nature of the business today. In the old days if you can get your food costs in control you make money. Now food costs are the least of my problems.*

It's harder to do business today. *And I don't think that's going to change. I think it's going to continue to be hard. We live in a really tough time for this country. We're destroying ourselves through our bureaucracies....We*

have a lot of ill-conceived laws that are being passed by Congressmen who pass them primarily to perpetuate their own positions in Congress.

There were industry changes.

There just isn't the military business anymore, but....A stumbling block to my developing commercial products is my way of thinking during years of doing business with the military. I don't want to spend money until we have the contract. I need to change that and to be able to take development risks without a contract. And since my cancer surgery, I have started thinking about what I really want to do the rest of my life. Decided to change markets, reorganize the management of the company, not work so hard, change my focus from operations to long-term strategy, and focus on my own finances and family. Have important investment decisions to make.

Some major changes are going on in the whole damn system [of the industry], so for us it's been a difficult time...I changed the objective because it didn't seem like it was a practical time to reach the objective. And I think that has to do with the giant gyrations in the industry, and right today it's more difficult probably than ever....

The value of experience today is knowing that you have to change. I have to change the way I spend my time, regardless of whether or not I sell the company now. The economy is forcing change, as well as my own interests forcing it. The challenge for the future is from the restructuring of this industry....I'm feeling excited about getting refocused.

There were business changes.

In order to build the company I had just bought, I had to change my entire way that I'd been doing things. I had to develop an ability to galvanize people, through whatever process, towards a common goal, and so I changed [completely]. And I learned some of the frustrations of operating a big company, you can't be the Czar, it just doesn't work, damnit....But once you had solicited opinions and given people the idea that you wanted them to get back to you and all of this, what some

[other company owners] would regard as nonsense, the force of the organization was awesome.

An important part of my job *[as new owner of this company] is being responsive to our employees, empowering employees. I want to diffuse all the decision-making through the line. It's been a patriarchal organization. It's been a plantation mentality here, where all the decisions were made at the top,.....It's very difficult for people to make that transition, they're scared to death to make decisions at the line level.*

There were personal changes.

We're going through this whole mid-life stuff *right now, the two of us. I guess we're at that age. We don't know what the hell we're doing, we're just drifting around...it's very hard, I think it makes the business decisions more difficult....we have gotten less involved in the business because of it and less committed to worrying about it...the business is definitely suffering from it.*

The process of becoming a more aware person, *becoming more aware of what was going on in the world, being willing to think about it, understanding my own nature as a human being better...had an interplay with my approaching decision-making in a more aware manner....it's sort of a meta-process, thinking about what you're doing instead of just doing it....For me it was, I think, the first time I ever realized that I could have feelings, that I was entitled to feel, and so it got into the whole bit of being aware of who I was as a person and it had a lot of effects on me.*

It was the toughest decision...*not clear-cut, but I just saw myself drinking too much and not giving a shit, so I said, "Hey, I got to make that change." I saw my own life sliding downhill...and I figured it ain't worth it, this side of it over here is just not worth it, I'd rather go someplace and be a failure than wait around with all the negatives. But one of the decisions that I made at that point in my life, which was the best part of my decision-making make-up, was that I said, "I'll never lie again about anything ever, I will never lie again." Because that's what leads to so much internal distress, trying to remember, first of all you feel bad about*

it and secondly you can't remember who you lied to about what. [The lie always surfaces] and when it surfaces it's the worst thing in the world. Really, a good businessman, the best thing he has is his credibility. [If you lose it] you may never recover it, all you've got to do is lie once.

Right now my goals *in life are a lot different than what they were before. They're real simple, just get my kids educated and take as good care of them as I can, and get them out there and get them comfortable, that's my most important thing, and naturally staying alive and living, and not having to go out and want to make ten or twenty million dollars.*

The easiest thing is to start looking around *and get excited about something and follow it, or create it, and I don't want to do that right now. I want to get my personal life in order too, that's something that during the whole business thing has suffered.*

Change was much on the minds of these entrepreneurs, from one perspective or another, and the on-going changes in their lives and of their lives were revisited again and again and again.

I don't like conflict, *I don't like confrontations, I don't like change. They're all C words. Yet I recognize their usefulness and I'm adjusting I think pretty well to their need and to the fact that there is good, change is good as opposed, most of my life, I mean, I try to structure my life without change because that's what I needed to do in order to survive and that's fine, I understand that but when that need isn't that great, there's nobody waving a checkered flag and saying the race is over, and now you can go on and you don't have to do that. So I'm trying to get away from that and to accept that change is positive, that it will lead to better things.*

I'm a creator of ideas. *But I wouldn't distinguish, react, accept or reject, mostly reject, other people's ideas. There's not a pride of authorship in the ideas—that's not where the ego is. The ego is in causing change. It's not pride of authorship, because if this idea doesn't work I'll have another one tomorrow that's better.*

People who see change as normal will be the people who are success-ful. Those who are resistant to change or try to keep things the way they are must fail because change is coming....When I talk about change I'm talking about fundamental things as opposed to technical things....that I'm really interested in mastering, it's life changes...I believe that you have to have this change in order to have growth. What I think I've discovered, which is not unique to me but it's something that I've proven with myself, is every time I've had to change—no matter how difficult it's been for me—what's happened next has just pumped me up to new levels. And I have this problem...that I'm always dealing with. "How much destruction am I allowed to sow for my own growth?" [For ex-ample, in ending the business partnership], the important thing to me was to get my freedom. I got my freedom and I introduced myself to another change, another growth cycle, and the change has been very positive for me.

Luck

Like change, luck also was a constant for these entrepreneurs. Virtu-ally all of them acknowledged the influence of luck on their decision-making, although some did so reluctantly, using an array of other words. They said luck and "timing." And "being in the right place at the right time," or "wrong place at the right time," or vice versa. "Flukes," "accidents," "breaks," "blessings," "existential sets of cir-cumstances," "the way the Good Lord does things," "that's life," "co-incidence," "lark" and that "it just kind of happened." Luck and just happening also could be bad, as in "it happened wrong."

Fully half of the group said of themselves, "I've been lucky." One said he "had been born under a lucky star," and another that

To be successful you have to feel lucky and to be lucky you have to think lucky. You'll be what you think.

There's an awful lot of luck in everyone's life.

The most common theme was that of being well-prepared for luck and of making your own luck.

I was lucky...*I was very lucky...real lucky....And you're just very well-prepared and that's just fundamental. You take as much of the guess work and luck out of it, there's always going to be an element of luck, but you really try to be extremely well-prepared.*

We've had very bad luck....*That was **lucky** in one extent...I think that you make your own **luck**....It wasn't **lucky** that I was invited...that's not exactly **luck**. It's life, it might have been **luck** except that I've learned from past experience...that it's a good idea...to be prepared. You make your **luck**.*

Often bad luck was the description for events the entrepreneur could not control—events that didn't just happen, but that he hadn't seen coming and couldn't have prevented if he had. Principal among them were economic environment events which could have enormous impacts on his decision-making.

Whether there's [more or] less *economic benefit derived from the exercise is so frequently the luck of the draw. I mean you open a restaurant today [for example] and do everything you did five years ago, you're not going to be nearly as successful today as you were five years ago and nothing [you're doing] is different. It's just a matter of the luck of the draw—when you happen to be born, when you happen to be able to get the first amount of money.*

There's something which is completely *left out of the [how to manage your business] literature, which just boggles my mind, and that's the fact that so much of what you do is not in an environment that you're controlling, or is in an environment that you're not controlling. I'm not controlling any of these things. I'm committing acts that have certain consequences—and I'm probably not even controlling them.*

You can do a great job *and have bad timing. It's luck. There are too many things out there that you just have no control over and you have to accept. Luck! Like, try to do a bond offering in this market, who could*

have predicted that Iraq was going to invade Kuwait and throw the whole bond market into a tizzy. We thought we were going into the strongest bond market we'd seen in the last three years....There's luck and there's timing and all these things that you don't have control over. But ultimately you do have control, because you have the ability to deal with these issues, not panic, mitigate their impact, and go on with it.

Luck *is just when you roll the dice. The more you roll, the more the chances you'll get a good roll....The more you play, the more your chances. So, when people say you make your own luck, that's what they mean. And yet there is something called luck. Like here we go out to sell a convertible debenture for the company, everything's going well, our earnings are in the right direction, I managed the underwriters...well, we go out and something crazy happens abroad. Now that's bad luck. That I couldn't account for. We finished it, but, that's bad luck, I mean I don't think that was fate...it was just one of those stupid things. You know it happens.*

Success

Many entrepreneurs felt the happy influence of success on their decision-making and thinking, and guided their decisions by what they felt were the keys to their success. Some of the keys were:

Maneuvering, *finagling, playing the game and the system...*

Having people *like me and help me...*

Being strategic *with people, that's the added value...*

Catching *the rising tide of the market...*

Having *excellent people skills...*

Standing up *for what you believe in...*

Being happy *in what you do...*

Seeing change as normal...

Being curious as hell...

Keeping your focus on making money...

Being self-aware and being at peace with yourself...

Doing what you like to do and being challenged.

In economic terms and company terms and in terms of business achievements, these sixty entrepreneurs were highly successful people. Given their business achievements, their definitions of success and its guidelines for decision-making had to be economic in some measure, if only in terms of keeping score. But in our interviews very few of them defined success by the size of their company revenues or the quality of their belongings, or seemed to be guided in their strategic decision-making principally by economic measures. What many of them said, instead, was that they measured success in personal terms. And for many the definition of success was also the key to their success.

Watching and helping young people and businesses grow...

Doing what I set out to do and developing a strong team...

Freedom and independence...

Doing what you want to do in your life...

Bittersweet feelings about their economic success were contrasted with their own personal definitions of success.

I don't consider this very successful. I am successful by the outside world and if I had real high motivations for status then I'd probably be happy. But I'm more internally driven, so to me when I say I've sold out

[it's true]....The other thing is, it's funny when people talk about success and brilliance, because the two have nothing to do with each other.

Many people would look *at my resume and career as a success story. But I can't say that that's the way I lived it or felt is, although I think it's worked out, I feel very fortunate about the way it's working out. I feel better about it in almost every way....I'm really enjoying working with these guys [in my company], moving things forward, being able to see these opportunities, and we may in fact make the ten, twenty million dollars coming out of this thing, in fact it's looking quite plausible but I'm just not focusing on that at all.*

[My great economic success], *that's in the eye of the beholder. I really do feel successful, I've probably gone a long way for a small-time guy from the midwest. I haven't gone as far as a lot of people. [What I'm saying] is last week's achievements don't feel like success. It makes you feel good that you don't have to go to the bank and borrow to pay your rent....Until you put things in perspective and look back and think how many people, how many wage earners there are and you're talking about being in the top point zero zero one percent in the whole world. And then you begin to get, that puts you in, if that's success...[but] I think that if you're at peace with yourself, you're successful. If you're not driven by demons when you wake up in the morning and you've got to have one more success or today isn't right for you, or you've got to make one more girl or your sex life isn't right, you know all those kinds of things. Those are the people who really haven't come to grips with themselves....If you're not really self-aware then you're not really a success. And so in that regard I certainly am successful. When I wake up in the morning I feel like it's okay, you know I've got some things to do that I still like to get done, and that's a challenge and so that's a success, and financially I know it's there and emotionally it's there. I reach over and I've got a woman that loves me sitting by me and I've got a kid that loves me down the road, and a lot of people around the country who profess they do, and some who don't but that's okay I can deal with those too....So I think success is, somebody said that success is doing what you want to do and making a living at it. And that could be, that could be, maybe*

doing what you really like to do. To me as long as there's a challenge out there and it's fun and exciting. The time I get worst, and boy my wife can attest to this, the time I get in trouble is when I really don't have anything to do, there's not any excitement, there's not any challenge, so to me I'm a success if there's another challenge out there and I can win it.

Realizing somewhere along the way that a purely economic definition of success was not right or not enough for them was a wake-up call.

I took what they said to mean exactly what they said, that it was a meritocracy, I put my head down and my butt up and I drove, and I remember fleetingly along the way some of my compatriots saying "Geez, don't you ever enjoy anything?" and it never even entered my head, I was achieving, I was getting promoted, I was getting raises that were as big as my starting salary, it was incredible stuff. But I wasn't, I didn't know then that there were other ways that I could be learning or being successful....and [I learned from the members of a peer group] they were showing me there was another definition of success,out of their freedom and independence and I wanted to experience that....You must be happy in what you do or you can't be successful in the way that I use the term successful.

One spoke ruefully about making bad strategic decisions in:

This great envelope of success, where for years there was enough buffer to take up the slack so it didn't matter.

And once out of that envelope, when the buffer was gone, when the bad strategic decisions did matter, and when they had turned his incredible financial success into bankruptcy, he spoke eloquently of what he had missed in success.

What didn't I get out of fifteen years of success? Well I didn't go to Europe once, I really want to go to Europe, I didn't get to read much history, I didn't get financial security, I didn't make any friends particularly, that type of stuff....And I was trying to think, well if I were going to

do it again, what sort of things would I want to get from success. They will be different than last time.

Failure

A significant number of these people described the sting of failure as the greatest influence on their decision-making and on their learning. The lessons of failure, most of them said, were the most powerful influences of all.

A noteworthy exception was the entrepreneur who said:

> **I'm sure I made some wrong decisions.** *There were decisions I made in terms of pursuing certain products that failed, both because of misjudging the marketplace or the availability of the technology. I would guess there were probably more failures than successes, but I tend not to dwell on those. Because I feel that there are too many of those, and you can learn more from what you did right than from what you did wrong. I don't think you can learn more from failure. If you dwell on your past failure, all it teaches you is how to fail. And perhaps how to take it better.*

This group of entrepreneurs used the word "failure" often, and didn't seem spooked by the word or by applying it to some of their own experiences.

> **I learned a lot,** *a lot of stuff is like bravado and sooner or later you're going to lose. I've lost plenty. I've lost a lot saying "Let's do it," and you lose. I don't like losing, but I've lost plenty. I've failed a lot. That's where I believe you really learn. I think the key to growth is failure, and I think you should also call it failure because a lot of people want to change that word, "Well, it's not failure, it's a learning experience." No, it's failure because that's what it is and that's the word you should use. Anything else is a rationalization. You need to fail, people that haven't failed, you don't need to fail as much as I have, but I believe that people need some failure.*

It failed. *From a financial standpoint it was a failure, from a learning standpoint I also thought it was a failure.*

The fact that I didn't sell it *earlier suggests that I was not able to carry my plan out. I think I would label that as a failure of my plan because that is my nature. That is the way I operate. I build these companies up and I sell them. I built this one up, I had some problems with it, I've built it up again. I haven't found the opportunity to sell it, and I think that's a failure of my own. I had that as an objective—and I still do, over time.*

I've had lot of failures, *but none that has put my business away. I failed three times at [trying to set up] the commercial department. It never did make money, lost money, lost, I changed managers in it I don't know how many times.*

They and others of the entrepreneurs also used other words and phrases for failure.

We missed the mark...

I took a bath... *killed me, really awful...*

That *also turned into a disaster...*

Everything *happened wrong...I was totally destroyed...*

It dissipated *a lot of assets...*

I've learned *from less-than-successes...*

All was lost.

Powerful lessons aside, nobody liked failure, nobody was proud of it. It damaged not only bank accounts and egos, but occasionally reputations as well.

I really hate to fail. *It's the only thing that really paralyzes me, to think of myself as a total failure.*

But thinking that with my ego I could cure all, real quickly,...I took [my] five million dollars and I only owed a million and a half, and tried to do another transaction again after that, took all my personal assets, because my ego was so big....[and lost it again]...I'd pay these people every month just to stay out, because I wouldn't go into bankruptcy....And paid off, I mean I have spreadsheets, and paid off and paid off and paid off....but still having the reputation that I don't pay, that I'm going to screw you...I think that's probably the hardest thing that ever happened to me.

An entrepreneur quoted an old Asian proverb that said for every success there are nine failures. It's knowing how to get through the failures and move on that really makes it possible to have the one success.

I have only one entrepreneurial success in my life, only one [the company I sold]....I've got a number of investments going on, but none of them are at the stage where they can be judged a success, and I've had a few failures. But if the ratio of one in ten is right I've got about five or six good sized failures to go, before I get to the next success, and this is hard. I'm at a point where I'm a little frustrated, because I'd like to think that I've learned enough that the success rate can be higher than one in ten or something like that.

The most common theme for these entrepreneurs was to say "I failed and I learned from it."

I think you really learn through your failures. You don't learn through your successes as much as you do through your failures. And that was a real failure. I mean we almost went bankrupt....A lot of intuitive decisions were made in there and a lot of products didn't work. A lot of market research should have been done that wasn't. [It had] a tremendous failure....It was going to be wonderful, but....If I'd sold two more of them, I would have been bankrupt. Every time I sold one, eventually I had to buy them all back. Really changed the way I made decisions.

The opportunity had come to go into the manufacture of a product. At least it was one of the times I did go into a product and put my own name on it and put it in the market-place and it failed miserably. It was just ridiculous. It was stupid and that's it. Well you know you learn....Probably if I think about the things I've done, I'm probably a risk-taker, but I don't think I am. I didn't feel this product was a risk. Well maybe I thought it was a risk but I didn't think it was going to have a downside.

I eventually knew, I eventually learned, that it was very hard to do a small business and the deal we did here [about ten million] was really as small as you could possibly do because nobody will talk to you otherwise. Nobody can make any money. [I learned] because I failed so many times. Trying to do small deals.

The lessons of failure strongly influenced their future decision-making, said these entrepreneurs, and it taught them things about themselves that they might not otherwise have known.

I didn't make any of those decisions. I was numb. I've seen it since—there's something that happens to you when you're really not doing real work that equates to real money for a long time...you lose your virility, you lose your belief that you can throw the ball. You've been envisioning throwing balls. It's just like the difference between watching TV and doing something. It's a very odd thing that happens when you float there on top. I went through almost seven months of feeling like I had fuzz in my head. I couldn't make decisions. And it wasn't just depression, I was sort of depressed but wasn't nearly as depressed as I was going to get. Because I didn't realize how bad it could get, but what was wrong was I had gone so long without really controlling something, really controlling it. I turn it, it turns...I turn it, it turns. I'd gone so long without that that I didn't know how to do it. And people made most of those wind-down, to a point, decisions for me, the layoffs were done by others...I couldn't face any of those decisions. After four or five months of not making decisions really, but watching something die and not knowing what to do, I knew I had to try and get work [for what was left of the company]. But I wasn't even sure anymore about how to do that....I wasn't making

decisions. I was still in this mode as if I'm running a larger organization. But that rapidly wasn't happening. The layoffs finally took us down to fifty people, we're doing two hundred thousand a month and finally the VP Finance said "You gotta declare bankruptcy" and somehow that woke me up. I discovered...that I didn't make decisions particularly thoughtfully, and I never ever understood risk. And I honestly think just today I have a sense of understanding risk. I never had an idea of how much risk I was really taking, not for an instant....I never had any idea of the downside, even though in my business I'd helped other people get through downsides.

The decision-making of these entrepreneurs was influenced by all these lessons of early experiences, success and failure and change, and by all the other people and events that occurred in their lives. And it was influenced, as well, by their active efforts to learn and to improve, by their proactive learning about themselves, their businesses and the people close to them, and about things that simply interested them.

Learning

A deliberate, active quest for learning was a common theme among all of these entrepreneurs.

Today good decisions depend on how much business knowledge you have, including what you know best, which for me is the financial management. I get it from as many sources as I can.

I just got a high school education, I never did go on. I just had trade school and then I worked nights for ten years. I wasn't really exposed to a lot, so when I got into [my own business] I felt like I had learned everything the hard way. Now [I work at learning]...around the kind of people I want to be around so I can learn something about business instead of the way I had been learning it. I've even thought about going back to school.

The way I've run my life so far is I want to see as broad a spectrum of things as I can and understand them. The more I understand the more I

can relate it to other pieces of the spectrum, the easier it is to move on and to employ serendipity and to say I know something about that let's go do that....So knowledge for me was to be able to appreciate what was going on around me. But one of the strong secondary motivations was to be able to talk to whomever I ran into about whatever they were interested in. It works, so far anyway....I just wanted to learn, anytime I wasn't learning I said to myself, "What am I doing here?"...I always want to learn as much as I can about as many things as I can.

It's a process of learning. You're always learning. The minute you stop learning you're going to atrophy, so you continually have to study. You have to read, to look at the market place, to understand where things are...what the trends are. It's certainly more complicated today than ten years ago.

Forgetting business, I have hobbies and interests that I get into, every two years or so. I can learn enough about it that I know that I've now reached a certain point of knowledge about it and then I move on to something else.

I've always read voraciously. I would study the particular specialty of each business and read everything I could find, that I could lay my hands on. What they were working on as well as the management material and everything else.

Learning all that stuff took time. I really went at it [consciously and deliberately], watching and listening. I took extension courses on how to manage your own company, and in fact I'm still in contact with a couple of those professors today....I just absolutely soaked it up like a sponge. And you know, where I did not do well in college before, in these courses nothing escaped my attention you know. Pages of notes and I knew it cold,...so I felt like I was kind of ready.

I try to do reading. I listen to other people. I look around. You start thinking about things. I try to keep myself abreast of how other people think. I look at them. I think about them. I watch them.

I continually strive to reduce the areas of ignorance, to acquire more tools....I'm honing my criteria for selecting things or rejecting things....and I've recently learned to fly.

The lessons of their active learning had to do with every facet of their business and personal lives, about anything they needed to know or wanted to know. Along with the lessons of their experience, the lessons of their active learning influenced better decision-making.

What I have learned is, and I know it, and every few years I have to remind myself to learn it again, is that I'm best when I understand what I'm dealing with so that I can influence the outcome. It's the difference between gambling and a game of skill. And I certainly feel more comfortable in games of skill and my experience in history has been that I do far better in games of skill.

SUMMARY: THE INFLUENCE OF EVENTS

Among these sixty entrepreneurs, the recurring themes of influences on their decision-making were the influence of other people—including management teams, partners, peers, mentors, friends, family—and the influence of other experiences and events.

Among the other influences described by the entrepreneurs were having worked from very early ages; having had management experience in larger organizations; measuring oneself—at about age thirty, against their perceived standards of where they should be in life, and in their fifties, against what they still hoped to do with their lives in their compressing time; experiencing life-changing events that they could not control; achieving notable success and especially suffering notable failure; being acutely aware of and strongly impacted by the constancy of change in their lives; being lucky; and being committed to their own active, ongoing learning.

External influences that they mentioned included: athletics, culture, environment, financial problems, being fired, family businesses, medical scares, psychotherapy and timing.

What was important for their decision-making and decisions, and therefore to the quality of their lives, was their awareness and then their responses—both proactive and reactive—to the opportunities of their lives. Were they able to accept and welcome the influence of others, had they learned the lessons of mistakes and failure as well as of success, had they learned from change?

One of the entrepreneurs said that good decisions are made out of opportunity, out of a feeling for opportunity, as opposed to a feeling of fear. Feelings for opportunity are responses that are accepting of influence and open to learning from change, that seek influence and welcome change.

In the rhizome, growth occurs opportunistically. The rhizome responds to opportunity by seeking it, to barriers by finding other opportunities, to change by changing. Whether it is crab grass in the lawn, a vine working its way up the wall, or mushrooms popping out through weaknesses in the ground. Or whether it is an entrepreneur's thinking and strategic decision-making.

11 ✒

Hitting the Home Run

My family had been in construction so I had some experience. I had a two year head start while I was still in college. I was older coming out of college and going to get [my first] job. I started at a lower level, as sort of an office manager. Then I put in some time as a project manager and cut my teeth for a couple of years and then very quickly jumped up to being the vice president of contract administration for a company which was doing $100 million a year. They were an international mechanical electric contractor.

I could do a linear projection. Simple methods of feedback in measuring how much pipe or how much wire or how much concrete or how deep a hole you're digging could translate into a rough approximation of where the thing had to come out. No one was doing stuff like that. If you could predict these things as a project manager then you could be a better estimator. If you could predict profits, you could be a hero.

I made a decision to take a very large project which they offered me, a grass roots refinery project. I was the project manager for three [large]

segments, which were about forty million dollars. [In all, it] was about two years of work. We went from zero to six hundred people in [a few weeks]. I was two and a half years out of school. I felt like I was stepping into the big leagues. My fixation was on hitting the home run. It wasn't on money, particularly. I went into it very naively, which is much of the trademark of a lot of my career.

One of the reasons we'd hit such a big home run was I'd constantly renegotiated the contract for this refinery to keep the revenues way ahead of us. It was a sort of a no-surprises philosophy. Prior to that I'd worked on Navy contracts in ship building, so I had a lot of experience. They put me into that role.

But I did hit the home run. We made tons of money. I sat back and felt the click of the bat and watched the ball go over the fence. And I didn't even get a bonus, though I did get a promotion about a year and a half later. It was a big promotion. The company went [public] and...needed a vice president of contract administration.

I found myself at twenty-seven in a job which was even more significantly over my head than the construction work. At least with the construction work, you eventually build something.

[This] was a company that got into a lot of trouble. Construction companies aren't really businesses, unless they have huge real estate holdings. Construction companies are a string of projects you happen to be doing at once. But people often confuse them for businesses, and try and apply [traditional standards of financial evaluation].

[This company] arose out of a sole proprietorship with a dominant patriarchal figure. But this dominant patriarchal figure was out of state. The company had essentially been taken away from him by his bonding company, which had tremendous concern over whether all of these [projects] were going to come out right.

This went on for a couple of years, and the company had received a very large government contract. In those days they were putting in large bulk mail handing facilities where they were going to push packages through

these large facilities, real expensive computerized, no-people type of things. We had gotten a whole bunch of them, way too cheap. The major facility in the midwest was in Chicago. We were real low on the bid and they needed someone to go back and bail it out.

You could do all you wanted with cost accounting at the corporate level, but if we didn't cut the bleeding with this one there wasn't going to be anything to do. They said I had to go or I was out. I was living in the northwest at the time and I just said "I don't want to move." It was a pure family decision. It was hard for me not to go from the challenge standpoint, but if I was going to keep house and home together we weren't going to move.

I was raised in a very unstable family and was very concerned that I might re-enact that. So it was not a complicated decision. I had three children. We weren't going to move halfway across the country. I had earned some bonuses finally, so I had a little money. I think it was twenty thousand dollars. Some princely amount.

I was less than thirty. I looked around for work for about three months and what I found were situations that were as constricting, or more constricting, than what I had had.

In those days, most construction companies were owned by patriarchal figures. I probably could get a job with two or three of them, but it was a job where I was going to have to step and fetch it. And I didn't like it. So I thought I could do what almost all unemployed people try and do now— become a consultant. I went to [my former employer's] bonding company, which had a lot of faith in me, and said "I'll bet you've got other problems. And I'll bet you would like someone to go look at those problems and perhaps either negotiate settlements, help solve them, finish the jobs—whatever you'd like. And I'd like to do that for an hourly rate."

The [bonding company] bought into it and gave me my first couple of assignments. This is one of those things that happens wonderfully. On the first job, they had a five-million dollar loss they'd already written off. We not only didn't have a five-million dollar loss, we had about a half-million dollar surplus. They were very happy.

Then I got locked in as a consultant with a company on a very large hydroelectric project. It was one of these things with about a total of about a thousand miles of transmission line strung side by side over two hundred and fifty miles. A huge dam at the top and cost overruns in the seven- to eight-hundred percent range on everything. A municipality had written the contract and it was terrible.

They called me up and the chairman of one of those companies—an old guy who later sort of became my [mentor]—hired me as his trouble shooter. That engagement resulted in about ten follow-on assignments over the next several years.

From that occurred a series of engagements which lasted ten years. I was doing work and throwing myself into my clients' problems and I ran into other construction management consultants who were doing this.

Most of those guys were retired engineer types. Most of them were in their sixties, and had spent their entire lives building projects. The way they did their work was with number two pencils and thirty-six column pads. [They'd] do little models like "What would happen if the mud hadn't hit?" or "What would happen if the trench was dug properly?" or "What would happen if there wasn't sand in the tunnel?" They'd work out these, page after page at thirty dollars an hour. I felt there had to be a way to use a computer to help me do this work. On a lark I bought one.

I had a problem that came up, a problem involving a large construction project. The project involved transmission line steel, great big towers. Each one of those towers was made up from between six hundred and a thousand pieces of steel bolted together. The steel was manufactured in six different plants around the world and sent to this place and each of the tower sites is on the back of God's head somewhere. I needed to make sure [my client] got the right steel there to build the tower, otherwise [it would] lose millions of dollars. So, I built a computer program. I wrote a database manager to find out where the steel was manufactured, where it was shipped, when it got to the yard who checked it....

That worked and we achieved good settlements. But I got really into the idea of taking this tool and using it in any way I could figure out to help my practice. It was sort of a process of building a learning curve while getting paid for it. Up until then I really wasn't sure how much money I was making. I was making a lot of money but I wasn't sure how much. [That] is a little embarrassing for a finance major but it's how I was doing it.

I needed a validation. I don't mean a validation saying "I'm worth this much." I mean a validation saying "It really does work, and that's how much it works." As a consultant, I was haunted by a ghost which said, "What if you don't get another assignment? What if someone doesn't call? What if you don't impress a person at this certain time?"

This was a time when I had a growing family and we were living on the edge of our means. I was earning $150,000 a year. It was a lot of money, but there was a haunting feeling that said, "Boy, you sure are lucky. How does this stuff happen?"

My father had been a very dynamic successful businessman. He was the vice president of [a large construction company] when he died. That's what business had been to me. Business means General Motors, people with real balance sheets.

I felt like I hadn't been part of a business. There was something compelling about [doing that]. So I began looking around for ways to cut some of the risk of not getting work or just getting into a mess. I very consciously said, "How can I be a business?"

[About that time,] I got involved in an engagement that again had a lot of paper in it. I was brought in by a bonding company. The scenario was all the same. And I said to myself, "I'm going to give this guy the construction consulting he needs...but I'm going to manage the documents in this case. I'm going to start a company to do that."

If you could keep track of all of the paper, you achieved your goal. Most people did [this] with pens and paper. I computerized it. The thing I

[stressed] was that [the old guys] would go at this stack of paper with a preconceived notion of what happened. And the ones whose preconceived notion was righter than it was wrong would typically win.

I said, "If we're going to spend the money to go through the goddamn thing, why don't you find out what's there? Then come up with your notions?" We knew what was in the documents, they didn't. They [would say] "I've got five pieces of paper." In the old negotiating world that would blow you away because you'd only have four. But I'd say, "Okay, let's talk about this one, let's talk about that one." Then they'd adjourn the meeting.

But I would still be ready. I'd say "You can adjourn the meeting but we need to be back tomorrow." We were just better prepared. I was aided by the fact that I didn't have years of experience to weigh me down. It was just a logical approach. I didn't know any better.

I started building the document management firm. I brought in a partner [because] I felt I needed a lawyer...to address the legal field. That's where much of the document handling went on. So I brought in a lawyer who was very computer-literate. He was a theoretical physicist who went to law school. I put up the money and had the idea. I made him a sweat equity partner. We wrote a contract I think in three or four days. Over a two year period he became a fifty percent partner. That was a mistake.

We were very successful. We shot up to six hundred thousand dollars a year in sales. We had a couple of great clients. No one had ever heard of this type of thing before. Our clients felt like they were in someplace in the third ring of Saturn, they were so far ahead of everybody.

We kept growing, which was a new thing. The consulting business didn't grow—it hit a nice little plateau but it didn't grow. At the document company, we did two-hundred and fifty the first year, five-hundred [the second] and then seven hundred [in the third]. [My partner] and I were taking out a-hundred-and-fifty or two-hundred each...real nice.

But we were making it up as we went along. We couldn't sit down and articulate why we were successful. We didn't know if other people were

doing this. We just did the work. We didn't even pay any particular attention to business details. We paid our taxes, that's about it. Well, this all went fine until the work stopped coming. [A big] case settled unexpectedly.

We sat around one day and my partner was grousing about the work not being there any more...things like that. And I was getting a little tired of [it]. I was the guy who used to get the work. He was saying, "I'm tired of being an inside guy, I need to be an outside guy."

I did a real stupid knee-jerk thing. I said "Okay, you son of a bitch. You get the work, I'll just sit here." And I did it. Revenue went down, low enough to where we weren't going to pay ourselves any more. We sat in the same office for years, literally in the same office, looking at each other.

Either we were going to sit and watch him pout and everything I'd worked for was going down the tubes or I was going to have to act. I didn't know how to approach him. A friend of mine suggested that I try it in writing. So I ground out draft after draft of what I wanted to tell him until I got one that I [liked].

There's this "Don't make a decision until you have to" impulse, especially if [the decision] relates to an emotional element. But I couldn't put up with the injustice that was building up. I'd gone through a divorce and that was a reasonable precursor to what was about to happen in the partnership.

Finally, I said, "We've got to change the partnership agreement. [It's] going to be changed like this: You're going to get so many points for bringing in work. You're going to get so many points for billing an hour. If you want to negotiate these points, I'm here to do it with you. But if you're not willing to concede the difference between the two things, then I am going to pull the string which you wrote into the contract agreement."

[My partner] had written a spring-loaded trapdoor clause that said if either one of us want to pull it in thirty days it must dissolve. He balked and held out and I pulled it. We separated. I wrote a note to him. It turned out the note was worth a hundred and fifty thousand dollars. It was based on certain things happening—I'd pay him out of earnings. So I started from scratch again.

This is another area that has just really killed me in the decision-making process...having sort of a childlike belief that somehow things are going to turn out all right. A lot of times they haven't. I convince myself that the natural forces of people and nature will make things work out okay— but a lot of times they don't.

When you're making it up as you go along and are economically successful, you presume you're right all the time. It's a real impact on the decision-making process. You make very different decisions when [you think] you're always right, and you often don't make correct ones.

When I started up again, it was hard. We didn't have any cash. I had no arrangements with the bank. I had to live off receivables. I had to make a payroll. But I was able to attract enough work to take us from fifteen thousand a month, which was where I took over the business again, back up to fifty or sixty thousand a month. In four or five months, I landed a couple of projects.

The company was at about eight hundred thousand or a million a year. And maybe a million-two a year later. In my head, it needed to be business and that's all that counted. I studied business—it sounds funny but it really is true. I read magazines about business and was always turned on by it. We designed a good logo...things like that. During that time, one of our largest clients got into a lot of [financial] trouble.

When their default eventually came, a New York law firm flew in and everyone's looking around for litigation support. We didn't call [what we did] that in those days, but we said "Well, we're one of those. In fact, we've been doing it a long time." We got our first look at people who did it on the east coast that did it mostly for the government. And they only

did a little subset of what we did. They didn't provide all of the document management services and types of expertise that we had.

They came to town [and] didn't even talk to us. They hired some bozos one big eight accounting firm to do work on one side, and a bozo from another big firm to do the work on the other side. I got scared again. [But] what goes around comes around. We ended up taking over one whole entire side of it because the big accounting firms fell apart. Somebody had to come in and bail them out.

During this time, we also got a contract [for doing litigation support related to] a huge commercial fire. It was more work than I could do. I began to realize I didn't like to work quite this hard every single day of my life, so I started a serious process of trying to learn how to delegate.

I had succeeded in putting together two young chaps who I was convinced could bear the brunt of operations by dividing projects between them. I decided that we were going to try to work in another big city. I thought, "If you work there, you've got to be there. You've got to have an office there."

The way we were running our computer in those days, if you've got an office there, you've got to have a separate computer there. If you do that, you're going to have a parallel staff there. I'd been reading a lot of business stuff, and in those days decentralization was in vogue. I thought that the best way to build inherent success into this was to take one of these chaps and move him down there. Leave one where he was and let them compete.

Not knowing which one would take it, I offered it to both of them. One of them said he would do it—the more ambitious of the two as it turned out. I knew that if we were going to open an office in the other city, I was going to have to sell those projects. And I didn't know how to approach the people down there. I went there and made about forty different presentations in three months. We got fifteen to twenty million dollars worth of work.

The idea of having two offices compete crumbled almost immediately. The guy who stayed where we'd been couldn't get any work to match the new location. We couldn't do all of our work in the new place. We had to send it back. Finally, the guy who'd stayed put quit. I made the guy who'd moved with me general manager, way over his head.

I wanted to eliminate the fear once and for all. Of not getting work. I think it had a lot to do with that. I wanted to hit sort of a series of ultimate home runs and then I wouldn't have to hit the home runs anymore. I had a belief that if I could sell enough to build that critical mass then it would begin to function and drive itself. I was wrong. There is no such thing as critical mass. It's just like construction companies, you're only worth the jobs that you have.

[I made some bad decisions] because the growth was pretty exciting. I was still getting things and doing things that I had never done before—staying at fancy hotels in New York and making deals is pretty exciting if you haven't done it before.

But the critical mistake in all of it [was] lack of experience [and] perspective. I don't mean super-adult type of perspective. I mean even often the type of perspective you might see in a brighter young business student who says, "Well things are going pretty well now—but do you know where we stand in the market?"

I wasn't asking any questions. I got the work, I did the work, and it was sort of like eating chocolate that was real sweet.

By then, we were going to do close to fourteen million, 240 full-time employees. I had vice presidents in charge of everything. I had six people who are earning over a hundred and twenty thousand dollars a year working for me. I had something over a two million dollar net worth. I was 43.

There came a point I wasn't sure I even wanted it to grow any more. I was going nuts up and down the coast every week, big contracts and big problems. We acquired a big line of credit and used a lot of it. We took on

two long-term leases. We had three full floors—two in one office tower and one in another. Desks for everybody. Macintoshes, we had two million dollars worth of computer equipment. You know how fast you can spend money on that.

I found myself saying, "I hope we reach the critical mass soon, because this is worse than when I was a consultant." Then, suddenly, 80 percent of our revenue settled. Cases settled or ended for one reason or another. They just ended.

It all came to an end pretty quickly. The guy I had promoted to vice president and general manager burned out the summer before [the problems started]. He was acting like he was on drugs. He wasn't, but he acted like [that] the entire fall. Finally, he walked in when I came back from vacation and said "I quit."

We went from a million two a month to two hundred and twenty thousand a month in three months. The bank watches this happen and they're pretty dumb but they're not that dumb. They start getting antsy. Then, we stopped making rent payments because we were conserving cash. We still had a couple of million dollars in the bank, mind you, but we had big ongoing liabilities.

We had such high fixed costs. We had to do seven hundred thousand dollars in revenue a month to break even. And I had a VP Finance who'd pulled a business through a Chapter 11 before and he'd seen these things and he knew what to do. He understood hoarding cash and telling people, "Everybody stand back. I don't know if we're going to come through this one." He was terrible on the other side but he was great on that.

[Other] people made most of the wind-down decisions for me. The layoffs were done by others. The woman who was our human resources vice president was a walking goddamn miracle, a fabulously effective person. I didn't make any of those decisions. I couldn't face any of those decisions. I was numb. I was in this death spiral emotionally.

It's a very odd thing that happens when you float there on top, not having to do work. I went through almost seven months of feeling like I had fuzz in my head. I couldn't make decisions. It wasn't just depression. I was sort of depressed [but not] nearly as depressed as I was going to get. I didn't realize how bad it could get.

The layoffs finally took us down to 50 people in March. We were doing two hundred thousand a month. Finally, the VP Finance said, "You've got to declare bankruptcy." That woke me up. He said, "You're going to put this company in Chapter 11. And you'll probably have to go through two." That hit the bullshit button right in the center.

I went away to think. I came back furious. I went back to the home office, where [the finance guy] lived, and said, "Look, you son of a bitch, I ran this company for ten years on eighty-thousand dollars a month in revenue. And I made three hundred thousand dollars a year. You aren't going to tell me I can't make this thing pay. You're crazy."

I then went to my lawyer. This is the point at which I started taking charge. We started a holding action against the creditors. We were plain and clear with all of them: We can't pay...it may be five years. But, if you guys step in and shut this thing down, I'm just going to pull the plug on it.

I pulled my people around and said "If you're going to leave, leave now. We're going to try and keep this thing going." That worked with everybody except for the personal guaranteed people—one building lease and the bank. I think it was a total of four million dollars.

I worked out a way to get out of the death spiral. I worked out a way to bring in a partner and start a new business up—use the old clients, no cash, because there was only one secure creditor and that was the bank. If I could satisfy the bank I could do this. We put together different permutations of how to pull it through, which included Chapter 11. Without any exaggeration, I have the diaries to prove it, every week and sometimes more often my lawyer and I reanalyzed the permutations.

And I finally became convinced that I was not going to pull the company out no matter what I did. I wasn't sure whether I was going to get through it or not, without declaring bankruptcy.

One of the problems was I needed some cash to get out. I didn't have any cash, so I got desperate and said, "Okay, if you're going to pull this out, you've got to come up with some cash. How much cash do you need?" The answer looked something like seventy five to a hundred thousand. So I got on an airplane and I went up to visit the guy who is my minority shareholder now. He had been an employee of the first companies that had hired me years before.

We'd established a friendship then. And I went up and said, "I need a hundred thousand dollars. I need a hundred thousand dollars under these terms and until I pay it back you get everything. If I die you've got to promise to take care of [my wife]. But when I give it back to you, you get 25 percent of the business." And he bought it—not easily because he is tight.

This [new partner] was willing to put up seventy five thousand dollars to the bank to take them out. Once they were taken out, the old corporation was put to death and I started a new company with no cash. We'd been negotiating an agreement for a month and finally they caved, we were doing some saber-rattling about something and they caved on the deal, said we'll do it but we've got to do the deal in 24 hours.

[Soon after that,] I was looking in Bartlett's Quotations, and I came across a quote which caught my eye. It was: "There are two things to aim at in life. The first is to get what you want and the second is to enjoy it. Only the wisest of mankind achieve the second."

And I said that's me, that's what I want. I decided that if I were going to do this again, which I had decided to do, that the company somehow had to be an extension of me. And the people who worked in that company were going to have to agree to that, that the people who used our services basically were going to be engaging us based on my contacts with them. I was going to be able to take on only so much work that I felt I could oversee.

I went to each of the clients and said, "We'll continue all of your work but our contracts have to have new names. I've had to bring in a financial partner. You've heard about [the old company's] problems. We couldn't get through them. Brought in a financial partner and as part of the deal I had to change the name."

I told the staff, "You're not going to get a raise for a year, maybe two. I can't promise you anything. You know me, and this is what I can offer. In return, I think you will make better decisions if you really know how the company's running, so in return the books are open. In addition to that, you'll get a bonus when we've achieved certain things. I'm going to tell you what I think we need to achieve."

At the end of all of this, I said, "Now go away and think about it because one of the things that is going to be crucial to starting us up again and being successful at this is that I'm going to have to feel like we got a deal. and I only want to remake these deals every so often." Well, they came back.

[When the troubles started,] we had 240 people. When it was over we had 17—a little tiny bit of work and three or four million dollars worth of debts. All the retained earnings were gone. I had nothing. We lost three to four hundred thousand dollars a month for month after month trying to keep it alive, paying our bills. There was no money left, the cash was all gone. All that was left was what we were bringing in on a monthly basis. The bank called all my notes, and had a guy in the office watching every nickel that came in and every nickel that went out.

I want to put a very serious caveat on this. Maybe because I can't stand the pain of thinking otherwise, I really believe all of these people acted in what they saw to be my best interest. I don't think any of them were malicious. The events that transpired could have been attributed to a malicious person.

I've been screwed by people who meant to screw me and I knew who they were. I knew it was happening. I don't always fight. I'll fight sometimes or I'll wait in the woods and hammer 'em good next time they

come around the road. I don't feel that way about any of the people [who worked on the bankruptcy], because I did say yes or no to all of the things which hung me. I didn't make decisions particularly thought-fully. I never understood risk.

I think just today I have a sense of understanding risk. I don't think I really understand it. I have a sense of it [but] I never had an idea how much risk I was really taking, not for an instant. I signed all of the papers, I did all of the things everybody says I did financially. But I never had any idea of the downside, again even though I'd taken people through downsides.

I'd made most decisions therefore in a perspective sort of the upbeat attitude of most business magazines. I always believed things were going to turn out right. So the process of going through bankruptcy and decid-ing to start up another company or make [my old one] continue was to strip everything away and start back at myself.

When the trouble came, I remember I was taking my family on a vaca-tion. The bottom was falling out and [my wife] is saying, "Maybe we shouldn't go." I said, "There's not a thing I can do about any of this. Let's get on the plane and go."

I went on vacation and I spent two weeks. In that two weeks, I started keeping a diary. I wrote a page to a page-and-a-half every morning. I review it at the end of the month. I go back over it and reread it just to think about the next month. The diary's both a personal diary and I also work on my relationships. I mention that because in reviewing my diary I find that one of the things that's been bothering me for years is that I dislike the people we work for.

We work for lawyers and lawyers are generally obnoxious people to be-gin with. They're unpleasant often dishonest people. Not dishonest in the great moral sense of the term but devious people—and manipula-tive. We provide a service which makes their work considerably more efficient. But we get no credit for it and in a way by doing it we're kind of living a lie, and the lie is this: They would do it themselves if they could.

They bring us in as a last resort or in an instance where they're forced by their client to do it because the client doesn't want to see them do it at a hundred and fifty bucks an hour. [One time, when I was complaining about this, an adviser] asked me:

"Well, who's your client?" I said the law firm.

"Who pays the bill?" An insurance company.

"Isn't your client the insurance company?" Yeah.

"Why don't you talk to the insurance company?" The lawyers wouldn't let us do that.

"I think I'd investigate that."

I went to [my staff] with this thing and said, "There's this whole claim side. These are the bill-payers. What do you say that I start trying to make a pitch to them?" Of course, the whole team said yeah. So we amended the strategic plan to include that. I believe in three or four years we're not going to work for law firms anymore.

I want to be able to enjoy the fruits of the business, and I would like very much to be able to enjoy doing the business for the matter of enjoyment, not the hit, something different between the hit and enjoyment. It's like in a way it's like the difference between seeing a beautiful rose and taking LSD, they're just two different things. I want to enjoy the rose, knowing that it has thorns and it dies.

I've become a quality of life idiot. I'm still pretty tentative and really recovering from failing. It may not change how I do things, but it certainly puts a very different angle on how I view this whole entrepreneurial process.

It really will [make me feel more comfortable] when I have some money in the bank. I haven't had money in so long—after having all the money I could spend—it's a strange feeling. I have finally subscribed to the fact that money is just the way you keep score. You've got to spend a certain portion of it first.

I have a feeling once I've gotten a couple of hundred thousand dollars in the bank [I'll feel completion]. My own estate plans are fundamentally just to keep putting the money away. My wife and I have a remarkably moderate lifestyle, which I like. [We have] plans to do something like live part of the year in a warm climate. And to go to Europe and to spend a summer in the south of France, in the cheap parts, the fun parts.

I really want to live those things. I want to see those things. You can't have those things unless you earn things that allow you to achieve them, and a business is a good way to do it. I am reaching the point very quickly [where I can take significant amounts of time off]. If I can't do that and achieve considerable savings, I'm not sure if it isn't better to scale back the whole thing. I'm 47...I know people who die at 48 or 49.

I'm tired of not having the money and tired of having stupid things that are out of my control. I'll feel better about this in a few months.

I have come through this and acquired people who counsel me in ways that you can rely on their counsel. I had none of that for years, and I pay attention to it. That's the first thing. The second thing is that I, through the diary and sort of monthly looking at life and planning, am forcing myself to keep long-wave cycle and scale and short-wave cycle and scale.

I used to make intuitive decisions, the idea was intuitive. The idea of the original computer I [bought], that was intuition. I used to think, well there's a reason, I don't use the term intuitive because I don't believe it. I think what we call intuition—other than sort of the new age view of it—is the sum of tremendous experience that comes in a flash.

Intuition is expertise based on experience but it exhibits itself in an un-formed way. I think all of this stuff they say about entrepreneurs is a reflection of inner values. In fact, I don't think they say enough about it. I think it's tremendously true.

I think businesses are very much the extension of the values and feelings and drives—some of them very neurotic drives—of businessmen and women who are entrepreneurs who can make the translation process [between an concept and value].

Because you can't really make something out of nothing you have to make it with sweat and effort and some luck—but mostly it's sweat and effort. And those ingredients are driven by these values. They're really only slightly modulated by the outside world. Only slightly. I've read this stuff for years and I've never even read it particularly well-told.

If you want to find out how to be a CEO of Exxon, I think you can do that. I think you can do that at Harvard Business School. I think you can find it out. I don't think you can find out how to run [a smaller company].

Today, I focus on being a manager. I'm a manager who has the advantage of always being able to go pick up a spanner wrench and turn the nuts and bolts—or at least show any client that I understand it.

When we—me, my core team members, my new partner—really carefully analyzed what it was we needed to put the same number of electrons through this thing...we decided we could buy used computer equipment whose total value is a hundred and twenty five thousand dollars. That was a decision that we figured out as a group. In about five or six meetings.

We had some incredible meetings—fear and anger and people almost got, did get, out of control. I let them yell and scream. In fact, we had one meeting that ended so sour that I got a call back from the vice president. She said, "You can't let this meeting end like this."

I said, "I think it's a pretty good way to end a meeting. Everybody's going to go away being real upset, which is okay. And they'll be back in a couple of days, let's have another meeting in a couple of days. See where that upset led."

No one had said anything untruthful. No one had said anything derogatory of other people. It wasn't that type of upset. And they did come back and solved the problem. It wasn't a miracle. It took a lot of work and has taken a real change in my style of managing people.

The [mission] of the business now is we are selective about who we work for, we don't work for assholes. Our aim is to turn down work with people we don't enjoy working with just to control the environment we're in. And to enjoy working together and to realize that the management job and our business together are the ups and downs. It's not the flat part, the flat part anybody can run. But it's always going to be ups and downs, there will always be serious endangerments to people's jobs, there may even be endangerments to the jobs of our core team members.

But we set up ways in which they earn enough money so they can put money aside for themselves. The understanding that we're in this to-gether we'll do it together. They don't get to tell Dad what to do...but on the other hand I'm going to sit down, and I really derive tremendous wisdom and we've advanced wonderfully as a group.

MAKE UP YOUR MIND

12 🐟

Purpose...and Personal Principles

The "how's" of decision-making for these sixty entrepreneurs included using varying patterns of analysis and emotion with the aid of intuition, as well as a variety of tools of the self at work and tools of working with others. They also included the influences of others and the influence of other experiences and events. As this group of entrepreneurs described them, these decision processes, tools and influences merged and overlapped with the "why's" of their decision-making. The "how's" of their decision-making were impacted by the value they placed on the arena of a decision, by the value they accorded to the processes and to the tools available to them, by the value they granted to the influences on their decisions, and by the value they placed on learning and change.

But also importantly, their making of decisions was impacted by their personal values. By "values" the entrepreneurs and I meant "principles" in which they believed and by which they lived. In a general

sense, principles include fairness, integrity and honesty, human dignity, service, quality or excellence, potential and growth, and patience, nurturing and encouragement.

The implications for decision-making we talked about, as one of the entrepreneurs correctly pointed out, were not simply those of personal values—but of personal moral values. Stephen Covey would call this decision-making "by principle."

> Principles are not values....Principles are the territory. Values are maps. When we value correct principles, we have truth—a knowledge of things as they are. Principles are guidelines for human conduct that are proven to have enduring, permanent value. [9]

The words with which these entrepreneurs described the "why's" of their decision-making included some of the principle orientations that they felt defined them and their businesses (such as being honest and taking responsibility), some of the goals they felt motivated their decision-making and their decisions (such as power or security), and some of the other forces that motivated them and their decisions (such as fear or opportunity).

Their salient words included: control, criteria, fear, feeling right, freedom, fun, helping, honesty, image, money, opportunity, people, power, pride, recognition, reputation, responsibility, risk, security, trust, uncertainty, values and world view.

The Golden Rule

With very few exceptions[10], these were entrepreneurs whose personal values, goals and motivations were admirable and understandable in the best tradition of the Golden Rule. They tried to make decisions guided by honor and honesty, and to make them in concert with the best interests of all of the various stakeholders with whom they worked and lived. They cared about doing the right thing for their customers, employees and families, and about doing the right thing right.

[As the] entrepreneur in a business this size, I'm pretty much responsible for everything in the end....Have I made the decision?...I haven't committed myself....That's all I want to do, I mean what I've done. That's about as far as I want to go. I don't want to have to keep doing that. I don't want to have to be responsible for it....Maybe that's my problem. I just don't want to accept the responsibility. [I'm] like an outsider in my own business.

Honesty, trust and loyalty were key decision values for this group of entrepreneurs.

I'm not going to lie...I shared everything with him [even though they're going to walk away from it]. There's only one truth, you know, there are a lot of lies, but there's only one way to tell the truth.

They were all set to do this deal and I couldn't do this deal and not tell them, so I had to tell them....If I can't do it that way [by being honest], I can't do it. And to me that is first and foremost in that situation....And it [the truth and the full story] might jeopardize it, might not, but to me my credibility is real important and in the long run it's going to benefit me. You know, if I decide arbitrarily, 'Gee, this time I'm not going to say anything,' it's going to come back to haunt me, number one, and I don't want that happening, and number two, I don't want to live with that, so I'd rather have it [the whole truth] be out there, I'd rather take my chances, most of the time it's going to come up in my favor, and the most important thing is the credibility that it brings over a long period of time....I would always tell him what was going on before he asked and so I've got a lot of credibility with him...plus I couldn't live with myself if I didn't....I have to do what I feel is best.

I think in the balance of things that maybe it's that trust and that loyalty and that belief in you [that employees have] that allows you to make unpopular decisions....It's all based on honesty somehow....Trust me because I trust myself and I know this is right...you know, when the money and the security and all the obvious things are there and you're countering with 'Yeah, but it doesn't feel right...trust me, I think I'm doing the right thing for myself as well as for all of you.'

I need to have a base and a foundation [for my decisions]. I need to have people I could trust and I need people who had loyalty and had the same set of values that I had or have and that's what I did....I think that's one reason why we were able to develop the relationships....I always do what I say I'm going to do, and if [for some reason] I don't, then I stop in the middle and put everybody on notice that I'm going to do something else, but I don't misrepresent a situation. I may change my mind in a situation but I never misrepresent.

My style is...you basically put your cards on the table and you develop a mutual trust....We learned a lot from each other, we learned to trust one another....a good relationship and a position of trust...if you can convince him that you're honest, you're not going to screw him, that you have absolute integrity, and that even if it costs you something you'll stand by your word...that's how long-standing relationships are made.

One entrepreneur labelled himself as not honest—while describing his behavior as not cheating anybody.

I'm not the most honest person in the world. I don't think it and I don't preach it. But I think you have to have a set of ethics that you live by, whatever that is, all right? And I believe that the young people in the company, I better set the proper example for them. If we commit money, we give money. If we tell them we don't have money, we don't have money, they hear it from us first. Don't cheat anybody, but get the best deal you can. If you commit to something, and I'm having a problem with this right now in the company, if you commit to something, do it. If you're going to do it, then do it right, even if the money doesn't come.

These people were trustworthy, and most of them also were trusting.

And I am very trustful, I believe people, I take people at their word, and the first moment that I discover that they're not dealing with me on that basis, then I don't penalize them, I just won't do business with them. I don't adjust my view of the world, I will not do business with somebody [I cannot trust]....and I, you know, because of the way I behave I set certain reciprocal expectations of their part and I make it real clear.

I think I'm expecting people, *accepting and expecting people to keep on wanting [the right things]....*

I really believe all of these people acted in what they saw to be my best interest....

I placed my faith and confidence in somebody else, which I do all the time, and I don't mind doing, I'll do it frequently.

Learning to Trust

A common pattern of personal growth for many entrepreneurs was of gradually moving from a position of trusting no one else to do things right, let alone make the right decisions, to a position of being able to trust others and rely on them both to make good decisions and do the work well enough. "Maturity," they called it.

I came to this with just incredibly deficient [attitudes] about others' abilities. I had no, the only person I could rely on ever was only me, ever, and I never felt I could rely on anybody else. That's what I felt. That I could never really rely on anybody else and so I never trusted anybody else to do the job well enough. Also my standards needed to change. What is well enough? And that needed to be changed. I needed to achieve a lot of maturity. What is acceptable and how do you get there? You don't bring somebody on board and expect him to automatically assume the same standards that you have and just do it like that, like magic, that just doesn't happen.

As these entrepreneurs have described it, their feelings about honesty and trust had a great deal to do with feeling right about their decisions, whether or not they worked.

I made a decision that was in agreement with my principles and the way I view the world...so I don't think I could have [made a different decision], but what I'm saying is, it was a big mistake, but it was the right decision. Right decisions don't always produce the results that you're looking for.

But it was also trusting that led to the most difficult of problems for many of them—other people not measuring up to their trust.

> *That's the biggest flaw in my decision-making process...and I'm afraid it's been consistent forever....In business you don't always have the opportunity to grow with people and get to really know and understand them, you have to take them based on quote a real or fabricated reputation or a real or fabricated set of facts. You see, you can't be distrustful of everyone. You'd destroy yourself if you did. So I wind up trusting everybody, and I don't get shot down that very many times, but the times that I have it's been a real nose dive. But I'm sitting here and I'm healthy and I'm happy and I'm enjoying myself and so the damage that was done was momentary in my life and it hasn't stayed with me.*

> *I do that constantly [make bad decisions because I trusted somebody to do something]. Little level and big level and so forth. I misjudge people and I tend to believe the best of everyone. My wife and some other critics will claim that I am too soft and too naive about people and I'm not cynical and that I expect everybody to be trustworthy because I am...I tend to, and that's true, I do. I don't distrust every soul that walks by, I tend to trust them first and that's been an error, I mean I made a lot of mistakes that way and I probably never will change it....[may be a good human quality] but it's a lousy business call.*

> *I'd probably make the same mistake again because I put faith and confidence in other people. They, I feel that they know what they're doing. Maybe as I get older and wiser I do ask a few more questions, but I still make decisions rapidly, and I still make bad ones, not all of them are good. I think most of the bad ones today involve more people-decisions rather than thing-decisions...I base my decisions on what people bring me.*

The pitfalls of trust—trusting too much or not trusting enough— were highlighted by the decision these entrepreneurs often described as their most difficult: hiring.

> *Hiring a [senior manager] comes to mind as the toughest decision....Hiring a new guy's a risk. It involves really letting go. First of*

all, I had an appreciation for the kind of damage that could be done by someone in that position is they're no good. I really was afraid to have to rely on somebody. So I had to talk myself into it...it was a tough process for me. And it required disciplines I'd never employed before. I'm learning how to find and use very good people—and I'm learning how to rely on them.

They also took seriously the responsibilities of trust.

They place a trust in me *or a confidence in me and it's carte blanche....you should always feel the burden or the weight of that, and the thing that you can give back is loyalty and trust, not that you're going to make every call right, but you're going to do your best to make the right decisions.*

I feel the load *[of their trust in me].*

I'd never forgive myself *if...I didn't do what I needed to do. I would feel responsible if I didn't.*

Feelings of Community

Many of these entrepreneurs described feeling responsible for some aspect of the common good, and for their communities, as well. They illustrated their involvements in "supporting the business community," "working in charities," "paying back society," "trying to correct social and racial injustices," "doing the community stuff," "wanting to teach," "establishing a community government that provides a vehicle for negotiating among different needs to arrive at truly harmonious consensus," "not allowing the mountains to be destroyed."

This will sound terribly corny, *but I truly made this decision with a lot of thought, internally, that I have an opportunity to give some hope to people in ways that they'll never get otherwise. I've got an opportunity, now this will sound stupid, but to give people the chance to become middle class when they'll never ever have a middle-class opportunity. I've got the chance to give a lot of people the opportunity to own a house who could never own a house.*

I've always given a lot back to the communities, always very deeply involved...was the recipient of the first non-faculty award of merit or something at [a local university]. Did lots of that kind of stuff, speaking and fund raising...I'll never forget in the 1960s, when [we] were just starting to cook and they'd see me spending a third of my time volunteering with the university. They'd say "What are you doing that for, where's the payoff?" I said "It's just the way I am, I believe that you keep these things in balance and they'll come back to reward you in the long-run and even if they don't that's fine." The reward is what it is.

This is why I spend whatever time I can and whenever I'm asked, talking to teenagers, people in their twenties or young professionals, to try to pass on part of the give back program, this insight and this knowledge....

One emphasized, on the contrary, that his work in the community was strictly in his business interest.

So this is strictly self-interest, because there are easement streets here [at my plant], and it's redevelopment, and...so these streets are getting repaved and the whole thing, [I'm just] taking care of my interests.

Teaching and Helping Others

"Wanting to teach" was a surprisingly common goal among this group. Over a third of the entrepreneurs talked about teaching concurrently with their work or planning to teach in a later stage in their lives.

Teaching is very satisfying....You can touch people, you can make people look at least at part of their lives differently.

I didn't think I wanted to stop teaching. I loved it.

The particular blessing I have is the capacity to speak and articulate what my vision is...and mission is. [I'd like to] teach personal skills, public speaking skills, based upon the idea that people succeed because they like themselves, have a sense of self-worth, know they can relate to someone else....I hope I'm going to be a good teacher.

About a third of the group specifically talked about wanting to help others. They described their work as "good, because I felt like I was helping people"; "exhilarating, we were actually helping people"; "feels good, because we make a difference."

> *I really enjoy helping people, I really get off on it, and it's a kick for me and so to have the opportunity to do it and especially to do it, to help, for your friends.*

> *What I'd like to do is...consult with small businesses that are going in the direction that I've been and to just share with them and help them and perhaps make it a little bit easier for them....I would feel good about putting something back that way,...I'd like to do it on my own terms in a way that feels fulfilling to me. It's like I don't give a lot of time or money to charities unless I feel it's going to where I want it to be going, I'm not giving money to pay for people's salaries...but [I do to] other places where eighty or ninety percent of it goes where it's supposed to go....We've got three or four foster children in other countries...and I feel like it's making a difference. What we have on our business cards is that we make a difference. That's actually real important to me.*

> *When somebody needed some help somewhere along the line it worked right for me....one of my strong needs is for the welfare of the people around me. But I don't pretend for a moment that if I don't want to do it, I'm not going to be forced to do it. The need I have to be involved in other people's lives is fully fulfilled by the people who are already part of my life. I don't feel a vacuum there.*

> *In terms of being introspective, what do you want written on your gravestone? My early message used to be "He was smart, he worked hard, he was rich." And I put the eraser to that about five or ten years ago, and now it would say "He helped me achieve what I wanted to achieve." That's really my whole self-image.*

Like trusting others, helping others sometimes short-circuited their decision-making.

That's me. Take care of it, and that's the way I do it, if there's a problem, solve it, if someone needs help, help. That's why what happened with that [wasn't so good], that feeling toward helping and solving problems has been to my detriment. Because whoever came in my front door with a problem or needing a product, I said, 'Hey, I'll help, hey, I'll do it.' I saw the solution so I took on their problems.

A lot of my decisions have been troubled because I worry not only about taking care of myself but about taking care of themselves....Well, what better fire bell to give me than "I need help!"...That was an agonizing period for me because the other side of always wanting to take care of people and help them is it's very hard to hurt people, and I took full complete personal responsibility for everything that was happening.

These entrepreneurs clearly felt that right decisions began with honesty, and included trust and concern for the welfare of others. They also were clear that while right decisions "didn't always produce the results" they wanted to achieve, their commitment was to what was fair and right regardless of the short-term outcome.

DECISION GOALS

What made a right decision good or bad? What signified that it had worked or had missed? What were these entrepreneurs trying to achieve? In describing the turning-point decisions of their lives, and the strategic decisions in their careers, they talked of meeting their own needs, of reputation and pride, of control and power, of freedom, fun, recognition, money, security. And of good marriages and family life and long-term friendships.

Money

Of money, a very few said that making money was their goal.

So I shifted gears, I was in a brand new business and once again I looked around, and that decision was really economically driven.

The money [was motivating my decisions]. But loved the people I worked with, absolutely loved them...a deal was a deal and that was it.

The money was nice. Lot of money, still wasn't saving it, was spending it.

I think my success came from being clearly focused on making money.

The good news is my future's great because I can get a lot, with money....I could almost guarantee that I will not be here in anything like this business, I will have gotten enough money and everything out of it, and [will be] pursuing some crazy thing. That's why I think the future will be brighter when I get past fifty.

More said money was nice to have but was not their principle motivator, and that it mostly represented a score for achievement.

I had no ambition whatsoever to make money, I never thought of it...it's certainly nice to have money, but...once you reach...you make a lot of money, and my money is a report card on, once you get past that stage are you going to still play the game? How big a yacht?

I found out that money was not my major motivator, and it never had been.

No, no, money was never part of my decision criteria.

I've never worked for money. I don't think I've ever worked for money. I mean, you know, you work to bring food home, but I mean I don't think I've ever been motivated for just money.

I'm more interested in growing the company than in money. It's an ego thing. The money part isn't what drives me.

Mainly I just wanted to learn. Anytime I wasn't learning I said to myself, 'What am I doing here? I'm just making money and that's no big deal.'

The philosophy we've always had is that we'll do business the way that we think is the best way to do it...if we can do that and make money that's great, and if we can't make money that's okay, we'll still do it. We've done a lot of that...that's a long range good will policy that we've always maintained and I'm sure it hasn't hurt us.

I made a [**conscious** career decision] because, one way of looking at it is saying I made it because it would maximize my career growth and opportunities and I liked what I was doing, in general, but another way of looking at it is saying that it maximized my pleasure, my gratification, my sense of accomplishment, my opportunities for monetary success. Although interestingly enough, money never played a big issue with me, it was never a big issue by itself, it was just away of keeping score....so money is the way of keeping score but the real value is in what you do, how you live your life, and unless you want to be a hermit, that's a lot of, that's inextricably wrapped up with people.

I hate to use this word but it's the right word, is ethics, they just didn't seem to have ethics. They were purely and solely driven by money...they always tried to tell me that everything's driven by money, and I always tried to tell them it's not true, very few people are driven by money. I know a lot of people in business and a whole lot of decisions that are made, and yeah, money is important but there's a lot of other things that are important.

I have finally subscribed to the fact that money is just the way you keep score, and that's all fine, but you've got to spend a certain portion of it first,...and my own estate plans which are fundamentally just to keep putting the money away, I don't have a lifestyle that, my wife and I have a remarkably moderate lifestyle, which I like.

Several remarked that "I didn't have a lot of money needs, still don't" or "I've never been much of a spender."

My economic needs are not that great...I don't need twenty-five million dollars to live on and I don't need a yacht and a plane, it's pretty simple to satisfy me.

I became personally familiar with lifestyles of almost all of these sixty entrepreneurs, and it was my observation that virtually all of them lived moderately—comfortably but without conspicuous consumption or ostentation. Those who had planes loved to fly. Those who had boats sailed them.

What motivated them and their decision-making were the excitement and challenge of making money, the opportunity and freedom to be their own bosses, the sense of security, the ability to express themselves in certain ways—which included doing things for themselves and for others.

What had an influence on me...help people and still make money...do something I really like and be my own boss and I can make more money....What motivates me most of all is the excitement, I guess it's a combination of the excitement, the money. I feel very strongly, I want to be secure financially. It's more than the money, it's the challenge, the turn on, it's a combination of the challenge, the turn on, the people, the money, all those things, you know, like the people here. We get along very well. I like the excitement and I like the money. It's really fun.

It opened up a whole vista of things that I could do for my family and friends and gave me the security to realize that I could make a few mistakes...it was an incredible sense of freedom.

I really want to live those things, I want to see those things, I want to touch them, I want to write about them, I want to take pictures, I want to paint them, and you can't have those things unless you earn things that allow you to achieve them.

But clearly, for me money has been important in the sense that it allows me to express myself in certain ways, dress a certain way, fly airplanes, whatever the situation happens to be, but as it's turned out relationships are far more important to me than money ever was. Experiences are far more important, and money is a tool to get to the experience. But the money itself hasn't turned out to be as important as I once thought it was.

A common pattern was that money was not a principal goal when the entrepreneur was young, starting a career or starting a business; that money became a principal goal as he got beyond the survival stage and that it signified, during those middle years, many different things including achievement and freedom and power; that once acquired it receded again as a motivator, and then represented both security and the luxury of expanding the caring side of oneself.

> *Back then, my sense of people and all that was related to a social concept.... There are some people like the DuPonts who are born with the purple, that own it all, and there're us working stiffs. I thought I'm never going to get to be one who owns it all, so why even worry about it? Then I was much more fulfilled by this business of making money and getting ahead. [But now I'm different,] I think now often times of value judgments. And what I was driven by then mostly was the access of fame and responsibility and power, and money was only a measuring stick for that....for whatever reasons, I was a money-driven person then, and I'm not now.*

> *You know that you could make as much as you'd ever need, when you've really got too much, when every month more comes in than you really need and you've got enough to put away and live the rest of you life...it's just not important for me....and that's the first time in my life I've been able to think about the larger issues, so it's a time thing...free time. It's wonderful, the opportunity that gives you, money gives you free time, anybody who says it doesn't...it's time and time is freedom. Once you reach those things then it all becomes self-actualization, so I guess I'm self-actualizing in the late-fifties here.*

Another view was more blunt.

> *I know that the desire to make money is purely sexual. Purely. Money equals power, power equals sex. I know it's [true for men]...I don't know if it's true for women.*

Money also was the root of a great deal of learning for these entrepreneurs. Not only learning that it was less important than good re-

lationships and life experiences, but also that making it over the long-term was hard, losing it in the short-term was easy.

Well you know we generated two million dollars in earnings in a year, that's mine, right? Well it is mine, until it went it was all mine. So it's true you can do that, but the risk of that is that you can lose it as fast or faster with greater consequences.

Even now I really don't do it very well, I have had a terrible time, [always thinking] it'll work its way out, if you keep the top line okay, everything else'll work out underneath it. That's not true, you have to experience it to learn.

I have never gotten over the awareness that something could come along and wash me away completely, I don't mean death, I mean in a corporate sense....I've never gotten over the fact that this company, like most companies that are smaller and that are much larger, are vulnerable to all kinds of things, scares the shit out of me.

If I could continue to afford to throw away a couple hundred thousand dollars a year [on this project]....No, I'm getting a little bit smart in my old age....I've been saying it for years, 'One more year, one more year,' and the handwriting on the wall is just clearer all the time.

Power and Control

Power and control also strongly impacted their decision-making. Many described the "ego-satisfaction" and "enjoyment" and strong sense of personal identity that came from having control and the ability to exercise power.

Being number one is the only way I can work...I was number one, no doubt about it, I just knew that about myself, I got things done.

The only way to have ultimate control is you own your own business.

They addressed the paradox of having ultimate control to make decisions but of losing power to the extent that they exercised their control.

> **Being an entrepreneur is** that I've got control and I can do what I want to do and...I exercise it when I have to but to me when, if you use power you lose it as far as I'm concerned. Okay, my feeling is that the real power is the understood power, okay. If I, you know, if I exercise that power, you know, you can do it and you can get away with it but then, I think, you lose the essence of it, because you're using your position to maintain as opposed to the fundamental strength of what you have going for you. You know, people either respect me for the job that I'm doing and that's what I want. If they only respect me because I have control over their jobs and there's a hierarchy and they see a verticalness in that then I'm not doing what I need to be doing.

> **Having the right** to have a new product no matter what, forcing it down everybody's throat. I've had all the right to do that, and I've screwed it up a number of times, and I've been successful more times than I haven't been, but I've almost sunk the company two or three times in doing it, so I really recognize my own limitations.

Others described learning painfully what they couldn't control.

> **Very much a learning experience,** I do not agree completely that I couldn't control these things, which of course is part of the problem, thinking you can control everything, I do think that to some extent I've been a victim of my belief....And they felt extreme psychological letdown and personal confusion when their control was lost.

> **My sense** of invulnerability started to fall....

> **The biggest frustration** is the inability to be in control.

> **I couldn't make any** of those decisions, I was numb. I've seen it since, there's something that happens when you're really not doing real work which equates to real money, for a long time, when things are happening seemingly as if by magic, you lose your virility, you lose your belief that

you can throw the ball....It's a very odd thing that happens when you float there on top...I went through almost seven months of feeling like I had fuzz in my head, I couldn't make decisions and it wasn't just depression...but what was wrong was I had gone so long without really controlling something, really controlling it, I turn it, it turns, I turn it this way, it turns, I'd gone so long without that that I didn't know how to do it....months of not making decisions really but watching something die and being, not really even knowing how to act, not knowing what to do.

Freedom and Fun

Almost all of these entrepreneurs talked of making decisions to maximize their freedom and their ability to have fun. "Freedom"—money, time, independence—was a common theme of success for them. "Fun" was their common description for the business, for work, for learning, for things happening, providing value, being creative, putting things together, selling, creating new products, playing with computers, working with people, building the business, buying companies, making money, adventure, going on vacations, being with family and friends, for hobbies, for enjoying the child in themselves.

They described some aspect of their lives as "fun," and said having fun was very important.

It was fun to work there because one could create a new structure, one could change things...it was like a game, I enjoyed it. I did it for me, but since I figured I'm a kid, that everybody else must be a kid, everybody enjoyed it, it was fun...because otherwise I get bored. I mean you can't just make money. I like to have fun and I think if people have fun they work better....My advice to people would be...you haven't accomplished enough because no one of us has accomplished enough, shit the world is out there and it's gone to pot, if we had accomplished anything the world would be a little better, and we certainly haven't, so who the hell ever accomplished anything? I think the key is to have fun in the process....To me the process is much more important. I'm enjoying what I'm doing. And I mean I've often thought could I leave business now at age fifty and be happy? Sure I can. Would I look back and say I've accomplished something? I'm not sure that I need to look back and say I've accomplished something. I know I can say I've had a lot of fun.

Travelling or working or doing whatever it is...I do understand the compression of time, I must tell you I would rather live forever and see all these fascinating things that are going to happen...but I don't think it's regretful not having done it, it's regretful because it's such fun...I don't mean work only I just mean anything....I think people should have varying interests at various times, they should change. But whatever they do, I think it's important to have fun. If you don't have fun you can't be nice to other people and you can't do it well, if you're not enjoying it you're not doing it well....I regret a lot of things, I regret all the mistakes I made, but I don't regret doing it because I had fun doing it....fun getting there.

Several others did regret not having more fun and said they would make those decisions differently if they could.

My respect for the people input absolutely goes into my decision process, always, it's more important than the financial decisions, and that's a big change with some executives today, they realize the priorities, and you can have all the financial strength you want, but if you don't take the long view and you don't have the people who can carry it out, who have a big stake in what happens, your chances of succeeding, particularly today, are very remote, and the chances of having any fun are also very obscure....The last twenty years have seen dramatic changes in the whole industry, some of the time we've called it right, in others we made some mistakes. And we always suffered, and I never had a long enough run where I didn't have to keep my hands on it to some degree to where I could go off and really have the kind of fun I love, for example, to me fun would be writing a book. I did, but I wrote a book under duress almost, at a time when it turned out we had some problems so I didn't have the luxury of taking a year off to write the book, I had to write it while I was running the business, and promote, and it was harder, that was fun, but it would have been great fun if I could have taken a year.

Credibility

Other goals for the decisions of this group of entrepreneurs were to have excellent reputations and to take great personal pride in what they did. Credibility was enormously important to them.

We were very fair in our dealings with everyone, on the outside, with the press, with our distributors, with our dealers, with our customers. And that began to permeate the whole company as we grew that business philosophy and that ethics philosophy. And, you know, that was a very important step...everybody thought of the company as bigger than it was, as extremely ethical, extremely fair, and this provided wonderful customer support, created customers as well, and that reputation is unblemished.

You want to be proud of what you do, you want to be proud of it in the years to come, not just today. But that comes with experience.

Credibility sometimes had been earned and preserved through extraordinary service, in order to correct some error in business judgment or operations.

I eventually had to buy them back. This is where I think we created our best reputation....The [product] didn't work and I didn't know what I was doing...I went out there and sold people...we could've sold many more of them. Thank God we didn't. We finally realized what was happening and...we bought them all back. We couldn't, we didn't have the money...so we made a deal with everybody that we would pay them each at five hundred dollars a month...bankruptcy would have been very easy at that stage of the game, on the other hand, I'd built up all those years [of my reputation]...at any rate, we did do that, we did pay them back and it did take us time but we did, and I think that worked out well....And [today] philosophically, we bust our hump to, if anybody calls and needs anything...if somebody's dissatisfied we just give them all their money back all the time...automatically, it's part of the thing over there. And the culture.

When credibility had been lost by a company, it was hard to regain.

[When we bought this company a year ago], we knew the company's customer service reputation was bad, but didn't know how bad people's perception of the company had gotten. I used to pick up thirty to forty [negative] letters a day, but now there'll probably be as many complimentary letters as there are negative letters. When I came here there

were thirty to forty a day, screaming-howling-I've-been-lifetime-wronged letters, all these terrible things....so we're flipping the company's reputation over.

When credibility had been lost by an individual, it was almost impossible to recover, and there was little else so painful.

Being a loser then, and having something that's so close, and having the reputation that I don't pay, that I'm going to cheat you, I think that's probably the hardest thing that ever happened to me....That's the thing that hurts the most, and still I have that reputation, you can't get out of it, and you can't go back and talk history with everyone....I was reading my great grandfather's obituary, he fought in the Civil War, and he was a stand-up gentleman, good guy, word, bond, all those things, which I don't have that, that hurts, that probably hurts the most right now. That hurts the most. I don't have it, and these [sons of bitches] turning these big companies upside down, and they're the presidents and they're insulated and so forth, and they go on to the next deal, and they still have their credibility, and that pisses me off.

Financial Security

Another common decision goal for this group of entrepreneurs was financial security. Many of them had thought about it when they were young, starting businesses. Many had worried about it as they became successful. Many were concerned about keeping it after they had earned it.

I more or less explicitly thought to myself, well if I had money in the bank then I would be protected.

I worry too much, you know, I worry [about] the stability of the business....I want to be secure financially....We're really doing well and you see my philosophy, I feel very strongly, I want enough money in the bank, then because we're not going to make it non-profit, my goal is to make everybody else who is a key player in this company rich....we're not going to make them so rich that they lose their sense of work but...so there's this big pot [in annuities] out there so that some day...I firmly

believe I've got to get that money in the bank and that's my bottom line. I want enough in the bank so that I can live off the interest, then I think I would run the place differently, I'll make decisions differently.

But really the only reason *I'm doing this is to provide sufficient money to live the rest of my life, it's not to build some giant institution. I already know how I'm going to get rid of my business,....*

I'll sell it to my partners *who don't own any of it...and they're going to be delighted to have it, they've always wanted to have it, I'm going to go and do something else.*

I think it's made me feel great *that we've got [this new product]. It's made me feel really more confident. See, when I get out of neurotic anxiety, we're really pretty secure. I mean...we're not capital intensive. The worst case scenario is, you get rid of all your people [and do it yourselves].*

But I'm real clear *that I won't leave before or without the full amount owed me from the buy out. Not going to risk the money, period. Not [the kind of] entrepreneur who will risk that money.*

Now [when our financial security] *has been taken care of, then I wouldn't mind taking whatever the residual is and pushing that up again, I think that's basic almost in the entrepreneur. The older you get you'd like to see some reserve...I've seen older entrepreneurs go under and the devastation is immense.*

Doing the Right Thing

Goals of the decision-making of virtually all of these sixty entrepreneurs included money, power, control, freedom, fun, credibility, pride, and security. They also included doing the right thing for the other people involved in or impacted by their decisions.

I've told everyone *in this organization that their own self-interest is more important than the corporate needs and objectives, and so I've had*

a number of our people come to see me sometimes and tell me about opportunities and some of the times I've encouraged them to take them, sometimes not. We've had a couple of people leave here, and I've helped them with their contracts and negotiations, and they hurt us when they left, but I think you've got to have that free open exchange as to what it is you want to do with your life.

[My top managers *have] been with me now for twenty-seven years...twenty years...seventeen...thirteen. That's kind of the way we grew....I'm loyal to everybody that's loyal to me. I would take the profits of the company and I'd divide them....The only thing I didn't cut was my payroll. I always kept the people that I wanted to keep.*

We keep people. *You know...the average length of time our reps have been with us is eight years. We've only been around, you know, fifteen [years] so we really keep people and we think a lot about people in this organization.*

I am much more conscious *of the fact that I'm making decisions and the impact that my decisions are having. I feel if I'm making a decision that impacts other people I put more thought into it...Each and every one of them. I am committed to [growing employees]. From the moment I walk in to the moment I leave, and there aren't enough hours in the day, there's always something. One of my staff members had a problem this week and it has taken a lot of hours to work it out, but my feeling is that in the long run we will all grow from it...if a person has potential and is a good person you need to work it through because we're all growing.*

Biggest objective *right now is to get [a long-time employee] busy into finding a job within our organization and to give him back his sense of importance and self-esteem. He doesn't really have any responsibility and I refuse to fit him into something perfunctorily. I mean he has a lot of skills and I have to find a way to channel that skill so he knows it's not a charade or any kind of a gift or charity, because that'll ruin him....It seems much easier to me to utilize that skill and take on the burden of utilizing it than to say there's no longer quite a place for you, because if that's the payback, I would hope that our organization wouldn't allow it*

because I would hope that the rigors of that payback would reverberate through the organization and hurt me from every angle or hurt our skill level throughout by other people saying, 'Well look, if that's the payback, I don't need to stay around, look how the company feels about loyalty and trust.'

Respecting Others

With very few exceptions, these entrepreneurs spoke highly of the people with whom they worked and who worked for them. The common themes were of respect and satisfaction with their people, genuine interest in helping them grow and strong loyalty to them.

I have a great loyalty towards people and, which is probably one of my values that gets me in trouble sometimes, and I don't like to clean house, I like to utilize that experience and talent that's there and make them part of my team, and it's a more difficult route to go.

He has raised our standard [with people] incredibly, beyond even what I thought was possible. Absolutely, he has led the way, he and I share the same standards which is incredible, it's almost like we're twins in many respects, we think a lot alike in many respects, but he is incredibly talented in, he can do what I can't do in regard to people. He knows how to use people and he drives them real hard but he knows how do to do it....I mean we're recognized by everybody because of him living out my vision, you know, executing my vision, because it's his vision also, so it's really easy that way.

I'm very blessed [with my people]...knew the stuff...magnificent job by our human resources vice president...she was a walking miracle on the way up and she was a miracle on the way down, a fabulous human being, a fabulously effective person...

I consider myself lucky to have this individual....He is a wonderful controller, one of the most conscientious, dedicated, great people that I've ever come across in being controller.

Exceptions to this theme came in two types. The first was from two entrepreneurs who simply did not like dealing with other people.

[The people here are] not real [to me]....These people would like a lot more hand-holding. I'm pretty aloof. I don't have much to do. [The company] kind of runs and I stay aloof. I don't take an active role. I'm at the God-like level where I don't get involved [in employees' conflicts]. They wouldn't generally come to me...which is not good. You need a leader that will deal with people. That's a real problem, that there's no cohesive leadership. I need to [fix] that.

I'm impatient with people. I know it logically—but that's me. What you are as a person comes through if you have enough time. I'm just not a people person. If I could design the perfect business, it would be only me. No other people. I'm project oriented and goal oriented. I understand it. That's not easy to change.

The other, and a more extreme divergence from the theme of respect and appreciation, came from a third entrepreneur who had had quite a few bad experiences.

If they were opposed to doing something, then it really wasn't going to get done unless I replaced them. So I was in the same [trap as] every owner who's a captive of his people....You find yourself being contemptuous of the people who accept your paychecks. Because they accept them, they're not worthy. I wouldn't work for that son of a bitch—me— and somebody who does has got to be inferior.

Other common themes among them were awareness of the paramount importance of having good, indeed excellent, skills in working with others, and commitment to improving those skills.

One of the great, most important things about the entrepreneur is people skills. People skills are everything, in fact there are people out there who are great entrepreneurs who are downright dumb, but have incredible people skills, and they're smart enough to surround themselves with people who can fill in for their intellectual inadequacies....There are people out

there who become successful by being unbelievable bulls, but you know, it's interesting they're successful for awhile but after awhile their success is many times fleeting....I think the people who have a consistent series of successes are people that are real good with dealing with people, are real genuine friendly kinds of people, they're good old boys....I don't worry that much about people who, if somebody's going to behave like an ass, everybody in the world's going to see, people who consistently behave like asses eventually pay the price.

People: A Competitive Advantage

Awareness that people are a competitive advantage for the future was another common theme.

On the people side, *the [acquisition] process will be much more hands-on and exposure driven, seeing how the presidents interface and relate with their people, spending time with the president....watching and listening and talking to the president talking to other people, trying to get data on all that...in the 1980s money was so available, debt, so today it isn't and you have to look for some other competitive advantage, and in the end it's people. There's always more money, they print it, but the people...*

I saw that you could do business *more effectively if you thought in organizational development terms. Instead of just power terms, and most of the executives just thought in terms of power and accounting, amassing assets at the top. They believed that's all that was needed and they believed in great charismatic leaders at the top but they had no idea about penetrating deep down into an organization and building a team...[but have to be] sensitive to the importance of human resources, programs and organizational development all the way down....*

So it's [our success] *really the change to better people.*

So I improved *the quality of the people and that's the name of the game.*

I'm beefing up my staff [with better people], *beefing it up, beefing it up...sometimes you find the jewels and that is most important.*

This business *is one hundred percent people.*

If you have the vision and you could communicate the vision and people bought into it, almost automatically, what I found...was that a lot of people were starving to find out how they fit in, once they found out how they fit in they'd just work their asses off.

Hiring

Many described greatly valuing employees who had the people skills that they themselves lacked. Hiring for those top jobs was among the most difficult of their decisions.

I didn't want to give up my authority before I knew that the guy can do it. Like the chicken and the egg....Prior to him I hired another one that was not exactly what I thought he would be...so I got this guy. I knew I could trust him, he is good at managing people. I could have probably hired a smarter guy, if I can say that, but I checked the other qualities that this guy has and I can balance him with the skills, I can complement him with the skills, but he has all the other [people] qualities that I need.

The bad decisions I've made in my life I made, when I made snap judgments, if you will. Or I haven't really garnered all the current facts to make a decision because no two decisions ultimately can be made the same way....All the decisions that have been bad decisions in my life have been made about people. They've never been made, I've never made a bad decision about a deal or a transaction, where my judgment has failed me is in judging people....I made a couple of investment decisions where the investments were fine but the people with whom I was dependent upon for the execution of those decisions were the wrong people.

What worries me the most is I've not been a great picker of top, I get middle management, I'm perfect on, I can get those guys that'll pull the horses boy and I'll get them pulling like mad. But it's the guy that's

whipping the horses that I've had problems with and that's why I'm looking for a very particular type of person in my life in order to make my life better.

The more major setbacks *have not been about buying the equipment and everything else, they've been hiring the people and managing the people. That's really more major decisions and problems. And which we seem to be addressing, we're getting more sophisticated [at] hiring....*

Several talked of their responsibility to put their people in the jobs that were right for them.

It was partly my own weakness *and not being able to train and communicate to the people the really complex process of understanding everything that we do, because you really have to do that in order to effectively sell what we do. And I did, what ultimately became, it's a common problem, I took the best person that I had in the business development department who wanted to be a manager, but I don't think he was really ever particularly good at that. He was a fine salesman and should have stayed a salesman. I put him in charge of the department because I didn't want to run the department. And by taking him out of the field and starting to spend more time managing and less time selling, all of a sudden we started floundering....You have to give people room to make mistakes,...if somebody makes too many mistakes, then you made the mistake because you gave them something to do that they weren't capable of doing, and maybe I do internalize things too much and say that it's all ultimately your responsibility, but I think our job as managers...in terms of people is to put people where they belong....if you're going to expect someone not to make any mistakes then I think you've got to either, one, totally train them or, two, give them a total system to operate in as a manager.*

According to most of these entrepreneurs, their ability to achieve their goals depended, in very important ways, on their ability to work through other people by making good hiring decisions and good management decisions. Doing business today and in the future, they said, was a joint effort with other people.

I deal with these people in my office in the same way that I deal with my children and my family. And the same way, consistency, business is no different than life, you should be able to segue back and forth between all of it and have your behavior be absolutely consistent, and everything has to do with the way that you deal with people, consistency is the way to do it, the generosity that you feel with people, the sensitivity that you deal with people's issues and in their lives. The thing that, everybody is a human, we've got to understand what makes a person tick, you can't be married to someone, you can't be a friend to someone, you can't be a father to someone, you can't be anything to someone unless you understand what is making that person tick and what their needs are and what their feelings are and what their sensitivities are and what their history is....

Well I think before you put together a product...you have to put together the system. The first part of the system and the overall part of the system are the people that create the organization. In business a company is a system, an organic process, and it has all the components which are people that must work together, just like components in a product have to fit together.

OTHER DRIVERS

The strategic decision-making for this group of entrepreneurs also was driven by their fundamental approaches to opportunity, risk, uncertainty and fear.

Opportunity

Virtually all of them described themselves as reactive and responsive to opportunity.

I am not suggesting that I haven't made any steps towards accomplishing something, but basically it's been a matter of something jumps up in front of you and you say, okay.

Generally they fall on me...[things that]would be a good idea.

A situation came along; an opportunity had come....

I've been reactive not proactive. And that's the way I've always been and I've known that, and I've tried and I've done a fairly good job over the last few years on my own not having to wait around [for somebody else to tell me] to narrow where we're going especially as we get bigger, because I by myself can do that, that is my nature, but to expect everybody else in my organization to do that to be as reactive as I can be, I can't expect that, to find that many more opportunities.

Many of them also described themselves as "looking for opportunities." This is a key, I think, to entrepreneurial success in managing change—actively looking for, seeing and feeling opportunities, rather than simply reacting to those that appear.

We tend to look at everything that comes our way as an opportunity....

I'll start talking to people and somewhere some opportunity will come up, as many others have come up, and I'll start studying. And then I'll do it if there is something worthwhile doing, I'll do it.

An interesting decision for me....I think there was a sense of where am I going and what's going to happen here in the next few years, is there really opportunity here or should I look for other opportunities?

I saw it was a crisis. I jumped on this....

We saw an opportunity to convert someone else's adversity into an opportunity for us and we acted on this opportunity. Sure it was a big risk.

So I had to pick opportunities that nobody else wanted....

I started looking for other opportunities...I saw it as an opportunity [for me] and I also saw it as a corporate opportunity where I was....

So everywhere you turn you see opportunity, you know, of some sort....The only way to do business is to get out there and find the opportunities.

Good decisions are made...out of opportunity, out of a feeling for opportunity, as opposed to a feeling of fear. Because if you operate...out of fear you're never going to make a decision,...you want to always be able to calculate what your downside risk is, but you've always got to focus on the opportunity.

Fear

Fear was an enormously powerful driver for many of these entrepreneurs, "profound, underlying" fear. Some described security fears, fears of failure, fears of making fools of themselves, fears of not being able to do what they set out to do, fears of being vulnerable to things they could not control. Being "scared to death" was a common expression—about starting new businesses or selling the services or handling family responsibilities or letting go of senior managers or being a good manager or just doing it well enough over and over.

There's a fatal flaw in this company...and the winds of change are coming [to make it worse]....It's pushing me to settle things....It could be too late. That's the other thing. You want to know why [I'm scared]? You never know tomorrow what's going to hit you. That's where I try to cover my bases and I've learned you can't cover your bases.

I was haunted by sort of a ghost which said, 'What if you don't get [more work]? What if [more orders] don't come in?'...there was an additional haunting feeling that said, 'Boy, you sure are lucky, how does this stuff happen?' and made me worry about the underpinning, the nature of it....much of the process...was driven by fear, really driven by fear....It's very hard for me to describe this. But it is as true as the day is long and it turns out it [is still there]....I got scared again...I mean really it's an interesting fear.

Many of them described "interesting" conflicts between opportunity and fear. Without exception they reported that opportunity won. This is another key, I think, to entrepreneurial success in the management of change.

That was pretty scary because that was the big entrepreneurial move for me, basically at age forty, it was scary....that process was scary because we suddenly go into a situation where I was taking no salary, we were living on borrowed money, literally started putting the house up as collateral.

It was scary, but you know, I was scared on the one hand but I was in my element on the other....was moving forward to overcome, I was still operating out of fear. For me at that point there was no going back working for somebody...it's frightening but it's wonderful.

My sons were thirteen, eleven and nine, so yeah I was scared. But you think about that for a couple of minutes and start working.

I was afraid to do it. Was afraid to delegate. I think that's the biggest caveat for an entrepreneur going from an entrepreneur-type operation to a professional type. But [I did it] realizing that I'm not able to do everything myself.

I knew I had to do it and I was absolutely scared to death because I knew that I had to let go and I was so afraid to really let go because that's what my problems were. I was just stretched way too thin, I wasn't doing anything well anymore. So I knew I had to do it but it scared me.

I was scared to death.....it was very heady stuff.I was really, it was more money than I had ever even dreamed of being able to find...had come to terms with it intellectually but still I was really afraid. I took a big risk.

Risk

Opportunity and risk or fear and risk were often in the same sentences for many of these entrepreneurs. A very few described themselves as tremendous risk-takers.

Another reason I think that I'm successful as an entrepreneur is that I take tremendous risks and I could never have taken those risks had I had

a family. Just every day risk-taking, risking everything, the risk-taking in my world is ridiculous....I knew at the end I'd make it, I had my house up I had everything on the line, and then I made it, so. So yes I knew, and believed it was right, and nobody in their right mind would have tried this.

It's just difficult *to maintain control and direction of the management unless you have that entrepreneurial risk...[of taking] concrete step, we're going to take whatever resources that we have and put them into the business [even though it's a public company]...I didn't know exactly what it would do, it just seemed to me that it would be pretty hard to follow a CEO who wasn't willing to take that kind of risk....put it all on the line.*

We're such entrepreneurs, *we're risk-takers during the downtime [hiring, expanding, buying equipment, starting new programs] as well as in good times.*

But most did not describe themselves as risk-takers. Many thought they had the downside covered.

I don't think of myself as a gambler, *there are many times I'll gamble with the downside covered in many cases, and I'll always [do the] what ifs, and many times if I had taken the support of my own convictions and [taken it all] and really gotten out there I'd have made lots of money. But instead I would either bring in a partner or only take the partial risk, so you don't throw it all on one dice.*

[Here we have] opportunity *to learn, to expand your horizons, and to disagree and to take risks, and that's really what I try to provide my people with is the opportunity to be risk-takers, but calculated risk-takers, you've always got to know what risk you're taking, and you do that by being well-informed.*

It's risk management, *risking your own career and making decisions and weighing failure versus success.*

If we start embarking down that path we're going to spend a lot of time and money, we're going to increase the risk...but on the other hand there's a monstrous payoff potential at the end of it....In the process of making a decision I have to gather information...I try and find the critical threshold decision...should I or should I not...[or] how much should we invest...the amount of risk associated with what is acceptable in our current environment....Thinking back on it, I've always been a prudent risk-taker, if that isn't an oxymoron....I believe in taking risks where the expectancy is a payoff....prudent calculated risk-taking. A risk means anything other than a certainty....it's a question of the magnitude of the risk.

It wasn't a game breaker. I wasn't betting the company. Yes, I had to put the house on the line. Yes, I had to invest capital in a risk venture. But I wasn't betting the whole thing. It would have been a major setback if it hadn't worked, but we would have survived. My kids would have eaten. I wasn't betting the whole kit and caboodle.

I guess I don't really find decisions that hard. I feel that generally that I've given enough thought. And I'm willing to suffer the consequences and work my way through it. Knowing that there is always a certain amount of risk, but it's also the risk that makes it exciting and interesting, because we're totally, let's say there were no uncertainty, then you really don't need a human to do it.

Many others simply did not see or did not acknowledge the risk, or, more importantly, did not understand the risk.

Other people have asked me, weren't you afraid of losing everything when you borrowed...every asset you had to get the cash. I really never gave a thought to losing it all....In terms of the risk/reward equation, well what I said to myself was 'I know you can do it. And where you are now you're not going to find another opportunity like this one. So go ahead and borrow the money, if you lose, so what, you'll go out and get another job and you'll be back on the income stream again and you'll have a smaller house but you know.' I really didn't give a hell of a lot of thought to losing, I was pretty well persuaded.

I would have advised anybody else not to put the money in. When I ran out of my own money, I went out and borrowed five million dollars from five of my best friends. And without any one of them asking, gave my personal guarantee and [my wife's], mortgage on our house, nobody asked for it. Yeah [because I was just so sure of it].

Probably if I think about it, if I think about the things I've done I'm probably a risk-taker, but I don't think I am. I didn't feel it was a risk. I didn't think so. Well maybe I thought it was a risk but I didn't think there was going to be a downside.

I mean I believed in all this stuff, I still do, but the problem is of course it by itself doesn't make it economically work and that's the, but I didn't see that and those things are real hard. But I discovered, so those things are intangible, and I didn't make decisions particularly thoughtfully, and I never ever understood risk. And I honestly think just today I have a sense of understanding risk. I don't think I really understand it, I have a sense of it, and I never had an idea how much risk I was really taking, not for an instant....I never had any idea of the downside.

My inherent belief that everything's going to turn out all right allows me to take these risks and not worry about falling on my face, but falling on my face is a theoretical possibility. I don't believe entrepreneurs, and that includes myself, understand risk in a real visceral sense, none of us are any good at all at measuring the rewards against the risk we're taking. Why do I go half a million dollars upside down in a company that could never have earned twenty thousand dollars a year for me? There's no possible justification for it. Why do I wind up signing a lease with a million four liability to me without any continuing stream of business, I've got to replenish that business every single month....I think that you have to pay attention to your internal integrity and you've got to pay your dues and take your chances.

Whether they identified themselves as great risk-takers or prudent risk-takers, whether they accepted potential consequences or didn't understand what chances they were taking, these entrepreneurs all

felt some degree of comfort with the concept of risk, the uncertainty of risk.

Uncertainty

The single uncertainty that was most unsettling to them was expressed by the few who had endured long periods, sometimes years, when their decisions hadn't produced their intended results. It was a deep uncertainty that overcame them with feelings of having no control and no personal power to change events. It came rarely, but powerfully, when they were forced to doubt their own ability to make good decisions.

I don't like uncertainty. It took me about fifteen thousand dollars worth of therapy to learn that....and I know that the greater the degree of uncertainty the more churning it produces in me. Often I will do things to make my decisions move ahead just to eliminate the uncertainty.

It's a survival mode. You start questioning your own decisions. I thought I could move this company [by my decisions]...but instead it got worse...and all of a sudden I start to question my own judgments. Once again, I start looking around and saying wait a minute, this doesn't make sense...and what about me? I was a part of this, I was the orchestrator...it's mine to live or die with. I've always been a pretty confident guy, thinking I'm knowing where I'm going. But I'm not always sure that I'm right anymore and that's not a good feeling.

I didn't make any of those [necessary] decisions. I was numb....sort of in this death spiral somehow emotionally....I worked out a way to get out of the death spiral.

If you're going to make a mistake, it's a hell of a lot better to make it at twenty-five than thirty years later...it comes back to health...I think that health is psychological. Pressure in short bursts is good for people, fear is good for people in short bursts. But you wouldn't want it [for long periods of time]. You become numb. And it's the numbness that'll kill you, because you lose all of your senses that are necessary to permit you

to survive....And it also has to do with energy levels. I don't think you can ever forget the importance of health in this whole process, because it would be so easy to give up [if you're sick]. You should ask your entrepreneurs how they feel about suicide. As to whether or not it holds any fear for them.

SUMMARY: DECISION PURPOSES

The range of purposes of decisions of this group of sixty entrepreneurs included the Golden Rule and honesty, trust and loyalty; the decision goals summarized here—money, power, control, freedom, fun, credibility, pride, security, and doing the right things for their people; and powerful drivers such as opportunity, fear, risk, and uncertainty. Their decision purposes were guided far more often, indeed overwhelmingly, by personal principles than by economic advantage. The only one of them who described himself as "not the most honest person in the world," also said "get the best deal you can, but don't cheat anybody."

Very few of them acknowledged being motivated by money; most of them described making money primarily as a way of keeping score of their achievements. Most of them needed to have control but tried to be sensitive about using power. They sought freedom—by which they meant money, time and independence, and they identified much of what they did, and more of what they wanted to do, as fun.

They also were drawn by opportunity, often in response to it but more often in search of it. They rarely, and often only belatedly, understood risk. They did not like uncertainty, even as they were very comfortable in dealing with change. And they were strongly driven by fear.

They valued their integrity and credibility ahead of virtually everything else, and went to great lengths to protect their reputations. They wanted financial security even as they put it at risk in their businesses. And they had learned to highly value personal relationships and the support of good people. Their caring for the best inter-

ests of other people extended far beyond the bounds of their own interests, unless they defined everything they did as being in their own interests, which only one or two of them did. (In the case of one of those people, I happened to know that he was caring and thoughtful of others in his business dealings as well as in his personal relationships.)

With the exception of the work which they did in their communities, and certain other helping avocations, their goals did not extend greatly beyond the parameters of their personal lives, but they nevertheless were rooted in honesty and honor and in concern for the well-being of others. These were principled people. The ground of their thinking and the "why's" of their decision-making were honest, trustworthy and fair, and their strategic decision-making reflected those principles, those values, more than any other purposes.

Among the "why's" of their decision-making, then, their principles—their integrity and trustworthiness and concern for other people—were the fundamental drivers of their decisions, at whose service they worked their decision processes, tools and influences.

MAKE UP YOUR MIND

13 ❧

So You Need Guiding Principles

I got started as an entrepreneur later than most people did. In terms of how my career turned out, I should go back to college and high school. I had dreams of being a Naval officer and going through all of that [but it] didn't turn out that way. I did end up in the military, in the Army as an officer, and enjoyed it.

While I was in the service, I got married. And that dictated that, since [we were] intending to have children, I not stay in the service. So, even though I liked the organization and the team aspect of the military, I made the decision not to stay. My decision to get out of the Army itself wasn't fully thought-out at the time. It was just a matter [of getting] married. The rest automatically followed. I wasn't going to recreate [my childhood].

There was a period after World War II when—even though my father never changed jobs—we ended up moving four or five times within a three year period. This was the period when I was eight years old to [about] ten. It was very unpleasant for me. I hated it. So I'd made a decision that my family was not going to be moved around a lot.

I think we're all influenced a lot by things we don't like.

I came back to [where I'd grown up] because I had background there. I applied at [a big oil company] and got a job as a management trainee. It quickly became clear that, if I was going to get anywhere in the corporate world, I needed more education. So, I took advantage of one of [the company's] programs and spent five years going to school at night. First, I went through an MBA program—which took about three and a half years—and then did another master's program.

While I was working on the MBA, I was in the marketing department and working on my own. Twenty five service stations were my responsibility, all of which were owned by independent dealers. I liked that job a lot because I liked being on my own. And having to problem-solve all the time. From there I went to the economics and corporate planning group. I was basically unhappy with that job because I was working on long-range projects that didn't have immediate feedback. I wasn't sure whether what I was doing meant anything. And there was dead time.

I'd gotten used to and rather enjoyed the frantic pace of having too much to do and not enough time to do it. That can become addictive. I think particularly for entrepreneurial personalities that's their addiction. It becomes a weakness of ours—we have to be too busy all the time. [Sometimes] you don't allow yourself the time to do the important things—sit back and think.

I suspect that what I and most entrepreneurs do is make ourselves frantically busy...but [that works] to the detriment of our families. At home at night, in the shower in the morning, on the golf course on the weekend, sitting on the beach—while you're supposedly relaxing, you're thinking about work.

I do most of [my abstract] thinking in the so-called off-hours. So, the reality is as a entrepreneur I work all the time. [Personal time] has become my planning time. In spite of my good formal academic training, I've never developed a formal training or planning operation within my company.

At the oil company, I ran up against the exact same thing I was running up against at the military. If I wanted to get where I wanted to be within the corporation—a high level management job—I was going to have to start moving. I turned down a lateral transfer to another part of the country. I ran into the [person who took the transfer] a month later. He just walked right by and didn't acknowledge that I existed anymore. So, I realized that I had caused myself a problem within the company. If I really wanted to go anywhere, I was going to have to move.

One of the things I observed was that one of the advantages to corporations of moving people [around] wasn't the professed thing—cross-training and learning the business—[but] was that it tied you to the corporation. You didn't have the time to make the connections and do all the networking that you do when you're around for a couple of years. [If you stay in one place,] you get to know people. Pretty soon, deals start coming about because somebody knows you or they hear about something or they talk to you.

When I made the decision [to leave the oil company], I deliberately started doing a little more networking. I started looking for other opportunities. I happened to read a blind ad in the Wall Street Journal, for a planning-type person—long-range planning and acquisition. I responded.

It turned out to be [a big regional bank] holding company. Ultimately, I accepted the job. The idea was that we were going to grow into this big financial conglomerate and I was going to do long-range planning and acquisition work. My dream was that I would become a corporate entrepreneur. We would find something that I could acquire and I would get in and get to run it.

Unfortunately, the company—through strategic decisions that had been made before I got there and a changing economy—got into a lot of trouble. Ultimately, it didn't survive. It was split up and sold off to pay off debts. [But] I recognized that, if you wanted to do things, you were better off in something that was rapidly changing—one way or the other.

I was given responsibility for a number of bad loans and real estate projects that we had taken back. I was given the sort of general thrust of "solve it"—turn it into cash so that we can pay off the banks. [I was] responsible for the marketing and the negotiation and the legal and all of the little nuances that go with it.

I was quite happy and did rather well. Ultimately, [because] a person above me left, I became in charge of all of the west coast operations for the owned real estate. [Eventually] the department was pared down to just myself. I was faced with a situation where it was clear that there wasn't going to be a future at this company. I needed to find something else to do.

I was 37 or 38. I hadn't really started the process of actively looking for another job yet. Through a social contact, [I met my eventual partners]. They'd gotten the idea of starting a real estate auction company. We had done a lot of auctions [at the bank holding company]. I saw it as an opportunity.

[My employer] had had a formal joint venture with another auctioneer, which had just terminated the year before. I went to my superiors and said, "I've got these guys who want to get started. I need to do something on the side anyhow, and we've all agreed that I need to start looking elsewhere. So why not let me put this together? We'll split any income that comes out of it and maybe it'll result in something for me and it can be an opportunity for the corporation."

My boss, who was the head of the company, basically said, "Go ahead and do that on your own on the side. You're free to consult with these people...but you're wasting your time." I suspected—and I still suspect—that he was still involved with the other auctioneer on the joint ventures.

[Our first auction, involving real estate,] was ultimately successful. But it was not as successful as we'd hoped. Costs went way over, not a lot of money was made. But we were off. Two of the partners put a hundred thousand dollars of capital in and we started.

It quickly didn't work out. Between [the money partners'] methods of spending and the learning curves that all companies go through, by the next year we had done several auctions which we'd lost money on. We were about a half a million dollars in bankruptcy, the liabilities exceeded the assets.

We had two contracts left. [Our senior guy] had decided three things: He didn't love it here, his [company in another state] needed him back and he wanted to get the hell out so he could dodge the bankers in case they tried to come after his assets. So he went back. He just disappeared.

I went to [the other money partner] and said this thing is in trouble. He said "Let's do those two. If we make enough money, you can at least get out of this thing whole. And we'll all figure out what we're going to do with the rest of our lives."

The first auction worked very well, and we made several hundred thousand dollars. Then the next one was just an incredible success. We ended up making six or seven hundred thousand on it alone. All of a sudden we were making money. In the mean time, I'd found one or two more auctions. So [the one money partner] bought out [the other] for nothing. I think we paid him by paying him big commissions on auctions for awhile. [So, now one guy] owned it all. He made a lot of money.

There was another auction where we had a lot of foreign buyers. It was the first time [they had come] with translators. It occurred to us that the real estate business wasn't so easy. You couldn't just go do an auction and make a million dollars. You had to do things much more corporately and methodically. You had to dot the I's and cross the T's and do what you said you'd do. There wasn't enough sex appeal to it for my remaining partner. Plus...he was making good money [doing other things]. It was clear to him and to me that the basis of why he thought the real estate auction would make sense for him—that he could use staff from the auction company—wasn't there.

I [told him], "This doesn't work. You've got to keep this business going all the time. You can't take all these people and put them on [other busi-

ness assignments] for four months." So we made an agreement that I would buy [the auction company] from him and we would share some office space and receptionists. But I would have the company as my own with my own personnel and he would keep [his other companies].

I then owned the company 100 percent. That was pretty scary because that was the big entrepreneurial move for me—basically at age 40. I agreed to pay [my former partner] $75,000 for the company. I had some money coming in from another deal...plus an initial $25,000 bank credit line to start up.

What I bought was the name and one contract [and] that auction didn't work very well. It was kind of scary. We suddenly go into a situation where I was taking no salary, was living on borrowed money, literally started putting the house up as collateral. I started getting nervous. It was a whole new level of risk.

I took over in the summer. By the next spring, I was probably two hundred thousand dollars bankrupt. I had at that time two contracts and business was very slow. I went ahead and did the one auction that we had, got a little money and limped forward to the second one—which was at the end of that same year. It wasn't going all that well. I made the promise to my wife that, if the next auction wasn't successful, I'd get out of the business. And, even if it was, I might get out of the business, anyway.

It was barely successful...but it was a turnaround [for us]. All of a sudden all sorts of other business came and the company started growing very rapidly. Then I had another decision to make—and it was one of the times when I changed my mind. During those difficult times I had said, "If I can ever get this thing going, I'm not going to have an overhead over ten thousand dollars a month. And if I can do half a dozen auctions a year and make some good money, that's it."

We did that auction [and a month later] we'd signed three or four contracts. I was all of a sudden hiring people and growing like crazy. Once the opportunity presented itself, I changed my direction. I went for the

growth. I talked a lot with one of the people that I used to work with at [the bank holding company], and put him on the board. He was a finance guy, and he helped me get my bank lines lined up. I sought his advice.

My philosophy is that there aren't many single answers to things. There are an awful lot of areas [where] you can go either way and it probably isn't going to be the end of the world. I think my philosophy on the successful entrepreneur is that you need a couple of very basic principles that set you in a certain direction. You will be a much more successful leader if you stick with those than if you get yourself heavily involved in every little detailed decision.

I've always thought that Ronald Reagan was a successful president. He wasn't the brightest man that was ever president of the United States, maybe one of the least bright. But, on an issue like taxes, he made up his mind that lower tax rates are better for people in general. When a Reagan sat in a meeting—or, on a much smaller scale, when you're president of your own company—competing forces will come in with their arguments. And [if your people are good] they will have very good arguments, so you need guiding principles.

As I get more comfortable with people, I decide how much I wanted to delegate to them. I think you have to be pretty Machiavellian to be an entrepreneur. The kinds of arguments people make, the kinds of process that they go through, the degree to which they participate in the process...[these things] tell me a lot about how much I can trust them to run [parts of the company].

Reagan was a successful president because he had a guiding principle. He wouldn't get confused with all the arguments. He'd simply say, when it was all said and done, does that mean more taxes?

In business, we have to do the same thing. My guiding principle was that I was going to be number one [in my market]. I picked a business that was very small, that required very little capital to get in, and that could quickly become a dominant force in the business.

Because my principle was find a niche of the market and stay in it, [there were deals] I said we wouldn't do. I resisted the temptations to go into art and antiques and other things. We did a few of those things as accommodations for people. But generally I said no [to such offers]. I wanted a niche—real estate marketing via auction. I believed that that was going to grow very rapidly.

The only time I got crazed was when I violated my principle, and it caused me a lot of trouble. I got too academic and said, "We've got all this opportunity here. Why don't we vertically integrate? We can have an escrow company and do all the escrow business." On the auction side I was about to lose a very important person because she was just getting worn out. [About the same time] somebody came to me and said, "Why don't we start a real estate marketing company? We'll try to market tracts because it's related to your business."

It was related and I was about to lose this other person. It was a perfect place to put her, so I started these other two companies. I lost between four-hundred and six-hundred thousand dollars before I got them both shut down. They dissipated energy [and] a lot of assets. They failed, in part, because I didn't spend any time with them. I gave them to people to run and gave them non-equity equity deals, where they would get a percentage of profits but they were still getting a salary and all the rest. They didn't do it.

We were making money and it was the idea of growing more and getting bigger...being able to have more control of your total operation, particularly on the escrow side. There was some logic to the escrow business because we'd had trouble with closings. I thought if I could get my own company with my own people I could have more control over the closing process in real estate.

If I'd been more analytical about it, particularly on the closing problem, I don't think I would have come to the decision that I ultimately came to. [The decision to close the escrow company] was more analytical. It was realizing that the escrow company didn't solve anything and that we had to come up with a solution because we were getting into a growth [pe-

riod]. It was becoming our Achilles heel, for our competitors to attack us. What we finally figured out we had to do was be more like a conventional broker. So we created a department to do that bird-dogging. That was a better solution than trying to have the escrow company.

We grew to a hundred-million dollars in sales. We got there with me and one or two other people. So, in order to grow, we needed to develop other people that could go out and sell the auctions. It was partly my own weakness and not being able to train and communicate to people. [It's] a complex process, understanding everything that [my company] does; and you have to [understand] that in order to effectively sell what we do. It's a common problem.

I took the best person that I had in the business development department. He wanted to be a manager, but I don't think he was really ever good at that. He was a fine salesman and should have stayed as a salesman. I put him in charge of the department because I didn't want to run the department. By taking him out of the field to spend more time managing and less time selling, we started floundering. No new contracts were coming in. A year later...we were in trouble.

Until then, we'd basically done what I call project auctions. We'd do the twenty houses or the hundred lots or...whatever. Then we finally did the first really large scattered-property auctions, where we had a house in this city and a condo in that one...property all over a large geographic area. Instead of having fifty or a hundred houses in one spot, we only had one house here, one there. We had a large auction [in which] we could market many properties at once. But, within that, [we could have] a couple individual auctions—so we didn't have oversupply.

We got great results. I said, "If I can get the market to figure out a way to make this work, this is where we're going to have the steady business." I thought I'd be able to pull that off and get regular auctions going. That's when we moved here. We had done a number of scattered auctions for various lending institutions. I set up the operation in anticipation of continuing that business and growing it.

[But] once the lending institutions got their portfolios cleaned up, we were never able to translate those scattered successes into regular auctions. We've never been able to figure out the delivery system to get the properties all together. And so we continued to do the scattered auctions—but only when we have a major institution who provides us with a basic group of properties.

I made the strategic error of anticipating a growth in business and gearing up for it on the operations side before I got it on the business development side. And then it didn't come. So, I [had to face] the hard survival decision process of cutting back and laying off people.

I try to keep people well informed. But there are some areas that I will keep to myself. I've learned that you need to keep some things from the people. I'm not totally open anymore, I don't think you can be totally open and run your company. You've got to keep your private counsel on some issues—particularly issues that involve major change, because people tend to get too nervous.

If you're going to cause any major directional changes within a company, you're much better off doing those as surprises. Get your ducks in order and then spring it on everybody, as opposed to letting rumors get started that all these things are going on.

I've found that the good people tend to come and ask questions about the [important] things that you're withholding from them. And they make suggestions in those areas, when they know that you're open to getting ideas.

I make an awful lot of decisions when I'm working out in the evenings. I'll make decisions in the process of exercising—running, walking or riding a bike. I'll also make an awful lot of decisions in the shower, in the morning. I don't often wake up at night, only in moments of major crisis. A couple of times I've not been able to sleep through the night.

I think that the process is going on while you sleep, maybe you get up in the morning and you're in the shower and thinking about that's going on

today and I'll make the decisions then. Things that involve fundamental sorts of shifts I will tend to stew with for a long time. Months.

I think I'm typical of many people. I will procrastinate on something until I have to make a decision. I'll create little traps for myself where I force myself to make a decision. I'll set up a meeting with somebody, knowing that that is when I have to make a decision. If I'm chickening out on [a hard decision], I'm very good at creating a situation where I can't get out of it. I'll box myself into a position where I have to make the decision.

I'm quite ready to change direction if a decision's wrong, but I tend once I've made a decision to stay with the decision. I use a military analogy, one that I bought off on in military training: When you're faced in the combat situation, you basically have three decisions. Either you go forward, go back or do nothing. And the one thing that is almost inevitably the incorrect decision is do nothing. So I will tend to make a decision [to go] somewhere.

I'd say that I recognized that I had Peter Principled in terms of entrepreneurial growing my company, I got to the point where I was screwing it up, and probably needed somebody else in there. Agreeing to the Peter Principle part wasn't so hard, bringing somebody else in was hard.

I finally decided that I had to [find some partners]. There was a high probability that the company wouldn't make it financially if I didn't. I figured [I'd] give this a shot and see how it worked out. A [group of] people approached me...one of their people [is someone] that I used as an adviser, the fellow who had once hired me. The initial motivation was the acquisition ability [my company had]. There was [an] area where you could make a lot of money. [Some of] the lenders that had projects backed—who wouldn't let us retail them—would bulk-sell the [projects] at a price at which you could turn around and make money.

I needed expertise and personnel, and that was what this group brought. I felt that the company needed a little bit more of the thinking of...the person is motivated by the bottom line. I needed a balance. I say, "Let's

do it right, and the bottom line will take care of itself." I felt that we needed somebody who said, "Let's do it well. Let's make sure we make a lot of money and then we'll worry about doing it right."

It solved some personal situations for me. I was able to get some money. Three new people came in. They bought three fourths...we all owned 25 percent of the company. I started turning over a lot of the decisions to them. I felt partly reasonably resentful because I didn't like a lot of their decisions. We went through a very difficult honeymoon—we got into it pretty heavily, immediately.

These people would come in and say "Do something." And I would say "They're full of it, don't do that." [The employees] were loyal to me, but they also had their jobs and they needed [consistent direction]. They were torn the most.

It's a philosophy of life [I support] that you take what is and go forward from that. That can work against you, but it's a basis for all my decision-making. You learn from the past, but you don't dwell on it—and you don't worry about it. What is is. Learn from [the past] and go forward. The important decision is how do you go forward.

Would I go back three years and make the exact same decision? Maybe not. But that's immaterial. Try to make tomorrow as good as you can make it.

I thought about it. I've never been any good at saying no to business; as soon as the business was available, I started saying yes. In terms of decision-making, learning to say no to a deal has been one of the hard things for me. Taking it as a personal affront when somebody does business with one of my competitors was probably a trait that helped us be successful. I did—and I still kind of do—take it as a personal affront that somebody would not understand that we're better than [our competitors].

We're big enough now that it doesn't bother me very much but for a long time it did, the industry was so small that we should have had a shot at virtually every deal out there. If we didn't get it, we did something wrong.

My philosophy on communication is that, ultimately, the responsibility lies with the communicator. The receiver has to participate. But, if the receiver doesn't understand, the person who is doing the explaining didn't understand the receiver's needs well enough to get the message across. I leave the responsibility of teaching on the teacher as opposed to the student. The student has to cooperate—but the teacher's got to figure out a way to make the student listen.

I don't deal well with conflict. I hate conflict. I try to avoid it a lot. It was one of the reasons that I went to managers, so that I could let them deal with the conflicts—particularly personal conflicts. I didn't want to be involved in the conflict. I try to set up an organization that will insulate me from it. I try to manage by creating a situation where you don't need conflict.

What we do doesn't require a huge amount of intelligence. It's not complicated. But it does require attitude. You're going to succeed or fail here by attitude. You end up tending to hire that way. I made a conscious decision for a long time to hire only people who knew people. If we needed somebody, I would go around the company and say, "We need such and such type person. Who knows somebody?"

I'm 51. I've gotten tired of the conflict and the pressure [involved in running a business]. I have started actively trying to figure out ways to get insulation, so that I don't have to deal with the conflict. That's one of the things that I've used the three other partners for. I've said, "What I enjoy doing is what I did yesterday afternoon and this morning. I enjoy putting a deal together. I'm going to spend all my time putting deals together. If somebody wants to sue us, you deal with it. If somebody's unhappy with their job, you deal with it, I'm not going to deal with it." I've insulated myself that way.

I don't feel a compression of time, in terms of things I've felt I had to get done. I'm not going to spend time doing things I don't want to do anymore. I'm either going to delegate it or ignore it.

I'm not going to live full-time here too much longer. I'm going to get up to the mountains. And I'm not going to work seven days a week at the auction company for a long time longer. I made that decision a couple years earlier, but [being in my] fifties brings that a little bit more to the fore.

I think a combination of ego and a degree of self-confidence [is necessary to form an entrepreneurial sensibility]. The really insecure person is going to have much more trouble than somebody who ultimately may be insecure but has a fair feeling of self-confidence and an ability to be...as objective as anybody can be about themselves. I don't think any of us are ever totally objective about ourselves, but that's a trait I look for.

I've already got [something new] going...a retail operation [in a mountain resort town]. I've got a friend who has businesses up there now...and we already bought a piece of property on Main Street....

I haven't figured it out yet—whether I could totally get out of the business in terms of ownership or retain some. Either way, I'd like to get to the point where I'm of counsel. I can go in and do enough business development to help the company and make myself some money. And I could do that out of my place in the mountains.

Getting back to business and the decision-making process, one of the things that I keep emphasizing is [that] you have to work day-to-day but make decisions in terms of the long run. I've always said the company will give our clients the best advice we can, because we want to be around. We want your business this year—but I also want it next year or five years from now. We intend to be around in the long run.

I've said to everybody, "Don't ever make the short term decision. Make your decisions based on something that you can live with a year from now—or two."

Personal values are by far the biggest influence on my decisions. While money's important, it's more important to me to do a job well and have it reflect well on me. I think [this] is my personal insecurity more than anything else. But it's the driving factor.

[People who don't articulate] a few core principles and stick with them...go by the wayside. You either find them out and get rid of them, or they aren't comfortable and they disappear.

Never bullshit a client. If you think it's worth a hundred dollars, tell them you think it's worth a hundred dollars—even if they really don't want to hear that. Produce what you say you can produce. [Do] things in such a way that you feel good about yourself, that you provided a service for somebody and they got their money's worth.

Money's important. You need to keep the place running. But the addiction of the business is the high that you get at the auction. It's the high that it worked, not that you made money. And the adrenalin pumping comes from the fact that you know it might not work. That's the risk. I think it's true for entrepreneurial people—they want that adrenalin addiction.

[For a long time,] I went into extreme depressions an hour or two after an auction. It's a little like a football game. You have the adrenalin rush and you work hard leading up to it—then you get the rush from the auction. Then you relax and the adrenalin rush goes away. It's not a depression in terms of you're feeling black. It's just you're tired...you've had it...you don't want to do anything.

I think that entrepreneurs do a lot of that, the risk-takers. I don't think people take risks simply because of some love of risk. It's the love of the high, like the gambler's high. And I've always been addicted to it. Before...the auction company, I used to gamble a fair amount. Not a lot of money but enough that I got the high. I would go to the racetrack and I went to Las Vegas.

Part of my personality is I think I saw too many grade-B westerns when I was a kid. The old rule of the west [was] that your word is your bond. Even if you change your mind later, if you made a commitment to something you stick with it. I learned pretty quickly that not as many people watched westerns as I did.

[Still,] that rule tends to dictate a lot of my behavior. And, quite frankly, it causes a lot of trouble for me in business. I tend to say if I'll do something I'll do it and stick with it—even if I wish later that I hadn't said a word. That's one of the reasons I suspect we'll never be successful in doing any government business. We always make our proposals on the basis of what we can and will do—and price it fairly. Our competitors make any promises, never have any intention of keeping them and don't deliver. They get the job and the government gets bad service.

I wish there was some sort of more mystical process that I went through—but there really wasn't. It was pretty straightforward.

14 ✍

Make Up Your Mind

Amid the richness and diversity of words and stories you have read in this book, it is easy to lose sight of their lessons. The most salient lesson is that awareness of self—*awareness of mind*—is critical to making good decisions. *Awareness of mind* is the intervening quality between our general knowledge of how to make good decisions and actually making them.

This central theme—the importance of *awareness of mind* in making good decisions—has emerged from the words and stories of these entrepreneurs in three parts: the process of their thinking, the patterns of their thinking, and the personal principles which determine their purposes.

The process of entrepreneurial thinking and decision-making illustrated by these words and stories is a rhizome. It is crab-grass-like thinking that is opportunistic, discursive, meandering and unstructured. It is personal, contextual and situational. Experimental, it finds

new ways to make connections. Innovative, it sees unique paths for progress. Exploratory, it maps new territory. All the while, it stays attached to what came before—it is rooted in substance and sustained by its roots.

At its best, this process embodies flexibility informed by principle and an attitude of openness to opportunity that serves principle.

The *patterns* of decision-making these entrepreneurs describe combine analysis and emotion. Each pattern uses one and then the other element to arrive at a decision. The stories in this book suggest that each of us has an instinctive, habitual pattern of inclining toward either analysis or emotion when faced with a decision. To be effective, we must validate or negate that inclination by attending to the other—by using *analysis supported by feelings* or heeding *emotion confirmed by data.*

These elements—analysis and emotion—are connected through the interweaving, and further validation or negation, of *intuition.* Intuition is not emotion, nor is it feelings, nor is it mysticism. It is our tacit knowledge of the matter at hand, our unconscious knowledge. It is a product of our experience and specific expertise and, therefore, favors the experienced and the expert. It is our most important decision-making tool.

Other tools of decision-making include dynamics of the self at work and working with others. Our skills with these tools and our knowledge of how to use them effectively determine the quality of our decisions.

Tools of the self at work include thinking, reading, writing, focus, creativity and introspection. Tools of working with others include consensus-building, listening, planning, strategy and negotiation.

Decisions are also influenced by other people and events and experience. Again, our skills—particularly our ability to learn to listen—and our awareness, strongly determine whether the influence of others will be effective and valuable to us.

The greatest influences on decision-makers are their personal principles. These define us as human beings, determine our purposes and drive us toward the decisions that achieve our purposes.

The entrepreneurs in these pages say that only rarely, and with the most extreme and long-lived pain, do they make decisions that run against their deeply-held personal principles.

Making good decisions comes from an awareness of all of these forces—from an *awareness of mind* and our process, patterns and purposes. Only with this most personal knowledge can we put to good effect the other aspects and general rules of making good decisions.

The key to good decision-making is knowing ourselves and how we think. As decision-makers, we need to know what we want—and how we want to reflect back on a well-lived life—and to be guided by that knowledge.

Other Steps to Good Decisions

What else do these sixty entrepreneurs say about good decision-making? They stress flexibility and fluidity and an appreciation for variability, as well as an understanding of their discursive and unstructured merging of analysis and emotional decision processes. They would recommend real-world training in the attitudes, experiences and skills of flexibility, fluidity and variability, since those are so uncommonly found in the literature or in academic programs.

Necessary, too, for good decision-making as these entrepreneurs described it, is clarification that intuition—or their tacit knowledge—is a tool of the experienced and expert, and, wherever it might be acquired, it is applicable to only relevant issues. It is a decision tool best acquired or developed through intensive or extended experience in some area of knowledge and then applied to that same or a similar area of knowledge. They would say it does not translate well.

Other important attitudes for good decision-making, based on their own experiences, are genuine empathy for others; an eagerness for opportunity (because "good decisions are made out of feelings for opportunity"); and a clear understanding of risk (which includes the certain knowledge that "it could happen to me").

Necessary also is knowing that our most significant, far-reaching strategic decisions deal with conflicts, dilemmas and paradoxes that do not lend themselves to conventional approaches or structured decision-making; and knowing that the inapplicability of the lessons of yesterday's success will increase more rapidly than we even can imagine. These entrepreneurs would say we need new paradigms for decision-making and new principles for judgment—such as the old fundamental ones, those of the Golden Rule that many of them described as the basis of their own decision-making.

The Proper Education of an Entrepreneur

Virtually every essay on entrepreneuring ends with a curricular recommendation or two for the proper education of the entrepreneur, most directed at improving entrepreneurship programs. What might these entrepreneurs add? Certainly they would begin by recommending a solid grounding in ethical principles, preferably through an evolving, step-by-step learning of the kind that teaches the student entrepreneur how to fish. They would recommend concentrations in how to be conscious, to be aware, to feel, to be thoughtful, to seek perspective, to consider diverse options and welcome diverse opinions, how to focus on others and relate to others, how to manage and how to lead, and how to live a balanced life—with emphasis on the attitudes of each, rather than the tasks.

Big curriculum! They might say that it is probably most accessible in a good, classical, liberal arts program, rather than in a business school. Many of them also would recommend that the would-be entrepreneur first go to work in an established organization, to learn firsthand, on that organization's time and money and through its resources, the attitudes and skills of cooperation, teamwork, management and leadership that will be essential for his own company's success. And

they would recommend that he acquire first-hand, through concentrated experience in an industry that interests him, that focused expertise which is the basis of the intuition that he will need to inform his decision-making.

Leadership

Perhaps one of the most interesting of all other maps in which to continue the exploration with these entrepreneurs is the subject of leadership. (With a few exceptions, "leadership" and "management" excerpts from the interviews also are not included or examined in this phase of my study.) These entrepreneurs were fundamentally concerned with becoming better leaders and managers. There was no question among them of the strength of their influence as leaders, or the weight of that responsibility, or of how desperately people wanted leadership from them, or of what tremendous impact they had when they were leading well. They made some interesting observations about the differences between managing and leading, and yet they also frequently used the terms interchangeably.

Some of the specific, significant issues of their decision-making are also issues of their leadership, such as their eager and proactive approach to learning; genuinely valuing adventure and fun; managing the psychological issues of their roles; working with and through other people; preoccupation with the effects of change on their organizations and on themselves; being grounded in a system of personal beliefs that are fundamentally secure; and understanding the power of their leadership for better or for worse.

THE MYTHICAL "TYPICAL" ENTREPRENEUR

This book concludes now with the story of a mythical "typical" entrepreneur who is an imagined amalgamation of the entrepreneurs whose words you've read.

The typical entrepreneur in this group of sixty (ignoring the countless distinctions among them) is male, white, in his early fifties, married for the second time (he had married very early the first time),

with two young-adult kids who are starting in careers outside his business. His wife works part-time in an unrelated field. He has a bachelor's degree from a good university, in engineering or business, has been working since graduation in the same or a closely-related industry, and has years and years of experience and expertise, and therefore intuition, in his business. He founded the company that he runs and he had a partner, but the partnership ended rather badly (about which he feels somewhat regretful) and he clearly prefers to be the undisputed "number one." He does little except work, although there are a number of other things he thinks he'd like to do, or learn about, later when he thinks he'll have more time away from his business.

The company is profitable, but not hugely so, and affords him and his family a comfortable living. He and his wife like to travel, and when they are out of town he leaves the business at the office. Otherwise it is rarely off his mind. He describes thinking about business decisions almost all his waking hours and acknowledges that he's obviously doing a lot of unconscious work as well, often waking up in the middle of the night or very early in the morning with a developing decision. His thinking sometimes is very random, jumping from this issue to that to another in the space of a few minutes, sometimes coming back to the first issue later, sometimes to his surprise. "Nothing linear about me!", he says. On other occasions, especially if the decision is a very important one, he'll stick to the issue or keep coming back to it until he has something that seems right, given the information he has, and that also feels right to him. He works hard at trying to make good decisions—at being more fully informed and better prepared for the opportunities he discovers, while also paying close attention to his feelings.

He has had both some serious health problems and some serious business problems. He is increasingly aware that he wants to do more with his life, including making some personal contribution to make the world a better place. Still, he identifies very closely with his company and feels confident and happy when the business is doing well. When it isn't, both he and his self-confidence suffer markedly. And he becomes less thoughtful of others, including both his family and his employees.

The typical entrepreneur runs his company very leanly, more so than he had in an earlier, heartier economy. He likes and respects his key managers, but he doesn't feel comfortable that they have adequate, "green-and-growing" younger managers coming up. His toughest decisions are hiring decisions, especially of key people. He tends to hire emotionally and to trust that the people he hires will come in sharing his values and soon learn to share his vision. That hasn't always (or often) been the case, and almost all of the decisions that have not worked for him have been people-related decisions.

Aside from not hiring well, his major business problem is the rapidly, and confusingly, changing industry environment, particularly government policies which he feels damage his ability to make a profit. His major business challenges are, one, increasing sales and, two, increasing sales without letting costs overwhelm them. His major personal challenge is learning to really listen to his key people. He really believes he has the best answers to most issues (after all, he's been doing this successfully for a long time) and that he can make the best decisions (he's the one with everything invested in the company, and the one signed on the personal guarantees, isn't he?). But he also knows that his people often have good ideas, too, and that if they don't sign-on, the work won't get done or won't be done well.

This typical entrepreneur is somewhat afraid that if he gives other people more to say in decisions, he may lose control of the direction of his company. On the other hand, he understands that his people are the key to the company's long-term success and to his ability to someday get more time away from business. For all these reasons, he genuinely wants to be a better manager.

He is just learning to think strategically. He thinks he is too busy running the company and earning a good living to spend much time thinking about exactly what he wants to achieve for the company or for himself and his family. He knows that too much of his time is spent putting out fires or solving short-term problems. But he is beginning to realize that he really needs to start some personal planning—last year's bypass surgery convinced him that he's not invulnerable after all. He has gotten where he is without much thought

about how he was doing it or where he was heading; introspection has not been one of his strong suites. Now with some prodding from his wife and his friends, and some nagging from his own gut, he is beginning to think more about his personal future.

In our interview, the typical entrepreneur's initial explanation of his strategic decision-making process was a shrug and an "I don't know." On reflection, however, he described recurring patterns of thinking and deciding as "my process." The language of his reflections and recollections was often poetic and eloquent, rich in metaphor and moving in its evocation of his feelings.

His strategic decision-making has changed somewhat over the years, becoming more conscious, for one thing, but it follows a general pattern that combines analysis and emotion. He makes significant decisions, which usually turn out to be "turning point" and strategic decisions only in retrospect, using both his analytical abilities and his emotions, and he is aided by his intuition.

This group of real entrepreneurs described what are essentially two different patterns of decision-making. One pattern is what I have called "analysis confirmed by feeling." The other is what I have called "emotions supported by data." The general drift of each decision-making pattern is that the entrepreneur's decision process begins with analysis (what the data and his head say) or with emotion (what his gut or "epicenter" or heart says). It proceeds pretty much on one track or the other, until there comes a point where he switches to the other track for back-up. That is to say that a decision reached through analysis is confirmed by his feelings about it or a decision reached by heeding his emotions is supported by the data that he has gathered.

Neither decision process is ordered or structured or methodical, nor replicated for every decision. Each is meandering, opportunistic, and discursive, proceeding in a crab-grass-like manner that I have called a "rhizome," following Deleuze and Guatarri. Nor is the "typical" entrepreneur usually conscious of using his decision-making process, so deep-seated and habitual has it become. But he is comfortable, and practiced, at beginning with either analysis or emotions, and at

relying primarily on that process to reach a tentative decision. He doesn't, however, always start with the same process—or even go through the entire process. It depends on what is happening around him, who else he might be listening to, for example, and on the nature of the decision. For example, this "typical" entrepreneur thinks that certain kinds of decisions should be made primarily by his emotions—such as hiring decisions. On those decisions he tends to short-cut his data gathering and analysis, and he almost always makes a bad decision because of it.

The role of his back-up decision process, whether it is feeling or data, is to confirm and support the tentative decision of his primary decision process, analysis or emotion. Almost never will the typical entrepreneur go forward without that confirmation of his decision. If his feelings do not confirm the analysis, or if the data does not support his emotions, he will stop, delay, and put the decision aside or consider it again. This is particularly true as his thinking becomes more sophisticated (older and wiser) and as his decisions become more important, more long-term and more clearly strategic. When he fails to work the whole process—combining analysis and emotion in his decision-making, leading with one and confirming with the other, in whatever way is comfortable for him—he almost always fails to make a good decision. Neither his analysis nor his feelings, alone, provide enough information for good decisions. As the consequences of his strategic decisions weigh more heavily and cast more broadly with the years, that lesson doesn't often need repeating. "Nothing teaches like failure," he says.

In either case, whether his preferred decision process is "analysis confirmed by feeling" or "emotions supported by data," intuition also plays an important role. Where it has some applicability to the decision being made, his intuition serves as interpreter of both his feelings and the data. "Intuition" is a squishy word, of course, subject to too many interpretations. But its meaning for this group of entrepreneurs is that very high level of expertise that allows them to make knowing decisions very rapidly. They described it as a high order of expertise developed out of a high level of experience. It is neither magical nor mysterious. It is that they know what they are doing,

know what decision is right, without thinking consciously about it, because they have been doing it for a long time and because they are experts at making both that type of decision and those particular decisions. They are not intuitive about everything, but only about the areas that they know well from their experience and expertise.

Also in either case, regardless of how he combines analysis and emotion in his decision-making process, the entrepreneur reaches into his personal collection of "decision tools" to help. I have called these tools the *self at work* and *working with others*. Tools of the self-at-work include thinking, reading, writing, being focused, creativity, and introspection. The typical entrepreneur is thoughtful rather than impulsive, and his thinking is of a "mulling" and "wandering-around" nature—again in the manner of the rhizome.

This typical entrepreneur reads quite a lot, mostly journals related to his business. Only infrequently does he use writing as a decision tool, although it is one of the things he thinks he probably should learn to do. He is very creative, and proud of it, but he is not very focused. This, too, is something he thinks he should improve, not only for his thinking but also for his listening and leading. The most important and most difficult of the decision tools in his collection is introspection. But unless forced to it by a personal or business crisis, he doesn't think he has time, or isn't comfortable, being introspective. Reluctantly, he is working on getting better at being introspective, too.

The most often used *working with others* tools for this group of entrepreneurs were consensus, listening, planning, developing strategy and tactics, and negotiation. The typical entrepreneur is quite skilled at developing consensus among his management team. He often uses it to get people to sign-on to his goals and objectives and to what he wants them to do.

The typical entrepreneur also is learning to accept the influence of others (most of the time), to listen to some others (people he likes) and to integrate their ideas in helping him make decisions (most of the time). He recognizes the value of the opinions of his key people. He is working hard at becoming a better listener, but it's often a real

struggle for him to focus on what someone else is saying. He used to take pride in being able to think about a dozen other things while talking with one of his people, but he has become increasingly aware that he is both missing a lot and, more importantly, failing to give his people the attention and respect they deserve. He didn't like hearing that from them, in a recent team-building meeting with an outside facilitator, but he has accepted it and is trying to change.

He quietly uses listening in a variety of ways—for feedback, to get information, to learn, to promote training and team building and to test and evaluate his employees. He usually tries to give his management team room to be creative, to make mistakes and to learn. He is trying to learn not to shoot the messenger. But he still retains, and sometimes forthrightly guards, his right to make the ultimate decision.

Planning is something that happens to the typical entrepreneur, rather than being a decision tool that he uses effectively or often. But he is getting better at planning, too, because the rapid changes and increasing complexities of his business and of the industry and government environments make it essential.

He is a practiced and skilled negotiator with both individuals and small groups. He is very proud of his ability to sell and to cut deals that are fair to both sides. He feels the same way about his decision-making. Nothing is more important to him than his integrity and his credibility. He will go to almost any lengths to maintain his reputation, perhaps especially in his relationships with people outside the company.

He does not suffer partners gladly, unless they happen to have an irresistible combination of complementary skills and diplomatic sensibilities. His own partnership experience had neither of those values, and he is glad to be out of it, although getting out of it cost him both anguish and money.

He is very sensitive to his customers. In fact, he defines his success largely by how well his business serves them, and especially by his company's retention of fine customers.

The typical entrepreneur does not have a board of directors, but he does belong to a group of company owner/president peers, who help him look at himself and his business and who bring many new perspectives and resources to him that he wouldn't otherwise have. He is not yet comfortable with the idea of having to be accountable to a board, however, even a board of advisers. His owner/president peer group strongly recommends that he form one, and he is exploring it in the back of his mind. He places a great deal of weight on what his peer group says, both out of respect for them as individuals and businessmen and in acknowledgment of the tremendous help and support they give him. He also uses the group effectively in working through his issues, and he feels less alone at the helm because of it.

The importance of his family is growing for him every year. Not that he didn't appreciate them during those years when he had been concentrating so much on starting the business, but he has realized lately how much pain he may have put them through in those early years and how much they mean to him. His wife had worked in the business in their start-up years, but he found it difficult to deal with her opinions when they differed from his. They finally decided that their relationship at home was suffering because of it, and since he didn't feel he could change, she no longer works actively in the company. He really enjoys talking with her about the business and relies greatly on her intuitive judgments. He also knows she's on his side ("against the world," he sometimes says) and their marriage is a great source of peace and stability for him. His relationship with their kids is better than ever. With career interests of their own now, they seem to really like talking with him. He's finding that he is a very good mentor to young people, including his own, and that's giving him a lot of pleasure. He is looking forward to spending more good personal time with his wife, and hopefully with them, in five or ten years when he will be thinking about working less, retiring or perhaps selling out. He resists thinking about just how he will "exit" from working full-time—the very idea makes him distinctly uncomfortable, and it also seems unnecessary at this point in his life. However, he has seen several older friends stumble badly in trying to manage their succession without having planned for it, so it worries him a little.

The typical entrepreneur also describes the influence on his decision-making of luck (he thinks he is very lucky) and timing, and of a myriad of other factors and changes which he can not control. He had learned a great deal from his early work experiences and early family influences and, especially, from the failures he experienced as he grew in his career. He hadn't particularly liked college and had been eager to get out and do his own thing. In his case that meant being his own boss. He had gotten an early start on that by starting this business just as soon as he could. He had seen an opportunity and jumped at it and had been quite successful almost from the start.

He has found, however, that his lack of organizational experience, especially his lack of management experience in organizations, impacts on his own ability to get his people involved in decision-making and in carrying out his decisions. He sees to his chagrin that the other owner/ presidents who had learned how to cooperate in groups and manage in organizations have a far easier time of working with and through other people to make things happen.

Interestingly enough, he is instinctively quite good at some of the essentials of leadership. He has a strong vision for the company and is able to communicate it clearly and well. And his optimism about the business, and his strong moral values, permeate the company. But he has found that that doesn't always translate to getting the work done. So he is working on being a better manager and a better leader, although it annoys him a bit that he has to think about these things in addition to the other problems of running the business. He sometimes feels that he has two different, demanding careers—one doing what the work is and the other managing. He's very good at doing the work and is proud of it.

The typical entrepreneur is actively committed to learning. He tries to come away from every experience and encounter with some new knowledge that he can use in his decision-making and in the business. And he goes out of his way to learn new things about the business and the economy—reading, attending seminars, talking with other people in the industry—as well as about the other things that interest him. Currently he's serving on a community task force.

The typical entrepreneur also is actively committed to doing the right thing for other people. He feels pride about the number of jobs he provides for people and for the training programs his company sponsors. He had felt better about the benefits program they had offered formerly, than he feels about the package they can afford to offer now. But various state policies and the high costs of medical insurance and the workers' comp crisis have left him no room beyond the mandated minimums. He often wonders why the government doesn't do a lot more to encourage entrepreneurial companies such as his. All the reports are certainly clear enough that it is the mid-size and smaller companies, the entrepreneurial companies, which produce most of the country's wealth. He's thinking of seeing if he can help do something about it.

His strategic decision-making, and indeed all of his decision-making, is motivated far more by his fine personal principles than by his interest in making money. Money is primarily a way of keeping score of his achievements, although there are a lot of things he wants to do with more profits.

This typical entrepreneur truly values trust and loyalty and compassion, and tries to conduct himself and his business in ways that reflect well on him and on the company. He had learned in some earlier experiences that lying both complicated his life beyond reason and made him miserable. He had resolved then to be honest about everything, even at the expense of profits, and to protect his integrity and credibility at virtually all costs. He insists that his values—honesty and honor, trust and concern for others—be the hallmark of his company and that business decisions be made always with an eye to maintaining long-term relationships. It has paid off well for him and for the company in spite of some short-term disappointments. He and the company are regarded with respect by his employees, his customers and his vendors. Even in bad times, his bankers know they can trust what he tells them.

In addition to the success of his business, and to having enough money to live comfortably, he enjoys the feelings of being in control of what happens in the business. Although he really likes his work, he doesn't like working quite so hard anymore, and he wants more free time, and he wants to have more fun. Having fun, in fact, is very important to him. His decisions are motivated by all of these things, fun and freedom no less than money and control, and honesty and credibility above all.

As he has begun to think more strategically about his and the company's future, his decisions have focused more on achieving some degree of financial security and less on looking for "home run" opportunities to exploit. The problem is that the amount of security he felt he needed keeps going up—last year he wanted two million in the bank before he felt he could relax a little, this year it's more like four million. That is going to take him a while, and require finding some good opportunities and taking some big risks. And probably signing more personal guarantees, in spite of the excellent advice he gets not to sign any more of them.

The typical entrepreneur has not yet suffered any enormous losses, but he has friends who have and he has seen them change from being productive decision-makers to being paralyzed. He really doesn't think of himself as a risk-taker. He says he is always careful about what he gets into, although he admits to never really considering the downsides of the opportunities he really likes.

The typical entrepreneur does have a great eye for opportunities. One of his problems, in fact, is that there are so many good opportunities today. Too many for the resources he has. A few years ago, he just would have gone for it and figured out later where to get what he needed. Today, however, he can't help but be aware of how many things he cannot control, and he is beginning to wonder if he understands risk any better than his friends had. One thing he's sure about is that he has to be more thorough, more fully informed, in his decision-making in the future.

On one hand, he's somewhat nervous about the future, afraid that business won't stay as good for the company as it has been. On the other, he's excited about the new products they are developing and the enthusiastic response from their customers. In addition to his usual optimism, he is thinking about the future with some uncertainty, and he's hesitant about some of the major decisions he's facing. "Probably just a reflection of the weak economy," he says, and the fact that he is thinking more about eventual changes in his own work life.

He recently heard a good speaker say, "We are the sum of our decisions," and he can't get that off his mind.

Appendix A ❧

What an Entrepreneur Is

What is an entrepreneur? The word "entrepreneurial" seems to be a high-tech rubber band, capable of being wrapped around virtually any phenomenon which has an aura of cleverness, creativity, newness or apparent riskiness. Its definitions and extensions are almost endless, from the 1980's "paper entrepreneurialism"[11] to the 1990's "entrepreneurial government."[12]

And its old myths are very old, having to do mostly with inventors and robber barons, rather than innovators and company leaders. Its many popular definitions[13]—which tend to take in anyone who starts anything, at best, and anyone who is trying to make a fast buck, at worst—are too inclusive, too indiscriminate in implication, to be taken seriously.

Early scholarly definitions were too narrowly psychological to be appropriate for a phenomenon that is primarily situational and whose outcomes are primarily economic.

Interest in studying entrepreneurship may have begun as early as the 18th Century, with Richard Cantillon's descriptions (published in 1755) of the entrepreneur as "risk taker" and as the "equilibrating mechanism in a market economy."

In a general sense, two changes have taken place in the evolution of the concept of entrepreneurship. One has to do with whether it is the entrepreneur—or the entrepreneur interfacing with his or her environment—that is the essence of the phenomenon. The other has to do with how the concept of entrepreneurship changes with the economic environment.

If we look at the writing about entrepreneurship in America, we find that its shifts reflect larger trends. In the late 19th century, as the country was beginning to industrialize, the captains of industry (robber barons included) were described in larger-than-life, mythical terms. Their stories emphasized the individuals. These were folk heroes—men who were strong enough to oppose conventional wisdom and grasp or create economic opportunity that others didn't see.

From the 1920s to the middle of the 20th century, as the businesses the folk heroes founded grew in size, complexity and power, their needs—and the needs of the nation as a whole—changed from conquest to management. The entrepreneur was no longer so important to the economy or to his business and interest in him declined. The values of what Alfred Sloan called "administrative management" were exalted. Masterful studies of the forms and functions of corporate business were written. They became the foundations for business education and public policy debate.

As the American economy deteriorated in the 1970s and 1980s, the nation's needs changed again. Interest in entrepreneurs was catapulted to center stage with the publication of several studies that showed small businesses created most of the country's new jobs. Journalists and scholars (most of whose backgrounds were in psychology or sociology—not business) announced that the old phenomenon was new again.

322

Entrepreneurship was again seen to be relevant to regaining the health of the economy and competitiveness in the world. Research interests shifted to figuring out and—if possible—to teaching the techniques of entrepreneurial behavior. It also shifted to trying to develop some guidelines that would help the nation help the phenomenon along.

Modern scholarship—focusing on economic outcomes—is very useful. In this context, the study of entrepreneurs is usually credited to Joseph Schumpeter[13a]. Schumpeter regarded the entrepreneur as a "disequilibrating force" in the market economy and as an innovator in the renewing process of "creative destruction."

The debate over the role of the entrepreneur—as equilibrator or disequilibrator—will likely continue as long as market economies flourish.

Entrepreneurs have been described in terms of the commonalities among themselves, in terms of the differences between them and non-entrepreneurs, and in terms of the varieties and complexities among them and their ventures.[14]

Psychological traits typically ascribed to entrepreneurs include: high needs for achievement, aggression, autonomy, independence and leadership; high tolerance for ambiguity, change, and uncertainty; internal locus of control; moderate propensity for risk-taking; low need for support, conformity or benevolence.[15]

Family backgrounds, birth order, education, experiences, psychological characteristics, successes, failures, goals and hobbies are among the many profile items about entrepreneurs that have been tabulated analyzed and summarized.[16]

Economic outcomes accredited primarily to entrepreneurs include: the creation of innovations, new ventures, new jobs, new products and new processes.[17]

Economic definitions of the entrepreneur have included "the fourth factor" of production (after land, labor and capital); employers of

factors of production; suppliers of financial capital; financial risk takers, innovators, decision makers; managers or superintendents; organizers or coordinators of economic resources; proprietors of businesses; and arbitragers or allocators of financial resources to alternative uses.[18]

This level of definition includes work that describes entrepreneurship as new venture creation; as "intrapreneurship"[19] and corporate venturing[20] (the former is often carried out in spite of corporate neglect and/or hostility; the latter is the result of corporate strategic intention and support); as a function of interactions among entrepreneur, organization and environment[21]; as a function of innovation[22]; and as purposeful behavior[23].

William Gardner's 1990 delphi research into characteristics of different aspects of entrepreneurship produced a list of eight major themes. It indicated that entrepreneurship:

1) involves individuals with special characteristics (such as risk taking, perseverance, commitment, etc.) that make them different from other types of people;

2) involves doing something new as an idea, product, service, market or technology in a new or established organization;

3) involves new venture creation activities such as acquiring and integrating resources into the new business;

4) involves creating value (which can accrue to society, the entrepreneur, stockholders, customers, etc.);

5) involves for-profit organizations only;

6) requires that the entrepreneur's organization grow;

7) requires some uniqueness (as characterized by a unique idea, concept, market, product, service or technology);

8) requires individuals who become owner/managers through starting or acquiring a business (any kind of business).

Another view is that entrepreneuring is a purposeful behavior directed at the management of economic change, uncertainty and innovation. Its characteristics include anticipating and adapting to change, finding and exploiting opportunity in change, capitalizing on and managing uncertainty, and creating and implementing innovation. Given this definition, entrepreneurial management is the form of management that will be most effective and productive for America's future—a future in which people and information are the principal strategic resources, a future in which the economic arena is global and inescapably interdependent, a future in which change and uncertainty are the norms and innovation is the path to success.

Entrepreneurship also has been defined in terms of its contributions to the health of the American economy.[24] The list of contributions includes creation of the majority of new jobs in the economy; opening of most of the entry-level jobs for the young, inexperienced, unconnected or otherwise unemployable; providing opportunities to women and minorities for productive and well-paying jobs not often available in established businesses; the creation and implementation of most basic innovations and some improvement innovations, as well as the majority of new products, new processes and exports; a significant portion of local, state and national income and taxation; and the promotion of human satisfactions that are often unattainable in large bureaucratic organizations.

In a discussion of the national policy implications of the economic productivity of new ventures, Karl Vesper, a dean of studies in entrepreneurship (who defines entrepreneurship principally as new venture creation), listed eleven major challenges to the United States and cited significant entrepreneurial contributions to each. The challenges were national defense, industrial productivity, foreign competition, energy conservation, mineral shortages, pollution control, agriculture, unemployment, disaster response, health needs and economic malaise. "Entrepreneurship," wrote Vesper, "seems to capitalize on certain characteristics that stimulate Americans to do their best."[24a]

Clearly, by whatever definition, entrepreneuring is vital to the economy and entrepreneurs' decision-making is worthy of study. Several of the entrepreneurs in this study remarked about the disparity between its contributions and the attention it receives. As one of them said:

> When entrepreneurial businesses are responsible for so much of the GNP, you'd think they'd figure it out.

A Paradigm of Entrepreneuring

Howard Stevenson has proposed a model of entrepreneuring which places entrepreneurial behavior on a far end of the continuum of general management dimensions.

Stevenson's paradigm defines the entrepreneur by his focus on responding to opportunity and other external pressures and by the nature of his responses (irrespective of whether they are effective) to both external and internal pressures.

What is most persuasive to me is that this definition is based on concepts of traditional general management work. It suggests that (like leaders) entrepreneurs take the normal tasks of management to another level—to a level of perspective, commitment, caring, involvement and behavior that produces qualitatively different results than the non-entrepreneur (or the non-leader). Indeed, one of my ongoing questions to myself was "what is different, with the individuals in this study, between what they do and what leaders do?; they all are heads of companies; why am I calling these people entrepreneurs rather than leaders?"

I believe that they have many characteristics in common, and many of the same themes recur in their stories[25], and that a leader may be an entrepreneur and an entrepreneur a leader, and at their best each is both. But their characteristics and behaviors and goals are not mutually inclusive.

The defining characteristics of leadership, as Warren Bennis has written, are qualities of judgment and character, including vision, competence and balance, collaboration, an attitude of serving, trustworthiness, empathy and the ability to inspire others through the communication of full self-expression. They are qualities which "inevitably deal with the nature of man," and which can transform entrepreneurs and non-entrepreneurs into the best of teachers, the best of what it is to be human.

Stevenson's paradigm of entrepreneurial behavior[26] depicts a continuum of traditional general management tasks: strategic orientation, commitment to opportunity, commitment of resources, control of resources, and management structure. The end points of the continuum are entrepreneurial behavior, which is elicited by external pressures on the organization, and administrative behavior, which is elicited by internal pressures. Examples of external pressures are

- diminishing opportunity streams; rapidly changing technology, consumer economics, social values and political rules (in the dimension of "strategic orientation");

- need for action orientation; need to manage risk; short decision windows; limited decision constituencies ("commitment to opportunity");

- lack of predictable resources needs; lack of long-term control; social need for more opportunity per resource unit; international pressure for more efficient resource use ("commitment of resources");

- increased resource specialization; long resource life compared to need; risk of obsolescence; risk inherent in any new venture; inflexibility of permanent commitment to resources ("control of resources"); and

- coordination of key non-controlled resources; challenge to legitimacy of owner's control; employees' desire for independence ("management structure").

The entrepreneurial management behaviors elicited by these external pressures, following Stevenson's model, are

- strategic orientation driven by the perception of opportunity;

- commitment to resources that is revolutionary, with short duration;

- commitment of resources that is multistaged, with minimal exposure at each stage;

- control of resources through episodic use or rent;

- organizational management through flat structures with multiple informal networks.

Contrast these management behaviors with the paradigm description of administrative behaviors: "strategic orientation driven by resources currently controlled; commitment to opportunity that is evolutionary and of long duration; commitment of resources that is single staged, with complete commitment upon the decision to commit; control of resources through existing ownership or current employment of required resources; and organizational management through a formalized hierarchy."

This is not to say that entrepreneurs are not subject, as well, to internal organizational pressures that elicit administrative behavior. It is to say that their responses to internal pressures tend to be less interested, less consistent, less effective. These problems are not as open to creative solution, perhaps, not as interesting, not as much fun. But the internal pressures are real, and pressing:

- social contracts; performance measurement criteria; planning systems and cycles ("strategic orientation");

- acknowledgement of multiple constituencies; negotiation of strategy; risk reduction; management of fit ("commitment to opportunity");

- personal risk reduction; incentive compensation; managerial turnover; capital allocation systems; formal planning systems ("commitment of resources");

- power, status and financial rewards; coordination; efficiency measures; inertia and cost of change; industry structures ("control of resources"); and

- need for clearly defined authority and responsibility; organizational culture; reward systems; management theory ("management structure").

An entrepreneur's response to them, as much as his response to external pressures, determines the difference between success and failure. My interest in his decision-making, and the initial motivation for this study, was an attempt to understand how an entrepreneur bridges and balances his responses to both external and internal pressures—why and how he makes turning-point decisions.

ENTREPRENEURS ON ENTREPRENEURING

Many of the entrepreneurs I interviewed for this book remarked about themselves as entrepreneurs or about entrepreneurs in general. They talked primarily of risk (notably of not understanding risk), and of problems inherent in the phenomenon. Their descriptions suggest the breadth and subtle similarities and differences among them; their words speak for themselves.

No question that they'll put the mortgage on the house....(we) take concrete, deliberate steps to put all the resources into the business.

They don't understand risk in a real visceral sense, are not any good at measuring the rewards against the risk they're taking....believe they can do whatever is necessary to deliver the goods and the quality....Are one with their businesses.

They're loners...[they] made decisions themselves, without weighing risk and reward. Do not see risk, only see the reward. Always think they can beat the odds.

They come up with an idea of a product and never ask the question "What if it fails?"

[He or she is always] trying to do things he shouldn't try, doing things he shouldn't be trying to do...."Whatever problem comes up we'll solve. Don't bother me with problems."

You feel indestructible...you're always saying. "Why can't we make it bigger!" This is a typical entrepreneurial shortcoming.

Doing everything, making all the decisions, not listening, and not delegating were the problems most frequently mentioned.

Pictures himself always at the bow calling all the right shots...without [acknowledging] the interactions of other people and their influence on his thinking, and their judgments, which he takes in as information....do all the work, know all the ins and outs of the business....are so indelibly linked to his success that even though he thinks he has a formula, even his formula is always changing, so it's hard for a replacement or for the next generation to follow.

Somebody who is out there alone and basically making every decision.

They have their fingers in every pie in the business.... [They] do everything, make every decision. Even if they don't want to, they do it all, don't know how to stop.... [They often] got started by taking risks and by doing everything. They don't know where to draw the line, to distinguish between doing everything and making all the decisions and not [having it occur] to them to stop. Things occurring and not occurring make a big difference.

[Entrepreneurial companies] have a problem because ownership and management are the same person and if they don't like the answer [from someone else or from themselves] they'll sabotage it somehow. Have to learn to pay attention to their internal integrity, separate from the business.

In good times, [an entrepreneur] doesn't spend enough time looking at decisions.

Don't know where responsibilities start and end, don't delegate well, want to keep hands in lots of different things and find it hard to break the habit of getting into it all.

[An entrepreneur] is good observer, good assembler of information, good analyzer of information early in career. As he becomes more successful, he starts imposing more and more of his views on the data and therefore the data and conclusions from it are less pure. Really want to be my own boss and really do my own thing and take care of that need; that's a need, not a want.

They are addicted to the frantic pace which they create, so they have to work all the time, and do, won't let go. "Today we're doing this and tomorrow we're going to do something else because that's the way I feel about it."

They're responsible for everything. [They] always did the work themselves, in their minds—each a lone ranger. Founders need to go away, to have a chance to start their own business again, because they can't handle their own businesses when it gets beyond a certain size.

They don't listen, because that's not how they won. They won against people telling them that won't work.

They also talked about entrepreneurs' special strengths and skills.

They are good at what they do, are well-informed, they're able to take information and they don't need a computer, have good sense, are very observant, are very sensitive, are very good at assimilating data and very quick at distinguishing what's important and what's not....

One of the great, most important things about the entrepreneur is people skills, people skills are everything. Can be downright dumb, but have incredible people skills, and be smart enough to surround themselves

with people who can fill in for their inadequacies....enjoy doing deals, enjoy conceiving something, bringing people together and getting it done and moving on to something else. Have no interest whatsoever in running anything on an ongoing basis.

[An entrepreneur] likes to build, or likes to take a structure that has collapsed and redesigns it and rebuilds it to be a better one.

They stand up for what they believe in, have passion for it, take ownership for their responsibilities.

They are good assessors of opportunities, good bringer-together of people, good assimilator of ideas, but don't want to run businesses....Not so much a pride of authorship of ideas—because if this idea doesn't work, I'll have another one tomorrow—but the ego is in causing change.

They want to build something, want to leave behind something that didn't exist. Have letdowns when we turn things over to someone else, so need to go get the next one and the next one....

We're always getting another one, when we're an entrepreneur at heart, we're artists, all artists at heart, doing this we're artists, creating a whole concept, all artists, all have another picture in us. I'm probably the kind of guy who's got eight more pictures that are just partially made and designed up there and they're just waiting.

The people aspect of it, this really was almost a fertile ground for the entrepreneurial mind....Add more value than the original idea, by establishing manuals, training, systems.

Businesses are very much the extension of their values and feelings and drives...and of the translation [of their ideas]. I have an idea and now am going to translate that into something which really earns money....

Because you can't really make something out of nothing, you have to make it with sweat and effort and some luck—but mostly it's sweat and effort. Those ingredients are driven by those values. Are driven by these propensities and take on those propensities, and they're really only slightly modulated by the outside world, only slightly....

These are some of the common themes, the roots and shoots, that run through the process of entrepreneurial decision-making. Some descriptions of entrepreneurs, by these entrepreneurs, agree with the research outlined above, others do not. It is a broad and discursive and elusive concept.

As Peter Kilby[27] has observed:

> The search for the source of dynamic entrepreneurial performance has much in common with hunting the Heffalump. The Heffalump is a large and rather important animal. He has been hunted by many individuals using various ingenious trapping devices, but no one so far has succeeded in capturing him. All who claim to have caught sight of him report that he is enormous, but they disagree on his particularities. Not having explored his current habitat with sufficient care, some hunters have used as bait their own favorite dishes and have tried to persuade people that what they caught was a Heffalump. However, very few are convinced and the search goes on.

MAKE UP YOUR MIND

Appendix B ✒

Models of Decision-Making

The literature on decision-making focuses primarily on theoretical models of technique—the how's, ranging broadly from descriptions of the tightly analytic, such as the structured use of quantitatively-derived decision trees, to the loosely intuitive, or it focuses on prescriptions—the ought's and should's—for making better decisions.

The "how's" have been described in various process models as intentional, consequential and optimizing[28], and in so-called "garbage can" models[29], which acknowledge limited rationality, conflict, complexity and preference ambiguity, as opposed to an ideal order and the existence of an optimal choice, and which are therefore subject more to time-ordered, circumstantial influences than to what the decision maker controls.

From perspectives of psychology to organizational structures, from information acquisition and processing to communications, from leadership to power and politics, from mathematics to poetry, and many gestalts in between, the literature on decision-making is complex, rich and worthy of its voluminous attention.

The two poles of these models are formal (or "decision") analysis and intuition. As poles, they represent the simplest of differences between general ways of thinking and making decisions. Except in description such as this, they are more complementary than exclusive, the weight given to one or the other a factor of the interrelationship of individual and environment and the problem being addressed.

Formal Analysis

Howard Raiffa has set the standard of work for the mode of choice that is "decision analysis." Raiffa argues that, although the best choice of alternatives is often clear without much analysis, or often issues aren't important enough to warrant great attention, there are many circumstances where careful analysis—systematic and hard thinking about alternatives, putting the numbers to the page—is essential. These are circumstances of uncertain consequences, uncontrollable events, and conditional responses—usual and common conditions in business today and in virtually every important decision that today's entrepreneur faces. The "simple science" of analyzing these real problems, Raiffa says, has four stages:

- Exhibit the anatomy of the problem in terms of a decision-flow diagram or a tree;

- Describe and evaluate the consequences in utility numbers;

- Assign probabilities to the branches of chance forks;

- Determine the optimal strategy by averaging out and folding back.[30]

The "art" of analyzing real problems, Raiffa continues, is "messier," because problems are messy—trees whose branches seem to proliferate everywhere and whose growth never stops. And problem messiness is compounded because the decision maker must "treat subjective probabilities as if they were objective," numerically scaling subjective feelings about vague but relevant uncertainties (including his attitude toward risk and his evaluations of the people involved and his hunches and vague impressions) "in terms of judgmental prob-

ability distributions," modifying them in light of sample information that is gathered. Similarly, he must continually reassess and revise all of the probabilities—subjective feelings and vague hunches having become numeric values—based on the experimental evidence being gathered. And then work backwards from the tips of the tree toward its root. The steps are:

- Understand attitude toward risk in broad terms;

- Adopt certain consistent rules which have intuitive appeal; use a surrogate commodity for money (such as a scale 0-10), which becomes the "ticket" value of the "prize" at the top of each branch;

- Multiply this "ticket value" by the probability of getting that branch;

- Sum these products over all the branches;

- Analyze by going backward, averaging-out and folding-back.

Simply put, those are the steps of formal decision analysis. Some variation of these steps, although usually less mathematical, is what generally is considered to be logical decision-making, or to be "analytical."

Similarly, in comparing traditional decision-making models, Michael Murray critiques "rational" decision-making ("expressed by the bottom line"), "political" decision-making ("a covert process based on self-interest, personal preference or ideology"), and the "legal" model, based on and derived from a set of fixed principles and precedents.[31] All of these models and their variations have in common three distinct phases—analysis, design and choice—and may include a re-analysis, self-evaluation stage and a final implementation phase.

As the entrepreneurs and I talked about whether or not their decision processes are analytical, we were asking whether they follow some procedure like this, some deliberate and conscious working through of some ordered and weighted steps of analysis.

Whether he uses formal decision analysis or some approximate version, the decision maker himself clearly is part of the analysis. And the decision maker, Raiffa notes, must choose; indecision or "refusal to play are themselves definite choices with both payoffs and consequences."

> Even if you don't analyze your decision problem by this methodology...you still must act. What will you do?

> In my opinion, there are three justifications for adopting the methodology of decision analysis: The underlying behavioral assumptions are appealing; This methodology is an operational mode of analysis; What will you do otherwise?

Intuition

"Do otherwise," Weston Agor would say. "Make decisions based on how you feel, trusting yourself," using your intuition.[32]

In a study of some 3,000 executives in their use of intuition in guiding key decisions, Agor found that intuitive management ability appears to vary, dramatically, by management level, level of government service, gender, occupational specialty, and to some degree ethnic background. Notably, the top executives in every field, including government service, scored highest in both intuitive ability and in their use and knowledge of using intuition to make important decisions.

Agor argues that intuition is most useful in decision situations where there is a high level of uncertainty and/or high risk, little previous precedent, variables which are not scientifically predictable, inadequate or inconsistent data, lack of correspondence between data and the decision to be made, where time is limited and there is great pressure to be right, and where there are several plausible alternative choices with good arguments for each one.

The daily fare of top executives includes solving complex and messy problems; dealing with rapid, constant change and omnipresent un-

certainty and with the motivation of peers and subordinates in uneasy and unstable times; and integrating factual information with personal needs, wants, attitudes and skills—all at an unrelenting pace and in the face of dwindling resources.

Note that these are the same messy-problem characteristics—uncertainty and ambiguity—for which Raiffa argued the merits of formal decision analysis. But, the point is, Agor would argue, there is neither time, resources nor purpose for engaging in formal decision analysis. Only highly skilled intuition can be a match for the contentious, messy management issues of the 1990s.

The interviews that appear in this book illustrate that the real point is that both analysis and intuition are necessary—along with emotional influences.

Of particular interest to me, given my notion that what is commonly called an entrepreneur's intuition is, in fact, expertise of a high order, were the responses given by top executives in Agor's 1984-1985 survey questionnaire about the nature of intuition:

> I don't think intuition is some magical thing. I think it is a subconscious drawing from innumerable experiences which are stored. You draw from this reserve without conscious thought.

> Not a conscious effort....After a lifetime of dealing with people and people problems and with many of these dealings having a life and death outcome, I feel that most life experiences are similar....These I store in the recesses of my mind to recall at later times when decisions must be made.

> Intuition allows one to draw on that vast storehouse of unconscious knowledge that includes not only everything that one has experienced or learned....

> I believe that good intuitive decisions are directly proportional to one's years of challenging experience, plus the number of related and worthwhile years of training and education, all divided by lack of confidence or fear of being replaced.

This view of intuition—that is it based on experience and expertise—increasingly is shared by researchers in psychology, as well. As Michelene Chi has said[33]:

> The more expertise a person has, the more intuitive he or she is. People who have expertise in a subject have a larger, more organized data base in their brain. And they can arrive at solutions to problems more quickly than those who have less experience. Intuition is not as magical as you might think.

Agor notes that individual executives are conscious both of using intuition in different ways for different types of decisions, and of the personal methods or "systems" they employ to maximize its value. The two major ways of using intuition, he writes, are at the "front end" of the decision, as an "explorer," and at the back end as "synthesizer and integrator."

The "explorer" flows with his intuition, playing with concepts and possibilities and ideas heuristically, making sense of any stimuli that come to his attention. The "synthesizer/integrator" has a more structured process, first gathering and sorting through or analyzing all relevant data, then digesting, sifting, mulling, incubating. A third group, "eclectic," uses intuition to make early decisions, prior to data, but keeps the data coming in for cross-checking and validation; or may use intuition after a decision is made to test feelings of comfort/discomfort.

In describing how they know their intuition is right, the top executives in Agor's study cite a "common set of feelings" which include a "certainness—an undeniable rightness which feels very comfortable." Similarly, another common set of feelings alerts them to pending decisions that are not comfortable and therefore not right: "We call them the '3 a.m. decisions'."

Intuition has been described by scholars as an activity of the right side of the brain, as "a way of knowing without knowing how you know," as a "flash of knowledge," as "a natural mental ability that gives the whole picture," "a way of recognizing the possibilities in a

situation," "a highly efficient way of knowing and of processing a wide array of information on many levels to achieve an instantaneous cue." In the words of some users, it is "strange feelings," "gut feelings," "powerful inner voices," "internal radar," strong urge," "overwhelming powerful feeling." Among physicians it may be called "clinical judgment."

However it is described, intuition is felt by its users. And it often is consciously utilized by them as a rational way of making better decisions. With growing acceptance and acknowledged use of intuition by business executives, interest has grown in understanding how it can be honed and strengthened. It is increasingly studied and practiced. Numerous articles, books and workshops describe and promote ways of increasing intuitive abilities. Among them are directions to "quiet the background noise of life," to adopt a "free-floating," creative, rather than coping, approach to life, and to trust yourself. And to do your homework.

The basic principles and guidelines of enhancing intuitive ability are similar among authors, as is the admonition that incorrect intuitive decisions are caused by failure to follow the basic principles of intuition. These principles include honesty and lack of attachment to one's own decision preferences, clarity of seeing and accepting what is real, rather than what we want a situation to be, and attention to the personal process of allowing intuition to work effectively.

Other guidelines for enhancing intuition include intent (valuing intuitive ability and determining to develop it); the ability to release physical and emotional tension; sufficient time available for reflection; being open to internal cues; and recognizing self-deception habits.

Humbler Decision-Making

Some authors have taken more inclusionary and cohesive approaches to decision-making. Hillel Einhorn and Robin Hogarth, for example, make a clear distinction between the modes of thinking used "constantly" in the complex decision processes of managers: "thinking

backward" and "thinking forward."[34]

"Thinking backward," they say, is "largely intuitive and suggestive," tending to be diagnostic and requiring judgment. It involves looking for patterns, making links between seemingly unconnected events, testing possible chains of causation to explain an event, and finding a metaphor or a theory to help in looking forward.

Thinking forward is different. Instead of intuition, it depends on a kind of mathematical formulation: the decision maker must assemble and weigh a number of variables and then make a prediction. Using a strategy or rule, assessing the accuracy of each factor, and combining all the pieces of information, the decision maker arrives at a single, integrated format.

Amitai Etzioni points out that "decision-making in the 1990s will be even more of an art and less of a science than it is today."[35] The expectation that decision-making should be intentional, consequential, and optimizing—in a word, "rational"—has given way, pushed by the accelerating rate of change, inseparable events, leaping technology, shrinking resources, human limitations and a general "lack of slack." In its stead are more adaptive ways of decision-making that acknowledge needs for flexibility, carefulness and human reasonableness—such as cooperation, coalition building, consensus and participation at every level.

Etzioni describes several centuries-old, adaptive decision-making strategies that serve far better than rational analysis in today's world. "Humble decision-making," he writes,

> is a mix of shallow and deep examination of data, generalized consideration of a broad range of facts and choices followed by detailed examination of a focused subset of facts and choices.

"Humble" decision-making includes mixed scanning, focused trial and error, tentativeness, procrastination, decision staggering, fractionalizing, hedging bets, maintaining strategic reserves and making reversible decisions.

That's a very different picture than the ordered stages and phases of rational analysis or an exclusive reliance on intuition. Yet it all sounds very much like what we all do most of the time in our real worlds, and it reflects, more accurately than either formal analysis or intuition, how the entrepreneurs in this story described their decision-making.

DECISION STYLES

Another related take on decision-making, a combination of the questions of "how" and "why," is exploration of "decision-styles." Based primarily on Jungian concepts of the patterning of thinking, sensing, intuiting and feeling functions, "decision styles" analysis has become a popular tool for executive development.

An example of pivotal scholarship on decision-making in the Jungian tradition is Ian Mitroff and Ralph Kilman's framing of archetypes of scientific inquiry.[36] The archetypes are the "Analytical Scientist," corresponding to a combination of Jung's sensing-thinking types; the "Conceptual Theorist," corresponding to a combination of Jung's intuition-thinking types; the "Conceptual Humanist," to Jung's intuition-feeling types; and the "Particular Humanist," to Jung's sensing-feeling types.

A similar typology, focusing on business executives, has been described by Alan Rowe and Richard Mason.[37] Rowe and Mason suggest four basic decision styles which in combination among individual executives pervade every function, level and aspect of management. The dominant combinations of these decision styles—directive, analytical, conceptual and behavioral—describe an individual's way of perceiving and understanding information, responding to stimuli, interacting with others, solving problems and making decisions. The four basic styles are:

> directive: makes decisions about and implements operational objectives in a logical, systematic and efficient way; task and technology focused, with needs for high degrees of structure and low levels of ambiguity;

analytical: consciously employs logical analytical planning and fore-casting; focused on task and technologies; comfortable with ambiguity;

conceptual: explores new options, creatively forming new strategies and taking risks; focus on people, social issues; less logical; tolerance for high levels of ambiguity;

behavioral: focus on people and needs; requires structure and low levels of ambiguity; also less logical.

Rowe and Mason argue the importance of alignment of an executive's decision style with his environment, organization, position and tasks. High alignment—"fit"—promotes optimum performance and peak experiences of an instinctive, subconscious nature. Lack of alignment produces negative reinforcement, loss of self-confidence, reduced commitment, lower motivation, lower performance and lower satisfaction. To achieve alignment and success, one must intuitively understand his dominant and backup styles and must find or reconfigure situations that are consistent with his decision style pattern.

What Rowe and Mason have called "the entrepreneurial style" is a combination of conceptual and directive styles (or the "dreamer-realist"). Similar to the high level of intuitive thinking among top executives in Agor's study, this decision style is common among both entrepreneurs and high level executives. Rowe and Mason found that 59 percent of the CEO/chairman group and 62 percent of the presidents in their study share this "entrepreneurial style" with the entrepreneurs for whom it was named. Characteristics of the "entrepreneurial style" are:

- conceives of a new idea by reflecting on a number of considerations and responding to intuitive feelings;
- shifting of mental images as he moves idea into reality;
- decisions are made, actions are taken and reflections are short-circuited for awhile;

- upon completion of detailed tasks, executive then needs to stop, step back, evaluate and reconceptualize the directions and plans;

- a new strategy is charted; then back to the directive mode, with its sequential attention to tasks and the making of decisions necessary to transform the ideas into reality.

In the real world, especially in the real world of entrepreneurs, decision-making is some combination of analysis, emotion, intuition and style, generally as mixed and messy and individual as the problems to which it is addressed. All of these approaches to decision-making and decision styles shed light on the retrospections and the stories of the sixty entrepreneurs in this rhizome.

Henry Mintzberg's very structured study of "unstructured decision processes" defined some key words in ways that I find useful in summing-up how they are used here. They are:

- decision: a specific commitment to action;

- decision process: a set of actions and dynamic factors that begins with the identification of a stimulus for action and ends with the specific commitment to action;

- unstructured: decision processes that have not been encountered in quite the same form and for which no predetermined and explicit set of ordered responses exists in the organization (or individual);

- strategic: important, in terms of the actions taken, the resources committed, or precedents set.[38]

Mintzberg and his colleagues had concluded from studies of individual decision-making that

> decision processes are programmable even if they are not in fact programmed: although the processes are not predetermined and explicit, there is strong evidence that a basic logic or structure underlies what the decision maker does and that this structure can be described by systematic study of this behavior.

He noted that research on individual decision-making

> relies largely on eliciting the verbalizations of decision makers'
> thought processes as they try to solve simplified, fabricated prob-
> lems, such as cryptarithmetic or chess. These are then analyzed to
> develop simulations of their decision processes. This research in-
> dicates that, when faced with a complex, unprogrammed situa-
> tion, the decision maker seeks to reduce the decision into sub-
> decisions to which he applies general purpose, interchangeable sets
> of procedures or routines. In other words,...by factoring them into
> familiar, structurable elements. Furthermore...(the decision maker)
> uses a number of problem solving shortcuts—"satisficing" instead
> of maximizing, not looking too far ahead, reducing a complex en-
> vironment to a series of simplified conceptual "models."

That is one way to explore individual decision-making. Mintzberg
pursued another, not through simulations but almost equally struc-
tured.

We, the entrepreneurs and I, have explored another approach. It was
unstructured, discursive, meandering, opportunistic—following re-
membrances and thoughts, rather than survey questionnaires or sys-
tematic examination of predetermined variables—in the manner of
a rhizome. Most importantly, our explorations were collaborative,
creating patterns in the meaning of their recollections.

Appendix C ✒

Strategy as Pattern

Another of the conceptual tendrils of this rhizome is strategy. What is strategy for the entrepreneur (other than an oft-times dirty word)?

In classic organizational theory, the concept of strategy is described as intentional planning to reach a predetermined goal, much in the manner of deciding to grow a tree and working backward to plan the specific characteristics of branching and growth from the root that must be developed to achieve that desired tree.

Bruce Henderson[39] defined strategy as "a deliberate search for a plan of action that will develop a business's competitive advantage and compound it." He went on to say:

> Strategy is the management of natural competition...The basic elements of strategic competition are these:
>
> 1) ability to understand competitive behavior as a system in which competitors, customers, money, people and resources continually interact;

2) ability to use this understanding to predict how a given strategic move will rebalance the competitive equilibrium;

3) resources that can be permanently committed to new uses even though the benefits will be deferred;

4) ability to predict risk and return with enough accuracy and confidence to justify that commitment; and

5) willingness to act.

Grounded in ancient military strategy and extended to modern game theory, scholarly theories of organizational strategy are focused primarily on the competitive activities of very large corporations. They tend to take either an economic approach, concerned with the position of the firm vis-a-vis its competitive environment, or an organizational approach, concerned with institutional or behavioral issues within the firm itself.

Among organizational approaches to strategy there is a broad range of definitions of what strategy is, what level of analysis is appropriate and what focus is productive. Typically, the dependent variable is the firm's performance relative to its competition, the tone of research results is prescriptive (with improved practice as its goal), and the emphasis is on top management decision-making and related issues.

Among definitions of strategy, including the classic "strategy as plan," Henry Mintzberg has delineated five which have been most actively pursued among strategy scholars. He emphasizes the overlapping, interrelated nature of these five definitions, describing the concept of strategy as itself a simplifying concept, an idea that allows organizations "to set direction, to focus effort, to define themselves, to reduce uncertainty and provide consistency...in order to aid cognition, to satisfy intrinsic needs for order, and to promote efficiency under conditions of stability (by concentrating resources and exploiting past learning)." "Strategy," says Mintzberg, "is a force that resists change, not encourages it." The five definitions are strategy as:

- plan: a consciously intended course of action, either general or specific, made prior to actions to be taken;

- ploy: a variation of plan that is a specific maneuver to best a competitor or opponent; strategy at its most dynamic and competitive;

- pattern: perceived consistency in behavior or actions, which may be either intended or not intended (emerging within the situation); may be inferred or deduced;

- position: the location of an organization in its environment, where its resources are concentrated; "root strategy"; strategy as mediating force between organization and environment; strategy as niche, or domain, or as collective and political; may be seen either as a plan or a pattern;

- perspective: an ingrained way of seeing the world; worldview; gestalt; collective sharing of intentions and/or actions; developed from plans and/or patterns; at least relatively immutable.

Of these "five Ps for strategy," as Mintzberg calls them[40], strategy as plan and strategy as pattern are the most frequently utilized concepts. Strategy as plan is the expected, the traditional definition, for both strategy scholars and others.

Strategy is a purposeful plan to accomplish something specific in a certain way. It includes goals and the intended means to achieve them.

The essential characteristic here is "intention." Deliberate plans are made in advance of future decisions and/or future actions, to achieve the intended goals on which the plans are based. "Strategy as plan" is the basis of the rules of game theory, military theory, administrative management theory and contemporary competitive strategic analysis.

What Is Real For Entrepreneurs

But "strategy as plan" is not, it seems to me, what goes on in entrepreneurial firms. It does not fit the phenomenon of entrepreneuring

nor the thinking of most entrepreneurs. Planned intention, planned action, planned follow-through to an intended goal all have little to do with the real worlds of most entrepreneurs. There, the entrepreneur tends to be driven by perceptions of opportunity, reactive rather than proactive, without regard to resources currently controlled. His preferred commitment of resources is short duration, rather than committed in advance to a long-range objective. His commitment is "multi-staged," with minimal exposure at each stage.[41]

Perhaps because of this lack of fit between the classic concept of "strategy as plan" and the reality of entrepreneuring, relatively little research and writing has been done on entrepreneurial strategy or on entrepreneurs' making of strategy. The first notable exception was Mintzberg's series of searches for strategic patterns in streams of actions in entrepreneurial and ad hoc firms.

I was genuinely elated when I first encountered this series of studies. Here was not only a definition of strategy that made sense for the phenomenon of entrepreneuring, that fit the entrepreneurial firm, but Mintzberg also had developed a proven methodology for getting at the difficult research issues of looking at entrepreneurs' strategy-making.

This distinction between strategy as pattern and strategy as plan is not clean and crisp, of course. Kenneth Andrews had defined corporate strategy as the company's pattern of decisions:

> ...that determines and reveals its objectives, purposes, or goals, produces the principal policies and plans for achieving those goals, and defines the range of business the company is to pursue, the kind of economic and human organization it is or intends to be, and the nature of the economic and noneconomic contributions it intends to make to its shareholders, employees, customers, and communities.[42]

Gordon Donaldson and Jay Lorsch, following Andrews and Mintzberg, also define strategy as patterns of decisions.[43] Their emphasis is similar to Mintzberg's—on the revelation of strategy over time:

...we define strategy as the stream of decisions over time that reveal management's goals for the corporation and the means they choose to achieve them. As such, a strategy may be explicitly stated or may be only implicitly understood by the decision makers.

STRATEGY AS PATTERN

The definition that fits entrepreneuring is "strategy as pattern." In it, Mintzberg describes intention (that requirement of strategy as plan) as only one of the possible ways in which strategy is made. Strategy as pattern in streams of actions, as it is defined by Mintzberg, includes both strategies as intended and strategies as realized.[44]

"Intended strategies," says Mintzberg, are a perceptual phenomenon formulated on the basis of a priori guidelines (i.e., planned). They may be "realized," in which case they become tangible, or "unrealized," in which case they do not lead to decisions or to actions. "Realized strategies" are a tangible phenomenon which can be operationalized, formed by a sequence of decisions made one by one. Realized strategies may be "deliberate" (intended) or "emergent." "Emergent strategies" develop out of and are realized through the reality and contingencies of the organization, rather than through intentions or plans. When considered together, through retrospective searches for patterns in streams of actions, realized strategies form a series of a posteriori consistencies—a pattern.

Mintzberg writes that intended and realized strategies can be combined in three ways:

- deliberate: intended strategies that get realized; and/or emergent strategies that get formalized; and/or intended strategies that get over-realized;

- unrealized: intended strategies that do not get realized;

- emergent: realized strategies that were not intended; intended strategies that change form and become emergent; emergent strategies that become formalized into deliberate strategies (as when the strategy-maker sees an unin-

tended pattern in the stream of decisions and actions and then adapts that pattern as an intention for the future; or when the strategy-maker creates a gestalt strategy out of an emerging pattern, as is often the case in entrepreneurial firms).

The essence of Mintzberg's definition of strategy as pattern, then, is that strategies can form as well as be formulated. Strategies can be based on plan and intention and also on unplanned, emergent decisions and actions. Action can drive thinking as well as vice versa. His classic exposition of strategy in large organizations described strategic changes which were not planned but were "the result of autonomous strategic behavior rather than being induced by a clear concept of strategy articulated by top management."

This is the concept of strategy—"strategy as pattern"— that I think is most applicable to entrepreneurial decision-making. It is also a concept of strategy that I think even the most extreme of entrepreneurs will accept. Even that entrepreneur who says "This is not a plan; I don't make plans!" agrees that his decisions and actions can, over time, reveal patterns that constitute some kind of retrospectively discovered "strategy."

An ear for those patterns—an ear for "strategy as pattern" in the stories of these sixty entrepreneurs—was among the operators, for both entrepreneur and me, of our talks.

End Notes ❧

Chapter 2

[1] Gilles Deleuze and Felix Guttari, A *Thousand Plateaus: Capitalism and Schizophrenia*. Minnesota, University of Minnesota Press (1987).

[2] Haridimos Tsoukas, "The Missing Link: A Transformational View of Metaphors in Organizational Science," *American Management Review*, 16, 3 (1991), p. 570.

[3] John Clancy, *The Invisible Powers*. Massachusetts, Lexington Books (1989). p. 28.

[4] Sheldon Kopp, *Who Am I...Really?*. California, Jeremy Tarcher, Inc. (1987).

[5] Warren Bennis, *On Becoming a Leader*. Massachusetts, Addison-Wesley Press (1989), p. 115.

[6] Elliot Eisner, *The Enlightened Eye*. New York, Macmillan (1991).

Chapter 4

[7] For a discussion of the relevant literature on decision-making, see Appendix B, "Models of Decision-Making."

Chapter 6

[8] For a discussion of strategic planning in entrepreneurial companies, see Appendix C, "Strategy as Pattern."

Chapter 12

[9] Stephen Covey, *The Seven Habits of Highly Effective People*. New York, Simon & Schuster (1989).

[10] The most notable exception was an entrepreneur going through a self-described "mid-life crisis," expressing a lack of caring about the business, the employee or his family, and not wanting to take responsibility for any of it.

Appendix A

[11] Robert Reich, *The Next American Frontier*. New York, Times Books (1983).

[12] David Osborne and Ted Gaebler, *Reinventing Government*. New York, HarperCollins (1991).

[13] In the mid-1980s, during the height of journalistic interest in entrepreneuring, virtually every newspaper and news magazine carried an article or reference to "The Entrepreneur." Some references were very sophisticated, such as variations on Robert Reich's "paper entrepreneurialism," applied to money managers and bond traders. Other references were less sophisticated—such as the word "entrepreneur" applied to every small business person hawking pet rocks, executive sandboxes or ice cream products from a trendy push-cart in an upscale neighborhood. In that climate, almost no single-operator small business person was exempted from the label. It is no less confusing that "entrepreneur" and "small business" continue to be used interchangibly by many journalists.

[13a] Joseph Schumpter, *The Theory of Economic Development*. London, Oxford University Press (1961); and *Capitalism Socialism and Democracy*. New York, Harper Bros. (1934).

[14] For an example of these analyses, see: William Gardner, "A Conceptual Framework for Describing the Phenomenon of New Venture Creation," *Academy of Management Review*. 10:4 (October 1985). pp. 696-706.

[15] See: Donald Sexton and Nancy Bowman, "Entrepreneurship Education at the Crossroads: A Plan for Increasing Effectiveness," *Journal of Small Business Management*. (April 1984); also, William Gardner "'Who is an Entrepreneur?' is the Wrong Question," *American Journal of Small Business*. 12:4 (1988).

[16] For examples of these analyses, see: Calvin Kent et al., editors, *Encyclopedia of Entrepreneurship*. New Jersey, Prentice Hall (1982); and 1981 through 1991 annual editions of the journal *Frontiers of Entrepreneurship*. published by Babson College in Wellesley, Massachusetts.

[17] See: Howard Stevenson, et al., *New Business Ventures and the Entrepreneur*. Illinois, Irwin (1985); Don Gevirtz, *Business Plan for America*. New York, Putnam (1984); and Karl Vesper, *Entrepreneurship and National Policy*. Chicago, Heller (1983).

[18] For an example of these analyses, see Robert Hebert and Albert Link, *The Entrepreneur*. New York, Preager Special Studies (1982).

[19] Gifford Pinchot, *Intrapreneuring*. New York, Harper & Row (1985). Pinchot's title illustrates the irresistible urge to play with the word "entrepreneur" and create various new meanings. Pinchot copyrighted his word, but many people use it anyway.

[20] Rosabeth Moss Kanter, *The Change Masters*. New York, Simon & Schuster (1983).

[21] William Sandberg, *New Venture Performance*. Massachusetts, Lexington Books (1986).

[22] Gerhard Mensch, *Stalemate in Technology*. Massachusetts, Ballinger (1979).

[23] Peter Drucker, *Innovation and Entrepreneurship*. New York, Harper & Row (1985). Drucker offers a definition which I think covers the most important aspects of the phenomenon: that it is purposeful behavior through which something new or different is created, through which value is changed or transmuted—and added. Drucker also made one of the first acknowledgements of the importance of the entrepreneurial sensibility in large corporate entities and in non-profit organizations.

[24] Among them are: David Birch, "Who Creates Jobs?" *The Public Interest*. 65 (Fall 1981); and Eli Ginzberg and George Vojta, *Beyond Human Scale*. New York, Basic Books (1985).

[24a] Karl Vesper, *Entrepreneuring and National Policy*. Illinois, Heller (1983).

[25] In *On Becoming a Leader*, Warren Bennis notes the common themes that recurred in his conversations with the American leaders whom he had interviewed in the 1980s:

> the need for education, both formal and informal; the need to unlearn so that you could learn...; the need for reflection on learning...; the need to take risks, make mistakes; and the need for competence, for mastery of the task at hand.

These are themes that also surfaced during my interviews with entrepreneurs. Learning, especially, both as an objective and as a result—from everyday experiences, from experimentation, from failure, from success—was a continuing issue for virtually all of them.

[26] This paradigm describes a "range" of individual and corporate behavior from "promoter" to trustee." It is based on these assumptions:

1) that the conventional psychological approach to defining the entrepreneur "is bound to fail" because entrepreneurship "is primarily a situational phenomenon," vulnerable to the "nature of the culture and the climate" established by the entrepreneur;

2) that "the strengthening of entrepreneurship has become a critically important goal of American society," because the accelerating "rate of change in the environment" requires that firms either respond extremely rapidly "to changes that are beyond [their] control," or that they are "so innovative that [they can contribute to that change],"

3) that "many of the practices of what we usually consider well-managed companies tend to inhibit entrepreneurial behavior."

[27]Peter Kilby, "Hunting the Heffalump," in *Entrepreneurship and Economic Development*. New York: Free Press (1971).

Appendix B

[28]James March, *Decisions and Organizations*. Oxford, Blackwell (1988). March traces process models from organizational psychologist H.A. Simon to management consultant Henry Mintzberg.

Simon's model included an intelligence phase (initiating activity), a design phase (exploring alternative courses), and a choice phase (selecting from among the alternatives). It was based on a concept of structured and orderly decision-making—determined by intention, clear alternatives rank by consequence, and choice made to achieve optimal results.

Mintzberg's model included instead a "dynamic, open system process subjected to interferences, feedback loops and dead ends"—an unstructured process. It was necessarily more complex and less orderly, with interrelated phases including "an identification phase of recognition and diagnosis routines, an alternatives development phase, with search and design routines, and a selection phase with screen, evaluation-choice and authorization routines." Mintzberg's model is also far more appropriate to the messy problems of contemporary management and the decision-making style of most entrepreneurs.

[29]Michael Cohen, James March and Johan Olsen, "A Garbage Can Model of Organizational Choice," *Administrative Sciences Quarterly*. 17 (1972). Cohen, March and Olsen conclude that:

> In a garbage can situation, a decision is an outcome of an interpretation of several relatively independent "streams" within an organization [because the problems, solutions, participants and choice opportunities so overload the...decision-maker that his intentions are] lost in context....

Chance and randomness are the more important elements of this decision process. Presumed rationality plays a lesser role.

[30]Howard Raiffa, *Decision Analysis*. Massachusetts, Addison-Wesley (1968).

[31]Michael Murphy, *Decisions*. Massachusetts, Pitman Publishing (1986).

[32]Weston Agor, *The Logic of Intuitive Decision-Making*. New York, Quorum Books (1986).

[33]Michelene Chi, a psychologist at the University of Pittsburgh, offered this quote in a 1990 *Los Angeles Times* article on business decision-making.

[34] Hillel Einhorn and Robin Hogarth, "Decision Making: Going Forward in Reverse," *Harvard Business Review.* January/February 1987.

[35] Amitai Etzioni, "Humble Decision Making," *Harvard Business Review.* July/August 1989.

[36] Ian Mitroff and Ralph Kilman, *Methodological Approaches to Social Sciences.* California, Jossey-Bass Publishing (1978).

[37] Alan Rowe and Richard Mason, *Managing with Style.* California, Jossey-Bass Publishers (1987).

[38] Henry Mintzberg, D. Raisinghani and A. Theoret, "The Structure of 'Unstructured' Decision Processes," *Administrative Sciences Quarterly.* June 1979.

Appendix C

[39] Bruce Henderson, "The Origin of Strategy," *Harvard Business Review.* (1989).

[40] Henry Mintzberg, "The Five P's of Strategy," *Harvard Business Review.* (1987).

[41] Howard Stevenson, *New Business Ventures and the Entrepreneuer.* Illinois, Irwin. (1985).

[42] Kenneth Andrews, *The Concept of Corporate Strategy.* New York, Basic Books (1971).

[43] Gordon Donaldson and Jay Lorsch, *Decision Making at the Top.* New York, Basic Books (1983).

[44] Henry Mintzberg, "Patterns in Strategy Formation," *Management Science.* 24, (1978).

MAKE UP YOUR MIND

Index